AN
INVITATION
TO
SEE

for Georgia

This book is okay
for drawing.

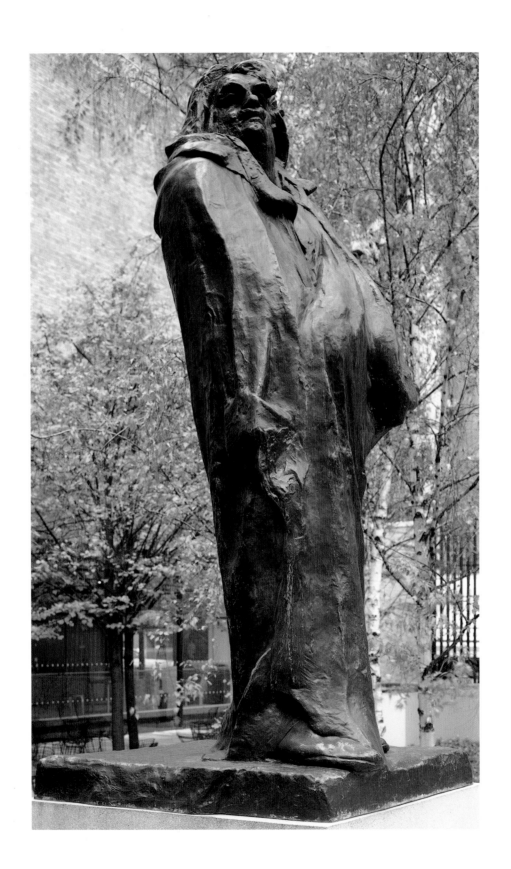

AN INVITATION TO SEE

150 WORKS FROM THE MUSEUM OF MODERN ART

HELEN M. FRANC

THE MUSEUM OF MODERN ART,
NEW YORK

To the Public of The Museum of Modern Art

Copyright © 1992 by The Museum of Modern Art, New York
All rights reserved
Library of Congress Catalogue Card Number 91-62544
ISBN 0-87070-398-6 (clothbound/MoMA and T&H)
ISBN 0-8109-6110-5 (clothbound/Abrams)
ISBN 0-87070-397-8 (paperbound)
Second printing, 1995

Produced by the Department of Publications
The Museum of Modern Art, New York
Osa Brown, Director of Publications
Edited by Harriet Schoenholz Bee
Production by Vicki Drake
Typeset by The Sarabande Press, New York
Printed and bound by Dai-Nippon, Tokyo
Printed in Japan

Published by The Museum of Modern Art
11 West 53 Street, New York, New York 10019

Clothbound edition distributed in the United States
and Canada by Harry N. Abrams, Inc., New York
A Times Mirror Company

Clothbound edition distributed outside the United States and
Canada by Thames and Hudson Ltd., London

Frontispiece: AUGUSTE RODIN. French, 1840–1917.
Monument to Balzac. 1897–98. Bronze (cast 1954), 9 feet 3
inches x 48¼ inches x 41 inches. Presented in memory of Curt
Valentin by his friends. [28.55]

CONTENTS

INTRODUCTION TO THE FIRST EDITION

THE TITLE OF THIS BOOK, like many of the ideas it contains, is taken from Alfred H. Barr, Jr., the first director of The Museum of Modern Art. In his introduction to *Masters of Modern Art*, published in 1954 on the occasion of the Museum's twenty-fifth anniversary, Mr. Barr wrote: "Today [the Museum's collection] numbers many thousands of works of art. A few of the best or most characteristic are reproduced here, more to give pleasure than for any systematic exposition or record. Even more, this picture-book is an invitation to see the originals!"

This more modest book deals only with paintings; it reproduces and comments upon one hundred and twenty-five from among more than two thousand now in the collection.* The choice has not been easy. Certain paintings would without doubt be included in any selection, but the respective claims of others are more difficult to assess. Every reader will therefore find here some of his favorites, wonder why others have been omitted, and perhaps encounter a few not previously known to him. Similarly, because space in the Museum's galleries, like the format of this book, is necessarily limited, on any one occasion the visitor will find on view a majority, but not all, of the pictures included here. The remainder, if not on loan, may be seen in the Study Center.

The principal criterion of selection has been to choose works that individually are of outstanding quality or significance, and that collectively demonstrate the remarkable diversity of styles and approaches characteristic of the modern achievement in painting. As Mr. Barr pointed out, this diversity is the result of differences among artists that "are real and significant, slowly developed, passionately believed in, and expressive not simply of artistic convictions but often of deeply felt philosophies of life."

This book is not intended to be an historical survey, and it does not attempt to define and trace the successive styles and movements within modern art. Its organization is somewhat unconventional. Though most of the earlier works will be found at the beginning, and the more recent toward the end, there are exceptions to that order, and throughout most of the book pictures are paired or arranged in sequences that disregard chronology and immediate stylistic or historical affiliations.

As the title indicates, the book is "an invitation to see." Its purpose is to focus attention on the individual paintings reproduced. Perception of the qualities in a work of art can sometimes be made more acute by comparing or contrasting it with another, with which it may share certain similarities while differing in other respects. It is such likenesses and differences—in subject matter, style, technique, and overall content—that are emphasized here. These comparisons are meant merely to be suggestive; except when specifically noted, they should not be taken as implying a direct connection between one work, or one artist, and another.

No reproduction, of course, can ever be more than a souvenir of the original, as a photograph is of a living person. With respect to color, printer's ink can only approximate the artist's pigment. The differences in texture between the heavy impasto of van Gogh's *Starry Night* and the even surface of Albers's *Homage to the Square: Broad Call*, for example, can only be suggested. Coated paper gives a uniform finish to all the reproductions, whereas in actuality some paintings are glossy, others matte, and still others (such as Pollock's *One*) deliberately exploit the contrast between these two qualities. But the greatest distortion of all is in scale. The originals range from Dali's diminutive *Persistence of Memory*, measuring 9½ by 13 inches, to Newman's wall-size *Vir Heroicus Sublimis*, almost 8 feet high by 18 feet long. Obviously, much of a painting's impact depends upon the spectator's kinesthetic response to its dimensions. The measurements of each work are given here, so that the reader can know its true size and recollect or imagine the effect it produces.

There is a distinction between "seeing" and "looking." As we walk down the street, a host of images impinges on our sight; we "see" but are not really conscious of many of these visual impressions. Prudence advises us, however, that when we reach the corner, we should "look" at the traffic light—is it red or green? Within the gallery of a museum, we are confronted simultaneously by many works of art. It takes an effort of will to stop before any single one long enough to examine it searchingly. Yet it is only after such focusing of the attention that we can really be said to "see" more than the superficial aspects of a painting.

Aware of the size of a collection or exhibition, and the limits of time at his disposal, the visitor is apt to enter the first gallery, pass around it, and then proceed to the next. Soon the familiar phenomenon known as museum fatigue sets in; and even before his feet begin to bother him, his eyes and mind feel taxed by the demands upon them, his attention slackens, and his enjoyment gradually ebbs.

But, when all is said and done, there really is no reason other than enjoyment for spending an hour or so looking

*Published in 1973 and reprinted successively thereafter, the original edition of *An Invitation to See* differed from the present book in containing one hundred and twenty-five paintings and no three-dimensional works.

at works of art—or reproductions of them—rather than reading a book, going to the movies, visiting friends, playing golf or tennis, or engaging in any of the other diversions for which most of us find all too little time. It is true that the charter of 1929 states that The Museum of Modern Art had been established "for the purpose of encouraging and developing the study of modern arts and the application of such arts to manufacture and practical life, and furnishing popular instruction"; a little later, this purpose was more succinctly defined as "helping people to use, understand, and enjoy the visual arts of our time." Today, however, these formulations seem to carry the overtones of being survivals of the nineteenth century's firm commitment to the utilitarian, and possibly even of its pious and optimistic belief that works of art can elevate man's mind and so improve his moral character—a proposition hardly susceptible of proof. Moreover, one of the delights of art is precisely that it is gratuitous, with no demonstrable practical application whatever. As for "understanding," inasmuch as artists themselves have sometimes confessed that they did not wholly comprehend their own creations (see, for example, Pollock's remarks on *The She-Wolf*, page 127, or Beckmann's on his *Departure*, page 86), it is probably presumptuous to believe that we can do so. In addition, there is Picasso's quelling observation: "Everyone wants to understand art. Why not try to understand the songs of a bird? Why does one love the night, flowers, everything around one, without trying to understand it? But in the case of a painting people have to *understand*. If only they would realize above all that an artist works of necessity, that he himself is only a trifling bit of the world, and that no more importance should be attached to him than to plenty of other things which please us in the world, though we can't explain them."

With Picasso's authorization, then (and that of the Declaration of Independence, which recognizes "the pursuit of happiness" as one of man's inalienable rights), let us freely allow ourselves to look at paintings for sheer delight. With this in mind, I venture to suggest that the visitor's enjoyment may be greater if he refrain from plodding from picture to picture in a systematic fashion. I recommend that he try the experiment of entering a gallery, glancing around it, fixing on the painting that most immediately attracts him, and making a beeline toward it; and that he then spend a few minutes in leisurely investigation of it before passing on to another, chosen in the same fashion.

Enjoyment, of course, can be of different sorts. Sometimes we want to listen to Bach, at other times to Tchaikovsky; today we feel in the mood for an Ingmar Bergman film, tomorrow for one of Chaplin's. The tremendous variety within the Museum's collection of paintings can hardly fail to offer something for our pleasure. Even among the limited selections in this book, one can find subjects as traditional as portraits, landscapes, cityscapes, still lifes, allegories, religious themes, and political topics. There are figurative paintings of many sorts, and examples of the many kinds of abstraction that have evolved in this century. There are everyday scenes transformed into poetry by the artist's view of them, fantasies that exist only in his imagination, and paintings that try to make visible what is unseen, such as the fourth dimension or the hidden processes of nature. Some pictures reflect a tragic view of life, others extol its joys; some are grave and serious, some satirical, some humorous. The handling of the medium may reveal the artist's intense emotion, the working of his unconscious impulses, or a strict discipline imposed by his intellect. Paint may be heaped up into heavy clots on the surface of the canvas, soaked into it, applied in dots, or laid on with unvarying smoothness. Color ranges from monochrome to many-hued radiance. The conventional rules of perspective may be carefully followed, distorted, or ignored; or spatial recession within a painting may be denied altogether.

In proposing that the viewer be guided first of all by his personal preference, I by no means imply that he should be content to react like litmus paper, instantly deciding "I like—don't like." Initial response to a painting should be a starting point and not a finish line. It should lead not only to a more prolonged scrutiny but also to the posing of questions. Just what is it in this picture that seems so pleasing? (Subject alone can be a snare, for the same theme might be execrably treated.) Is it the color? The light? The conveying of the artist's emotion? The sense of movement, or of absolute calm? The handling of paint? The forms themselves, or their decorative arrangement and the relationship among them? The play of lines, or the indication of volume? The impression of intimacy, or of grandeur and monumentality? Fidelity to observed fact, or its transformation? Above all, how has the artist gone about achieving his effects?

Nowadays we are besieged with countless images of all kinds—in newspapers and magazines, on billboards and TV screens. We are accustomed to looking at most of them primarily for the information they impart; our eyes and minds are conditioned to comprehend "what" the message is, without pausing to analyze "how" it is stated. But painting's former function of providing information has largely been taken over by the photograph. Furthermore, modern painting seldom has the office of celebrating established religion or civil authority, and only rarely does it deal with traditional subjects by means of widely accepted conventions. Painting has become increasingly concerned with *how* it makes its state-

ment; the quantum of its total content that depends on form rather than on any ostensible subject is proportionately greater than in the past.

Yet painting does not speak some arcane language that we need special skill to master. As children, we all responded to its basic elements of colors, lines, and shapes; but age and sophistication tend to blunt that uninhibited perceptiveness. The art of seeing art lies in retaining the child's ability to respond simply and directly, and tempering this with the adult's capacity for more concentrated attention and philosophical inquiry.

Sometimes extraneous facts intrude upon our faculty of observation. We are flooded with data about artists and movements, ranging from gossip-column items to erudite criticism, and these may color our view or prevent us from seeing what lies right before our eyes. René d'Harnoncourt, director of The Museum of Modern Art from 1949 to 1968, used to tell an anecdote about his teaching days. He gave his students the assignment of visiting an exhibition of van Gogh's paintings, shortly after the publication of Irving Stone's fictionalized biography of that artist, *Lust for Life*. The class came back, reporting in detail how certain works reflected van Gogh's mental illness or foretold his suicide; but when asked to describe the predominant colors in those pictures, the students were unable to do so.

Once having examined a painting with care and tried to determine what in it particularly attracts him, the visitor might next seek out others that share those features. In the course of this quest, he may encounter works that he finds equally appealing, though they display quite different characteristics. He may even discover that some pictures that at first sight were little to his liking, or had nothing to say to him, merit after all his respectful attention, if not his unqualified favor. Frequently a painting that attracts us immediately soon begins to seem overobvious and boring, while another that at first sight seemed "difficult" may in the long run afford us more lasting pleasure. Not only do our tastes change, in art as in everything else, but also the appetite for looking at paintings usually increases with practice. It may be likened to a spectator sport: the more we see our favorite game, the more we are able to appreciate its strategies and distinguish among the styles of the various players and teams. We become actively committed partisans rather than passive onlookers.

The comments accompanying the reproductions in this book are not meant to be either limiting or comprehensive. Their purpose is to clear away obstacles (as by identifying a subject or explaining a puzzling title), point out features that may be overlooked, or suggest ways of looking that in some instances may be applicable to other paintings also. Facts about the artists' lives and careers, and the discussion of movements, have been kept to a minimum and included only when of special pertinence to the particular work. Reading about art can widen our knowledge and, by illuminating certain aspects of it, add another dimension to our enjoyment; but it can no more be a substitute for the experience of seeing than reading the program notes for a symphony can be for the act of listening to it.

In some cases, the comments cite formulations by other critics; more frequently, the artists themselves have been quoted. What artists have to say about their work is almost always interesting but not necessarily conclusive, and is often baffling. "The truth is, we can only make our pictures speak," van Gogh wrote in his last letter, just before his death. Apart from the difficulty that anyone has in being objective about himself, there are semantic ambiguities. Leaving aside the fact that Rousseau and Hirshfield both thought of themselves as "realistic" painters, how confusing it is to discover that whereas some artists regard their pictures as being "real" to the extent that they offer an accurate transcription of observed phenomena, conversely others hold their paintings to be "real" precisely because they contain no reference to anything that exists outside the works' own material substance. Monet tried to be true to nature by recording as exactly as he could the color, light, and forms he observed in his water garden. Klee and Newman, on the other hand, did not attempt to depict what can be seen in nature but rather to emulate in their paintings the creative forces whereby nature brings order out of chaos. How many different meanings, also, have attached themselves to the words "abstract" and "abstraction"! And how surprising to know that when Malevich, van Doesburg, and Mondrian purged their art of any imitation of forms occurring in the real world, they were not seeking to be hermetic but, on the contrary, to develop a universal language that eventually could be understood by all.

Instead of indulging in mere solipsistic self-expression, as has sometimes been alleged, the modern artist does in fact work for the public, as did artists of the past. His task in communicating, however, may be more difficult than formerly. He seldom works on commission, so his potential patron is usually unknown to him. There are no longer fixed traditions governing subject matter, iconography, style, and technique. Like nearly everything else in modern life, art is in a constant state of flux, with change proceeding at a more accelerated rate than at any previous time in history. The public for art is wider than ever before and is exposed to a glut of art, in the original and in reproduction. Consequently, it may be fickle in its allegiances, likening art to fashion and demanding novelty rather than respecting true innovation;

8

on the other hand, it may cling to what it already knows and be affronted by any sudden change in direction.

What is rejected today may nevertheless find acceptance tomorrow, or possibly be appreciated for qualities quite different from those for which it first won favor. In the long run, the role of the public is indispensable. This was recognized even by Marcel Duchamp, whose body of work is probably as abstruse as any ever produced. In a speech made in 1957, he said:

In the last analysis, the artist may shout from all the rooftops that he is a genius; he will have to wait for the verdict of the spectator in order that his declarations take a social value and that, finally, posterity includes him in the primers of Art History. . . .

In the creative act, the artist goes from intention to realization through a chain of totally subjective reactions. His struggle toward the realization is a series of efforts, pains, satisfactions, refusals, decisions, which also cannot and must not be fully self-conscious, at least on the esthetic plane.

The result of this struggle is a difference between the intention and its realization, a difference which the artist is not aware of. . . .

The creative act takes another aspect when the spectator experiences the phenomenon of transmutation: through the change from inert matter into a work of art, an actual transubstantiation has taken place, and the role of the spectator is to determine the weight of the work on the esthetic scale.

All in all, the creative act is not performed by the artist alone; the spectator brings the work in contact with the external world by deciphering and interpreting its inner qualifications and thus adds his contribution to the creative act.

If the modern artist has more difficulties than artists of the past, in part because his freedom opens so many options to him, the modern public, too, has problems peculiar to our time in fulfilling its essential role of spectator and ultimate arbiter. That a pluralistic society has predictably given birth to many contradictory forms of art coexisting simultaneously is bewildering in itself.

Certainly, the artist does not deliberately seek mystification. Van Gogh, whose art never found acceptance in his lifetime, and whose paintings convey the perturbation of his highly intense, emotional sensibility, wrote in 1888: "In a picture I want to say something comforting as music is comforting." Similarly, in 1908, when Matisse's radical departures from natural color and form were still shocking to most of the public, he wrote: "What I dream of is an art of balance, of purity and serenity devoid of troubling or depressing subject matter, an art which might be for every mental worker, be he businessman or writer, like an appeasing influence, like a mental soother, something like a good armchair in which to rest from physical fatigue."

Writing half a century later, in the midst of the Age of Anxiety, the critic Leo Steinberg is not content to allow modern art, the artist, or the viewer so relaxed and hedonistic a role. He says:

Contemporary art is constantly inviting us to applaud the destruction of values which we still cherish, while the positive cause, for the sake of which the sacrifices are made, is rarely made clear. . . .

Modern art always projects itself into a twilight zone where no values are fixed. It is always born in anxiety. . . . It seems to me a function of modern art to transmit this anxiety to the spectator, so that his encounter with the work is—at least while the work is new—a genuine and existential predicament. . . . And we the public, artists included, should be proud of being in this predicament, because nothing else would seem to us quite true to life, and art, after all, is supposed to be a mirror of life.

Each viewer, then, is free to make his own choice. He can find good authority for allowing himself to contemplate art in order to seek refuge from the everyday problems that beset him, or for regarding it as an intensification of modern man's most anguishing concerns. Fortunately, his choice need not be an either-or, once-and-for-all decision. The paintings remain, to be visited and revisited, inviting his exploration and awaiting his changes of mood, his growth in perception.

Art, like poetry, speaks in metaphors, and poets have often been among those most sensitively attuned to its language. Let us, then, give the last word to Marianne Moore:

WHEN I BUY PICTURES
or what is closer to the truth,
when I look at that of which I may regard myself
* as the imaginary possessor,*
I fix upon what would give me pleasure
* in my average moments:*
.
Too stern an intellectual emphasis upon
* this quality or that detracts from one's enjoyment.*
It must not wish to disarm anything;
* nor may the approved triumph easily be honored—*
that which is great because something else is small.
It comes to this; of whatever sort it is,
it must be "lit with piercing glances
* into the life of things";*
it must acknowledge the spiritual forces
* which have made it.*

INTRODUCTION TO THE REVISED EDITION

IN THE ALMOST TWO DECADES that have elapsed since *An Invitation to See* was first published in 1973, new developments in art forms and theories, the ascendancy of some younger artists, and the acquisition by The Museum of Modern Art of notable examples of both earlier and later date have made appropriate this substantial revision of the original edition. Because of the important role played by three-dimensional works in the evolution of modern art, thirty sculptures and constructions have been included, and almost a quarter of the hundred and twenty paintings here reproduced and discussed are new selections. Keeping the number of items within the limits of the book's modest format has required the making of draconian decisions. It has necessitated choosing a very small representation from among the thousands of works in the Museum's collection; moreover, for every new inclusion among the paintings, one formerly shown had to be sacrificed. As partial compensation for these restrictions, the comments frequently refer to other related works, which visitors to the Museum may wish to seek out for themselves.

Many artists today work on a very large scale that severely taxes the capacity of any institution's available exhibition space. The Museum of Modern Art has therefore adopted a policy of periodically changing the installation in the east-wing gallery on the third floor, where the most recent works are displayed. Elsewhere throughout the Museum, also, because works may be in conservation, out on loan, or unavailable for other reasons, on any one occasion the visitor will find that not all the selections included here are on view.

As in the original publication, works of art on facing pages have been paired in order to suggest comparisons or contrasts in style, technique, subject, or content that may heighten the viewer's perception or stimulate further independent explorations of likenesses or differences. Many of the comments on paintings included in the first edition have been substantially rewritten in the light of recent research or criticism. But in providing information intended to facilitate understanding of a movement, an artist, or a specific work, we should be well advised to heed an admonition given by Henri Matisse in 1951:

A work of art has a different significance for each period in which it is examined. Should we stay in our own period and consider the work of art with the brand-new sensibility of today, or should we study the epoch in which it was made, put it back in its time and see it with the same means and in a context of parallel creations (literature, music) of its period in order to understand what it meant at its birth and what it brought to its contemporaries? Obviously some of the pleasure of its present existence and of its modern action will be lost if it is examined from the point of view of its birth. In each period, a work of art brings to man the pleasure that comes from communion between the work and the man looking at it. If the spectator renounces his own quality in order to identify himself with the spiritual quality of those who lived when the work of art was created, he impoverishes himself and disturbs the fullness of his pleasure. . . .

As stated in the introduction to the first edition, the principal criterion of selection has been to choose works that individually are of outstanding quality or significance, and that collectively demonstrate the remarkable diversity of styles and approaches characteristic of the modern movement. Experimentation and the breaking with tradition continue to characterize modern art. Since the 1950s, the medium of painting has been expanded by the incorporation of photomechanically reproduced images, by the adoption of the silkscreen process, or by the affixing to the ground of metal, wood, or other materials.

Throughout the twentieth century, the nature of three-dimensional works has been altered by even more radical innovations. While the age-old methods of carving, modeling, and casting in bronze have not been abandoned, they have been supplemented by new materials and techniques. Besides the traditional wood, stone, clay, and bronze, artists have made use of such substances as iron, steel, metal wire, plastics, glass, plywood, cardboard, and cloth, and they have often mixed materials within the same work. Color, almost wholly absent from sculpture in the immediately preceding centuries, has been freely applied. The new technique of welding has resulted in constructions that are more akin to engineering and architecture than to conventional sculpture, and artists have frequently relied upon foundries to fabricate their works. In a development analogous to the introduction of collage into painting, the principle of unity has been violated, as works have been built up by the assemblage of constituent parts — sometimes newly made, but more frequently "found" objects. The properties formerly considered to be essential to sculpture have been disregarded: space has invaded mass; motion and buoyancy have been introduced, where formerly there had been immobility and weightiness; soft sculpture and potentially variable forms have been substituted for rigidity and permanence.

During the Renaissance, artists such as Leonardo da Vinci and Michelangelo were equally renowned as paint-

ers and sculptors, but thereafter artists tended to be active exclusively as one or the other. In this century, however, many of the foremost artists — among them Matisse, Picasso, Arp, Miró, Ernst, Stella, and Johns — have produced works in both two and three dimensions.

A significant number of modern artists elect to work in series, exploring the possibilities inherent in a given theme or format and the variations that they can introduce into its treatment. In a kind of balancing act between the conceptual and the perceptual, many of them seem to be setting themselves the problem of formulating visual equations, in each of which there is one constant and a number of variables. Included in this book are paintings drawn from Delaunay's Windows, Malevich's Suprematist Compositions, Monet's Water Lilies, Albers's Homages to the Square, Motherwell's Spanish Elegies, Dubuffet's Corps de Dames and Paris Circuses, de Kooning's Women, Louis's Stripes, Warhol's Marilyn Monroes, Stella's Notched V's, Diebenkorn's Ocean Parks, and Bartlett's Swimmers; and three-dimensional examples from among Brancusi's Birds, Matisse's Jeannettes, Picasso's four versions of a Head of a Woman (Marie-Thérèse Walter), Arp's Human Concretions, and David Smith's Zigs.

In the past, the artist predetermined the meaning of each of his works, which viewers understood because of their familiarity with mythology, religious iconography, an historical event or personage, the identity of a sitter in a portrait, or the moral to be drawn from allegorical pictures such as those by Hogarth or Greuze. Only landscapes, genre scenes, and still lifes, assigned by the academies and salons to lower ranks in the hierarchy, did not demand such literary foreknowledge. *Trompe l'oeil* paintings were exceptional in that, dispensing with associative references, they directly engaged the viewer's perception by challenging him to distinguish between depicted and "real" objects.

Many modern works of art make a virtue of paradox or ambiguity instead of clarity, or attempt to engage the spectator in a kind of dialogue, both conceptual and perceptual. Rather than immediately disclosing their meaning, they require a certain effort on the part of the viewer. Before the subject of an Analytic Cubist painting becomes apparent, its new conventions of rendering form and space must be understood. A gestural Abstract Expressionist painting seeks to make the beholder aware of the process that brought it into being. A picture by Estes (page 159) confronts one with the puzzling task of disentangling objects from their reflections and re-reflections. The postmodernist Salle asserts that instead of himself projecting the meaning of such a painting as *Géricault's Arm* (page 168), each beholder must interpret it in accordance with his own individual response. Sculptures such as Moore's *Large Torso: Arch* (page 21) or Arp's *Human Concretion* (page 73), or the constructions of di Suvero (page 143), David Smith (page 145), or Tony Smith (page 165) cannot be apprehended from a single vantage point but require the viewer to walk around them. Oldenburg's *Floor Cone* (page 153) unsettles the spectator's sense of scale by its gigantic size, while its softness establishes an equivalence with his own body. Judd's Untitled construction (page 163) elicits from the beholder an awareness of himself both in relation to the work and to the surrounding environment they share. Many other examples could be cited, but taken together they imply that much of the pleasure to be derived from looking at a work of art depends upon a deliberate interaction with it. This of necessity obliges one to devote a certain amount of time to the contemplation of each object, rather than passing on too heedlessly and hastily to the next one, and the next, and the next.

Some words of the philosopher and historian Étienne Gilson may be pertinent here. He issues an invitation: *to pursue the dialogue with the discoveries of modern art as eagerly as we do with the discoveries of modern science. . . . Nor should one be afraid to embark on the somewhat strange adventures to which we are invited by some of these masterpieces. It is only too possible that some of them will always remain for us like those secret domains of which, in dreams, we vainly try to find the key. . . . He who sincerely exposes himself to creative art and agrees to share in its ventures will often be rewarded by the discovery, made in joy, that an endlessly increasing accumulation of beauty is, even now, in progress on this man-inhabited planet. At a still higher level, he will know the exhilarating feeling of finding himself in contact with the closest analogue there is, in human experience, to the creative power from which all the beauties of art as well as those of nature ultimately proceed. Its name is Being.*

150 WORKS
FROM THE MUSEUM
OF MODERN ART

UNLESS OTHERWISE NOTED, all works cited in the texts are in the collection of The Museum of Modern Art. In dimensions, height precedes width, followed in a few cases by a third dimension, depth. Accession numbers are enclosed in brackets, the two digits after the decimal point indicating the year in which the work was acquired by the Museum.

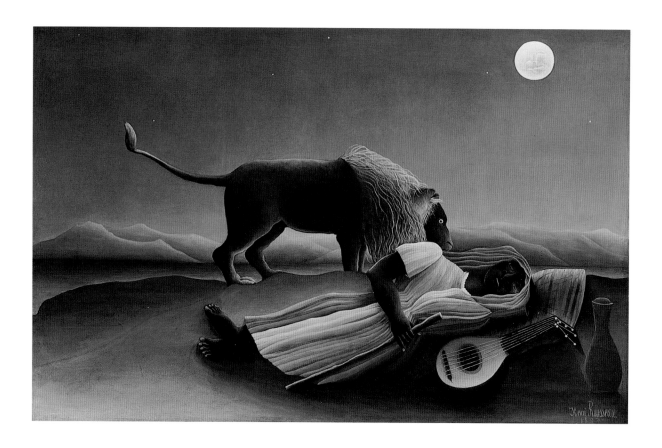

HENRI ROUSSEAU. French, 1844–1910.
The Sleeping Gypsy. 1897. Oil on canvas, 51 inches x
6 feet 7 inches. Gift of Mrs. Simon Guggenheim. [646.39]

"Night and silence! who is here?" Puck's query might
well serve as rubric for this mysterious painting. Rous-
seau, a self-taught artist, thought of himself as a realist
and sought to emulate such nineteenth-century academi-
cians as Gérôme, who was famous for pictures of wild
animals in bare stretches of African landscape. When in
1898 Rousseau offered to sell *The Sleeping Gypsy* to his
native town, Laval, he called it "a genre painting" and
described its subject: "A wandering Negress, a mandolin
player, lies with her jars beside her (a vase with drinking
water) overcome by fatigue in a deep sleep. A lion
chances to pass by, picks up her scent yet does not devour
her. There is a moonlight effect, very poetic. The scene is
set in a completely arid desert. The gypsy is dressed in
oriental costume."

The mayor of Laval referred the matter to the local
museum; Rousseau's offer was never accepted, however,
the authorities evidently finding his work as little to their
liking as did those who saw the paintings that he regu-
larly submitted to the Salon. The public in general re-
garded him as a laughing-stock, but a few perceptive
critics and artists of the time (Gauguin among them) and,
somewhat later, the Cubist painters and poets, admired
his art. Subsequently, the Surrealists discovered in his
paintings the qualities of naïveté, simplified form, and
imaginative power that they particularly valued.

After having been lost to sight for some twenty years,
The Sleeping Gypsy was rediscovered in the 1920s. Pi-
casso brought it to the attention of the adviser of the
American collector John Quinn, who bought it. When
after Quinn's death the painting came up for auction in
1926, the Surrealist poet Jean Cocteau wrote a panegyric
of it in the catalogue, in which he said: "We have here the
contrary of poetic painting, of anecdote. One is con-
fronted, rather, by painted poetry, by a poetic object."
Pointing out that, in spite of Rousseau's careful attention
to detail, there are no footprints on the sands around the
gypsy's feet, Cocteau suggested that the lion and the river
may be the dream of the sleeper.

Scorned by the public of its day, and first esteemed by
artists and poets, *The Sleeping Gypsy* is now one of the
most popular paintings in The Museum of Modern Art.

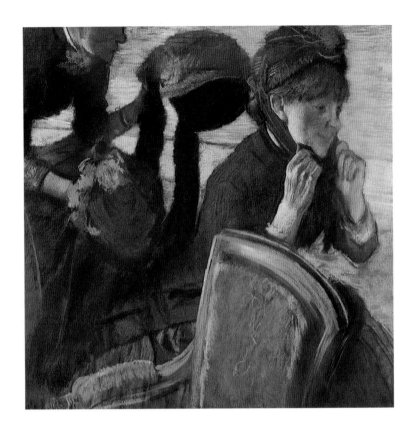

HILAIRE-GERMAIN-EDGAR DEGAS. French, 1834–1917. *At the Milliner's*. c. 1882. Pastel on paper, 27⅝ x 27¾ inches. Gift of Mrs. David M. Levy. [141.57]

Though *At the Milliner's* is the earliest in date of the paintings in this book, and indeed one of the earliest in The Museum of Modern Art, at the time it was done it epitomized modernity. Its modernism lay in its touches of pure color, with the high-keyed tones favored by the Impressionists contrasting with darker areas; the choice of a contemporary, even trivial, subject; and, especially, the daring composition with uptilted perspective and figures cut by the framing edges. Degas presents the scene as if in a cropped close-up, but though he was in fact interested in photography, it was probably rather a growing familiarity with Japanese prints, then much appreciated in Paris, that led him and other artists of the time to adopt the seemingly casual composition of their pictures, as well as a high vantage point that contradicts the traditional Western scheme of deep perspective, in which lines converge toward a single vanishing point.

Degas once defined the abiding principle of art as "the summing up of life in its essential gestures." His interest in occupational attitudes led to his many studies of ballet dancers, women bathing, and laundresses washing or ironing. *At the Milliner's* is one of more than a dozen works that he made at about this date with a millinery shop as the subject. Here, he has caught in one vivid glimpse both the pleased expression and the gesture of the woman trying on a bonnet, as well as the action of the attendant proffering two others for her approval. The picture is rendered in pastel, a medium Degas made particularly his own. He preferred its matte surface to the gloss of oil pigments and liked the freedom it gave him to draw rapidly in color, using broken lines to convey the blurred effect of figures seen in action.

The model for the woman trying on the hat was the American painter Mary Cassatt, who lived and worked in France as a close associate of the Impressionists. She was in large part responsible for stimulating interest in their art in the United States and encouraging patrons in this country to buy their works.

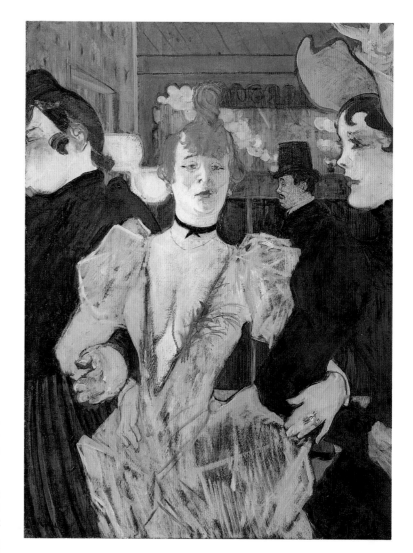

HENRI DE TOULOUSE-LAUTREC. French, 1864–1901.
La Goulue at the Moulin Rouge. 1891–92. Oil on card-
board, 31¼ x 23¼ inches. Gift of Mrs. David M. Levy.
[161.57]

The Moulin Rouge, which opened in Montmartre in
1889, quickly became the most popular of the *cafés
concerts* that were a distinguishing feature of Paris night
life toward the close of the last century. Here artists,
entertainers, intellectuals, and people of every social
class forgathered to dance, gossip, and see the cabaret
show, which drew on the varied talents of singers, danc-
ers, clowns, and contortionists; and here Toulouse-
Lautrec loved to go, not only for diversion but also to
sketch the ever-changing spectacle offered by the
habitués.

La Goulue ("the Glutton") was the nickname of
Louise Weber, who was the reigning belle of this milieu
for a brief time, until her voracious appetite caused her to
become grossly fat. Toulouse-Lautrec has shown her at
the height of her favor as, arrogant and self-assured, she
enters arm in arm with two companions. Their sober,
high-necked costumes serve as foils to her light, filmy
dress, with its deeply plunging décolletage accentuated
by a sprig of green and the demure black ribbon encir-
cling her neck. The types of the three women, too, are
artfully contrasted. The wasp-waisted figure of the still-
slender dancer is set off by the plumpness of the woman
at the left, while the piquant profile of the pretty young
girl at the right makes one all the more conscious of the
pinched mouth and hardened expression of *La Goulue*,
whose face beneath its heavy makeup already shows the
ravages of age and dissipation.

Again, as in Degas's *At the Milliner's*, the figures are
cut off by the edges of the picture. The space here is even
shallower, and the three principal figures are brought
forward to the front plane. The flattened shapes, pattern-
ing of dark-and-light contrasts, and rhythmic curves are
all devices that Toulouse-Lautrec used to great effect in
his posters.

15

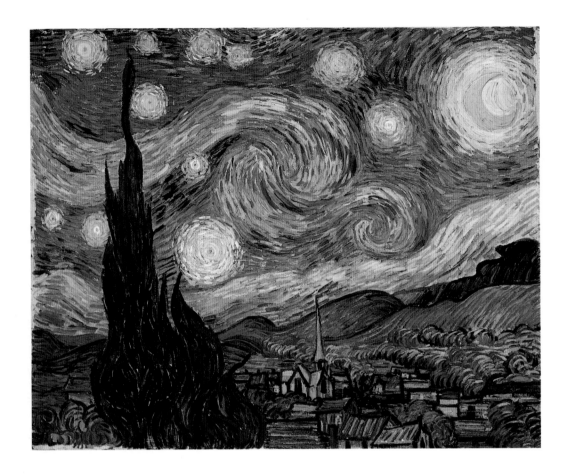

VINCENT VAN GOGH. Dutch, 1853–1890. To France 1886.
The Starry Night. 1889. Oil on canvas, 29 x 36¼ inches. Acquired through the Lillie P. Bliss Bequest. [472.41]

To Vincent van Gogh, coming to Provence in 1888 from his native Netherlands and a two-year sojourn in Paris, the brilliant sunlight and vivid colors of the Midi were intoxicating. Even though this is a night scene, it is pervaded with a southern intensity of blues, greens, and yellows. The moon is as burningly radiant as the sun; the stars explode like firecrackers.

Soon after his arrival in Arles, van Gogh wrote of wanting to create a "star-spangled sky," and in subsequent letters he noted that this idea continued to haunt him. *The Starry Night* is the second and more visionary of his two versions of the theme. Above the rooftops of the quiet village, the curves of the surrounding hills are first paralleled and then exaggerated by the turbulence in the sky, which rolls onward like a roaring ocean. The left-to-right motion across the canvas is punctuated by two vertical accents: the cypress trees at the left, soaring upward like flames, and the pointed spire of the church in the middle distance. Swirling strokes of thickly laid-on pigment enhance the rhythmic effect and express the fervent emotion underlying van Gogh's nocturnal vision.

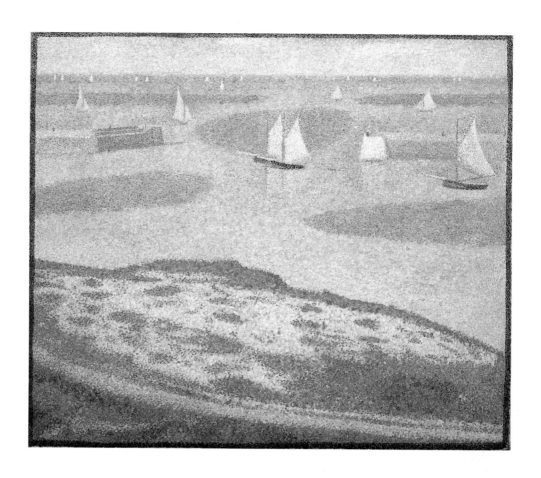

GEORGES-PIERRE SEURAT. French, 1859–1891.
Port-en-Bessin, Entrance to the Harbor. 1888. Oil on
canvas, 21⅝ x 25⅝ inches. Lillie P. Bliss Collection.
[126.34]

Though painted just a year before van Gogh's *Starry
Night*, Seurat's *Port-en-Bessin* could hardly present a
greater contrast. Instead of a Provençal landscape, which
even at night seems to retain the brilliance of a sun-
drenched day, we have the pale and hazy atmosphere
along the Normandy seacoast. In place of van Gogh's
agitated sky, here the serenity overhead is reflected in the
tranquil water, upon which the shadows cast by the
clouds form five symmetrically placed ovals. The central
one provides a backdrop for the sharply angled white
sails of the two overlapping fishing boats placed almost
precisely midway between the sides of the canvas.

Seurat wrote that calm of line is given by the horizon-
tal. In *Port-en-Bessin*, horizontals prevail. They lead

backward from the gentle curve of the pathway in the
foreground to the breakwaters in the middle distance and,
finally, to the unbroken line of the high, distant horizon.
The only vertical accents are those provided by the masts
and pointed sails of the fleet.

Seurat's painting technique, also, could hardly differ
more from the vigorous impetuosity of van Gogh's thick
brushstrokes. Here, each dot of pigment has been sepa-
rately placed, its position methodically calculated with
respect to those around it. Seurat had closely studied the
color theories of nineteenth-century physicists and,
seeking to attain purity of tone and clarity of light, pains-
takingly used the tip of his brush to juxtapose minute
dots of color, intermixed with white, in a technique
called pointillism or divisionism. Seen at a little distance,
these points blend to produce an effect of shimmering
luminosity. With equal precision, Seurat painted a dotted
frame to enclose the seascape's overall blondness within
a darker tonality.

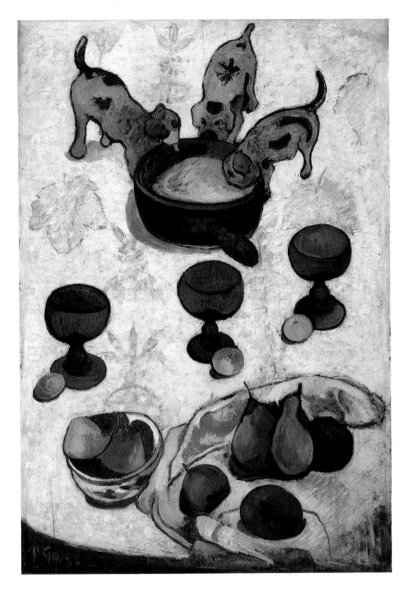

PAUL GAUGUIN. French, 1848–1903. In Tahiti and the Marquesas Islands 1891–93, 1895–1903.
Still Life with Three Puppies. 1888. Oil on wood, 36⅛ x 24⅝ inches. Mrs. Simon Guggenheim Fund. [48.52]

Painted only a few years after Degas's *At the Milliner's* (page 14), *Still Life with Three Puppies* likewise shows the influence of Japanese prints in its uptilted perspective and flattened space. In every other respect, however, this picture reveals how radically Gauguin had broken with the premise of the Impressionists, with whom he had exhibited just two years before. Whereas they sought to capture in their paintings a fleeting moment of life and show it with utmost fidelity, Gauguin asserted that "painting is an abstraction." He demonstrated his dictum by constructing compositions that were deliberately artificial in their choice of color, dark-and-light contrasts, and spatial arrangement of simplified forms drawn with accentuated outlines and a wholly arbitrary use of cast shadows.

Alfred H. Barr, Jr. has pointed out: "As in the fairy tale of *Goldilocks and the Three Bears* the objects in this still life . . . come by threes—three puppies, three blue goblets, three apples." Gauguin found inspiration for creating an art of intentionally childlike simplicity in the illustrations of children's books and the peasant art of Brittany, where he painted *Still Life with Three Puppies*. Paradoxically enough, however, the still-life-within-a-still-life in the lower right corner is a testimony to his continuing admiration for Cézanne, one of whose canvases of fruit on a tablecloth (somewhat similar to that reproduced on page 32) he owned and took with him to Brittany.

Two years after painting this picture, Gauguin set off for the South Seas, in quest of an environment still more primitive and remote from European conventions.

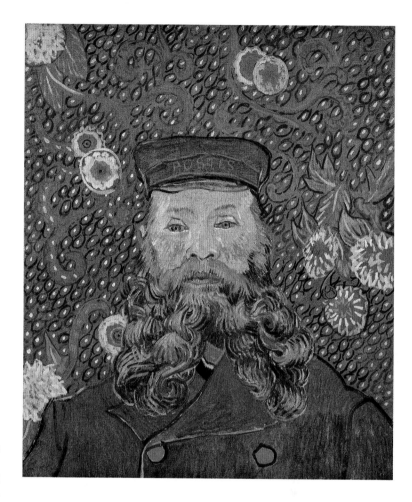

VINCENT VAN GOGH. Dutch, 1853–1890. To France 1886.
Portrait of Joseph Roulin. 1889. Oil on canvas, 25⅜ x 21¾ inches. Gift of Mr. and Mrs. William A. M. Burden, Mr. and Mrs. Paul Rosenberg, Nelson A. Rockefeller, Mr. and Mrs. Armand Bartos, Sidney and Harriet Janis, Mr. and Mrs. Werner E. Josten, and Loula D. Lasker Bequest (by exchange). [196.89]

This is believed to be the culminating work in a series of portraits of Joseph Roulin and members of his family that van Gogh began to paint in the late summer of 1888 and continued until shortly before his departure for the asylum at St. Rémy in May of the following year. Roulin, a postman in Arles, had become a trusted and solicitous friend of the artist, who wrote in a letter to his brother Theo that "though he is not quite old enough to be like a father to me, [he] has all the same a silent gravity and tenderness for me like what an old soldier might have for a young one." Van Gogh made several references to Roulin as having a face "like Socrates," "interesting to paint," and being "ugly as a satyr" until his countenance became illuminated by the excitement with which he argued his revolutionary principles.

Viewed close up, the strictly symmetrical head has the severity and emotional impact of an icon, the gold lettering POSTES on the cap corresponding to the inscription that would identify a medieval saint. The blue uniform with its gold buttons serves as foil to the exuberant, carefully tended beard, painted with swirling strokes that resemble passages in *The Starry Night* (page 16). In contrast to the immobility of the figure, the elaborately patterned background with its scrolled stalks and oversize blossoms recalls the spiraling clouds and exploding stars of that dynamic landscape.

In this striking portrait, van Gogh combined two facets of his late art. He succeeded in rendering a psychologically accurate likeness of a man for whom he felt warm affection and respect, while at the same time he revealed the preoccupation with antirealistic, decorative patterning that he shared with Gauguin.

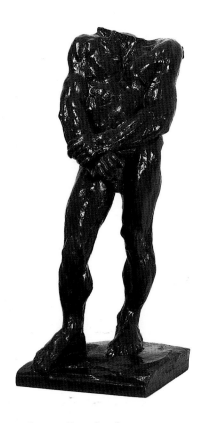

AUGUSTE RODIN. French. 1840–1917.
Headless Naked Figure Study for Balzac. 1896–97.
Bronze (cast 1970), 39 x 15¼ x 12½ inches, including
base. Gift of The Cantor, Fitzgerald Collection. [436.75]

Rodin dominated the art of sculpture in the latter nine-teenth century and early twentieth, much as his colossal *Monument to Balzac* (frontispiece) towers over the Mu-seum's sculpture garden. Yet, in spite of his great reputa-tion and many important commissions, some of his major works encountered disfavor and even ridicule from critics and the general public.

In 1891 Rodin received from the Société des Gens de Lettres a commission for a monument to Balzac to be placed in front of the Palais Royal. The artist set out eagerly upon a project that ultimately was to occupy him for seven years. To deepen his understanding of the writer, who had died almost forty years before, Rodin read his works intensively, consulted contemporary de-scriptions of his appearance, and visited Balzac's native Touraine to find similar ethnic types.

Major decisions had to be made: what stance and what gesture should be given to the figure; should he be nude or clothed, and if the latter, in what garb; and above all, how could a head be portrayed that would be not merely a likeness of Balzac but, as Rodin stated, would be ex-pressive of "his intense labor, of the difficulty of his life, of his incessant battles and of his great courage"—words that suggest the extent to which Rodin may have identi-fied himself with his subject. The robe that Rodin even-tually decided upon was chosen because of Balzac's habit of working in a sort of dressing gown.

In all, Rodin created over forty studies—some nude, some clothed, some showing the whole body, some the torso, some the head alone. But when in May 1898 he exhibited the completed plaster, the sponsoring commit-tee protested that it was only a "crude sketch" and, refusing to recognize it as a finished product, broke their contract with the artist. Rodin defended his concept by writing to the Société: "I sought in *Balzac* . . . to render in sculpture what was not photographic. . . . My princi-ple is to imitate not only form but also life. I search in nature for this life and amplify it by exaggerating the holes and lumps, to gain thereby more light, after which I search for a synthesis of the whole."

The public clamor against the work was nevertheless so strident that Rodin withdrew it from exhibition, took it to his home in Meudon, and set it up in his garden. It was never cast during his lifetime, and in fact it was not until 1939 that a committee formed for the purpose succeeded in having the monument publicly installed in Paris.

Headless Naked Figure Study is one of ten bronze studies for the *Balzac*, all, like the monument itself, cast posthumously. During the years he devoted to the sub-ject, Rodin progressed from his original quest for realism in every detail to an increasingly Symbolist and sim-plified representation, culminating in so radical a depar-ture from naturalism as to cause the work's rejection. In this study, Balzac is conceived as a virile, muscular ath-lete; the stance with the weight on the rear leg and the right one advancing resembles that of Rodin's earlier *St. John the Baptist Preaching* (1878–80) and the headless and armless study for it which he called *The Walking Man* (Stanford University Museum of Art, Stanford, Califor-nia). In the frontal view of the torso, the crossed hands cover the groin, but looked at from the right side, the right hand can be seen as firmly gripping the penis. Michelle Facos has written that this study "associates cerebration with procreation—the intellectual and physi-cal aspects of the creative process." In the final work, the intense energy is concentrated in the mighty head, tower-ing over the unbroken silhouette of the simplified drap-ery. In Albert E. Elsen's words: "The side views of the *Balzac* enforce its sexuality. . . . His head has become a fountainhead of creative power, and by a kind of Freud-ian upward displacement it continues the sexual em-phasis of the earlier headless nude study. What more fitting tribute to Balzac's potency as a creator from the sculptor most obsessed with the life force!"

HENRY MOORE. British, 1898–1986.
Large Torso: Arch. 1962–63. Bronze, 6 feet 6⅛ inches x 59⅛ inches x 51¼ inches. Mrs. Simon Guggenheim Fund. [608.65]

Rodin's habit of exhibiting partial figures—torsos or segments of the body such as hands or feet—confounded the critics and infuriated the public, but he regarded these truncated parts as finished works, saying, "Beauty is like God; a fragment of beauty is complete." After 1900, younger artists, among them Brancusi and Lehmbruck, found in Rodin's fragments a precedent for their own efforts to liberate sculpture from the shackles of realism, and they adopted arbitrary proportions of the body or its parts for aesthetic and expressive purposes.

Henry Moore, who came to occupy in the twentieth century the same preeminent position of international renown that Rodin had in his lifetime, owned a cast of *The Walking Man* and admired his predecessor most when his works had an unfinished look. After the Second World War, Moore and his wife moved to an old house in Much Hadham, Hertfordshire, called Hoglands, dating back to around 1600; they believed it might once have been a butcher's shop or belonged to a farmer who did his own slaughtering, for digging in the garden they constantly found old bones, whose forms inspired some of Moore's sculptures. But his interest in what he called "the structural beauty of bones" went back many years earlier: "I began finding the shapes of bones fascinating in my student days at the Royal College of Art—for next door to the R.C.A. in South Kensington is the Natural History Museum, and I made innumerable visits there . . . examining and drawing the great variety of specimens. . . . One common form-principle in all bones is, of course, structural strength—since their purpose is interior support. . . . Through evolution bones got lighter but yet had to retain their strength—and in some bones one can find the modern engineering principle of steel girder construction. . . . Almost all my sculpture is based on female form, but the *Arch* is very much derived from male form." He later noted that "the word ARCH was added by me sometime after I had done the sculpture, for people to see that aspect of it, but the work is really based on the shoulder-bone structure of a male torso."

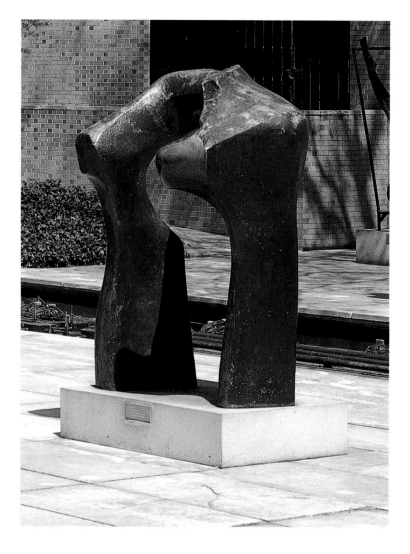

Unlike Rodin's *Monument to Balzac*, the *Large Torso: Arch* was not originally intended to be a monument, but it has since attained that status. As Moore has explained, the architect I. M. Pei saw the newly acquired work in the Museum's sculpture garden, and "he said that if it were three times as big it would be just what he needed in front of a building he had just designed. . . . I had always intended to make it bigger. Most everything I do I intend to make on a large scale if I am given the chance. . . . Size itself has its own impact, and physically we can relate ourselves more strongly to a big sculpture than to a small one." As a result of Pei's initiative, a twenty-foot-high cast of the *Arch* now stands in front of the entrance to the Bartholomew County Public Library in Columbus, Indiana, as the gift of Mr. and Mrs. J. Irwin Miller, who commissioned the library.

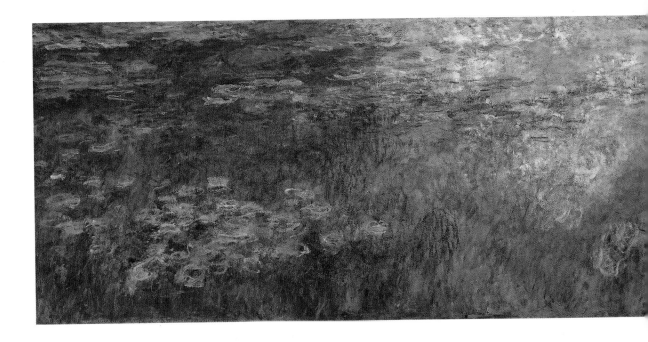

CLAUDE MONET. French, 1840–1926.
Water Lilies. c. 1920. Oil on canvas; 2 panels of a trip-
tych, each section 6 feet 6 inches x 14 feet. Mrs. Simon
Guggenheim Fund. [666.59.1–.3]

These panels, the left and central sections of a three-part
painting, are among a large number of huge canvases
portraying Monet's garden in Giverny, a village on the
Seine to which he and his family moved in 1885, and
which remained his home until his death. Seven years
later, the success of a large retrospective exhibition of his
work in Paris enabled him to buy the house he had been
renting as well as a strip of marshland across the road
between the railroad line and a small branch of the River
Epte, which he diverted to form a pond and initiate the
water garden that became a virtual obsession during the
final three decades of his life. Over the years, the water
garden was enlarged and developed, and stocked with
plants bought from a specialist in aquatic flora in Lyon.

In a letter of 1890 to the critic Gustave Geffroy, Monet
wrote: "I've gone back again to things that are nearly
impossible: water with the weeds of the bottom waving
below it: marvelous to see, but to want to paint it is
enough to drive one crazy." He painted a number of series
and isolated works based on the water garden, but not

until 1914 did he embark on the ambitious project of
developing a cycle of mural-size landscapes portraying
the total ambience.

He undertook this at the urging of his friend and ad-
mirer, the philosopher, journalist, statesman, and former
premier, Georges Clemenceau, who had a country house
at nearby Bernonville and visited Monet regularly on his
weekly visits from Paris. Troubled by failing eyesight and
deeply saddened by the recent deaths of his second wife
Alice and his son Jean, Monet was then leading the life of
a recluse, concentrating his flagging energies on the
struggle to set down his impressions of the water garden.

Impelled by Clemenceau's encouragement, in August
1914 Monet drew up plans for a new garden studio,
adjacent to the pond and large enough to accommodate
fifty big canvases. The studio was completed in 1916, and
he began working there on progressively larger paint-
ings. From among these he and Clemenceau proposed to
select a series on the water-lily theme that Clemenceau
had commissioned on behalf of the French state. On
November 12, 1918, the day after the armistice, Clemen-
ceau, once more premier, accepted two paintings offered
by the artist in celebration of the victory.

Originally it was intended that the landscapes given to
the state be housed in a pavilion to be erected in the

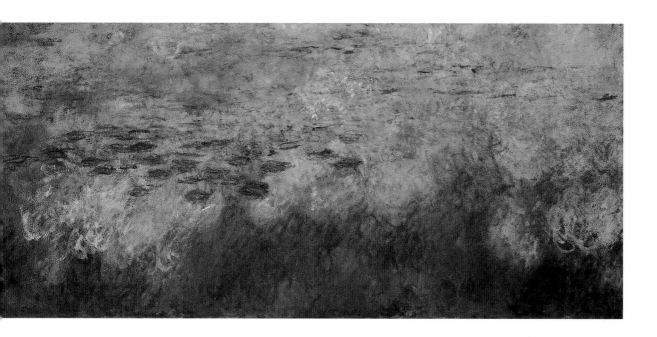

garden of the Hôtel Biron, which Rodin had bequeathed, together with the works still remaining in his hands, as a gift to the French government. It was subsequently decided that Monet's murals should instead be installed in the Orangerie, at the end of the Tuileries Gardens.

As Monet worked on the huge canvases, he combined some of them into diptychs and triptychs; he and Clemenceau repeatedly rearranged the paintings into groups, tentatively selecting those to be included in the Orangerie cycle, which was meant to present to the viewer the entire circuit of the pond as seen under the altered conditions of light and atmosphere caused by changes in weather, season, or time of day. But double cataracts and near-blindness forced Monet to abandon painting in 1922, and he died on December 5, 1926.

The following May, nineteen mural panels, installed in adjacent rooms in the Orangerie, were dedicated by Clemenceau. But during the 1930s and 1940s, a gradual change in taste led to a decline in Monet's reputation; few took the trouble to visit the Orangerie murals, while the garden and pond at Giverny were choked with weeds, and quantities of large water-lily canvases lay all but forgotten in the abandoned studio. Not until the 1950s were these works rediscovered and reevaluated. Eventually the garden, pond, and house were restored and declared a national monument, and on the death of Monet's son Michel in 1966, some sixty of the paintings were bequeathed to the Musée Marmottan in Paris. Previously, in 1959, The Museum of Modern Art had acquired this triptych and a related panel almost twenty feet long.

Since we know that it was Monet's express intention to capture reality with the utmost fidelity, it is ironic that these landscapes should appear almost abstract to contemporary eyes. As Alfred H. Barr, Jr. wrote: "The floating, ambiguous images and the flat, steeply rising perspective tend to give the scene an unreal or abstract effect. At the same time, Monet has given emphatic reality to the painted surface by means of broad, sweeping brushstrokes combined with a many-layered, scraped and scumbled technique of extraordinary richness. These qualities together with the large scale are among the factors which have made Monet's late works important to many of the abstract expressionist painters."

Here at the Museum in the heart of bustling midtown Manhattan, so remote from Monet's peaceful village, the *Water Lilies* triptych fulfills his wish to offer "the illusion of an endless whole, of water without horizon or bank; nerves tense from work would be relaxed there . . . [and] offered the refuge of a peaceful meditation in the center of a flowering aquarium."

23

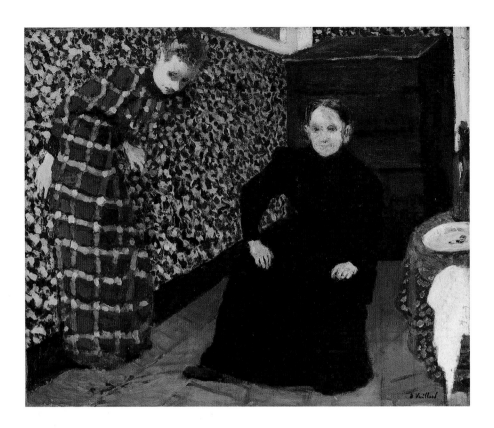

ÉDOUARD VUILLARD. French, 1868–1940.
Mother and Sister of the Artist. c. 1893. Oil on canvas,
18¼ x 22¼ inches. Gift of Mrs. Saidie A. May. [141.34]

In keeping with Vuillard's adherence to principles formulated a generation earlier by the critic Edmond Duranty, this little picture is both a double portrait of his mother and his sister Marie, and a painting of an interior. An artist, Duranty said, should devote himself to contemporary life, and he should show people casually, as they are, in the midst of their everyday environment, which in fact is an expression of their character.

Vuillard often painted his own milieu, and one of his favorite subjects was his mother, who, widowed while her children were still quite young, supported the family by setting up a corset-making establishment. Instead of showing her at work with other seamstresses, as he frequently did, here Vuillard has portrayed her seated as if to receive a visitor, to whom Marie, pressed up against the wall, is bowing shyly in greeting. Only a corner of the room is seen, the table at the right and the picture on the left wall being cut off at an angle, in the manner of Degas (see page 14). As Duranty had pointed out: "We are not always standing in the middle of the room, with its walls running neatly away on either side of us. . . . There is in the foreground an expanding space which . . . can lose the ceiling, it can pick up objects on the floor, it can cut off furniture at unexpected angles. Our line of sight is cut off at each side, as if by a frame, and whatever is sliced off by that frame is invisible to us."

The small size of the picture is well suited to its intimate character. The frontal figure of Mme Vuillard in her black dress is set off against the plain surfaces of the floor boards, which are tilted in rising perspective to the massive chest of drawers behind her. She seems indomitable and self-assured, in contrast to the deferential young Marie, whose figure, despite the bold pattern of her dress, merges with the allover pattern of the wallpaper, emphasizing the self-effacement expressed in her attitude. Such intimations of psychological contrasts and emotional response are characteristic of Vuillard's art during the 1890s.

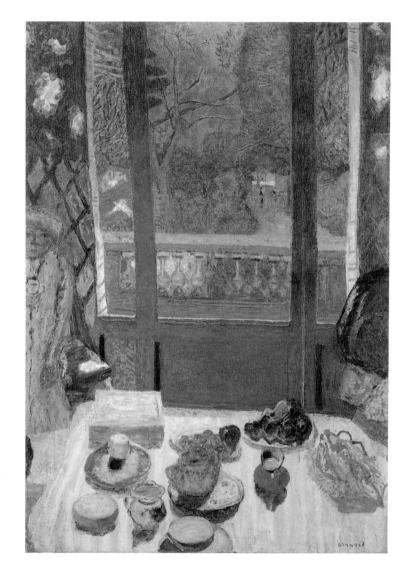

PIERRE BONNARD. French, 1867–1947.
The Breakfast Room. c. 1930–31. Oil on canvas, 62⅞ x
44⅞ inches. Given anonymously. [392.41]

In his youth Bonnard, like Vuillard, belonged to an avant-
garde group that, under the influence of Gauguin, worked
in reaction to Impressionism, seeking to replace the ob-
jective notation of observed reality with a more subjec-
tive, emotional response. Subsequently, he turned aside
from all prevailing modernist tendencies, electing in-
stead to explore and carry further the Impressionists'
legacy of concentration on color and light.

The Breakfast Room with its boldly patterned wall-
paper is alive with vibrant color. The still life of the laid
table in the foreground in itself provides a dazzling array
of hues, higher in key than those outdoors as viewed
through the window. Purely naturalistic, local color is
modified or abandoned for the sake of a more arbitrary,
decorative scheme, as evidenced by the blue and purple
shadows cast by the objects on the tablecloth and the
tonality of the window uprights. Pigment is laid on in
short, broken brushstrokes that capture the shimmer of
ever-changing light.

Bonnard differed from the Impressionists in con-
structing his pictures according to strict rules of balance.
The composition of *The Breakfast Room* is symmetrical.
The vertical lines and planes of the walls, the uprights of
the windows, and the abruptly curtailed figures at the
sides are countered by the horizontals of the far edge of
the table, the lower part of the window sash, and the top
of the balustrade. The stripes of the tablecloth lead the
eye up and out to the view of the terrace and the garden.
A screen of trees prevents this prospect from opening out
into an unlimited vista; as in Vuillard's painting, what we
see is a glimpse of a private, intimate world.

25

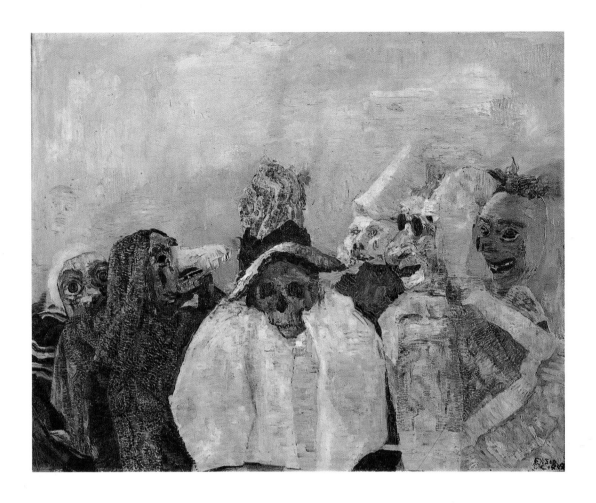

James Ensor. Belgian, 1860–1949.
Masks Confronting Death. 1888. Oil on canvas, 32 x
39½ inches. Mrs. Simon Guggenheim Fund. [505.51]

On the ground floor of the house in Ostend where Ensor
was born, his mother's family kept a souvenir shop,
where sea shells, porcelain, fans, chinoiserie, puppets,
and masks were sold. The masks were of particular im-
portance because the occasion of carnival was elab-
orately celebrated in Ostend. Images of the carnival,
during which bands of figures in fancy dress thronged the
streets and reality was cloaked and distorted by fantasy,
mingle in Ensor's art with images of death, which be-
came increasingly frequent in his work after his father
died in 1887. In *Masks Confronting Death*, there may
also be a reminiscence of such late-medieval allegorical
representations as the Triumph of Death, which shows a
gay band of courtiers out hunting, who suddenly encoun-
ter corpses in various stages of decomposition; or the
Dance of Death, which portrays the skeleton as the ulti-
mate guise of every mortal, be he emperor or beggar.

In this painting, Ensor has exploited to the full the
expressive possibilities inherent in the exaggerated fea-
tures of carnival masks. "Scandalized, insolent, cruel,
malicious masks," he wrote. "I have joyfully shut myself
in the solitary milieu ruled by the mask with a face of
violence and brilliance. And the masks cried to me:
Freshness of tone, sharp expression, sumptuous decor,
great unexpected gestures, unplanned movements, exqui-
site turbulence." The emotional impact of *Masks Con-
fronting Death* is all the greater because it is not painted
in somber, funereal tones but in vivid, high-keyed colors
drenched with light—which Ensor called "the Queen of
our senses."

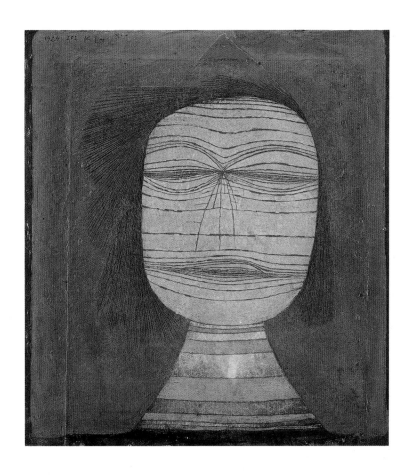

PAUL KLEE. German, 1879–1940. Born and died in Switzerland.

Actor's Mask. 1924. Oil on canvas mounted on board, 14½ x 13⅜ inches. The Sidney and Harriet Janis Collection. [616.67]

In his formative years, Klee was influenced by Ensor, and perhaps this may first have attracted him to the theme of masks. The theater, however, was always among the most constant of Klee's interests, recurring hundreds of times as a subject in his art. He frequented theatrical and ethnographic museums, and during the 1920s made for his son a Punch-and-Judy show peopled with numerous puppets, many of them revealing his familiarity with primitive masks and sculpture. Physiognomy is another dominant theme throughout Klee's art. In many of his works, he reveals the close connection between humans and animals, and even their interchangeability—a

concept often encountered in primitive cultures and children's fairy tales, as well as in Ensor's carnival figures.

In *Actor's Mask*, on the other hand, the face despite its catlike eyes bears less resemblance to an animal than to some geological formation. The frontal image with its hypnotic stare is almost completely flattened, so that here, as the critic Andrew Forge has noted, "mask and face are one." He goes on to say: "The strata-like formation out of which the features grow is ancient. It is as though time had slowly pressed out the eyes, the mouth. Pressure seems to bear across the face in the parallel red lines. The yellow features, with their gathering of red lines, suggest a bursting through of the surface by an even greater pressure." The hair is rendered with the same system of striations that Klee sometimes used, at about the same date as this painting, for landscapes or botanical subjects.

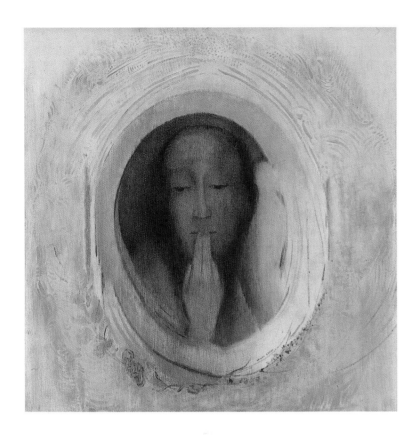

ODILON REDON. French, 1840–1916.
Silence. c. 1911. Oil on gesso on paper, 21¼ x
21½ inches. Lillie P. Bliss Collection. [113.34]

Painted in monochromatic browns within an oval frame
and set against a pale green background, this somber
figure with hooded eyes has a secretive, otherworldly
aspect. The thin oil wash used as a medium contributes
to the evanescent effect. The picture's mood of melan-
choly reverie relates to the literature of the Symbolists,
with whom Redon was closely associated.

To artists and writers of that movement, as Robert
Goldwater has noted, silence was "not merely the simple
absence of sound, nor was it an end in itself; one culti-
vated silence as a means of shutting out appearances in
order to concentrate upon essence, and so isolation be-
came the condition through which the artist could ignore
the material and thus be able to penetrate the spiri-
tual." Maurice Maeterlinck conceived of silence as "a
force that makes it possible to communicate with the
unknown."

This is an evocative image, and at the same time, with
its gesture of upraised fingers sealing the lips, a quite
literal representation of silence. It is not only more ex-
plicit than many of Redon's paintings and prints but is
also related to other renditions of the subject in Western
art. Among the specific sources almost certainly known
to Redon are Fra Angelico's fresco in the cloister of San
Marco in Florence, showing St. Peter Martyr holding a
finger to his lips to enjoin silence, and a marble relief
known as *Le Silence* by the nineteenth-century French
sculptor Auguste Préault on a tomb in the Père-Lachaise
Cemetery in Paris. The relief shows the same gesture as
the figure in Redon's painting and encloses the head in a
similar way within an oval frame against a rectangular
background.

Redon treated the subject of silence in several other
works. Closest to this picture is a mural done at about the
same time (1910–11) as a decoration over the doorway to
the library of his friend Gustave Fayet, which occupied
what had formerly been the cloister of the abandoned
abbey of Fontfroide. These and other connections with
the painting in The Museum of Modern Art have been
discussed by Theodore Reff, who identifies the features
as those of the artist's wife and suggests that, as she had
recently been extremely ill, *Silence* may be a personal
expression of Redon's profound sadness and sense of the
imminence of death.

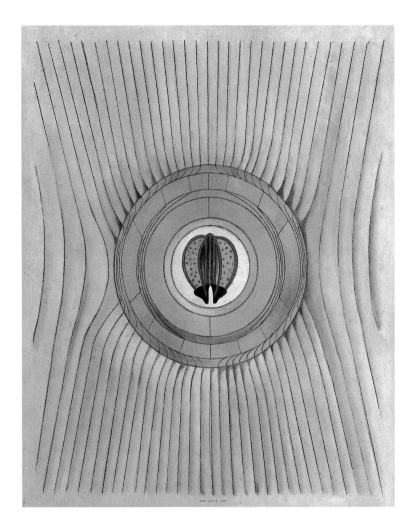

MAX ERNST. French, born Germany. 1891–1976. In France 1922–41, 1953–76; in U.S.A. 1941–53. Naturalized American citizen 1948, French citizen 1958. *The Blind Swimmer*. 1934. Oil on canvas, 36⅜ x 29 inches. Gift of Mrs. Pierre Matisse and the Helena Rubinstein Fund. [228.68]

The subject of Redon's *Silence* is the absence of speech, that of Ernst's *Blind Swimmer* the absence of sight. The two paintings have in common an emblematic quality, a blond tonality, and a similar compositional format—in one, an oval within a square, in the other, a circle within a rectangle. In addition, both have personal references, oblique in Redon's picture and more specific in Ernst's.

The figure of speech "blind swimmer" recurs several times in Ernst's writing. For example, he describes his situation at an early stage in his life, between 1910 and 1911: "The young man, eager for knowledge, avoided any studies which might degenerate into breadwinning. Instead his pursuits were those considered futile by his professors—predominantly painting. Other futile pursuits: reading seditious philosophers and unorthodox poetry. . . . Attracted by the most audacious spirits, he was willing to receive the most contradictory influences. . . . What to do about consequent confusion? Struggle like a blind swimmer?"

Having decided that he wished his art to be one of revelation, one memorable day in 1924 Ernst discovered a procedure that he called *frottage* ("rubbing"). By dropping pieces of paper at random on the floor and rubbing them with black lead, he obtained impressions of the wood's graining. Gazing fixedly at them, he found they intensified his visionary capacities. "By widening in this way the active part of the mind's hallucinatory faculties I came to assist *as spectator* at the birth of all my works. . . . Blind swimmer, I have made myself see. *I have seen.* . . . Enter, enter, have no fear of being blinded." In 1934, he wrote: "I met a blind swimmer."

In this painting, there lies quiescent within the innermost of a series of concentric circles an organism that resembles a seedpod, a larva, or one of the extinct Paleozoic marine invertebrates called trilobites. From the rims of the disks that surround it, lines extend outward in a pattern like ripples of water or the graining of wood.

In the summer of 1934, the year in which he painted this picture and another of the same title, Ernst spent the summer on Lake Geneva. From the riverbed at Maloja, he and his fellow artist Giacometti gathered granite stones that had been left as glacial deposits and abraded into ovoids by currents and the friction of their rubbing together. Ernst collected quantities of them, and by adding color and other decorative elements transformed them into figures, flowers, and birds, leaving the original forms of the stones more or less intact. His encounter with these prehistoric residues may have suggested to Ernst the imagery of this painting, in which we sense a metaphor for embryonic or primeval life and the secret workings of nature's creative forces. *The Blind Swimmer* therefore may allude not only to the act of creation in general, but even more specifically to Ernst's attitude toward his own creativity.

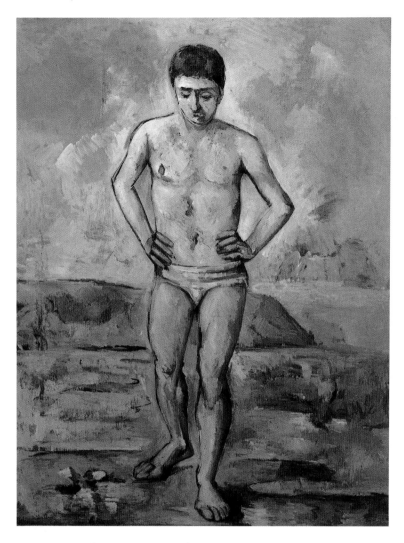

PAUL CÉZANNE. French, 1839–1906.
The Bather. c. 1885. Oil on canvas, 50 x 38⅛ inches.
Lillie P. Bliss Collection. [1.34]

Though based upon a photograph of a nude model, the male body in Cézanne's *Bather* is as far removed from photographic realism as it is from classical idealism. From the standpoint of academic "correctness," the drawing is awkward and imprecise, yet the figure rises before us in impressive monumentality. He is not engaged in bathing nor, indeed, in any overt action, but seems to pause in his advancing stride as if lost in meditation or struck by something on the ground before him.

The effect of immobility is enhanced by his placement in the center of the canvas and the symmetrical pose of his bent arms, with fingers firmly buttressing the waist. Though his position in the front plane of the picture brings him close to us physically, his bowed head and contemplative, downward gaze make him psychologically remote.

Figure and landscape are interlocked in a system of similarities and contrasts. The repeated horizontals of the background, echoed in the banded lines of the bather's trunks and the fingers above them, serve as counterpoint to his vertical form. The flesh of his body is the same color as the stretch of ground behind him; its blue and violet shadows and rosy highlights are like the tones of the rocks, water, and sky. The same type of brushwork is used for both figure and landscape. It is a complex juxtaposition of strokes, which neither suggest texture nor model form in a conventional way but, by their freely changing character, impart a sense of vibrancy to the surface of the canvas. They make us constantly aware that we are not looking at a simulacrum of the visible world but instead at an artificial construct—a painting.

Equally important in this respect is the manner of drawing, with lines that are sometimes long, continuous curves and elsewhere broken and angular. Instead of delineating the contours of the body, they obey their own rhythmic, seemingly arbitrary laws. The dark half-oval line at the bottom of the bather's face does not correspond to the structure of his chin, and immediately to the left there is a break before the beginning of the dark strokes defining his right shoulder and upper arm. Here again, the strokes do not bound these parts of his body but suggest the existence of other planes that might be revealed were he to shift position. They also imply that the spectator's gaze, too, is constantly shifting. Thus, the lack of motion in the subject portrayed is counteracted by the freedom and variation of the lines and brushwork. Instead of freezing his subject within a moment of time, Cézanne leads the viewer to an ongoing visual exploration, somewhat analogous to his own process of observation and re-creation in the course of painting the picture.

PABLO PICASSO. Spanish, 1881–1973. To France 1904. *Boy Leading a Horse*. 1905–06. Oil on canvas, 7 feet 2⅞ inches x 51⅝ inches. The William S. Paley Collection. [575.64]

Early in 1906 Picasso projected a large, horizontal painting, *The Watering Place*, in the foreground of which appear four mounted riders and a walking figure leading a horse. The work was never completed, but it is known through a gouache in the Worcester (Massachusetts) Art Museum that shows the whole composition, and through several other drawn, painted, or engraved studies. The largest of these is *Boy Leading a Horse*, a full-scale rendering of the central motif.

In its monumentality and frontality, and in the withdrawn, introspective mien of the striding youth, this picture invites comparison with Cézanne's *Bather*. The broken contours, type of brushwork, and use of similar tones of landscape, figure, and horse also recall those features in the *Bather*. Picasso had recently had the opportunity to see a large number of works by Cézanne, thirty-one of whose paintings had been exhibited in Paris at the Salon d'Automne of 1905 and ten others at the Salon of the succeeding year.

The sentimentality and predominant linearity of Picasso's earlier Blue and Rose periods have here been supplanted by a more sculptural and classical mode, coupled with a shift to a neutral tonality of browns and grays. These changes reflect a second influence upon Picasso at this time—that of Greek art, which he had been studying at the Louvre. The frontal view of the horse, which has few precedents in painting, was probably derived from antique models, as was the commanding gesture of the hand with which, in the absence of reins, the boy bids the animal to follow.

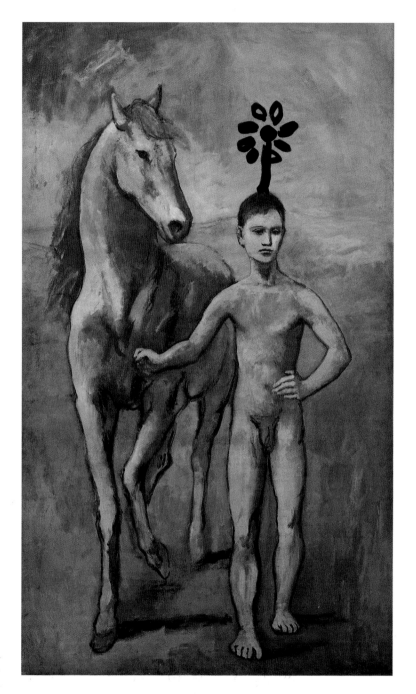

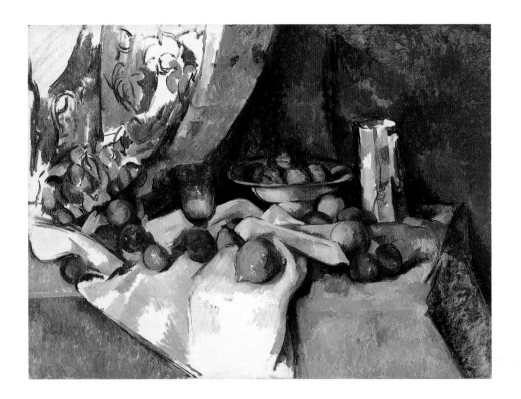

PAUL CÉZANNE. French, 1839–1906.
Still Life with Apples. 1895–98. Oil on canvas, 27 x 36½ inches. Lillie P. Bliss Collection. [22.34]

The still life provided Cézanne with a subject ideally suited to his analytical, contemplative manner of working. To obtain contrasts of color and form, he could choose and arrange objects, which would remain immobile under his protracted scrutiny. In this unfinished painting, lemons, apples, a pear, and a glass are placed upon a rumpled white napkin thrown over an underlying tablecloth. Behind them stand a compotier and a figured jug, and at the left are folds of a patterned curtain.

Cézanne took from the Impressionists, with whom he was briefly associated, the practice of painting directly from nature with small touches of pure, luminous color. But whereas the Impressionists tried to capture momentary effects and preferred high-keyed tones that made objects appear to dissolve in a shimmer of light and atmosphere, Cézanne sought instead to emphasize the solidity and basic geometric structure of his forms, and to create a sense of permanence rather than transience.

To achieve his aim, he closely observed the manner in which local colors appear altered by the recession of planes and the reflection of adjacent objects. Using small, elongated strokes, he translated these modulations into a system of tonal gradations. Intensely concentrated observation of his motif was followed by painstaking selection of the colors that would best render each nuance and enable him to "realize his sensations before nature," confident that "when the color has its appropriate richness, the form will attain its full volume."

Still Life with Apples, like the earlier *Bather* (page 30), shows Cézanne's subtle distortions of nature. The tabletop is uptilted, and outlines are discontinuous to indicate the existence of multiple planes shifting in depth. As in *The Bather*, the handling of the brushstrokes makes us realize that we are not looking at a literal representation of nature but at a painting that reconstructs the artist's response to it. This, however, is not an intensely subjective, expressionistic response such as that of van Gogh, for example, whose *Starry Night* (page 16) makes us as aware of his own emotion as of the scene he portrays. While fully conscious of the voluptuous appeal of his motif, Cézanne's approach is more objective. He externalizes his sensations, analyzes what produces them, and concentrates on the problems of transcribing them. He offers both an intellectual and a sensuous experience.

PAUL CÉZANNE.
Le Château Noir. 1904–06. Oil on canvas, 29 x 36¾ inches. Gift of Mrs. David M. Levy. [137.57]

Following the death of his mother and the ensuing sale in 1899 of the family estate, the Jas de Bouffan, Cézanne moved to a small apartment in the center of Aix. While his wife and son resided chiefly in Paris, he lived alone for most of the time, driving out daily into the Provençal countryside in search of motifs to paint. A prominent feature of the region is the Château Noir, a complex built in the second half of the nineteenth century. Set on a plateau atop a steep hill whose slopes are covered by thickly growing vegetation and large boulders, it consists of two buildings at right angles to each other, surrounded on three sides by a broad terrace. Its name is a misnomer, for in fact it is not a château, and its color is the warm yellow stone of the nearby Bibémus quarry. The designation "black" may refer to the sinister reputation of its builder, alleged in local legend to have been an alchemist in league with the devil—hence the alternate name, "Château du Diable."

Obviously undeterred by such tales, Cézanne sought to buy the property, which was unoccupied for most of the year. Though unsuccessful, he was able to rent a small room in which to store his paraphernalia, and he was permitted to paint outdoors wherever he wished. From the east side of the sun-drenched terrace he had an unobstructed view of his beloved Mont Sainte-Victoire.

Cézanne painted the Château Noir several times from different aspects. Here, the main building, with its strictly geometric horizontal and vertical lines and its orange façade and large red door, is centered between the dark blue-green of the dense foliage and the deep blue of the sky, with the darker blue of Mont Sainte-Victoire's truncated top visible beyond. Painted a decade after *Still Life with Apples*, this canvas shows the technique that Cézanne adopted in the last years of his life. Instead of modeling solid objects with short parallel strokes of the same tint set side by side, here he applied large patches of different hues, laid on with wide brushstrokes that sweep rhythmically across the surface. No drawn contours bound the shapes of the buildings or interrupt the dynamic vitality of the irregular masses of the forest. Even the cloud-filled sky seems vibrant with life.

Another version of *Château Noir*, owned by Picasso, is now in the Musée Picasso in Paris. The present painting used to hang in Monet's bedroom at Giverny; once, showing it to a visitor, he is reported to have declared, "Yes, Cézanne, he is the greatest of all of us."

ANDRÉ DERAIN. French, 1880–1954.
Bathers. 1907. Oil on canvas, 52 inches x 6 feet 4¾ inches. William S. Paley and Abby Aldrich Rockefeller Funds. [683.80]

Derain and Matisse were two of the most prominent among the artists whose paintings, with bright, unnaturalistic colors applied in flat decorative patterns, profoundly shocked viewers at the Salon d'Automne in Paris in 1905. One critic derided their "formless confusion of colors; blue, red, yellow, green; some splotches of pigment crudely juxtaposed," while another applied to them the sobriquet *Fauves* ("wild beasts"), a name that came to be generally adopted.

Soon, however, Derain turned away from flatness and a predominant reliance on expressive color to seek more sculptural effects attained through tonal modifications. This painting clearly shows the influence of Cézanne, whose many pictures of grouped bathers were well known to Derain. His interest in solid forms was also stimulated by an appreciation of African sculpture, which he studied in the ethnographic collections of museums in London and Paris and began to collect in 1906. These primitive works, as well as woodcarvings by Gauguin, prompted him to undertake his own carvings of drastically simplified stone figures.

Bathers manifests Derain's desire to create a monumental work with compactly modeled figures within a landscape setting. Curving forms are combined with angular gestures, faceted planes, and brushstrokes vaguely reminiscent of Cézanne's. Some of Fauvism's unnaturalistic coloring persists in the vivid blues and greens, but it goes hand in hand with more Cézannesque tan or rosy flesh tones. The stylized face of the central figure has sometimes been said to demonstrate the influence of African art, with which, however, it actually has little in common. Likewise, despite obvious references to Cézanne's paintings of bathers, the static, isolated figures in Derain's canvas are quite unrelated to the interlocking rhythms of those compositions.

When shown at the Salon des Indépendants in 1907, *Bathers* evoked scorn from the same critic, Louis Vauxcelles, who two years before had coined the designation *Fauves*. He wrote of "the barbaric simplifications of Monsieur Derain. . . . Cézannesque mottlings are dappled over the torsos of bathers plunged in horribly, indigo waters."

Sometime after this Salon, the painting was purchased by the dealer D.-H. Kahnweiler. Sold in 1923 in an auction of his property, it passed into an obscure Swiss collection and for decades remained all but unknown to art historians. Its first public showing after the Salon des Indépendants of 1907 was in The Museum of Modern Art's 1976 exhibition "The 'Wild Beasts': Fauvism and Its Affinities," and it was acquired four years later by the Museum.

PABLO PICASSO. Spanish, 1881–1973. To France 1904. *Les Demoiselles d'Avignon.* 1907. Oil on canvas, 8 feet x 7 feet 8 inches. Acquired through the Lillie P. Bliss Bequest. [333.39]

Many decades have passed since *Les Demoiselles d'Avignon* was painted, yet on first encounter it can still shock the spectator almost as much as it did its earliest viewers. This is not due to any action it portrays, for the poses are static, and nothing more dramatic is happening than the drawing back of a curtain at the left and the entry of a woman at the right.

The impressively large canvas with its distorted manner of representation is nevertheless charged with violence throughout. It is implicit in the tension produced by the crowding of figures within a shallow, compressed, and ambiguous space; in the sharply jutting angles and unmodulated, sicklelike curves of their faces and bodies; and in the jagged highlights.

Picasso's subject was the interior of a brothel; the title was given to the painting many years later in ironic reference to a notorious house on the Carrer d'Avinyó ("Avignon Street") in Barcelona. Originally the center of the scene was occupied by a sailor holding a wine vessel; the figure entering at the left was identified by Picasso as a medical student, who in some preparatory drawings carries a skull and in others a book. The confrontation between the two expressed the artist's fear of death through venereal disease, which the sailor had contracted at the bordello and the medical student has come to cure.

As Picasso worked on the painting, its narrative elements disappeared, and it became what William Rubin has called an "iconic," expressionistic picture symbolizing sexual passion and death. Its style underwent as many radical changes as its composition. The figure at the left recalls Assyrian or Egyptian sculptures Picasso had seen at the Louvre. He had recently acquired two Iberian stone heads, and some of the conventions of that pre-Roman sculptural style appear in the two women in the center.

Even more radical changes followed a visit to the Musée du Trocadéro in June, after which Picasso repainted the figures at the right, giving them acutely distorted, sharply angular features. Though Picasso was already familiar with African Negro sculpture, he later declared that on this occasion he received a "shock" and a "revelation." The primitive masks appeared to him "not just as sculptures. They were magical objects . . . intercessors . . . against . . . unknown, threatening spirits." In the context of his evolving painting, the women at the right became apotropaic figures whose sexual energy could exorcise disease and mortality.

Still another influence, that of Cézanne, is apparent in the fusion of figures and background within a shallow space, and, most obviously, in the uptilted table with tablecloth and fruit at the center below.

This disconcerting mingling of styles was intentional, according to Leo Steinberg. He has stated: "Picasso's ultimate challenge is to the notion that the coherence of the art work demands a stylistic consistency among the things represented. . . . And the shock of the *Demoiselles* resides largely in the frustration of this expectation." Rubin, too, believes that the stylistic disparities were purposeful and were meant to span the polarity between Eros and Thanatos—"from the allure of the female body to 'the horror' of it."

Les Demoiselles d'Avignon is not, as has sometimes been alleged, the first Cubist picture. Cubism was an art that sought to depict a new kind of realism through detachment and intellectual analysis and control, whereas the *Demoiselles* is violently emotional and expressionistic. In this breakthrough work, the twenty-six-year-old Picasso expunged any vestiges of nineteenth-century painting still remaining in Fauvism and moved from a perceptual to a conceptual mode. But, as Alfred H. Barr, Jr. has pointed out, over and beyond its historical significance, "it is also a work of formidable, dynamic power unsurpassed in European art of its time."

35

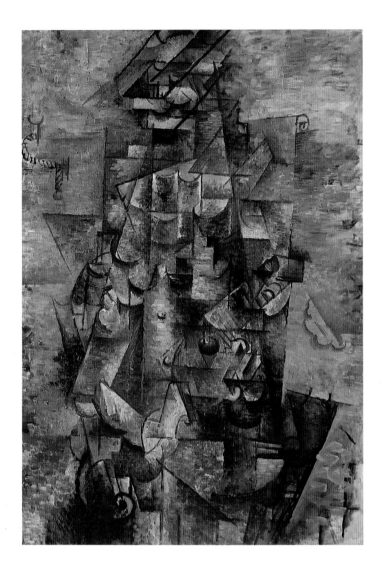

GEORGES BRAQUE. French, 1882–1963.
Man with a Guitar. Begun 1911, completed early 1912.
Oil on canvas, 45¾ x 31⅞ inches. Acquired through the
Lillie P. Bliss Bequest. [175.45]

The paintings shown on this and the opposite page exemplify a remarkable symbiotic relationship between two artists. As Braque was later to say, between 1909 and 1914, he and Picasso were "rather like two mountaineers bound together," as they jointly developed the style that became known as Cubism.

In the summer of 1908, in the small Mediterranean village of L'Estaque, Braque painted a number of landscapes that differed from those Cézanne had done in that

area, for he imposed on his motifs a non-illusionistic kind of reality. He stylized buildings as cubes, created volumes by the faceting of planes, inspired by his study of African sculpture, and tilted planes at right angles to the picture's surface to indicate the positions of the volumes within the shallow space. Forsaking the bright colors of his preceding Fauvist style, he employed a muted palette of greens, ochers, grays, and black.

The paintings that he sent in September to the Salon d'Automne were rejected by the jury, which included Matisse, who described Braque's pictures as "made up of small cubes"—leading to the designation of Cubism given to the nascent movement.

The following summer Braque, painting at La Roche Guyon in the Seine valley, and Picasso, working at Horta de Ebro in Catalonia, carried still further the reduction of buildings and elements of the landscape to geometrical forms. Realizing that they shared common goals, the two men began their close association; they engaged in constant discussions and eagerly showed one another whatever they had produced each day. However abstract their paintings may appear, their aim was to devise a new kind of representational art. Instead of seeking to imitate nature and create an illusionistic likeness through traditional three-dimensional modeling, linear perspective, and local color, they combined memory and the analysis of form with visual observation, showing figures and objects, not as they would be seen at a given moment, but as if viewed from different aspects at different times.

They took from Cézanne, besides the use of a shifting viewpoint (as in *The Bather*, page 30), the device of *passage*: the planes that defined an object were left open on one side to elide with others adjacent to it on the flat surface of the canvas, even though the objects might occupy different locations in depth. Elements were absorbed within an allover scaffolding of horizontal and vertical lines. These were meant to be read as the edges of semitransparent, shifting planes that indicated diagrammatically the parts of bodies or objects within a shallow space. Consonant with their intent of creating a conceptual, rather than a descriptive, image, the role of light was reduced, and colors were restricted to browns, tans, and grays.

Once we have learned to decipher this Cubist code, we can readily discern the subjects depicted. In *Man with a Guitar*, we can identify the profile of the player at the top, his long right arm bent at the elbow, and the strings, keys, and other fragmented parts of his instrument. Set symmetrically within the canvas, the guitarist is an imposing presence. The background is enlivened by textured brushwork laid on in parallel strokes, while at the upper left a rope hanging from a nail is a wittily interpolated bit of *trompe l'oeil*.

PABLO PICASSO. Spanish, 1881–1973. To France 1904.
"Ma Jolie." 1911–12. Oil on canvas, 39⅜ x 25¾ inches.
Acquired through the Lillie P. Bliss Bequest. [176.45]

Picasso's painting, like Braque's, takes as its subject a
symmetrically placed figure playing a musical instru-
ment, here variously identified as a zither or a guitar.
Instead of the landscapes that they had depicted in the
earlier phase of their evolving Cubism, the artists'
themes were now the paraphernalia of their studios, ob-
jects encountered at local cafés, and portraits of their
friends and acquaintances.

Here, as in Braque's *Man with a Guitar*, we can make
out the sitter's head at the top of the composition and her
left arm bent at the elbow. The fingers of her other hand
are seen at the lower right, the instrument's vertical
strings appear in the center, and at the bottom of the
picture we find the musical staff and treble clef, and the
letters MA JOLIE. This refers both to the refrain of a
popular song of the day and also to Picasso's affectionate
pet name for his then-current love, Eva Gouel (Marcelle
Humbert).

The printed or stenciled letters Picasso and Braque
introduced into their pictures of this period offer the
viewer a hint of the underlying reality and also define
the flat plane of the surface, in contrast to the objects that
occupy the shallow space behind them. Braque later ex-
plained the use of this device by saying that "being
themselves flat, the letters were not in space, and thus, by
contrast, their presence in the picture made it possible to
distinguish between objects situated in space and those
that were not." Together with the clearly distinguishable
brushstrokes, the bold letters serve notice that the "real-
ity" with which we are dealing here is that of the picture
itself, not that of the "real" world.

Again, as in Braque's *Man with a Guitar*, the elements
of the painting are absorbed within a gridwork of hori-
zontal and vertical lines. In such paintings, which appeal
to the mind as well as to the eye, the recognizable frag-
ments within the formal abstract framework set up a
tension between our perception of the subject matter and
our mental concept of it, between illusionistic descrip-
tion and its subordination to an artificially ordered struc-
ture. As William Rubin has observed, "the poetry of
Analytic Cubism owed much to the very ambiguity of its
forms"—analogous to the ambiguity that characterizes
much modern literature.

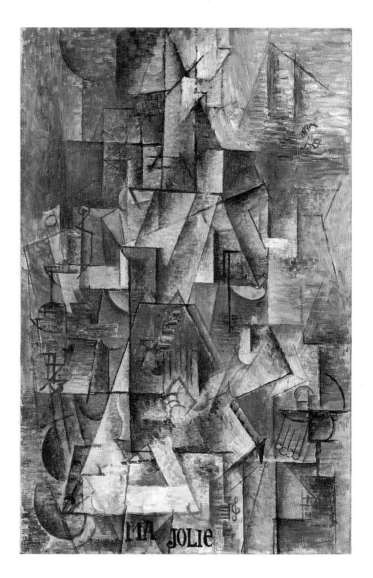

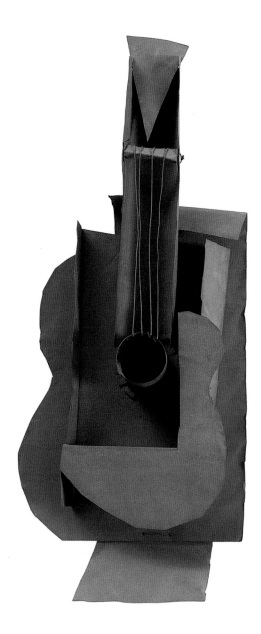

PABLO PICASSO. Spanish, 1881–1973. To France 1904. *Guitar*. 1912–13. Construction of sheet metal, string, and wire, 30½ x 13¾ x 7⅝ inches. Gift of the artist. [94.71]

In an abrupt departure from the age-old tradition of sculpture, which created solid forms by carving or modeling, Picasso with *Guitar* initiated a radically new type of openwork construction, innovative also in its use of the new materials and techniques of sheet metal and wire.

A musical instrument, a favorite motif in his paintings, is here broken up as in Analytic Cubism and the segments arranged in overlapping planes that are partially cut away to provide simultaneous views of the different levels and allow one to see into and through the object. With its superimposed planes within a shallow space, *Guitar*, which is conceived as a relief rather than as a sculpture in the round, emulates similar devices in Cubist painting.

The interplay of curving and rectilinear metal shapes contrasts with the vertical lines of the wire strings. These terminate in a central cylinder that represents the hole of the sounding board. Viewed directly from the front, its rim appears like an inscribed circle, though in actuality it projects forward from the instrument's back plane. By a remarkable process of inversion a concave, inner space is paradoxically represented by its opposite—a convex, outward protrusion. Picasso told his dealer, D.-H. Kahnweiler, that this seeming contradiction had been suggested to him by the structural principle he observed in an African Grebo mask that he owned. Not only the nose and lips of this mask were shown as projecting, but the eye sockets, too, were represented as salient rather than receding features.

The Museum owns a cardboard-and-string maquette for *Guitar*, also a gift from the artist.

NAUM GABO. American, born Russia. 1890–1977.
Worked in Germany, France, and England. To U.S.A.
1946. Naturalized American citizen 1952.
Head of a Woman. c. 1917–20, after a work of 1916.
Construction of celluloid and metal, 24½ x 19¼ x
14 inches. Purchase. [397.38]

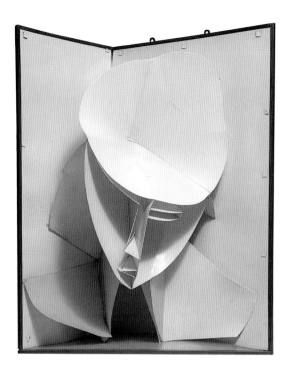

Gabo's *Head of a Woman*, like Picasso's *Guitar*, breaks
with traditional sculpture by opening up mass to the
penetration of space and giving voids and solids equal
importance. Gabo's medium, also, was as unconventional
as Picasso's—celluloid, a material invented in the United
States in 1869, which became widely used interna-
tionally for the manufacture of combs, fans, and other
small articles. The influence of Analytic Cubism is ap-
parent in the head's transparent, intersecting planes and
its counterpoint of curving and angular shapes, like those
of *Guitar*.

Born Naum Neemia Pevsner in Bryansk, Russia, Gabo
was sent by his father to study medicine at the University
of Vienna but became more interested in mathematics,
physics, chemistry, and physical engineering, as well as
art history. After coming into contact with Kandinsky
and other avant-garde artists, he embarked on a series of
travels that brought him to Italy, where the Futurists were
in the ascendancy, and to Paris, where his older brother,
Antoine, a painter, familiarized him with the works of
the Cubists and those of a fellow-Russian, Archipenko,
who was opening up holes in his sculptures to allow for
the penetration of space and making figures incorporat-
ing such unorthodox materials as glass and paper.

At the outbreak of the First World War, Gabo joined
Antoine in Oslo, Norway. There he embarked on his own
exploration of sculpture, made his first constructions, and
adopted the name Gabo to differentiate himself from his
brother. With the overthrow of the czarist regime, the
two returned to Russia, where the revolutionary govern-
ment welcomed the newest ideas in art and architecture.
Two factions holding competing ideologies were headed
respectively by Malevich, the founder of Suprematism
(see page 50), and Tatlin, leader of the politically ori-
ented Productivists, who sought to direct art away from
aesthetics and apply technology for utilitarian social
purposes.

Reacting to both these tendencies, Gabo and Pevsner
on the occasion of an open-air exhibition in Moscow in
1920 issued their Realistic Manifesto, setting forth the
principles by which they believed art should be guided:
"The realization of our perceptions of the world in forms
of space and time is the only aim of our pictorial and
plastic art. . . . We renounce sculpture, the mass as a
sculptural element. . . . We bring back to sculpture the
line as a direction and in it we affirm depth as the one
form of space." The name of their movement, Con-
structivism, was given to it by critics and writers; the
artists called themselves "constructors," because they
built up their works as an engineer builds up a construc-
tion. Contradicting those who described their art as ab-
stract, they were convinced that what they were doing
was representing a new reality, hence the title they gave
their manifesto.

Gabo made a first metal version of *Head of a Woman* in
Norway in 1916; another, in enameled brass, was bought
by the Soviet government in 1920/22 and is now lost.
This celluloid model, included in the 1920 Moscow ex-
hibition, was sent to Germany and the Netherlands in
1922 for a large, officially sponsored show of Russian art.
Gabo went to Berlin to supervise the Constructivist sec-
tion and, judging correctly that the Soviet regime was
beginning to turn away from its support of avant-garde
art in favor of Social Realism, decided to stay in Ger-
many. After ten years there, he lived successively in
France and England before coming to the United States
in 1946, where he remained until his death.

Gabo used several titles for this work, first calling it
Constructed Head No. 3, then *Head of a Woman,* and
frequently *Head in a Corner Niche.* Some Corner Con-
structions of 1915–16 by Tatlin served as precedents for
the projecting, angled form that draws the spectator into
its enfolding space. Set within its metal-bordered frame,
the head resembles an icon, and in fact Gabo often set it
high up on the wall—the position of honor given to
sacred images in Russian homes.

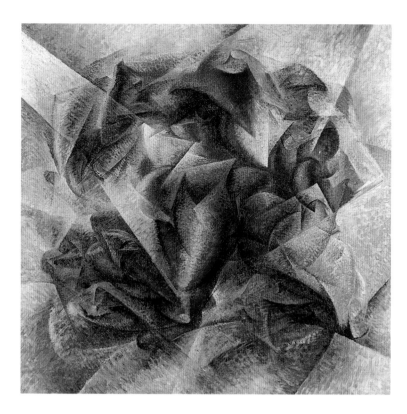

UMBERTO BOCCIONI. Italian, 1882–1916.
Dynamism of a Soccer Player. 1913. Oil on canvas, 6 feet
4⅛ inches x 6 feet 7⅛ inches. The Sidney and Harriet
Janis Collection. [580.67]

Bursting upon one's sight like an exploding pinwheel, the
Dynamism of a Soccer Player conveys an immediate
impression of furious energy, even before one deciphers
the figure of the athlete that is its embodiment. In Febru-
ary 1909, the poet and editor Filippo Tommaso Marinetti
had published the impassioned Manifesto of Futurism, in
which he proclaimed: "We shall sing the love of danger,
the habit of energy and boldness. . . . There is no more
beauty except in strife. . . . It is in Italy that we launch
this manifesto of violence, destructive and incendiary, by
which we this day found *Futurism.* . . ." Boccioni was
among a group of young artists who soon met with Mari-
netti to propose that painters be included in the move-
ment. In April 1910 they issued Futurist Painting:
Technical Manifesto, outlining the principles that would
guide their art: "The gesture which we would reproduce
on canvas shall no longer be a fixed *moment* in universal
dynamism. It shall simply be the dynamic sensation itself
[made eternal]. Indeed, all things move, all things run,
all things are rapidly changing. . . . To paint a human
figure you must not paint it; you must render the whole of
its surrounding atmosphere." These words embody not
only Marinetti's ideas but also those of Henri Bergson,
who in his *Introduction to Metaphysics* had written:
"Consider the movement of an object in space. My per-
ception of the motion will vary with the point of view,
moving or stationary from which I observe it. . . . I call
such motion relative. . . . But when I speak of an absolute
movement, I am attributing to the moving object an inner
life and, so to speak, states of mind."

Boccioni's *Dynamism of a Soccer Player* is a visual
manifesto of the Futurists' goals enunciated three years
before. The shallow space and shifting, transparent
planes reveal the influence of Analytic Cubism. It also
exemplifies another principle, which he set forth the fol-
lowing year—that of making the spectator a participant
in the action by painting "lines of force" to encircle and
involve him.

To heighten the radiance of the colors and make the
shadows luminous, Boccioni retained the pointillist tech-
nique of applying pigments in dots (see page 17) or used
tiny strokes. The eye is led into the center of the picture
by diagonal beams of light that intensify the disintegra-
tion of the player's form through motion. As he worked on
the canvas, Boccioni found it too small to accommodate
his swirling patterns and enlarged it by sewing additional
pieces onto three sides. The painting, owned by Mari-
netti, remained in the possession of his widow until it was
acquired by Sidney Janis in 1954.

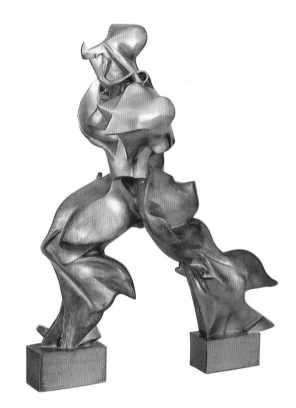

UMBERTO BOCCIONI.
Unique Forms of Continuity in Space. 1913. Bronze (cast 1931), 43⅞ x 34⅞ x 15¾ inches. Acquired through the Lillie P. Bliss Bequest. [231.48]

The year before he painted *Dynamism of a Soccer Player*, Boccioni issued the Technical Manifesto of Futurist Sculpture, in which he proclaimed: "Sculpture must . . . give life to objects by making their extension in space palpable, systematic, and plastic. . . . Systematization of the vibrations of light and the interpenetration of planes will produce Futurist sculpture. . . . We . . . proclaim the ABSOLUTE AND COMPLETE ABOLITION OF DEFINITE LINES AND CLOSED SCULPTURE. WE BREAK OPEN THE FIGURE AND ENCLOSE IT IN ENVIRONMENT." This theoretical statement of Futurist principles as applied to sculpture preceded Boccioni's actual practice of that medium, to which, however, he soon began to apply himself side by side with painting.

None of Boccioni's sculptures were cast in his lifetime, and the plasters of three-quarters of them, accidentally destroyed in 1917 after a posthumous exhibition in Milan, are known to us only through photographs. Fragments of several works, including *Development of a Bottle in Space* and *Unique Forms of Continuity in Space*, were collected and carefully reconstructed by Marinetti and other friends of the artist. In the first-named of these, Boccioni, scorning traditional subjects, made the bottle into a complex, dynamic form. Its round shape expands with a spiraling momentum like that of the athlete in the center of *Dynamism of a Soccer Player*.

Soon, however, wanting to evoke a more emotional response to his sculptures, even if produced through nontraditional means, Boccioni embarked upon a series of great striding figures. Related to this series is the large charcoal and pastel drawing that he called *Muscular Dynamism*. Its forceful lines suggest but do not describe the image of a body in motion. The lost sculptures, *Synthesis of Human Dynamism*, *Muscles at High Speed*, and *Spiral Expansion of Muscles in Action*, culminated in *Unique Forms of Continuity in Space*, which Boccioni in a letter of September 4, 1913, referred to as his "most recent and liberated work."

Poised on two blocks of slightly unequal size, the figure advances with a giant stride, yet, as Joshua Taylor has observed, "its impetuous step rests lightly on the ground as if the opposing air gave the figure wings. It is muscular without muscles, and massive without weight." Swirling, streamlined shapes incorporate in three dimensions the "lines of force" that surround the powerful body in its vehement forward rush. Though Marinetti's initial Manifesto of Futurism had exalted the beauty of speed and declared that "a roaring motor-car . . . is more beautiful than the *Victory of Samothrace*," unquestionably Boccioni had that famous masterpiece in mind when he challenged its classical, representational mode with a wholly modern, abstract form of expression, in which planes and volumes denote dynamic forces that propel themselves through the surrounding atmosphere.

41

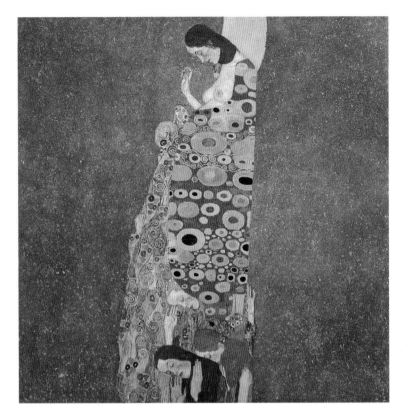

GUSTAV KLIMT. Austrian, 1862–1918.
Hope, II. 1907–08. Oil, gold, and platinum on canvas,
43½ x 43½ inches. Mr. and Mrs. Ronald S. Lauder and
Helen Acheson Funds, and Serge Sabarsky. [468.78]

At the turn of the century, Vienna was the cultural hub of
Central Europe. Its leadership, however, depended less on
the visual arts than on its contributions to music, with
composers such as Gustav Mahler, Richard Strauss, and
Arnold Schönberg, and on the modern architecture pio-
neered by Otto Wagner, Joseph Maria Olbrich, Josef
Hoffmann, and Adolf Loos. This situation changed in
1897 when a group of artists broke away from the conser-
vative Künstlerhaus that dominated art exhibitions to
form a new organization, the Secession. It was dedicated
to showing the most advanced work of Austrian and
foreign artists and to realizing the ideal of the
Gesamtkunstwerk, the total work of art, propounded by
Richard Wagner. The group's selection of the thirty-five-
year-old Gustav Klimt as president was a somewhat sur-
prising choice, for until he decided to cast in his lot with
the young rebels, he had achieved a reputation as a deco-
rative painter who executed commissions for official
buildings in an eclectic, academic style.

Commissioned to decorate the ceiling of the Assembly
Hall in the University of Vienna, Klimt painted three
panels to represent Philosophy, Medicine, and Jurispru-
dence. Included in the complex allegory of Medicine was
a pregnant woman, a motif that Klimt developed further
in an easel painting, *Hope, I*, now in the National Gallery
of Art at Ottawa. This he proposed to include in a major
retrospective of his work to be held in November 1903 at
the Eighteenth Exhibition of the Vienna Secession, but
he withdrew it on the advice of the Minister of Culture
and Education, who deemed the portrayal of a nude
woman in an advanced state of pregnancy too shocking
to be exposed to the public. The work was purchased by
Klimt's friend Fritz Waerndorfer, who screened it behind
double doors in his home lest it offend visitors.

In 1907–08, Klimt again took up the theme in *Hope, II*,
which during his lifetime bore the title *Vision*. Embody-
ing the intertwined ideas of love, birth, and death that
recur frequently in his art, it is a Symbolist work that,
like Redon's *Silence* (page 28), is subject to various inter-
pretations. The composition differs radically from the
first version, for here the woman is clothed, except for her
bared breasts; with bent head and upraised hand, she
seems to be praying for the safe delivery of her expected
child, menaced by a death's head half hidden above her
protuberant belly. A group of women below join their
petitions to hers. Symmetrically placed in the center of
the picture, the woman with ramrod-straight back and
small head set above an unnaturally elongated body ap-
pears, in Fritz Novotny's words, like a "human column on
a square of canvas."

Klimt's father was a goldsmith, and the artist's respect
for craftsmanship and love of precious metals led him to
develop his so-called "golden" style. Inspired by his
experience of the sixth-century mosaics of Ravenna that
he saw on trips to Italy in 1903 and 1904, Klimt sought to
re-create the exotic splendor of the Orient, drawing upon
sources as diverse as Byzantine art, Mycenean metal-
work, Persian miniatures, and Japanese screens.

In *Hope, II*, the rounded forms of the figure's swelling
breasts contrast with the flat, richly patterned robe, set
off against a dark, flecked background. In a sensuous
display of luxurious ornamentation, golden ovals of vari-
ous sizes float across the surface, and a filigree of golden
spirals further dazzles the eye.

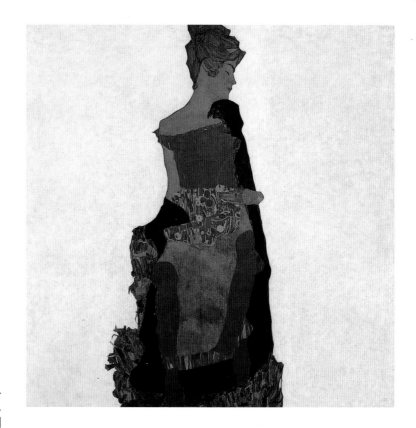

EGON SCHIELE. Austrian, 1890–1918.
Portrait of Gertrude Schiele. 1909. Oil, silver, gold-bronze paint, and pencil on canvas, 55 x 55¼ inches. Purchase and partial gift of the Lauder Family. [451.82]

A year or so after he came to Vienna in 1906 from his native small town to study at the Academy, Schiele had the good luck to meet Klimt. The forty-five-year-old artist befriended the seventeen-year-old youth and became both his artistic and spiritual mentor. After quitting the Academy in revolt against the conservative classicism of its training and its antimodern outlook, Schiele joined a group of progressive artists, headed by Klimt, who in 1905 had broken with the Secession to form the Österreichischer Künstlerbund (Austrian Artists Union), and he participated with them in their second exhibition, the "Kunstschau 1909."

In that year, Schiele painted two portraits of his younger sister, Gertrude. Brother and sister had a very close relationship, especially after the death of their father in 1905, and the young girl often posed for Schiele's nude studies. The first portrait, called *Woman in a Black Hat*, showed her in a frontal position, clad in a dress and scarf ornamented with large circles. Confiscated by the Nazis when they occupied Trieste during the Second World War, the painting was later sold at auction and is now in the Georg Wächter Memorial Foundation, Geneva.

This second version, which remained for many years in the possession of Schiele's family, reveals the obvious influence of Klimt in the towerlike figure centered against a neutral background. In contrast to *Hope, II,* however, the background here is pure white, and instead of Klimt's brilliantly colored, exuberant ornamentation, flesh, hair, and gown are all toned down to ochers, grays, and black, relieved by only a few small areas of red and touches of silver and gold-bronze paint. The girl's head, with eyes closed as if in reverie, is silhouetted in profile. The plunging line of the dark wrap that falls from her shoulder is broken only by her right hand; the lower part of her body is veiled by a diaphanous gown.

Schiele was soon to develop a highly personal, expressionistic style completely at variance with the dreamlike quietude of his *Portrait of Gertrude Schiele.* In his paintings and drawings, he presented nude self-portraits with angular, contorted gestures, colored with bright, unrealistic hues, and naked models in erotic, frequently pornographic poses. By a strange twist of destiny that seems to echo the triad of love/birth/death in Klimt's *Hope, II,* Schiele's wife died of influenza in the sixth month of her pregnancy, and he too succumbed three days later, at the early age of twenty-eight.

43

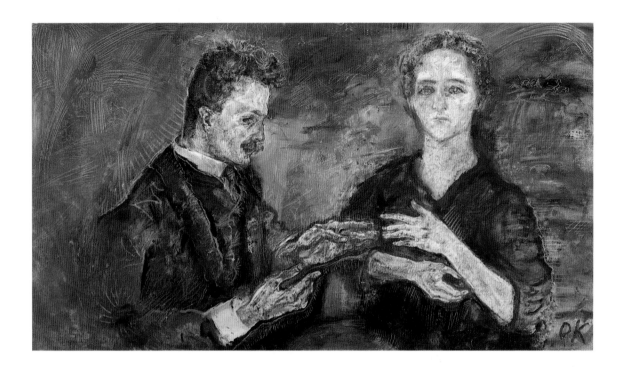

OSKAR KOKOSCHKA. British, born Austria of Austrian-Czech parents. 1886–1980. Worked in Germany and Czechoslovakia. In England 1938–70. Naturalized British subject 1947. Traveled extensively throughout lifetime. Died in Switzerland.
Hans Tietze and Erica Tietze-Conrat. 1909. Oil on canvas, 30⅛ x 53⅝ inches. Abby Aldrich Rockefeller Fund. [651.39]

Unlike Schiele, who came from a provincial working-class background, Kokoschka was the son of a prominent businessman with humanist interests, and when he came to Vienna he moved easily in that city's social, intellectual, and artistic circles. Adolf Loos encouraged him to forsake architecture for a career as a portraitist and arranged for many of his first sittings. Among Kokoschka's early works in his newly adopted métier is this painting, commissioned by the prominent art historians Hans Tietze and his wife, Erica Tietze-Conrat, for the overmantel of their house.

The double portrait, a traditional subject in art, has here been given a twentieth-century interpretation. With its emphasis on the psychological relationship between the sitters rather than the mere transcription of their physical characteristics, it could hardly differ more from the preeminently decorative mode of Schiele's *Portrait of Gertrude Schiele* (page 43), done in the same year.

The couple do not look directly at each other; their intimate communion is more subtly expressed by the sensitively drawn, nervous hands. As in Michelangelo's *Creation of Adam* on the ceiling of the Sistine Chapel, an electric tension is generated between the fingers that approach closely without quite touching.

The artist stated that in a creative approach diametrically opposed to "theories on art asserting the human being to be seen as a kind of *nature morte*," he sought "to render the vision of people being alive, due to the effect of an inner light." Light does indeed seem to emanate from these figures. The striated lines that surround them are like rays, and the thinly painted, high-keyed color of the background, with its mysterious graffiti, envelops the pair in its shimmering atmosphere.

WILHELM LEHMBRUCK. German, 1881–1919.
Standing Youth. 1913. Cast stone, 7 feet 8 inches x
33½ inches x 26¾ inches, including base. Gift of Abby
Aldrich Rockefeller. [68.36]

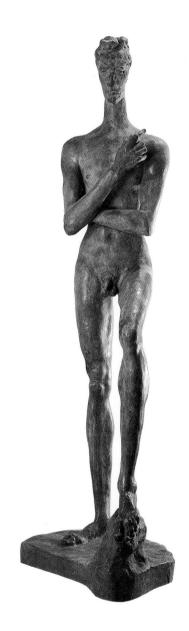

Like Cézanne's *Bather* (page 30), Lehmbruck's *Standing
Youth* represents a nude man with bowed head, left leg
advancing and rear leg bent. Yet in all other respects the
two works differ radically. The proportions of Cézanne's
figure, based on the photograph of a model, are normal,
whereas the unnaturally elongated body of Lehmbruck's
youth is pared down to gauntness. In the Cézanne, the
arms set akimbo affirm the torso's solidity; in the Lehm-
bruck, the left arm bent at the elbow shields the body
from the outside world, and the right forearm brought
diagonally across the chest is a further protective barrier.
The hand of the *Standing Youth* is disproportionately
large, like those of the sitters in Kokoschka's double
portrait, but here, instead of reaching outward to seek
communion, the fingers gesture inward, contributing to
the sense of withdrawn contemplation implied by the
inclination of the head.

In 1901, as a "master student" at the Düsseldorf Acad-
emy, Lehmbruck began to create large academic nudes
and projects for monuments to mythological heroes. His
artistic outlook was broadened, first by a large retrospec-
tive of Rodin's works shown at Düsseldorf in 1904, and
then by two years of travel in the Netherlands, England,
and Italy. Journeying to Paris in 1907, Lehmbruck joined
the Société Nationale des Beaux-Arts and exhibited a
Mother and Child at the Salon.

Lehmbruck moved with his family to Paris in 1910 and
remained there until the outbreak of war in 1914, estab-
lishing contact with many of the modernist painters and
sculptors. The smooth surfaces and simplified shapes of
his large *Standing Woman* of 1910 (City Art Museum of
St. Louis) indicate that the influence of Rodin had been
supplanted by that of Maillol, though the figure's lithe
youthfulness and pensive expression are quite different
from the robust maturity and Mediterranean exuberance
of that artist's women.

Kneeling Woman of the following year signals a major
change in Lehmbruck's style, and one not appreciated by
critics at the time. Its attenuated form, bent head with
melancholy expression, and upraised right arm with fin-
gers pointing inward foreshadow the *Standing Youth*. But
its gentle, rhythmic grace and drapery carefully arranged
in parallel, flowing curves do not prepare one for the
exaggerated elongation and stark emaciation of that fig-
ure, whose ascetically diminished flesh is the expression-
istic vehicle for a spiritual, rather than a corporeal,
energy. "All art is measure. Measure against measure,"
Lehmbruck declared. "The measures or, in the case of

figures, the proportions, determine the impression; the
effect, the physical expression, the line, the silhouette—
everything. . . . Sculpture is the essence of things, the
essence of nature, that which is eternally human."

Predictably, when the Nazis came to power
Lehmbruck's sculptures—the antitheses of those ideal-
ized specimens of the master race that Hitler sought to
develop in art as well as in sports—were condemned as
"degenerate art." No fewer than a hundred of his works
were confiscated by the cultural commissars and even-
tually sold.

MARC CHAGALL. French, born Russia. 1887–1985. In France 1910–14, 1923–41; U.S.A. 1941–48; France 1948–85. Naturalized French citizen 1937.
I and the Village. 1911. Oil on canvas, 6 feet 3⅝ inches x 59⅝ inches. Mrs. Simon Guggenheim Fund. [146.45]

Chagall came from Russia to Paris in 1910 and remained there for four years. Though quick to adopt the Cubists' superimposition of fragmented objects arranged within a flattened space, he differed from them in employing brilliant colors like those in the paintings of his friend Delaunay (see page 49) as well as in the icons of his motherland.

This is the first of Chagall's pictures called *I and the Village*, of which he made several versions. It was painted soon after he moved into La Ruche ("the Beehive"), a settlement of vanguard artists, where for the first time he had enough space in which to work on a large scale. There he met and formed a close friendship with the poet Blaise Cendrars, who supplied the title for this and several other paintings by Chagall.

I and the Village is a memory picture of Chagall's native Hasidic community on the outskirts of the industrial city of Vitebsk. There pious Jewish peasants lived in intimate and mystical rapport with their animals, who they believed possessed souls just as humans did. In an interpretive description of this work, Susan Compton has written: "Chagall's picture encapsulates this idealized view of that world: the wide-eyed peasant, a cross round his neck, faces the beast who also wears magic beads. Although their eyes are joined by a symbolic line, they look at each other across a universe, suggested by the quartered disc of the sun and its moon joining it at a moment of eclipse. Behind them lies the line of the earth, bordered by little houses, two of them upside-down like the peasant woman who seems to flee from a man. Are these figures harvesters in a segment of a picture of the four seasons, or does the peasant represent death, with a scythe on his shoulder? . . . Chagall's images of death are balanced by the flowering Tree of Life below"—the bouquet held upright in the peasant's large fingers.

The cow is among the many animals that frequent Chagall's pictures. As in Marc's painting (opposite), it served as a cosmic symbol and, together with the bull, represented the sun, in antithesis to the moon. Here the circle that connects man and cow may indicate a desire for unity between human and beast and their two kinds of consciousness—logical and rational on the one hand, instinctual and spiritual on the other.

The composition is constructed geometrically, based on circular forms crisscrossed by diagonals that intersect below to form a triangle. In his autobiography, Chagall recalled that as a schoolboy he had been a poor pupil, excelling only in geometry and drawing: "Lines, angles, triangles, squares carried me far away to enchanting horizons." The free associations of his half-remembered, half-imagined world are here carefully controlled within a Cubist-inspired framework of interlocking planes.

FRANZ MARC. German, 1880–1916.
World Cow. 1913. Oil on canvas, 27⅞ x 55⅝ inches. Gift
of Mr. and Mrs. Morton D. May and Mr. and Mrs. Arnold
H. Maremont (by exchange). [118.88]

Franz Marc, together with Vasily Kandinsky (see pages
62–63), was the founder of the Blue Rider (*Blaue Reiter*)
group that included like-minded artists, writers, and
composers from many countries, who rejected material-
ism in their quest for "the underlying mystical design
of the visible world." Each artist was free to express
himself in accordance with what Kandinsky called "in-
ner necessity." He declared that painting must be liber-
ated from the task of reproducing the objective world and
instead evoke the world of the spirit through abstract
color forms that, like music, could speak directly to the
human soul.

Marc shared Kandinsky's concern with the symbolism
of color and by 1911 had developed a systematic pictorial
vocabulary, in which blue stood for spirituality and mas-
culinity, yellow for sensuality and femininity, and red for
earthly materiality. He differed from Kandinsky, how-
ever, for instead of renouncing the representation of na-
ture, he used its images in a nonrealistic way to express
transcendental ideas of man's yearning for unity with the
cosmos. He regarded animals as purer than humans and
as embodying more of nature's vitality.

The year 1913 signaled a new approach in Marc's art,
in which he sought for original causes—the creative
forces in the universe. A student of theosophy and of
Eastern and Western philosophies and religions, he found
that in many ancient mythologies the cow was venerated
as the symbol of procreation and nurture. In Egypt the
deity Hathor, who was said to have created the world and
all it contains, was often represented as a cow and, as is
well known, in India the "sacred cow" is worshipped to
this day. The iconography of Marc's *World Cow*, however,
seems to have been inspired by a Nordic rather than an
Oriental source. In the medieval Icelandic cycle, the
Edda, the world is said to have been created when rivers
from the south began to melt the primordial ice mass, and
drops of water quickened by the warm air gathered to
form the body of the giant Ymer, begetter of other giants
and of the human race. At first the only creature endowed
with life, he soon had a companion in the cow Audumla,
who like him arose from the melting ice. The cow became
the ancestor of all living creatures, the symbol of fecun-
dity, and the archetypical nurturer, giving nourishment
through four rivers of milk that flowed from her udders.

In Marc's painting, the majestic, rounded form of the
cow spreads across the width of the canvas. She rests
upon and is surrounded by blocks of ice, not a verdant
pasture, and is painted red, the color of earth's fiery
substance. A tiny newborn calf makes apparent her enor-
mous scale and conveys her function as progenitrix. In
the lower corners, other animals come to drink at the
flowing streams. The mountains in the background are in
the form of triangles, the shape Kandinsky regarded as
symbolic of the striving soul. The strong black diagonal
cutting across the foreground is probably a "line of
force," a device Marc had adopted from the Futurists and
used in other paintings of this time.

Frantiŝek (or Frank) Kupka. Czech, 1871–1957. To France 1895.
Mme Kupka among Verticals. 1910–11. Oil on canvas, 53⅜ x 33⅝ inches. Hillman Periodicals Fund. [563.56]

Though developing independently, and always somewhat of a loner, the Czech artist Frantiŝek Kupka shared certain ideas with Kandinsky and Marc: a cosmic vision of the unity of the human spirit and the hidden forces of nature, a reliance on color as the primary means of expression, and a belief that colors and music were analogous in their ability to speak directly to the soul. These concepts led Kupka, like Kandinsky and Marc, increasingly toward abstraction.

After studying first in Prague and then in Vienna, where he participated in the Secessionist movement (see page 42), Kupka moved to Paris in 1895. He exhibited at the Salon d'Automne and was influenced by Neo-Impressionism and Fauvism—both movements that emphasized color. He numbered among his friends Duchamp's brother Jacques Villon, his neighbor when the Kupkas moved to Puteaux outside Paris in 1906, and many other Cubist artists. Kupka disliked Cubism, however, finding it too monochromatic, too static, too flat and spatially restricted, and above all bound by a rational and logical view of perceived reality rather than by the search for a "new reality" beyond the temporal.

As Kupka developed toward abstraction about 1909, he took as his point of departure Seurat's theories on the simultaneous contrast of color and the researches of nineteenth-century physicists ultimately derived from Sir Isaac Newton's analyses of color and light. Instead of painting with pointillist dots, Kupka experimented with vertical planes with which to divide the rhythmic spaces of his canvases and impart a suggestion of motion to their images. He found prototypes for these divisions in the studies of human and animal locomotion by the photographers Jules Étienne Marey and Eadweard Muybridge and in the vertical separation of frames in cinematography. Kupka was also influenced by observing how the light and color of stained-glass windows in Gothic cathedrals seem to flicker as one moves along their rows of massed columns.

Mme Kupka among Verticals was begun as a portrait of his wife, Eugénie, but was left unfinished. In 1911 he obscured all but the head by painting over the entire canvas with vertical planes of cool, prismatic colors that seem to generate their own light and optical vibration.

Kupka soon decided to abandon representation altogether and rely on abstract structures alone to convey his meaning. In 1912 he sent to the Salon d'Automne a large canvas, *Amorpha* ("without shape"), which he also called *Fugue in Two Colors*—red and blue. It was probably the first purely abstract painting to be exhibited in France. Kupka told an interviewer: "I believe I can find something between sight and hearing and I can produce a fugue in colors as Bach has done in music." The painting is now in the European Collection of the National Gallery in Prague, but The Museum of Modern Art owns some twenty-seven studies for it. They are among hundreds of his works in various mediums that Kupka and his wife presented to the Museum in the year before his death, in appreciation of the early recognition of his art which, at Duchamp's suggestion, Alfred H. Barr, Jr. had included in the 1936 exhibition "Cubism and Abstract Art."

ROBERT DELAUNAY. French, 1885–1941.
The Windows. 1912. Oil on canvas, 51¼ inches x 6 feet
5 inches. Gift of Mr. and Mrs. William A. M. Burden.
[339.85]

Like Kupka, Delaunay opposed the Cubists' adherence to
monochrome, making light and color the principal com-
ponents of his paintings and explaining them by musical
analogies: "I played with colors as one may express
oneself in music, by a fugue of colored, fugued phrases."
Taking his cue from the treatise of the nineteenth-
century scientist Eugène Chevreul, *On the Law of the
Simultaneous Contrast of Color*, which had also influ-
enced Seurat and Kupka, Delaunay about 1912 "con-
ceived of a painting which would consist only of color, of
contrasts of color which simultaneously would develop
through time and be perceived all at once. I used the
scientific term of Chevreul: simultaneous contrasts."

According to the inscription at the lower left of the
canvas, *1912 premier contraste simultané*, this is the first
of a series of Window paintings that Delaunay executed
in the summer of that year. When one of them was shown
at the Salon d'Automne, Guillaume Apollinaire called the
new development that he saw in Kupka's and Delaunay's
work "Orphic Cubism," and he wrote an important arti-
cle describing the movement for a Paris journal. Both
artists, however, repudiated the term "Orphism."

This is the widest of the Window series (another of
which is also in the Museum's collection). Painted in
delicately shaded rainbow hues, it shows a view over-

looking the city as seen from Delaunay's studio. Promi-
nent at the right are the Great Wheel and the Eiffel Tower,
erected on the Champ de Mars in 1889 for the Interna-
tional Exposition that commemorated the centennial of
the French Revolution; actually, a postcard served as
basis for these motifs.

In accordance with his ideas of simultaneity, Delaunay
here combined views that could never have been seen
from one vantage point at a single moment of time. As in
Kupka's portrait, the canvas is divided into segments by
vertical planes. "The breaking up of form by light creates
colored planes," Delaunay said. "These colored planes
are the subject of the picture, and nature is no longer a
subject for description but a pretext."

The open-house salon that Delaunay and his Russian
wife, Sonia Delaunay-Terk, held on Sundays was a popu-
lar meeting place for many artists, Chagall among them.
His paintings, nevertheless, had less impact in France
than in Switzerland, Germany, and Russia, where they
were frequently exhibited. One of the first to recognize
Delaunay's innovations and be influenced by them was
Paul Klee. When one of the Window series was shown in
Zurich in the summer of 1912, he wrote a review for a
Swiss paper in which he said that this was "the sort of
painting which is self-sufficient and borrows nothing
from nature, possessing an entirely abstract existence as
far as the form is concerned." Recognizable objects are,
however, still discernible in this work, but in his next
series, Disks, Delaunay eliminated them as he moved to
total abstraction.

49

KASIMIR MALEVICH. Russian, 1878–1935.
Suprematist Composition: Airplane Flying. 1915 (dated 1914). Oil on canvas, 22⅞ x 19 inches. Purchase. [248.35]

A year or so after Delaunay, in Paris, had created with his Disks the first purely abstract paintings, such as *Simultaneous Contrasts: Sun and Moon*, Malevich, in Moscow, took an even more decisive step by ridding art of any reference whatsoever to the natural world. In 1915 he exhibited a series of thirty-five Suprematist Compositions, consisting of squares, rectangles, trapezoids, and circles in red, black, blue, and yellow, arranged on a white ground. He called his art Suprematism to signify "the supremacy of pure feeling or perception in the pictorial arts." He explained its premises, saying: "The artist can be a creator only when the forms in his picture have nothing in common with nature. . . . Forms must be given life and the right to individual existence." The Suprematist Compositions of Malevich and his followers were the first purely geometrical abstractions. He did not use the term "abstract" for such works, however, but called them "non-objective," to indicate their complete liberation from representation; and he proclaimed Suprematism to be "the new realism in painting."

Like Gabo, Malevich opposed Tatlin's anti-aesthetic, utilitarian approach to art. His goals were visionary and utopian, emphasizing an art of feelings and emotions. He was interested in aerial photography, and in both his theoretical writings and his paintings, such as this one, he identified flight with man's "great yearning for space, . . . to break free from the globe of the earth." "It was nothing other than a yearning for speed . . . for flight . . . which, seeking an outward shape, brought about the birth of the airplane," he declared. The blank background was essential for the realization of his concept: "The blue color of the sky has been defeated by the Suprematist system, has been broken through, and entered white, as the true real conception of infinity, and therefore limited from the color background of the sky," he wrote. "I have torn through the blue lampshade of color limitation, and come out into the white; after me, comrade aviators sail into the chasm—I have set up semaphores of Suprematism. . . . Sail forth! the white, free chasm, infinity, is before us."

With no horizon line to orient the viewer, in this Suprematist Composition the geometrical elements that represent the airplane float freely in space. There is no clearly defined "up" or "down," for the canvas is allowed to rotate. Photographs taken at various times and places during Malevich's lifetime show it installed so that the diagonal thrust of the composition proceeds from lower right to upper left, as here, and at other times it goes in the opposite direction, from lower left to upper right.

CONSTANTIN BRANCUSI. French, born Romania. 1876–
1957. To Paris 1904. Naturalized French citizen 1951.
Bird in Space. c. 1941. Bronze, 6 feet high, on two-part
stone pedestal, 17⅜ inches high. Gift of Mr. and Mrs.
William A. M. Burden. [497.64]

Bird in Space is the fifteenth in a series of marble or
bronze variants on a theme that preoccupied Brancusi for
over three decades. The earliest of them is the *Magic
Bird*, which dates from 1910–12. Its Romanian title,
Pasarea Maiastra—the first word meaning bird and the
second either magic or master—refers to a folk tale:
"Prince Charming was in search of Ilena Cozinzene. The
master bird is the bird that spoke and showed the way to
Prince Charming." In that first version, the white marble
bird, though stylized, is clearly recognizable; but as the
sequence progressed, the bird became increasingly taller,
more slender, and more abstract. By 1926 its portrayal
had departed so far from naturalism that when one ver-
sion was sent to the United States for exhibition, the
customs authorities seized it because it did not conform
to the accepted definition of sculpture as the representa-
tion of a living person or animal and so could not enter
the country duty-free as a work of art. In the ensuing trial
the verdict conceded its aesthetic worth and led to wider
public acceptance of abstract sculpture.

Brancusi went to Paris from his native Romania in
1904 and enrolled in the École des Beaux-Arts. In 1907
he worked briefly in Rodin's studio but broke with the
master because, as he declared, "Nothing can grow in the
shadow of a giant tree." Another reason was probably
that, like other progressive sculptors of the time, he
wished to abandon modeling for direct carving in wood
or stone. This predilection is apparent in the numerous
bases or composite pedestals, which on occasion he exhi-
bited without any superimposed sculpture.

In the *Bird in Space* reproduced here, the form has
become simplified to a high degree, consonant with Bran-
cusi's dictum: "Simplicity is not an end in art, but we
arrive at simplicity in spite of ourselves as we approach
the real sense of things." He sought not merely to portray
a bird but to capture "the essence of flight," and the
underlying theme, as in Malevich's Suprematist airplane,
was the conquest of space. But whereas Malevich exalted
the idea of liberation through flight into space by a ma-
chine, represented by geometrical shapes, Brancusi em-
bodied similar concepts in a living organism, a bird,
streamlined but subtly asymmetrical in its outlines. The
highly polished surface of *Bird in Space* disguises the
density of its bronze material; its luminosity catches
the light, and changing reflections intensify the effect
of upward motion as the observer moves around it.

The pedestal of *Magic Bird* is a three-part limestone

assemblage, with Brancusi's *Double Caryatid* of 1908 as
its middle portion. By contrast, this *Bird in Space* is set
upon a two-part stone pedestal—the upper element a
cylinder, the lower one a cruciform block. An old photo-
graph, however, shows that it originally rested upon a
base of paired truncated pyramids, one inverted above
the other—an indented form suggested by the serrations
of African wood sculpture, which influenced many of his
works. Over the years he elaborated this form in several
versions of the *Endless Column.*

The stone cylinder and cross-shaped block that now
serve as pedestal for this *Bird in Space* contrast with the
sculpture they support in several significant respects: a
composite versus a unitary form; the matte surface of
stone versus the high glitter of polished metal; manmade,
geometrical shapes versus organic, subtly inflected con-
tours; and the heavy mass of the stone base, bound by
gravity to the earth, versus the bird's implied weightless-
ness as it soars freely into space.

51

ROGER DE LA FRESNAYE. French, 1885–1925.
The Conquest of the Air. 1913. Oil on canvas, 7 feet
8⅞ inches x 6 feet 5 inches. Mrs. Simon Guggenheim
Fund. [222.47]

La Fresnaye's *Conquest of the Air* is a far more literal
tribute to flight than Malevich's *Suprematist Composi-
tion: Airplane Flying* or Brancusi's *Bird in Space*. Avia-
tion was still in its infancy when this picture was painted.
In 1908, Wilbur Wright had broken records with a fifty-
six-mile, one-hundred-and-forty-minute flight from La
Fresnaye's native town of Le Mans, and in the following
year Louis Blériot made the first air crossing of the
English Channel. Picasso and Braque were both aviation
enthusiasts, and in 1912 frequently used for the latter the
nickname "Wilbourg," adapted from "Wilbur." In the
spring of that year, Picasso painted three pictures incor-
porating the slogan NOTRE AVENIR EST DANS L'AIR ("Our

Future Is in the Air"), the title of a booklet that advocated
the use of aerial bombing by the French military.

The interest of La Fresnaye in aviation was more than
casual, for his brother Henri was director of the Nieuport
aircraft manufacturing plant near Meulan, the village
represented in the landscape at the lower left of the
picture. The two men seated at the table (possibly the
artist himself and his brother) are engaged in conversa-
tion, presumably on the topic referred to in the title. That
this is a conceptual rather than a representational treat-
ment of the theme is evident by the disproportionately
large size of the two figures and their indeterminate
location with respect to the landscape. Furthermore, the
tiny balloon floating aloft, its rounded shape repeating
that of the clouds, is only a symbol of aeronautical tri-
umphs and not a depiction of the most up-to-date tech-
nological advances. The sun and moon appear as two
circles among the clouds. The sailboat at the right, be-
sides connoting a favorite sport of the brothers, also
suggests a parallel between man's intellectual ability to
tame the forces of the wind so that he can navigate upon
the waters and his new mastery of air currents that enable
him to fly. The huge tricolor asserts La Fresnaye's na-
tionalistic pride and confidence in the role that France
was destined to play in the future of aviation. Between
1911 and 1914 he painted several pictures on patriotic
themes, in which the French flag figures prominently, but
none matches the spaciousness, balanced composition,
and brilliant color of *The Conquest of the Air*.

For this large painting, La Fresnaye used Cubism's
geometrized forms and dissected space to create a monu-
mental composition on an heroic theme. In the over-
lapping planes of clear color there are also some
reminiscences of Delaunay.

PIET MONDRIAN. Dutch, 1872–1944. Worked in Paris 1912–14, 1919–38; in New York 1940–44.
Composition, V. 1914. Oil on canvas, 21⅝ x 33⅝ inches. The Sidney and Harriet Janis Collection. [633.67]

In *Composition, V* Mondrian went still further than either Braque in *Man with a Guitar* or Picasso in *"Ma Jolie"* (pages 36–37) to establish a gridwork of verticals and horizontals as the predominant structure of his painting. Here, the overall pattern of small rectilinear units almost obscures any lingering traces of the original subject. Departing from the studio ambience favored by Picasso and Braque, Mondrian has selected an outdoor theme. The picture's alternate title is *Façade, 5,* and it is one of a series of Façade paintings of about the same date, including *Blue Façade* (*Composition 9*). The *Composition, V* possibly originated in drawings of the church of Notre Dame des Champs on the Boulevard Montpar-nasse, but all that remain are faint references to its arches and the Greek cross of its rose window at the left center.

In this frontal view of the façade, the composition has been almost completely flattened. There is only a suggestion of atmospheric space in the manner in which the lines of the grid are muffled by light overpainting or fade toward the outer edges. In spite of its greater tendency away from naturalism and toward the total geometrical abstraction that Mondrian was to adopt a few years later, *Composition, V* is far less severe in its effect than the Analytic Cubist paintings of Picasso and Braque. Paint is brushed on with delicate strokes that blend into one another rather than bluntly asserting their separate identity, and instead of monochromatic tans and grays there is a soft harmony of pale blues, pinks, and ochers—pastel variations of the primary colors to which Mondrian was soon to restrict himself and would continue to use throughout the rest of his life.

53

GEORGES BRAQUE. French, 1882–1963.
Still Life with Tenora (formerly titled *Clarinet*). 1913.
Pasted paper, oil, charcoal, chalk, and pencil on canvas,
37½ x 47⅜ inches. Nelson A. Rockefeller Bequest.
[947.79]

In the summer of 1912, Braque introduced an innovation into his Cubist compositions by cutting pieces of different kinds of paper into shapes that he glued onto the surface of his canvas and combined with drawing in pencil, chalk, or charcoal. This cut-and-pasted-paper technique is known as *papier collé* (from the French word *coller*, to paste). Like collage, another innovation that preceded it, which introduced into the works bits and pieces of alien materials such as oilcloth, *papier collé* was a blow at traditional notions of what were appropriate mediums for art. It was also a means of enriching the textures of the works (sand was sometimes mixed in with the pigments) and of adding traces of color to relieve the previously strict monochrome of Cubism. Here the central motif is one among the musical instru-

ments that appear so frequently in Cubist paintings. Formerly believed to be a clarinet, it has now been identified as a tenora, a Catalan folk instrument. It cuts diagonally across an uptilted tabletop on which sits a wineglass; a rectangle behind it may represent an unfinished canvas. These elements are given an illusion of depth by discreet shading and are partially encircled by an incomplete oval.

Over the drawn objects are superimposed cut-out pieces of paper; two dark vertical rectangles of different dimensions, across which a long narrow rectangle of brown wallpaper printed with a pattern of simulated wood graining runs diagonally; then a smaller rectangle of white paper, delicately tinted with oil paint in a lighter shade of tan; and finally a rectangle clipped from a newspaper, bearing the bold letters of its masthead. The instrument and the wineglass are drawn partly on the pasted papers and partly directly on the canvas, large areas of which are left blank. The total effect of the symmetrical composition is uncluttered, airy, and elegant.

PABLO PICASSO. Spanish, 1881–1973. To France 1904. *Pipe, Glass, Bottle of Rum*. 1914. Cut-and-pasted papers, pencil, gouache, and gesso on cardboard, 15¾ x 20¾ inches. Gift of Mr. and Mrs. Daniel Saidenberg. [287.56]

Still working in close association and friendly rivalry with Braque, Picasso was quick to adopt his newly invented technique and in the autumn of 1912 made the first of his own *papiers collés*. The drawn or cut-and-pasted shapes in *Pipe, Glass, Bottle of Rum* represent familiar studio or café paraphernalia, arranged like a still life on a sharply uptilted tabletop. The only object whose silhouette is exactly that of the cut-out paper that forms it is the pipe; the contours of none of the others correspond with the outlines of the large brown pasted papers on which they are partly inscribed. The bold black capitals on the piece of pasted newsprint that serves as label for the bottle contrast with the delicate calligraphy of Picasso's signature in the lower right corner, similar to the script on his calling card as depicted in another work of the same year. The white ground of the field, built up with a gesso coating over the cardboard support, is more densely filled than that of *Still Life with Tenora*.

In both Braque's composition and this one, the images are far more readily legible than those in *Man with a Guitar* or *"Ma Jolie"* (pages 36–37). The winter of 1912–13 marked a fundamental change in the style of the two pioneering Cubists. Whereas previously they had analyzed and dissected figures and objects, using the fragmented forms to create a new conceptual reality, they now constructed their compositions by combining recognizable shapes and planes of color in an invented, "synthetic" vocabulary of forms. Though the shading of objects in *Still Life with Tenora* and *Pipe, Glass, Bottle of Rum* produces the semblance of a third dimension, by comparison with the shallow illusionistic space of Analytic Cubist paintings the schematic drawing, together with the thinness of the pasted-on papers, results in an overall effect of flatness.

55

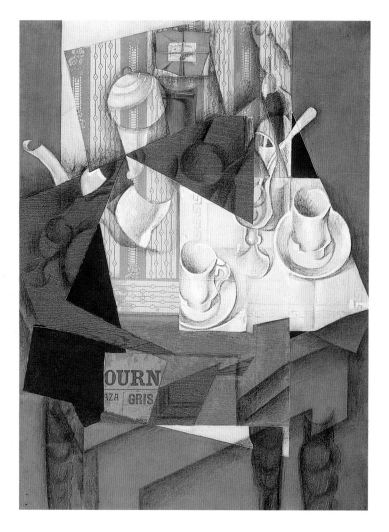

JUAN GRIS (José Victoriano González). Spanish, 1887–1927. To France 1906.
Breakfast. 1914. Cut-and-pasted paper, crayon, and oil over canvas, 31⅞ x 23½ inches. Acquired through the Lillie P. Bliss Bequest. [248.48]

Juan Gris, the third leading innovator of Cubism, came to Paris from Madrid in 1906 and settled in the same building in Montmartre in which lived his compatriot Picasso, six years his senior. Trained in science and engineering, Gris developed his own version of Cubism in a fashion more logical and methodical than the empirical, intuitive approach of Braque and Picasso. Though he quickly adopted the *papier collé* technique, he differed from the other two artists by his use of bright color.

Breakfast, like Braque's *Still Life with Tenora* and Picasso's *Pipe, Glass, Bottle of Rum*, shows a still life arranged on a tilted tabletop in a compositional scheme that ultimately derives from Cézanne (page 32). The objects are clearly outlined and illusionistically modeled in light and shade, though partially fragmented and viewed from several incompatible angles of vision. The table is represented by imitation wood-grained paper, the wallpaper by wallpaper, and the snippet of newspaper has been slyly selected to include the artist's own name. Gris's eye-fooling tricks challenge us to distinguish the actual bits of pasted paper from those simulated with crayon and paint; thus, in the *trompe l'oeil* tobacco packet at the top of the canvas, the folds and string are rendered in crayon, but the label is real.

The severity of the strong verticals and geometrically exact rectangles and triangles is tempered by the bright blue of the painted background. Against this, Gris arranged his drawn and cut-out elements with mathematical precision to create what he called his "flat, colored architecture."

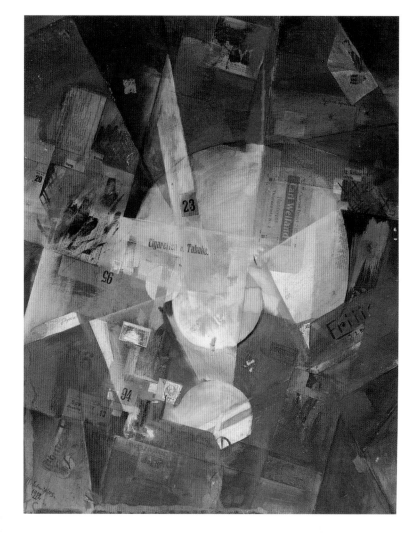

KURT SCHWITTERS. British, born Germany. 1887–1948.
In Norway 1937–40; in England 1940–48. Naturalized
British subject 1948.
Picture with Light Center. 1919. Collage of cut-and-
pasted papers and oil on cardboard, 33¼ x 25⅞ inches.
Purchase. [18.50]

In contrast to Braque, Picasso, and Gris, who selected
with deliberation the pieces of paper they shaped and
incorporated into their *papiers collés*, Schwitters scav-
enged through the streets, trashcans, and wastebaskets of
Hanover with the acquisitiveness of a magpie, collecting
discarded scraps to use in his collages. Yet he always
insisted that his aims were aesthetic, and that the form of
his compositions was more essential than the materials
of which they were made. "I could not, in fact, see the
reason why old tickets, driftwood, cloakroom tabs, wires
and parts of wheels, buttons and old rubbish found in
attics and refuse dumps should not be as suitable a mate-
rial for painting as the paints made in factories," he
declared. "I called my new works utilizing such mate-
rials MERZ. This is the second syllable of *Kommerz*. It
originated in . . . a work in which the word *Merz*, cut
from an advertisement of the *Kommerz und Privatbank*
and pasted on, could be read among the abstract ele-
ments. . . . Merz stands for freedom from all fetters. . . .

Freedom is not lack of restraint, but the product of strict
artistic discipline."

The Cubists had already made use of scraps of mate-
rial, but, as William Rubin has pointed out, "The greater
range and more personal selection of Schwitters's collage
materials allowed him to conjure from them an intimate
nostalgic poetry."

Picture with Light Center combines a central radiating
pattern with Cubism's interlocking planes. The structure
of its composition, with a large central circle overlapped
by a smaller one and intersected by diagonals, resembles
that of Chagall's *I and the Village* (page 46). Here, some
sections have been painted in oil, but in his later works,
which are usually smaller in size, Schwitters tended to
use pasted-on elements exclusively.

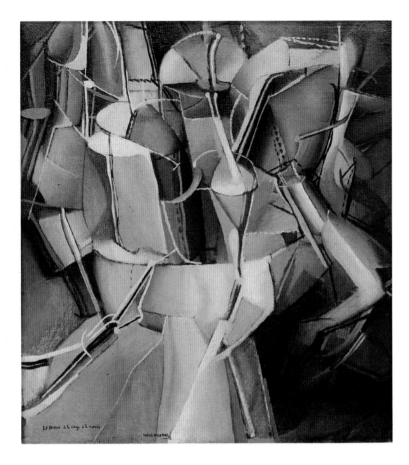

MARCEL DUCHAMP. American, born France, 1887–1968. In U.S.A. 1915–18, 1920–23, 1942–68. Naturalized American citizen 1955.
The Passage from Virgin to Bride. 1912. Oil on canvas, 23⅜ x 21¼ inches. Purchase. [174.45]

While still in his twenties, Duchamp determined to "get away from the physical aspect of painting" in order to create ideas rather than mere "visual products." Since he "wanted to put painting once again at the service of the mind," he gave special importance to the titles of his works. The title of this picture refers to the rite of passage, the transition undergone by a young woman in passing from the virginal to the married state. Many years later, Duchamp observed that, in a sense, the painting also marked his "own passage from something into something else"—notably, from Cubism and his former attachment to traditional means of painting to a more dematerialized, intellectual concept, which he thought of as "reduction" rather than "abstraction."

In his famous *Nude Descending a Staircase*, now in the Philadelphia Museum of Art, Duchamp had attempted to give "a static representation of movement" in a manner he considered "closer to the Cubists' interest in decomposing forms than to the Futurists' interest in suggesting movement." Here, since his theme was not physical motion but the metamorphosis of a woman from one state of being to another, he represented her in two different aspects. She is shown as an ambiguous fusion of the organic and the mechanical. At the left, as the Virgin, she resembles the figure in *Nude Descending a Staircase*, with inclined head, long spinal column, and bent knee. To the right, she becomes the Bride, assuming a form that Duchamp would repeat, with variations, in other works of 1912 and the next few years, culminating in *The Bride Stripped Bare by Her Bachelors, Even* (the *Large Glass*) (also in the Philadelphia Museum of Art), which preoccupied him intermittently from 1913 to 1923, and which he finally abandoned unfinished. Though the colors here still relate to the monochrome of such Cubist works as Picasso's *"Ma Jolie"* (page 37), they are tinged with warmer, pinkish tones, appropriate to the organic nature of the humanoid machine (compare Picabia's *I See Again in Memory My Dear Udnie*).

Like Duchamp's related paintings on the theme of the Bride, this picture is packed with metaphors and arcane allusions. Some he himself has elucidated, while others have given rise to as much "explication" as have the writings of James Joyce. Duchamp's disavowal of the "physical side of painting" notwithstanding, the viewer who lacks any key with which to decode *The Passage from Virgin to Bride* can nevertheless be fascinated by the subtleties of its rich, though subdued, coloring, the sensuousness of its shading and its glossy surface, and the intricate play of its convex and concave forms.

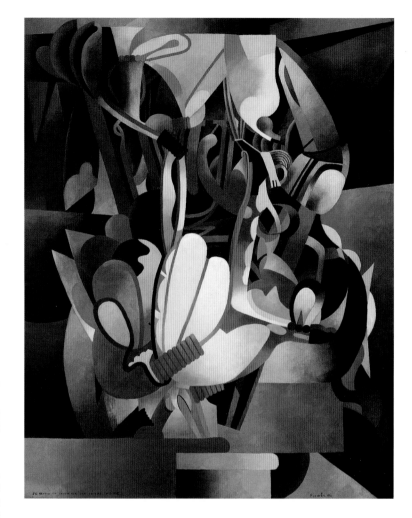

FRANCIS PICABIA. French, 1879–1953. Active in New York and Barcelona 1913–17.
I See Again in Memory My Dear Udnie. 1914 (perhaps begun 1913). Oil on canvas, 8 feet 2½ inches x 6 feet 6¼ inches. Hillman Periodicals Fund. [4.54]

Aboard ship on a voyage to the United States in 1913, Picabia was fascinated by the dancing of a certain Mlle Napierskowska (whose performances were so suggestive that they caused her arrest during her American tour). In the course of that year and the next, he produced a number of large canvases inspired by his recollections of the star dancer, giving one of them the mysterious name *Udnie* that appears again in the title of this picture.

Whatever their basis in actual experience, these impressions have been completely transformed into abstract terms in Picabia's *I See Again in Memory My Dear Udnie*. He explained his paintings of the time by saying that he did not seek to reproduce objects in nature but "to render external an internal state of mind or feeling" by arrangements of line and color that "suggest the equilibrium of static and dynamic qualities." Though the attempt to portray states of mind was also among the aims of the Futurists, here the means of expression has nothing in common with their representations of swift, energetic movement. In this painting, the general effect is monumental, and the rhythms rise upward rather slowly instead of evoking swift motion. Within a three-dimensional setting, lit from ambiguously situated sources, some of the shapes look as if they had been carved out by a fretsaw from shallow slabs, while others suggest the nozzles of hoses. In combination, these elements seem to shed their inanimate character and allude to male sexual organs probing receptive female forms. The sensuousness of the painting is augmented by its unusual color harmonies. Pale creamy tones, warmer pinks, smoky reds, and shades of lavender are concentrated in the center and set off by neutral grays, blacks, and browns.

Picabia, together with his friend Duchamp, was one of the first to explore the machine as a symbol for human eroticism. In the next few years, the sexual references in his works with machinelike forms were to become far more overt than they are here.

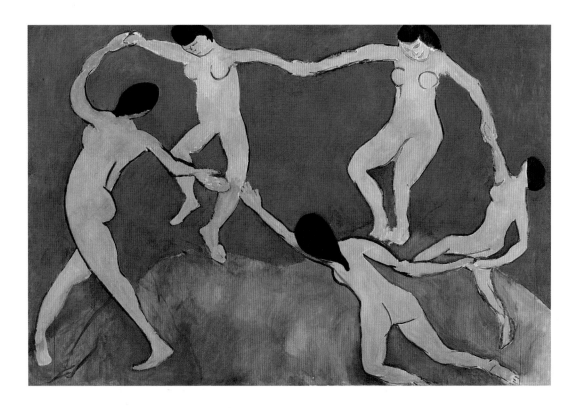

HENRI MATISSE. French, 1869–1954.
Dance (First Version). 1909. Oil on canvas, 8 feet
6½ inches x 12 feet 9½ inches. Gift of Nelson A. Rocke-
feller in honor of Alfred H. Barr, Jr. [201.63]

In 1905, while summering on the French coast near the
Spanish border, Matisse watched Catalan fishermen
dancing in a circle on the beach. He incorporated a ring
of dancers into the background of his *Joy of Life* (Barnes
Foundation, Merion, Pennsylvania), painted in 1905–06.
It was bought by the American collectors Leo and Ger-
trude Stein and seen in their Paris salon by a Russian
businessman, Sergei I. Shchukin, who before the First
World War was the greatest collector of modern art in the
world. In 1908, he began to commission from Matisse
paintings to decorate his house in Moscow, and on a visit
to Paris early in 1909 he proposed a further commission
for a painting to hang on his staircase.

Matisse seems to have painted this first version of
Dance very quickly in order to clinch the commission
before his patron left Paris. After seeing it, Shchukin
wrote Matisse that he found it of "such nobility, that I am
resolved to brave our bourgeois opinion and hang on my
staircase a subject with nudes," and he ordered a second
panel, *Music.* Matisse continued to work on the two
themes, and at the Salon d'Automne of 1910 he showed

both *Music* and *Dance, II*—the latter far more intensely
colored and violent in its movements than the hastily
executed first version. The horrified reaction of the critics
so alarmed Shchukin that he thought of canceling his
commission, but he reconsidered, and both works, now in
the Hermitage Museum, were sent to him late in the year.

The dance had become an established theme in
Matisse's art by 1909. In this composition, as in *Joy of
Life*, the fishermen on the shore have been transformed
into female nudes, and the formal measure of their tradi-
tional sardana stepped up to a more exuberant pace. Col-
ors are limited to areas of green, blue, and flesh tones,
with blacks and browns for the dancers' hair. The danc-
ers' bodies have been flattened to silhouettes, with only a
few lines to indicate features or anatomical details. The
rear figures are as large as those in the foreground, elim-
inating perspective and further negating any semblance
of depth in the picture.

As John Elderfield has said of *Dance*: "Its extreme
flatness, totally nonatmospheric space, and highly ab-
stracted and schematic manner of representation mark a
more complete break with Renaissance illusionism than
produced by any previous painting. The surface is
opened and expanded to give color its own visibility and
own voice in a way totally unknown in the West since
Byzantine art."

The Rope Dancer Accompanies Herself With Her Shadows

MAN RAY. American, 1890–1976. Lived in Paris 1921–40, 1951–76.
The Rope Dancer Accompanies Herself with Her Shadows. 1916. Oil on canvas, 52 inches x 6 feet 1 ⅜ inches. Gift of G. David Thompson. [33.54]

Man Ray's painting, like Picabia's *I See Again in Memory My Dear Udnie* (page 59), was inspired by the movements of a dancer, but the two works are as different from each other as either is from Matisse's *Dance* or as any of these three is from representations of the dance by van Doesburg and Mondrian (pages 64–65). Man Ray's *Rope Dancer* is a wholly abstract composition of two-dimensional negative and positive shapes. The large, vertical slabs of color, painted in flat tones of orange, green, red, blue, yellow, and purple laid on with a palette knife, are set against a light gray background. They are linked together by the scalloped line of the tightrope at the top and the curves spinning out like lassos from three tiny superimposed figures joined at the waist—multiple aspects of a single dancer.

As he has explained, Man Ray began by making drawings for a ballet dancer in three positions. After enlarging them onto different sheets of spectrum-colored paper, he cut out the forms and destroyed them, retaining only the surrounding pieces, which he arranged as patterns for the large overlapping fields of color. These abstract shapes were then enlarged and transcribed onto the canvas. Only after having done this did he recall his original idea; he then added the ballet dancer above, surrounded by an aura of light. She holds in her hands the ends of five ropes, each of whose serpentine curves connects with a different color. Man Ray inscribed the title of the painting below. When he arrived in Paris in 1921, André Breton hailed him in an ode as "the catcher of the unseen and the celebrant of shadows."

X-ray photographs taken in 1989 revealed a quite different composition for the upper part of the picture. This section, now painted over, originally corresponded to an ink drawing, the *Ballet-Silhouette*, in the Peggy Guggenheim Collection, Venice; Ms. Guggenheim had bought the painting itself from the artist in 1939. The drawing, formerly thought to be a preparatory study, was more probably done later to preserve Man Ray's original concept, for he said that after finishing the *Rope Dancer* the idea continued to obsess him, and he made both the ink drawing and an air-brushed watercolor of the subject.

The first version of the composition shows the dancer in a sequence of three separate positions at left, center, and right. Each figure is silhouetted against a dark ovoid shape, representing the projected beam of a spotlight. The rendering is that of mechanical drawing, a subject in which Man Ray had excelled at school. He used its technique and abstract imagery in a series of drawings done late in 1915, perhaps influenced by the machinelike forms in the works of Duchamp and Picabia.

61

Painting Number 201. 1914. Oil on canvas, 64¼ x 48¼ inches. Nelson A. Rockefeller Fund (by exchange). [299.83]

Painting Number 198. 1914. Oil on canvas, 64 x 36¼ inches. Mrs. Simon Guggenheim Fund. [2.54]

VASILY KANDINSKY. French, born Russia. 1866–1944. In Germany 1901–04, 1907–14, 1922–33; in France 1906–07, 1917–21, 1933–44. Naturalized German citizen 1928, French citizen 1939.

Diametrically opposed to the orderly construction and restricted color range of the paintings by Malevich, van Doesburg, and Mondrian (pages 50, 64, and 65) are these four panels created as an ensemble for the New York apartment of Mr. and Mrs. Edwin R. Campbell. Depicting neither recognizable objects nor geometrical shapes, they evoke the response of our emotions rather than our intellect.

Kandinsky left Moscow in 1901 for Munich, where he became one of the foremost exponents of progressive art. Together with Franz Marc, he founded the Blue Rider movement and edited its influential almanac (see page 47), and in 1912 he published his most famous essay, "Concerning the Spiritual in Art."

In 1910, Kandinsky painted the first purely abstract picture. Though objects seemed an impediment to his intention of letting the viewer "forget himself and dissolve into the picture," he had difficulty in finding forms with which to replace them, since he could never bring himself "to use a form which developed out of the application of logic—not purely from *feeling* within me. . . . All the forms which I ever used . . . created themselves while I was working, often surprising me."

Campbell, a Canadian by birth, had come to the United States in 1902, and after marrying the daughter of a General Motors tycoon abandoned the practice of medicine to take part in the automobile industry. He already had a collection that included paintings by Claude Monet and Winslow Homer when introduced to Kandinsky's

Painting Number 200. 1914. Oil on canvas, 64 x 31½ inches. Mrs. Simon Guggenheim Fund. [3.54]

Painting Number 199. 1914. Oil on canvas, 64⅛ x 48⅜ inches. Nelson A. Rockefeller Fund (by exchange). [298.83]

work at the Armory Show in 1913 by Arthur Jerome Eddy, a corporation lawyer, and the author of articles and books on many topics and a collector of modern art, including works by Kandinsky. He persuaded Campbell to commission the four panels for his circular foyer and sent the artist, then in Europe, measurements of the two wide and two narrow spaces that they would occupy.

Kandinsky painted the works in his atelier in Murnau in the spring of 1914. With the outbreak of war a few months later, he returned to Russia, where he remained until 1922. He entrusted the paintings to Herwarth Walden, director of Der Sturm gallery in Berlin, who sent them to Stockholm for exhibition in 1916 before shipping them to New York for installation.

Following a divorce in 1921, Campbell moved away and died in 1929. Thereafter the four panels became separated. Two that had been in Florida were acquired in

1941 by The Solomon R. Guggenheim Museum; the pair that had been left unframed in an attic in Connecticut were auctioned in 1954 as "two modernistic panels" and purchased by an antique dealer for fifteen and twenty-five dollars, respectively. After a restorer on a television program, "Treasure Hunt," tentatively identified them as being by Kandinsky, they were bought by The Museum of Modern Art. When subsequently it was realized that they were the pendants of the other pair, the four panels were reunited in 1983 through an arrangement between the two museums.

The compositions have at times been given various titles and have most frequently been interpreted as representing the four seasons, respectively winter, spring, summer, and autumn. But Kandinsky's statement that his paintings are "a graphic representation of a *mood* and not of . . . objects" should give us pause.

63

Theo van Doesburg (C. E. M. Küpper). Dutch, 1883–1931.
Rhythm of a Russian Dance. 1918. Oil on canvas, 53½ x 24¼ inches. Acquired through the Lillie P. Bliss Bequest [135.46]

A few years after Malevich started from scratch to create a "pure" art from simple geometrical forms, a group of artists in the Netherlands achieved total abstraction by working in the opposite direction. They began with naturalistic forms and, by analyzing their essential elements, gradually reduced—or abstracted—them to compositions constructed entirely of rectilinear shapes.

Rhythm of a Russian Dance is the culmination of a detailed analysis that van Doesburg carried out through a sequence of seven preceding studies (also owned by the Museum). He moved progressively from his first naturalistic sketch of a dancer to the final painting, which is composed of flat bars arranged at right angles to one another in such a way that their shapes, and the spatial intervals between them, are an abstract transcription of the rhythmic, staccato dance movements.

Van Doesburg was the organizer and principal theorist of a group of painters and architects, whom he brought together in 1917 under the name of de Stijl ("the Style"). Their aesthetic principles restricted the artists' means to the basic minimum of the straight line and right angle (symbols of man's intellectual dominance over the diffuse, capricious forms of nature) and to the three primary colors red, yellow, and blue, together with the neutrals black, gray, and white. They regarded the painting thus created as the new, universal art of the future and named it Neo-Plasticism. It was described as "*abstract-real* because it stands between the absolute-abstract and the natural, or concrete-real. It is not as abstract as thought-abstraction, and not as real as tangible reality. It is aesthetically living plastic representation: the visual expression in which each opposite is transformed into the other."

PIET MONDRIAN. Dutch, 1872–1944. Worked in Paris 1912–14, 1919–38; in New York 1940–44.
Broadway Boogie Woogie. 1942–43. Oil on canvas, 50 x 50 inches. Given anonymously. [73.43]

The author of the quotation on the opposite page was Piet Mondrian, a cofounder with van Doesburg of de Stijl. The *Composition, V* (page 53) is among the paintings he produced in his progression from naturalism to pure geometrical abstraction. Once having adopted the strict tenets of Neo-Plasticism, Mondrian adhered to them throughout his life, at times producing extremely ascetic compositions of only a few rectangles separated by black bars. *Broadway Boogie Woogie,* however, is much more complicated. The square and rectangular elements are greatly increased in number and diminished in size, so that the painting is far more agitated than van Doesburg's *Rhythm of a Russian Dance.* Part of its dynamic excitement is due to its asymmetry, and to the manner in which

the bands of color intersect the edges of the unframed canvas. Mondrian was the first to abandon enclosing frames, instead using the device of having his paintings project forward from a mount, in order "to move the picture into our surroundings and give it real existence."

Mondrian's *Broadway Boogie Woogie,* his last completed work, was painted in New York, where he came to live during the Second World War, and it reflects the accelerated tempo of the American metropolis. A devotee of dancing and jazz even before coming to this country, Mondrian declared: "True Boogie Woogie I conceive as homogeneous in intention with mine in painting: destruction of melody which is the equivalent of destruction of natural appearance; and construction through the continuous opposition of pure means—dynamic rhythm." The painting was executed with the aid of a technical shortcut that Mondrian learned in America—the use of strips of adhesive tape to lay out his composition on the canvas.

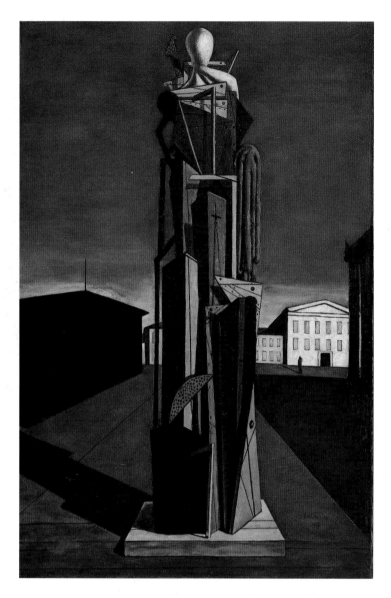

GIORGIO DE CHIRICO. Italian, born Greece. 1888–1978.
Worked in Paris 1911–15, 1925–39.
The Great Metaphysician. 1917. Oil on canvas, 41⅛ x
27½ inches. The Philip L. Goodwin Collection. [98.58]

At a time when modern painters were attempting to por-
tray reality in new ways, and when many of them, to
assert the actuality of the picture's existence, were em-
phasizing its flatness at the expense of illusionistic space,
de Chirico set quite different goals for his art. In 1915 the
military authorities summoned him home to Italy from

Paris, where he had been living since 1911; he was ex-
empted two years later from active service for neuro-
psychological reasons. In a convalescent hospital in
Ferrara he met and became friends with another patient,
Carlo Carrà, who had been one of the original five artist-
members of the Futurist movement, but who had de-
serted their ranks to create an art based on a return to the
tradition of Italian Renaissance masters of the fifteenth
century.

The shared interest of the two men led to their found-
ing the so-called "metaphysical" school. This was not a
formal movement like Cubism but rather a state of mind
that proposed a new counter-reality beyond that of the
perceived world. By wrenching ordinary objects out of
their normal context and placing them in incongruous
juxtapositions, they sought to break with logic and com-
municate directly with the subconscious mind. As Alfred
H. Barr, Jr. has written: "To the Futurists' concern with
motion and the dynamics of the modern industrial age,
the 'metaphysical' painters opposed an art of philosoph-
ical reverie, uncanny quiet, static incongruity, evoking a
sense of mystery by assembling mysterious objects in
strange settings." These concepts were later to prove
highly influential for the Surrealists.

Like many of de Chirico's works, *The Great Meta-
physician* shows in deep perspective the large square of
an Italian city, devoid of human presence save for a tiny
figure in the background. The vast piazza is dominated
by a huge monument set close to the picture plane, which
dwarfs the surrounding buildings by its gigantic scale.
The lofty pedestal is a scaffolding built up of parts of
stretchers and architects' or draftsmen's implements,
such as T-squares or triangles. Atop this structure, the
disproportionately small bust of a mannequin overlooks
the square. On the receding pavement the statue and a
mostly obscured building at the right cast the deep
shadows of dusk, which has drained all but the last traces
of sunlight from the darkened sky, more green than blue.

De Chirico had begun to introduce mannequins into
his paintings in 1914 and developed the theme in a num-
ber of his "metaphysical" paintings, among them *The
Seer*, *The Double Dream of Spring*, and *The Duo*, all
dating from 1915. In these pictures, as in *The Great
Metaphysician*, he ironically replaced classical, heroic
statues with mindless, inanimate figures.

Yves Tanguy. American, born France. 1900–1955. To U.S.A. 1939. Naturalized American citizen 1948. *Multiplication of the Arcs*. 1954. Oil on canvas, 40 x 60 inches. Mrs. Simon Guggenheim Fund. [559.54]

With its clearly modeled forms set in deep, illusionistically rendered space, *Multiplication of the Arcs* is a landscape within the tradition of Surrealism's precursor, de Chirico, whose work first inspired Tanguy to become a painter. Instead of de Chirico's empty, open areas, however, the entire lower half of this canvas is densely crowded with pebbles, boulders, and bonelike shapes, interspersed with large shafts of granite.

This painting, Tanguy's last major work, is the consummate expression of his lifelong preoccupation with strange rock formations. During his childhood, he spent his vacations at his family's house in Locronan, in the Finistère region of Brittany, and he seems always to have retained a vivid impression of its rocky shore and of the Stone Age menhirs and dolmens that abound in the nearby fields. The curious bastionlike tablelands that he saw on a trip to Africa so fascinated him that he incorporated their shapes into several early paintings. In 1939, he traveled across the United States and was

struck by the geological phenomena of the Southwest.

The title of the picture, *Multiplication of the Arcs*, indicates that Tanguy's interest in rocks led him to acquire some familiarity with geology and its terminology. "Island arcs" are curving chains of islands, such as the Aleutians or the Antilles, found off the shores of continents; "mountain arcs" are the similarly curved systems of mountains that rim the coasts inland. Behind these primary festoons of mountains there may arise secondary arcs, such as the Canadian Rockies, formed by deposits washed inward from the coastal ranges. According to one theory of geophysics, continents were born by the slow accretion of materials resulting from the eruption of undersea volcanoes and extruded from the ocean, together with sedimentary rocks continually added at the margins of the land.

Tanguy's *Multiplication of the Arcs* would seem to be an artist's, rather than a scientist's, vision of a process that took place billions of years ago. In true Surrealist fashion, he has accentuated the forms of the spherical pebbles with parti-colored layers—like those that his fellow-Surrealists Ernst and Giacometti gathered from the glacial deposits in Switzerland in 1934 (see page 29)—to make them resemble eyes.

67

SALVADOR DALI. Spanish, 1904–1989. Active in Paris and New York.
The Persistence of Memory. 1931. Oil on canvas, 9½ x 13 inches. Given anonymously. [162.34]

The title of this painting is particularly apt, for Dali's limp watches have become among the most memorable invented images of our day; once seen, they stamp themselves indelibly upon the mind. "My whole ambition in the pictorial domain," he declared in his book *Conquest of the Irrational*, "is to materialize the images of concrete irrationality with the most imperialist fury of precision." To this end, he aped the meticulous technique of the nineteenth-century French painter Jean Louis Ernest Meissonier, producing what he called "hand-painted dream photographs." This verisimilitude gives Dali's fantastic visions the gripping credibility of our most vivid dreams—they are super-real. Like many other Surrealists, Dali was influenced by de Chirico's mysterious pictures and especially the evocative use of deep spatial perspective, which has the effect of detaching from everyday reality the figures and objects represented.

The small size of *The Persistence of Memory* (it is only slightly larger than this book) concentrates its impact. Beyond stating that there may be some influence from Einstein's theory of relativity, Dali has given almost no clues to the interpretation of this picture, leaving us free to speculate on its meaning. The watches become limp, much as Alice's looking glass dissolves. The landscape is barren and uninhabited, the sole tree dead, the rocky cliffs without vegetation. The only living creatures in this wasteland are the ants and the fly. Surprisingly, they attack the inorganic watches rather than what, at first, seems to be the carrion of some strange beast in the central foreground, but which on closer inspection proves to be a caricaturelike, profile self-portrait of Dali, with eyes closed in sleep or death.

Perhaps we have here a distant echo of a theme found in paintings and sculptures of earlier centuries, in which man is portrayed as a mortal being subject, with time, to death's corruption. In *The Persistence of Memory*, however, it is the instruments of time itself—the watches that measure it—which lose their durability and become vulnerable to scavenging attacks.

JOAN MIRÓ. Spanish, 1893–1983. In Paris 1919–40. *Object*. 1936. Assemblage: stuffed parrot on wood perch, stuffed silk stocking with velvet garter and doll's paper shoe suspended in hollow wood frame, derby hat, hanging cork ball, celluloid fish, and engraved map, 31⅞ x 11⅞ x 10¼ inches. Gift of Mr. and Mrs. Pierre Matisse. [940.65a–c]

In the 1930s, the making of objects became a major preoccupation of the Surrealists, who assembled found articles chosen for their metaphorical, literary associations rather than for their purely aesthetic visual appeal. Duchamp had provided important prototypes by his "assisted" Readymades, such as *Why Not Sneeze?* of 1921, a painted metal birdcage containing simulated sugar cubes made of marble, a cuttlebone, and a thermometer.

Miró's *Object* differs from other constructions by the Surrealists because, though the rest of its elements were "found," its centerpiece, a large wooden cylinder, was cut to his specifications by a carpenter. Rising from a hat with crown removed that serves as a base, its hollowed-out form enshrines the woman's leg like a reliquary. *Object* also differs from other Surrealist assemblages because, far from disregarding aesthetic values, it has definite visual and tactile appeal. The hat's velvety surface, the map's crisp paper, the cylinder's smooth polished wood, the leg's sleek silk stocking, and the parrot's soft feathers, all entice our caress. Color ranges from the black hat through the neutral tones of the cylinder, the leg, and the cork ball to rise to a crescendo in the bird's brilliant plumage.

Everything in this assemblage suggests potential but arrested motion: swimming in the case of the fish; perambulation in the case of the leg, which in addition is movable, since like the cork ball it is suspended from a string; and flight by the bird. Each of these implied movements is assigned a different element in which to operate. The fish navigates through the water of the oceans charted on the map; the leg would tread upon the earth; the ball swings like a pendulum through the air, into which the bird would take its flight. One might also imagine that if the parrot were to alight on the branch, the impact of its weight would send a tremor through the precariously cantilevered branch and set the ball on its string to oscillating.

This work has sometimes been titled *Poetic Object*, and indeed, as William Rubin has observed: "Miró's 1936 object may be read—and Miró concurs with this interpretation—as a kind of poetic fantasy, a chain of associations literally springing from the head of the man whose hat forms the base of the construction." Like many Surrealist objects, this one has implied erotic connotations, such as those of the leg, isolated like a fetish, and the ball and phallic-looking branch that supports the parrot.

BALTHUS (Baltusz Klossowski de Rola). French, born 1908.
The Street. 1933. Oil on canvas, 6 feet 4¾ inches x 7 feet 10½ inches. James Thrall Soby Bequest. [1200.79]

The Street is the second version of an imaginary scene taking place on the rue Bourbon-le-Château in Paris's Sixth Arrondissement, near to where Balthus had his studio. In 1927, he had painted the same setting in a smaller version, done in a loosely impressionist manner; but when he returned to the theme in 1933, all the forms were sharply defined and filled with flat colors. Some critics have suggested that the change was due to Balthus's experience of the clear bright light of Morocco, where he spent six months in military service.

Like de Chirico, Balthus admired the art and architecture of the Italian Renaissance. On a trip to Italy in 1926, he copied some of Piero della Francesca's frescoes of the Invention of the True Cross cycle in Arezzo, and others by Masolino and Masaccio in the Brancacci Chapel in Florence. The influence of those works is apparent in the stylized figures and geometrized architecture of the buildings bordering the street in this painting.

In the words of James Thrall Soby: "The figures have an hypnotic intensity, as though seen in a dream or viewed on a moving-picture film which abruptly and inexplicably has stopped on its sprockets. . . . [They] are puppet-like in their sleep-walking irrationality, yet at the same time alive and majestically composed." The chef with tall toque on the pavement at the left is not a living person, however, but a signboard for the restaurant, advertising the day's menu.

After its completion in 1933, the picture was seen and admired in Balthus's studio by his Surrealist friends and by the dealer Pierre Loeb, who the following year staged an exhibition of the artist's paintings at his Galerie Pierre. The works' erotic character shocked viewers and critics, and they found no buyers. *The Street* was kept in the gallery's back room until purchased three years later by Soby, who shipped it to the United States. He hung it in the living room of his house in Connecticut, until he was disconcerted to find that, because of the highly suggestive position of the right hand of the lad seizing the young girl, it had become the object of excited attention for his nine-year-old son and his friends as a "naughty" picture. Soby wrote Balthus to ask whether he would consider repainting the offending passage, and to his surprise and delight, the artist agreed. After keeping the picture in his studio for nearly two years, he returned it in 1955. The alteration rendered *The Street* sufficiently discreet to allow it to be publicly exhibited, and it was included among the many works bequeathed by Soby to the Museum.

RENÉ MAGRITTE. Belgian, 1898–1967.
The Menaced Assassin. 1926. Oil on canvas, 59¼ inches
x 6 feet 4⅞ inches. Kay Sage Tanguy Fund. [247.66]

The most important event in Magritte's career took place
in 1922, when at the age of twenty-four he was shown a
reproduction of de Chirico's painting *The Song of Love*
(1914). Years later, in an autobiographical essay, he de-
clared that it moved him to tears, because it dealt "with
poetry's ascendancy over painting and the various man-
ners of painting. De Chirico was the first to dream of
what must be painted and not *how to paint*." In the large
canvas *The Menaced Assassin*, the impact of de Chirico is
apparent in the enigmatic content, dreamlike atmosphere,
and upward-tilting perspective, somewhat akin to Bal-
thus's later picture, the somnambulistic *Street*. But the
subject matter of Magritte's painting is entirely idio-
syncratic to him and comes from a quite different tradi-
tion, a literary rather than a visual one.

The Menaced Assassin* depicts one scene in a narrative
whose total scenario we do not know. It clearly relates,
however, to the dime novels to which Magritte was ad-
dicted. Prominent among these was *Fantomas*, which ran
in installments in periodicals in the years before the First
World War. Its eponymous antihero was the Emperor of
Crime, a ubiquitous evildoer who, somewhat like the
Joker in *Batman*, constantly changed his appearance and
identity. His pursuers were the detective Juve and a jour-

nalist, Fandor. Magritte and his brother frequented the
cinema in Brussels, where a series based on the novel and
with the same title was shown in 1913–14. Besides also
following the adventures of the detectives Nick Carter
and Nat Pinkerton in illustrated weeklies, Magritte was
an ardent reader of the tales of Edgar Allan Poe and
Robert Louis Stevenson.

In *The Menaced Assassin*, the murderer of the woman
whose nude body lies outstretched on the couch pauses to
listen to a record on the phonograph before taking his hat,
coat, and suitcase to make his getaway. He is unaware
that his escape is blocked by the two men in the foyer at
left and right, one armed with a cudgel and the other with
a net to entrap him. These bowler-hatted figures, repre-
sentatives of law and order, closely resemble Magritte
himself as he appears in photographs—his fantastic Sur-
realist imaginings masked, in David Sylvester's words,
behind "his disguise as small shopkeeper or clerk in his
Sunday best." The gruesome scene is observed by a trio
outside the window, perhaps colleagues of the detectives
or merely witnesses.

Magritte himself would undoubtedly have cautioned
against too persistent attempts to unravel the picture's
mystery. In an interview some twenty years after it was
painted, he said: "If one looks at a thing with the inten-
tion of trying to discover what it means, one ends up no
longer seeing the thing itself, but thinking of the question
that has been raised."

Jean (Hans) Arp. French, born Alsace (then part of Germany). 1887–1966. Lived in Switzerland 1959–66. *Mountain, Table, Anchors, Navel*. 1925. Oil on cardboard with cutouts, 29⅝ x 23½ inches. Purchase. [77.36]

Early in his career, Arp made Cubist-inspired, geometrical abstractions but soon discovered his true bent lay in creating freely curving, "biomorphic" shapes that suggest, rather than imitate, organisms found in nature. A poet as well as an artist, he was readily attracted to antirational movements—first Dada, which came into being during the First World War and, in his words, "aimed to destroy the reasonable deceptions of man and recover the natural and unreasonable order," and later Surrealism, which took shape as a successor to Dada between 1922 and 1924. Arp's best-known statement about art, probably written in the 1920s, was first pub-

lished in 1932 and printed entirely without capitals and almost without punctuation. In it, he declared: "art is a fruit growing out of man like the fruit out of a plant like the child out of the mother. while the fruit of the plant grows independent forms and never resembles a balloon or a president in a cutaway suit the artistic fruit of man shows for the most part a ridiculous resemblance to the appearance of other things. reason tells man to stand above nature and to be the measure of all things. thus man thinks he is able to live and to create against the laws of nature and he creates abortions."

Mountain, Table, Anchors, Navel dates from the time of Arp's close involvement with the Surrealists, who encouraged him to "ferret out the dream, the idea behind my plastic work, and to give it a name." Engaged in this quest for interpretation, Arp gave his works titles as poetic as they are irrational. He informs us: "These titles were often abbreviated little stories such as this one for 'Mountain-Table-Anchors-Navel': 'A dreamer can make eggs as big as houses dance, bundle up flashes of lightning, and make an enormous mountain, dreaming of a navel and two anchors, hover over a poor enfeebled table that looks like the mummy of a goat.'" The navel, which appears in many of Arp's plastic works and poems, seems to have had a particular cosmic significance for him, at times denoting the generative forces of nature, at other times the sun, or the passage of time as measured by the face of a clock.

The technique of *Mountain, Table, Anchors, Navel* might be regarded as a translation into two dimensions of the painted wood reliefs that Arp had begun to make in 1916. On the other hand, the cutouts, one of Arp's many formal inventions, might also be thought of as a variant of his collages, with shapes excised rather than pasted on. Since, like other Surrealists, he was sometimes interested in introducing automatism and the laws of chance into his compositions, it is worth noting that the open spaces allow for the possibility of changing the aspect of this work by altering the background against which it is set— black instead of white, for example.

JEAN (HANS) ARP.
Human Concretion. 1949. Cast-stone replica of original plaster of 1935, owned by the Museum, 19½ x 18¾ x 25½ inches. Purchase. [328.49]

In 1930 Arp, whom Alfred H. Barr, Jr. once described as "a one-man laboratory for the discovery of new form," began to supplement his painted wood reliefs with sculpture in the round, modeled in plaster. He called these works "Concretions" and explained them by saying: "Concretion signifies the natural process of condensation, hardening, coagulating, thickening, growing together. Concretion designates the solidification of a mass. Concretion designates curdling, the curdling of the earth and the heavenly bodies. Concretion designates solidification, the mass of the stone, the plant, the animal, the man. Concretion is something that has grown. I wanted my work to find its humble, anonymous place in the woods, the mountains, in nature."

In *Human Concretion*, Arp met the challenge of creating a work whose complicated form could not be apprehended from any single viewpoint and that, in conformity with his ideas about the laws of chance, would have no fixed orientation but would appear entirely different when seen from different angles. The juncture between two bulbous shapes seems smooth when seen from one aspect and dramatically twisted from another. This linking section is wholly obscured when the piece is viewed from either extremity, the two major masses then giving the impression of being independent of one another. The end of the larger section is softer, fuller, and more organic in appearance than the smaller one, which presents a circular outline and appears harder and flatter.

Human Concretion is one of Arp's most complex and mysterious sculptures. It is wholly abstract, yet susceptible to many interpretations. Margherita Andreotti has suggested some of them: "Depending on its orientation, it seems to nestle like some forest creature, raise its head inquisitively, or curl in upon itself like a human or animal embryo."

73

FERNAND LÉGER. French, 1881–1955. In U.S.A. 1940–45.
Exit the Ballets Russes. 1914. Oil on canvas, 53¾ x 39½ inches. Gift of Mr. and Mrs. Peter A. Rübel (partly by exchange). [11.58]

By 1913, Léger had absorbed the lessons of Cézanne's treatment of form and color and Cubism's underlying geometrical structure and had developed an abstract style of his own that emphasized contrasts of colors, lines, volumes, and planes. He restricted his range of colors to create greater contrasts between the forms. In *Exit the Ballets Russes*, for example, he used only red,

blue, green, yellow, and brown for the figures and stairway, giving his shapes firm black outlines and strong white highlights to emphasize their solidity.

Léger treated the subject of the staircase in several paintings at about this date, possibly in recollection of Duchamp's famous *Nude Descending a Staircase* of 1911 (now in the Philadelphia Museum of Art), but primarily because the theme allowed him to impart a rhythmic sense of movement in space to his articulated, geometrical forms. In this painting, human beings are transformed into robots made up of cylinders and cones, with ovoid heads. Subsequently, Léger's wartime experience in the army increased his admiration for the beauty of machines, and he developed a style in which both figures and objects are rendered as depersonalized, tubular forms, as in *Three Women* (page 97). Here, despite the machinelike personages, the everyday subject is more realistic and less conceptual than Duchamp's *Passage from Virgin to Bride* (page 58) or Picabia's *I See Again in Memory My Dear Udnie* (page 59).

Exit the Ballets Russes was formerly owned by the famous dancer and choreographer Léonid Massine, who became a member of Diaghilev's troupe in the same year that Léger painted the picture.

OSKAR SCHLEMMER. German, 1888–1943.
Bauhaus Stairway. 1932. Oil on canvas, 63⅞ x 45 inches.
Gift of Philip Johnson. [597.42]

Schlemmer's subject, figures on a stairway, is the same as that of Léger's *Exit the Ballets Russes*, which it also resembles in its general proportions and color range. Though the idealized forms are drastically simplified, the personages are not transformed, as are Léger's, into automata.

The light-filled interior with its large windows and glass stair parapet is an actual depiction of the architecture of the Bauhaus at Dessau, the pioneering school of art and technology founded by Walter Gropius, which in the late 1920s and early 1930s led the world in the field of modern design. Schlemmer painted the picture from memory in Breslau on the basis of earlier studies, three years after leaving the Bauhaus, where he had been an instructor in theater and ballet. The dancer *en pointe* in the background recalls the latter activity.

The two side figures and the lower one seen from the rear, all cut by the frame, give the viewer the impression of being a participant in the upward movement. By making the architecture that he represented seem a continuation of the real space we occupy, Schlemmer made the painting a close-knit part of its surroundings.

Bauhaus Stairway was the principal painting in an exhibition of Schlemmer's work in his native town of Stuttgart in 1933. Ten days after the show opened, it was closed by the Nazis on the charge of "art bolshevism," and Schlemmer was dismissed from his professorship at the Breslau Academy. The Bauhaus at Dessau had already been closed by the authorities the preceding year.

PAUL KLEE. German, 1879–1940. Born and died in Switzerland.
Castle Garden. 1931. Oil on canvas, 26½ x 21⅝ inches. Sidney and Harriet Janis Collection Fund. [106.82]

Klee was a poetic philosopher engaged throughout his life in a quest for the pictorial means best suited to expressing the ultimate truths that transcend reality. Carolyn Lanchner has noted: "Klee's work, in its multiplicity of styles, variety, and inventiveness, is a virtual index of the art of our century. He was the only artist of his generation who allowed his work to range freely between the figurative and the nonfigurative, the openly gestural and the tightly geometric, the wholly linear and the wholly chromatic."

Among the more than forty paintings by Klee in the Museum's collection, we may cite as an example of this diversity the contrast between his *Actor's Mask* of 1924 (page 27) and *Castle Garden*, painted seven years later. The former is characterized by clear outlines, linear patterns, and the clash of dissonant colors. In *Castle Garden*, shapes dissolve, dark lines are fragmented, and pale colors are enveloped in a soft, luminous atmosphere.

Klee was a member of the Blue Rider group, and like its founders, Kandinsky and Marc, he believed that art should express the spiritual rather than the material. During a trip to Paris in 1912, he met Delaunay and after returning to Germany translated for the influential publication *Der Sturm* an article by that artist on his theories of light and color (see page 49). In 1926, Klee joined the faculty at the Bauhaus, where he was active as teacher and theoretician until 1931. After the Bauhaus moved from Weimar to Dessau, for a time he shared an apartment with his longtime friend and mentor, Kandinsky, of whom he wrote in a sixtieth-birthday tribute: "There has never been a word of his that was not a light for my own work, an encouragement, and a confirmation."

Many of Klee's paintings incorporate impressions gleaned during his extensive travels. *Castle Garden* is one of a group of pictures he made following a trip to Northern Italy and Sicily in 1931. In order to portray light-filled space through color, he filled the canvas with small dots of pigment in a manner that recalls Seurat's pointillism, but the fact that the dots are square instead of round indicates that his actual source was Early Christian and Byzantine mosaics seen during his recent trips. In mosaics, the small, irregularly set squares of stone or glass catch the shimmer of light and convey an immaterial, spiritual world. The effect of these multicolored tesserae is replicated here, but in contrast to Klimt, who adopted in his paintings the brilliant hues and radiant gold of the sixth-century mosaics of Ravenna (see page 42), Klee chose a gamut of delicate blond tones that more closely resemble those of the late-Roman mosaics he had seen many years before on a trip to Tunisia in 1914. In the mosaics, figures and objects represented are clearly recognizable, but the shapes in *Castle Garden* lack such firm definition, and the viewer discerns their separate identities only after prolonged scrutiny. The buildings seem weightless, as if floating in space, and their forms merge with the terraces of the landscaped garden.

In accordance with the Cubist principle of viewing objects from many sides and combining different aspects on the picture plane, the structures in the right quarter of this canvas are shown perpendicular to those in the rest of the painting, in which all the elements are displayed vertically. The flow of their steep ascent counteracts the horizontal disposition of the rows of colored cubes. All rigid geometry is dematerialized in the soft light that pervades this radiant dream world.

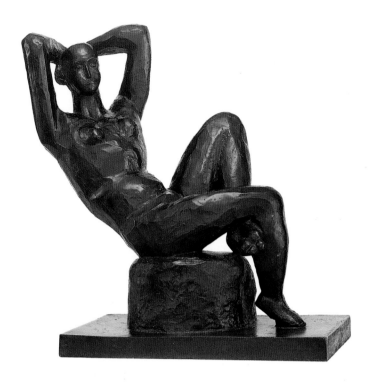

Henri Matisse. French, 1869–1954.
Large Seated Nude. 1923–25. Bronze, 31¼ x 30½ x
13¾ inches. Gift of Mr. and Mrs. Walter Hochschild (by
exchange). [527.87]

In the winter of 1906–07, Matisse turned to a traditional
theme and modeled a reclining nude about twenty inches
long. When it was damaged before completion, he dupli-
cated its pose in a life-size painting, *Blue Nude—
Souvenir of Biskra* (The Baltimore Museum of Art), and
then salvaged the sculpture to complete the bronze *Re-
clining Nude, I*. The "ugliness" of its expressive anatom-
ical distortions, which show the influence of African
sculpture, and its contorted pose repelled visitors to the
Salon des Indépendants of 1907 and subsequently to
the apartment that Leo Stein, who bought it, shared with
his sister Gertrude. It was nevertheless much favored by
Matisse himself, who incorporated it as a compositional
element in his paintings more often than any other of his
sculptures.

Sculpture had been a large part of Matisse's early
activity, but except for the five versions of *Jeannette* of
1910–16 (see page 94), a head of his daughter Mar-
guerite of 1915, and three minor bronzes of 1918, he had
virtually ceased to work in that medium until the creation
of the *Large Seated Nude*. It marked an abrupt departure

from the easy charm of the decorative, relatively realistic
paintings, drawings, and prints that he produced pro-
lifically during the serene years between 1920 and 1925
that he spent with his family in Nice in an apartment
overlooking the Mediterranean.

The subject of this piece appeared frequently in
Matisse's art of 1923–25: "odalisques," or models partly
nude or draped in Oriental costume. Their relaxed grace
and voluptuous allure, however, are in striking contrast to
the strained pose and angular lines of the *Large Seated
Nude*. The figure leans precariously backward, with no
supporting chair or sofa, its unbalanced posture upon an
ottoman creating a sense of tension. In place of the sin-
uous curves of the odalisques with their full breasts and
rounded bellies, the breasts of the bronze woman are
small and rise above the two blocks of rib cage and
abdomen, which are divided by a sharply indented waist.
Facial features are only summarily indicated lest they
detract from the pure ovoid of the head, borne on the
somewhat elongated cylinder of the neck and framed
within the triangular spaces enclosed by the upraised
arms. Another triangle is formed by the left leg, bent
tightly at the knee, with the curve of its thigh paralleling
that of the arm above it. The left foot is tucked under the
knee of the other leg, which is bent at a right angle, while
its tilted foot lightly touches the ground, with the heel
coming close to yet another geometrical shape, that of the
cylindrical hassock. In many areas the plaster model
appears to have been cut with a knife and smoothed with
the side of its blade, rather than being gently modeled
with the fingers.

This impressive work initiated the second great period
of Matisse's sculptural activity; it concluded in 1931 with
the last of his four life-size reliefs of Backs, which were
produced over a period of some twenty years beginning
in 1909.

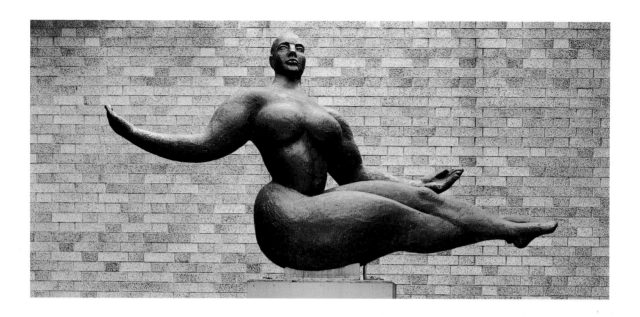

GASTON LACHAISE. American, born France. 1882–1935. To U.S.A. 1906. Naturalized American citizen 1913. *Floating Figure*. 1927. Bronze (cast 1935), 51¼ inches x 8 feet x 22 inches. Given anonymously in memory of the artist. [3.37]

Matisse's *Large Seated Nude* is an experiment in tense, precarious imbalance; Lachaise's *Floating Figure*, by contrast, is a tour-de-force of exuberant equilibrium. In the former, angularity prevails in the severe planes of the modeling and the acute bending of the joints; in the latter, all surfaces are smooth, and curves flow rhythmically through head, torso, and limbs, uninterrupted by articulation at the wrists, knees, or ankles. The small-breasted, assertive figure of the *Large Seated Nude* lacks all feminine appeal; the *Floating Figure* is a paean to the sexual allure of rounded breasts, thighs, and buttocks.

In his native France, Lachaise had received thorough training, first as artist-craftsman and then as sculptor, at the Académie des Beaux-Arts in Paris. After meeting and establishing a liaison with an American woman, Isabel Nagle, he followed her to the United States in 1906, but as she was married, it was only in 1913 that he was able to make her his wife. She became his muse, whose ample physical endowments he celebrated and glorified in his sculpture. Ironically, whereas in Germany in 1911 Lehmbruck's delicate *Kneeling Woman* had been criticized because it did not conform to the prevailing standards of the female form (see page 45), when the clay model of Lachaise's *Standing Woman* was first exhibited in New York in 1918 it was condemned for being fat, grotesque, and counter to the American ideal of slender womanhood. "His vision is monstrous, how can you show these things?" railed the dean of American sculptors, Daniel Chester French. Lachaise worked on *Floating Figure* for almost ten years before completing it.

Lachaise admired the sculpture of many cultures, including the small paleolithic idols of fertility goddesses with protuberant buttocks and huge breasts, and the clear precision of Egyptian stonecarving, but most of all the unbridled eroticism of the sculpture of India and the Malay peninsula. His *Floating Figure* is kin to the *apsaras*—celestial beings who hover like angels around the divinities in Hindu and Buddhist sculpture.

An admirer since childhood of circus performers and acrobats, Lachaise produced several figures of them, including *Two Floating Nude Acrobats* of 1922 (Private collection); their triumph over gravity indirectly foreshadows *Floating Figure*. A more specific prototype is a *Floating Figure* of 1924 in the Fogg Art Museum, Harvard University. In this, the large breasts and the pose with legs crossed below the knee anticipate the later version, but Lachaise severed the arms below the shoulders and the feet above the ankles to concentrate on the rounded masses of thighs and breasts and enhance the effect of levitation.

In 1935 The Museum of Modern Art gave Lachaise a retrospective that included all his major pieces; it was its first show devoted to a living American artist. Five months later, he died of leukemia.

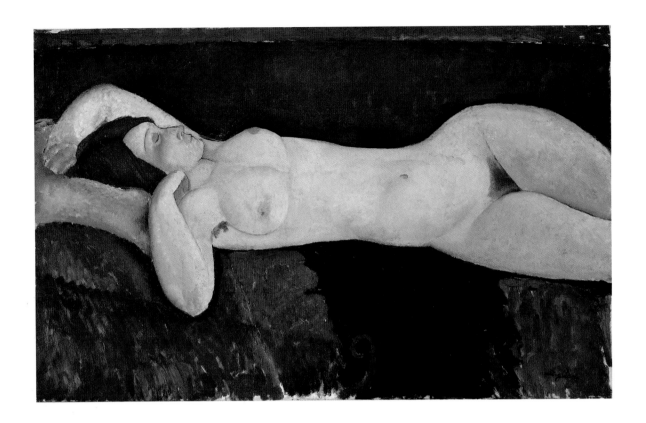

AMEDEO MODIGLIANI. Italian, 1884–1920. To France 1906.
Reclining Nude. c. 1919. Oil on canvas, 28½ x 45⅞ inches. Mrs. Simon Guggenheim Fund. [13.50]

The reclining nude has been a favorite subject of painters ever since the Renaissance. The Italian-born Modigliani was a natural heir to this tradition and took the same delight in rendering the soft flesh, rounded swelling breasts, and sinuous curves of his model as did such old masters as Giorgione, Titian, and Veronese. James Thrall Soby has observed that Modigliani's nudes "are an emphatic answer to his Futurist countrymen who, infatuated with the machine, considered the subject outworn and urged its suppression for a period of ten years."

Modigliani, however, modernized his treatment of the theme by subtle simplifications and distortions—for example, the elongated torso and exaggerated outward thrust of the left hip. Modern, also, is the cutting off of the body by the framing edge of the canvas instead of showing it full length. The shadow that surrounds the figure emphasizes its flowing outline and enhances the contrast between the pale, evenly painted tones of the woman's body and the dark, rich colors and broken brushstrokes of the textured surface on which she lies.

Modigliani began his series of nudes in 1917; when two that he had recently completed were displayed in the window of the gallery where he was having his first exhibition, they were judged so scandalous that the gendarmerie ordered the show to be closed. This, the last of Modigliani's figure paintings, he himself designated *le grand nu.*

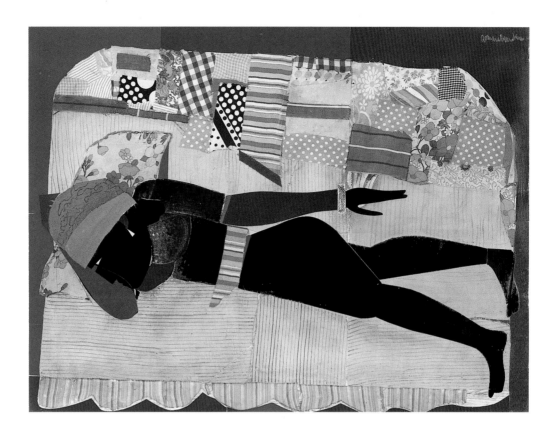

ROMARE BEARDEN. American, 1914–1988.
Patchwork Quilt. 1970. Cut-and-pasted cloth and paper with synthetic polymer paint on composition board, 35¾ x 47⅞ inches. Blanchette Rockefeller Fund. [573.70]

Bearden's treatment of the reclining nude is in complete contrast to Modigliani's. It certainly owes nothing to classical tradition. A knowing student of many cultures, Bearden here found inspiration for his figure in ancient Egyptian sculpture. By turning the reproduction sideways, one can readily see how closely the proportions of the high-waisted body, the position of the legs, and the rendering of the left arm and hand resemble those in Egyptian tomb reliefs. Bearden said that he had also given the figure overtones that relate it to the ancient Benin bronzes of Africa.

The body seems carved out of granite instead of made of human flesh. The sensuous appeal of this picture lies, rather, in the patchwork quilt for which it is named. The quilt is, of course, the product of a quite different culture—the folk art of rural America. Here the bright, gay patterns provide a foil for the black figure and the flat areas of blue, orange, and green in the background.

Bearden said of his art: "I am trying to explore, in terms of the particulars of the life I know best, those things common to all cultures." As Carroll Greene stated: "His goal consistently has been to create a universal art in a contemporary medium while remaining true to his particular cultural heritage."

In the 1960s, as the civil rights movement was increasingly engaging public attention, Bearden helped found the Spiral Group, its name denoting an upward and outward path for Black artists. During this period, he began to create collages whose themes drew on his memory and experience of America, especially the rural Southern communities around his native Charlotte, South Carolina. At the same time, his many years as a case worker for the New York City Department of Social Services made him well aware of the problems of urban Blacks.

Beginning in the early 1960s, Bearden produced figurative collages in monumental scale, some as single compositions and others in series. With obvious pleasure in color and design, he combined cloth, paper, paint, and montages of photographs in sophisticated compositions, creating highly original images of forceful impact.

81

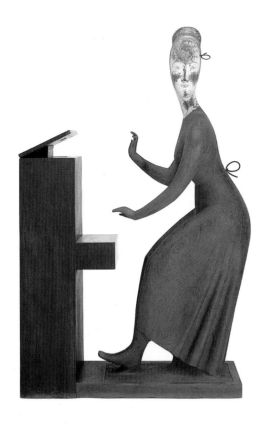

ELIE NADELMAN. American, born Poland. 1882–1946.
Worked in Paris 1904–14. To U.S.A. 1914. Naturalized
American citizen 1927.
Woman at the Piano. c. 1917. Wood, stained and painted,
35⅛ x 23¼ x 9 inches, including base. The Philip L.
Goodwin Collection. [105.58]

Profoundly different as they are in scale, material, and
mood, Nadelman's *Woman at the Piano* shares with La-
chaise's *Floating Figure* a primary reliance on curves to
produce their aesthetic effect.

Born in Warsaw, in 1906 Nadelman spent six months in
Munich, where he came into contact with two very dif-
ferent kinds of art that were to become the opposing
poles of his creative imagination: classical Greek sculp-
ture and eighteenth- and early-nineteenth-century dolls.
Later in the year he arrived in Paris and deciding to
become a sculptor studied the statues at the Louvre and
worked from the nude. By 1909 he had evolved a system
of analytical drawing, in which the underlying anatomy
of heads and bodies was graphically delineated. His
carved female heads in classical style were shown inter-
nationally in numerous highly successful exhibitions,

and in 1911 the entire contents of his show in London
was bought by Helena Rubinstein. She became his great-
est patron, and at the outbreak of war in 1914, aided him
in coming to America.

That year began Nadelman's interest in the ironically
simplified depiction of contemporary social types. In
1917, at a wartime benefit show, "Allies of Sculpture," he
exhibited four painted plaster figures. One of them, por-
traying a hostess seated in a wrought-iron chair, outraged
the exhibition's organizers, who believed that they were
being mocked and had the work removed. In a letter to
the newspapers defending himself, Nadelman wrote that
at the exhibition "the subject matter of almost all [the]
works represents nude men, nude women, and nude men
having the bodies of nude women. I have exhibited some
works whose subjects are dressed women, as one sees
them in everyday life. Well, the majority of the visitors
on seeing the dressed women found them indecent and
were so shocked that they removed them from their origi-
nal place to a remote corner where they could not be
seen. . . . When the public does not find nude women in
sculpture, they wonder whether the works are artistic or
not. And when one represents women in dresses or men
wearing hats, the public, not being accustomed to this, do
not know whether there is art or solid insolence." Two
years later, Nadelman compounded his offense by in-
cluding in a show of his sculpture other representations
of contemporary figures, carved in wood and painted.
Woman at the Piano was among them. "Is Nadelman
serious?" demanded one outraged critic. "Where does
plastic beauty end, and decadence begin?" Another de-
clared, "The artist is a joke, and he clothes his subjects
with the grotesque and the bizarre . . . he works with
crudity, and not one of his numbers even remotely sug-
gests aestheticism. . . . [*Woman at the Piano*] might
easily be a demonstration in a department store." Nadel-
man's only full-length male bronze, *Man in the Open Air,*
met with equal disfavor for its amalgam of a classical
nude type with an English dandy's bowler hat and bow tie.

Blinded by their prejudices about what materials, what
subjects, and what costumes were appropriate for "high"
art, viewers could not perceive the grace and wit of such a
work as *Woman at the Piano.* In Lincoln Kirstein's words,
the diminutive instrumentalist, capturing the essence of
expressive gesture, "by the very arch of her back and
poised hands attracts the attention of an entire world to
her single struck note."

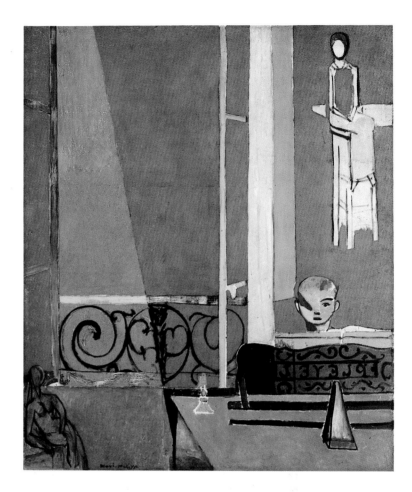

Henri Matisse. French, 1869–1954.
Piano Lesson. 1916. Oil on canvas, 8 feet ½ inch x 6 feet
11¾ inches. Mrs. Simon Guggenheim Fund. [125.46]

The subject of the *Piano Lesson*—an inhabited interior, with a view through an open casement to a garden beyond—is basically the same as that of Bonnard's *Breakfast Room* (page 25). But whereas Bonnard's painting represents an extension of the Impressionist tradition, the rigorous simplification and geometrizing of forms in this picture are evidence of Matisse's assimilation of certain Cubist principles. It has been described as uniting "the abstract precision of a Mondrian with the quiet emotion of the best intimist painting."

This very large canvas shows Matisse's sixteen-year-old son Pierre practicing on the Pleyel in the living room of the family villa at Issy-les-Moulineaux, a suburb of Paris. His back is turned to the green lawn of the garden behind him, and unlike the self-confident player in Nadelman's *Woman at the Piano*, who appears to be well pleased with her performance and the attention of her unseen audience, the boy seems a reluctant captive, barricaded by the piano in front of him and strictly monitored by the metronome that controls his tempo and which, as John Elderfield has noted, points directly to the head of the austere guardian seated behind him. She is not a real woman, however, but an elongated version of one of Matisse's paintings of 1914, *Woman on a High Stool*. This clothed and rigid personage in dull blue, gray, black, and white wittily complements the relaxed brown nude in the lower left corner—Matisse's bronze *Decorative Figure* of 1908 (The Hirshhorn Museum and Sculpture Garden, Washington). Theodore Reff has observed of the boy that "only his left eye, the one aligned with the metronome and high stool, is open, very intently staring; whereas the other one, which might be distract-

ed by a peripheral glimpse of the garden or the nude, is closed by a wedge of shadow, its shape an echo of the metronome's."

As Alfred H. Barr, Jr. has pointed out: "The painting is full of other subtle analogies and entertaining polarities. Besides the two intricately contrasted female figures, the big triangle of green, as it echoes and expands the small foreground triangle of the metronome, may be noted; and also the play between the black arabesques of the music rack and window grill. The sharp converging points of green, black, pink and grey provide a valuable moment of excitement in an otherwise disciplined calm, just as the vigorously pyramidal metronome disturbs the general flatness of the rest of the picture."

Though Pierre Matisse was originally destined by his father to be a musician, he did not pursue that career but instead became an art dealer, directing from 1931 until his death in 1989 one of New York's most prestigious galleries of modern art.

OTTO DIX. German, 1891–1969.
Dr. Mayer-Hermann. 1926. Oil and tempera on wood,
58¾ x 39 inches. Gift of Philip Johnson. [3.32]

Dix was one of a number of German painters who, after
the end of the First World War and the social upheavals
that followed it, in reaction against the modes with which
they had previously been associated, such as abstraction,
expressionism, and Dada iconoclasm, turned instead to
the realistic depiction of the contemporary world. As
with many other modern movements, the name New Ob-
jectivity (*Neue Sachlichkeit*) given to this tendency was
not one selected by the artists themselves; it was coined
by Gustav Friedrich Hartlaub, director of the Kunsthalle
in Mannheim, who in 1925 presented an exhibition that
brought together works by those who "have remained
true or have returned to a positive, palpable reality."

Committed to the portrayal of the modern environment
and everyday life, the artists working in this manner
viewed their subjects with a cool detachment, an attitude
of cynical resignation and skepticism devoid of
sentimentality.

Dr. Wilhelm Mayer-Hermann, the subject of this por-
trait, was a prominent Berlin throat specialist. Dix pre-
sented him in strict frontality, surrounded by accessories
that echo his conspicuous rotundity. His round face, with
half-moons under the eyes, bulbous nose, pursed mouth
with full underlip, and double chin, rises directly with no
indication of a neck above the arched shoulders that slope
into the curved arms encircling his corpulent torso.
Though the characterization verges on satire, we sense in
it no malice.

The roundness of the instrument strapped onto the
doctor's forehead is repeated in enlarged scale by the
spherical X-ray apparatus behind his head. The polished
surface of this globe reflects a distorted image of the
clinic. The circular motif is picked up by the outlet on the
wall at the left, the clock face above it, and the medallion
on the base of the machine at the lower right, which
encloses the artist's monogram and the date.

Despite the meticulous attention to detail, the painting
is not "realistic," for in actuality its composition and the
manner of painting are artfully stylized. The precise
draftsmanship and even finish, giving equal emphasis to
every element, have precedents in the work of such Ger-
man artists of the fifteenth and sixteenth centuries as
Cranach and Holbein. The technique, too—tempera over
gesso on wood, covered with transparent or semi-
transparent glazes—was one that Dix adapted from the
old masters.

When the Nazis came to power in 1933, Dix was
among the first artists to suffer at their hands. He was
dismissed from his teaching post at the Art Academy in
Dresden and banned from exhibiting. Some two hundred
and sixty of his works were confiscated from museums
and galleries and either sold or destroyed; many figured
prominently in the shows of "Degenerate Art" at
Dresden and Stuttgart. The Social Realism that Hitler
espoused was a cliché-ridden art that portrayed a senti-
mentally idealized world, and the New Objectivity with
its commitment to exactitude was castigated as ex-
emplifying crass materialism.

Dr. Mayer-Hermann fled Berlin in 1934 and immi-
grated to New York, where he established a successful
practice that numbered among its patients several stars of
the Metropolitan Opera. Dix's portrait of him, included
in The Museum of Modern Art's exhibition "German
Painting and Sculpture" in 1931 and acquired the follow-
ing year, was the first important German painting to enter
the collection.

GEORGE GROSZ. American, 1893–1959. Born and died in Germany; in U.S.A. 1932–59. Naturalized American citizen 1938.
The Poet Max Herrmann-Neisse. 1927. Oil on canvas, 23⅜ x 29⅛ inches. Purchase. [49.52]

Early in his career, Grosz was a leader of the Dada movement in Berlin and made his reputation as the creator of mordantly satirical cartoons. In 1925 he turned to oil painting and, like Dix, adopted the outlook of the New Objectivity.

This is the second of two portraits that Grosz made of his friend Max Herrmann-Neisse, whom he drew and painted many times. A pen-and-ink study for this picture is in the Museum's collection. A poet, playwright, and critic of literature, drama, and cabarets, Herrmann-Neisse had many contacts with artists and was represented by several of them.

The first version of this portrait, done in 1925, was shown in the New Objectivity exhibition of that year in Mannheim. In 1937 it was confiscated from the Mannheim Kunsthalle by the Nazis, who found it doubly offensive as an example of "degenerate art"—its subject was both a Jew and a hunchback. After the war, it was returned to the Mannheim gallery.

The Museum's portrait, done two years after the first one, accompanies its characterization of the figure by attributes such as the round table with glass, bottle, and ashtray. In contrast to Dix's portrait of Dr. Mayer-Hermann, the sitter is viewed at an angle instead of frontally. He sits slouched in an armchair, his clothing rumpled, and behind his steel-rimmed spectacles his gaze is withdrawn as if in reverie. The large hands with prominent veins recall those in Kokoschka's double portrait of the Tietzes (page 44), but here the fingers are clasped in a gesture that, like the furrowed brow, seems to indicate tension rather than relaxation, despite the slumped posture.

In an article written in 1929, Herrmann-Neisse paid tribute to his friendship with Grosz: "I always felt completely at home with George Grosz. We had almost the same disposition and manner of thinking, the same propensity for collecting, the same (aggressive) sympathy for life's small attractions, we came from very similar environments, we drank kirschwasser with the same pleasure, spoke, if not quite the same dialect, yet the same language, we were both lyrical as well as cynical, proper as well as anarchical. I sat for him countless times most willingly, was happy in the sanctuary of his studio. . . . He worked on my portrait with great care, assuming with complete seriousness the burden of creative work, while in the apartment below a schoolgirl always practiced at the same hour the same boring piano piece, and we amused ourselves with talk of all the types and incidents from our native havens in the provinces, of the equally unwittingly comic aspects of the little groups of Berlin artists, of the weekly markets, the fairgrounds, tent circuses, low music-halls, night lodgings, and we were one in heart and soul. And between times we made excursions to all the lowdown areas: a public dance hall for roadside repairmen, a musical-comedy hall with a female orchestra, or a Bavarian beerfest."

Herrmann-Neisse fled Berlin in 1933, immigrated to London, and died there in 1941. Grosz came to the United States in 1932, where he had an active career until the year of his death.

MAX BECKMANN. German, 1884–1950. In Amsterdam 1936–47; in U.S.A. 1947–50.
Departure. 1932–33. Oil on canvas; triptych: center panel, 7 feet ¾ inch x 45⅜ inches; side panels each 7 feet ¾ inch x 39¼ inches. Given anonymously (by exchange). [6.42.1–.3]

Though Beckmann was among the most prominent of the artists featured in the New Objectivity exhibition of 1925, he was not closely aligned with any group. Rather than being committed, like Dix and Grosz, to the representation of contemporary life, as a student of many Eastern and Western philosophies he sought, like the Blue Rider group, "to grasp the unutterable things of this world." In contrast to Kandinsky, however, who adopted abstraction as his vehicle for exploring the spiritual, Beckmann preferred to use "the metaphysics of the material" to suggest transcendent visions by means of sensuous perceptions of reality.

Departure is one of nine completed triptychs and an incomplete one that Beckmann painted between 1937 and 1950. It was created between May 1932 and November 1933, the period during which the Nazis came to power, and Beckmann was dismissed from his professorship at a Frankfurt academy. Subsequently no fewer than fifteen museums were purged of his paintings as "cultural Bolshevism"; he said, nevertheless, that *Departure* had no specifically tendentious meaning but could be applicable to all times.

In his studio notebook, Beckmann recorded the title of the left panel as "The Castle," that on the right as "The Staircase," and the central one as "The Homecoming." But in order to mislead the Nazis he affixed labels to the backs of the canvases identifying them as decorative designs for Shakespeare's plays, respectively, *Hamlet*, *Macbeth*, and *The Tempest*.

Many attempts have been made to interpret these scenes, whose richness of allusion, unexpected combinations of striking images, and ambiguity are typical of many modern expressions in literature, the theater, and film as well as in art. Beckmann said that he not only would not but could not unravel the picture's meaning: "I can only speak to people who consciously or unconsciously, already carry within them a similar metaphysical code. Departure, yes departure, from the illusions of life toward the essential realities that lie beyond."

The two side wings, darker and more crowded than the panel they flank, obviously express brutality, repression, horror, and despair, in contrast to the brightness, openness, and calm conveyed by the central section. Beck-

mann's widow said that of various explanations given for the *Departure*, she preferred that given by Perry T. Rathbone: "The side panels symbolize, on the left, man's brutality to man in the form of a callous executioner and his victims; on the right, the unbearable tragedy that Nature itself inflicts on human life as symbolized by the mad hallucinations of a woman encumbered by the lifeless form of a man. . . . Out of this earthly night of torment and mental anguish, the figures of the central panel emerge into the clear light of redemption and release, embarked for Eternity." In the central panel, the veiled figure at the left holds a fish—the age-old Christian symbol of redemption; the crowned figure at the right turns his back on the past and with upraised hand faces resolutely toward the open sea, which will bear the voyagers to their unknown future; while between these two men the child, an embodiment of love and hope for the future, is borne by a woman who wears a peaked Phrygian cap, a conventional emblem of freedom. Lilly von Schnitzler, a friend and patron of Beckmann's, recalls that he told her in 1937: "The Queen carries the greatest treasure—Freedom—as her child in her lap. Freedom is the one thing that matters—it is the departure, the new start."

Claude Gandelman has suggested that there is a specific relation between the triptych format and the German Expressionist theater of the 1920s, in which the stage was often divided into three sections to show action taking place simultaneously. Beckmann was an ardent theater-goer, wrote two plays, and numbered among his close friends in Frankfurt the actor and director Heinrich George. In a diary entry he wrote of "the entire life as only a scene from the Theatre of Infinity." He frequently depicted stage and circus performers and in 1942 painted a triptych, *The Actors* (Fogg Art Museum, Harvard University), in which the action that takes place on the stage is accompanied in other parts of the picture by workers constructing a set, the orchestra playing in the pit, and actors in costume offstage. Particularly influential for Beckmann may have been the simultaneous staging developed by the director Erwin Piscator. Gropius, founder of the Bauhaus and architect of Piscator's new stage, said: "The aim of this theatre . . . is *to catapult the audience into the middle of the scenic event* and to unite the audience spatially with the scene of the motion. . . ." Another feature of Piscator's direction is the crowding of the stage's flattened space, which projects the characters and objects outward toward the spectator. Similarly, in *Departure* the crowding of the side panels with many figures eliminates traditional illusionistic perspective.

GUSTAV KLUTSIS. Russian, 1895–1944.
Maquette for *Radio-Announcer*. 1922. Construction of painted cardboard, paper, wood, thread, and metal brads, 45¾ x 14½ x 14½ inches. Sidney and Harriet Janis Collection Fund. [1226.79]

The five years between the Revolution of 1917 and 1922 was a time of heady excitement for artists, architects, and designers of the Soviet Union. Encouraged by the régime, they were eager to apply their talents to the task of creating a new, utopian society.

Klutsis, a native of Riga, came to Moscow in 1918 and studied at the Free State Art Studios (*Svomas*) where Malevich was teaching. Under his influence, Klutsis be-

gan to make Suprematist Compositions of his own, built up of planes floating freely in a neutral space. In the next two years, he became interested in poster design, typography, and architectural design, and in the interaction of forms in space as embodied in the early constructions of Pevsner and Gabo. But he soon departed from a concern with aesthetic goals to adopt Tatlin's Productivist doctrine that art's primary purpose should be to apply technology to the fulfillment of society's utilitarian needs.

A golden opportunity for Klutsis to put his art at the service of propaganda came in 1922 on the occasion of the fifth anniversary of the Revolution and the Fourth Congress of the Comintern. This construction is the maquette for one of a number of kiosks he designed to be placed at major intersections for the transmission to the public of Lenin's speech. Its function is clearly proclaimed by the inscriptions on the upper part of the work. Over the large, bright letters spelling LENIN written vertically on the angled wings is superimposed horizontally in black capitals the Russian word for "speech"; around the top of the wings other black letters spell out RADIO-ORATOR (or "Announcer"). In this project, Klutsis incorporated all the principal characteristics of three-dimensional Constructivist works. Its geometrical panels, "architectural" supports, and gaily painted conical loudspeakers below are supported on struts, and the elements of the structure are held together by the reciprocal tension of cables.

FRANCIS BACON. British, 1909–1992.
Painting. 1946. Oil and pastel on linen, 6 feet
5⅞ inches x 52 inches. Purchase. [229.48]

The days of Stalin's bloodletting were still ahead when
Klutsis constructed his *Radio Announcer*, and the speech
by Lenin it was intended to transmit was one spoken to a
nation proudly celebrating a memorable anniversary.
Bacon's *Painting* dates from 1946, when Europe had be-
come a vast charnel house, and the full extent of the
havoc was only gradually coming to light. The picture
was originally titled *Man with Microphones*, and the ap-
paratus flanking the figure emphasizes the important role
of communications in controlling a subjugated populace.

The tyrant, with teeth bared in a feral grimace, seems
all the more menacing because he is unidentified and
unidentifiable, though the mouth and jutting jaw vaguely
resemble news photographs of Mussolini. This ano-
nymity, and our inability to define or explain just what is
taking place, aggravate the sense of horror.

Beneath an umbrella that shields him like a baldachin
the monstrous figure sits on a rostrum surrounded by
microphones, with a patterned carpet at his feet. The
large size of the canvas, the pose, and the accoutrements
are those of a state portrait. Hovering behind him a huge
butchered carcass, split open, assumes the form of a
crucified figure, with festoons of what appear to be en-
trails above it. The chrome tubes of the circular railing
run like spits through sides of beef. Drawn window
shades shut out any world beyond this claustrophobic
chamber of horrors.

Bacon has said that the images in *Painting* developed
by accident. He had started to paint a bird alighting in a
field, "but suddenly the lines that I'd drawn suggested
something totally different, and out of this suggestion
arose this picture. . . . It was like one continuous accident
mounting on top of another. . . . And I carried it out very
quickly, in about three or four days." All the elements in
this painting have their source in Bacon's vast store of
images—many drawn from personal experience, and
others derived from photographs or reproductions cut
from the quantities of newspapers and magazines filling
his studio. Their common denominator is violence. Be-
sides the likeness to Mussolini, already mentioned,
among the photographs on Bacon's studio wall was one
showing Hitler staring out of a window; directly in front
of his face are a windowshade cord and tassel like those
in the picture. The sleek tubular railing skewering the
sides of beef has an unexpected origin in a chrome-and-
glass coffee table that Bacon had made when he worked
as an interior decorator and designer in the late 1920s.

Bacon has said of his equation of the split carcass with
the Crucifixion: "I've always been very moved by pic-

tures about slaughter-houses and meat, and to me they
belong very much to the whole thing of the Crucifix-
ion. . . . When you go into a butcher's shop and see how
beautiful meat can be . . . you can think of the whole
horror of life—of one thing living off another."

Though it may seem startling to find Bacon speaking
of the beauty of meat, one should remember that artists
before him, including Rembrandt, took slaughtered ani-
mals as their subject. Looking beyond the nightmarish
terror of Bacon's theme in this picture, one is struck by
the unexpected harmonies of vivid color and realizes,
too, that few painters since Velázquez have handled pig-
ment with such technical virtuosity.

89

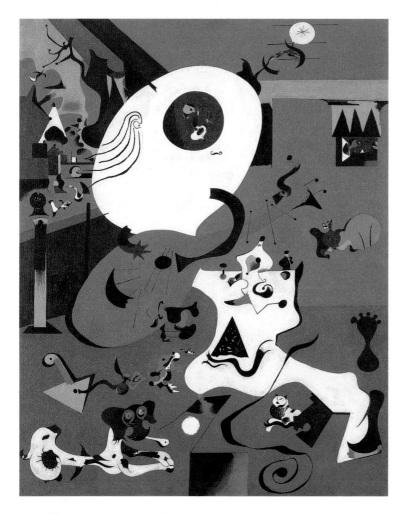

JOAN MIRÓ. Spanish, 1893–1983. In Paris 1919–40.
Dutch Interior, I. 1928. Oil on canvas, 36⅛ x 28¾ inches.
Mrs. Simon Guggenheim Fund. [163.45]

The traditional subject of an interior with figures is explored in the paintings reproduced on this and the opposite page. On a visit to the Netherlands in 1928, Miró was attracted by genre paintings of this theme as rendered by the seventeenth-century Dutch "Little Masters" and brought back a number of postcards of their works. *Dutch Interior, I* is the first of three compositions in which he freely adapted pictures of this type.

Hendrick Maertensz Sorgh's *The Lutenist* (Rijksmuseum, Amsterdam), which formed the basis for the Museum's painting, shows a swain with brimmed hat seated with crossed legs, playing his lute to a lady who leans with one elbow resting upon a table laid with a cloth, fruit bowl, wineglass, and a dish. In the foreground are a cat and a dog; at the left, a window opens out onto a view of Amsterdam. A painting hangs on the rear wall, with the narrow arches of interior windows above it.

All these details have been completely transformed in Miró's gay, brightly colored interior. In spite of the indications of space given by the wall, ceiling, and floor, and the three-dimensionality of the window embrasure, the room, together with the figures and objects it contains, is essentially flat. Ribbonlike arabesques, wholly arbitrary patches of color, and patterning in areas of black and white take the place of modeling.

Thanks to Miró's gift to the Museum in the 1970s of seven pencil studies and a charcoal-and-pencil cartoon for this painting, it is possible to follow in detail the evolution of its composition from its realistic, three-dimensional source to its conversion into this light-hearted, whimsical picture, filled with biomorphic shapes and arabesques. In his detailed analysis of the successive stages, William Rubin wrote: "Through a process of aesthetic generalization Miró at once flattens, melds, and elides Sorgh's forms into continuous patterns that he invests with a sinuous rhythm absent from the original. . . . Through such condensations and metamorphoses Miró was able throughout to improvise an autonomous suite of abstract shapes that fit together like parts of a jigsaw puzzle. Suppression of all sculptural modeling . . . locates the whole image directly in the picture plane, where the decorative colors, freed of the baggage of shading, shine forth in all their purity and saturation."

In addition to his metamorphosis of the individual components in Sorgh's painting, Miró altered the everyday atmosphere of his prototype and turned it into a fantasy by introducing a number of motifs of his own invention, such as the footprint at the right, the bat flying above, and the bird swooping down from the ceiling.

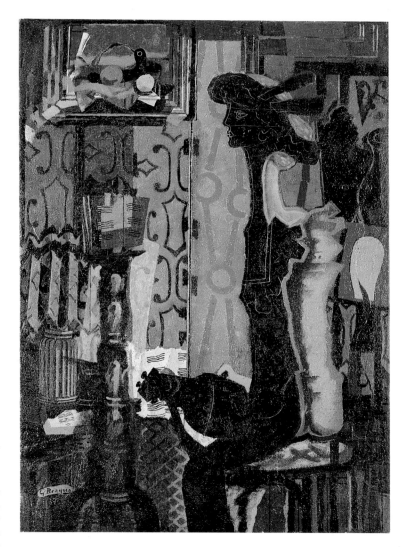

GEORGES BRAQUE. French, 1882–1963.
Woman with a Mandolin. 1937. Oil on canvas, 51¼ x
38¼ inches. Mrs. Simon Guggenheim Fund. [2.48]

Like Miró's *Dutch Interior*, Braque's painting shows a
figure seated in a room playing a stringed instrument,
with a picture hanging on the rear wall. Both works also
freely interpolate three-dimensional elements into an es-
sentially flat composition. The two paintings are entirely
different, however, in their mood, style, and total effect.
In contrast to the areas of flat color that provide a back-
ground for the figures and objects in Miró's painting,
every part of *Woman with a Mandolin* is filled with com-
plex forms and designs. The woman is shown as a black
silhouette, with its contours paralleled by white lines. A
lighter shape appears behind her like an astral presence.
The elongated form of the woman becomes assimilated
into the total decor of the room, fusing with the many
other vertical accents throughout the composition, such
as the chair back and legs, the music stand, and the bands
of wallpaper ornamented with diverse patterns. The
three-dimensionality suggested by the music stand,
fluted lamp base with pleated shade, and frame of the still
life at the left is denied in the right half of the picture, in
which the elements are flatter and harder to decipher.

According to some interpretations, the dark figure of
the woman accompanied by the lighter form behind it has
a psychological significance analogous to the two images
of the girl and her reflection in Picasso's *Girl Before a
Mirror* (page 98). It may, however, be simply a variant of
the double view often used by the Cubists to show dif-
ferent aspects of a figure simultaneously, as in Braque's
Man with a Guitar (page 36). The similarity of subject
between that painting and this one—a seated player in an
interior holding a stringed instrument—makes espe-
cially apparent the change in Braque's style from the
severity and monochromy of his Analytic Cubism to this
easily legible, essentially decorative picture, enlivened
with color and a delicately textured surface.

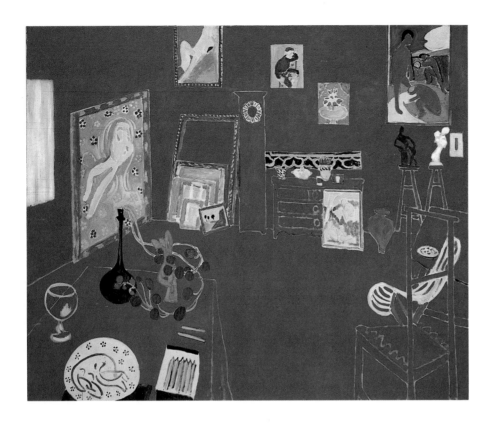

HENRI MATISSE. French, 1869–1954.
The Red Studio. 1911. Oil on canvas, 71¼ inches x 7 feet 2¼ inches. Mrs. Simon Guggenheim Fund. [8.49]

Matisse frequently introduced his own works into his paintings, as he did in *Piano Lesson* (page 83). Here, in a boldly inventive, complex composition, the private world of his creations and possessions becomes the dominant subject. He has presented in miniature scale and approximately their true colors a selection of his paintings, sculptures, and ceramics—among them, on the stand to the right of the chest of drawers, the same bronze *Decorative Figure* shown in *Piano Lesson.* Like the nudes in *Dance* (page 60), the objects are arranged in a ring, its pivotal point being the grandfather clock in the background.

Against the monochromatic ground of Pompeian red that both unifies the painting and emphasizes its surface, the articles of furniture, schematically indicated by yellow outlines, seem weightless and impalpable compared to the more "real" works of art and a few other objects—notably the artist's implements and a vase with trailing green vine on the table at the left. Though there are vestiges of conventional perspective, the uniform,

all-pervasive red tends to negate depth in the same way that outlining reduces the weight and volume of the furniture, and joins background, foreground, and sides in a single frontal plane.

In John Elderfield's words: "The room is prepared for visitors: we are invited to see a carefully arranged exhibition of the painter's art. . . . Nearly all of Matisse's different media are represented in the interior, but paintings dominate. . . . All of Matisse's different subjects are shown—still life, portraiture, landscape, and figure compositions—but the idealized figure compositions dominate." The works represented range in date from 1904, the year of *Upright Nude,* the sculpture seen on the table in the foreground, to current production. Included are *The Young Sailor, II,* 1906–07, above the chest of drawers; on the rear wall to the right, *Le Luxe, II,* 1908, and *Decorative Figure* of the same year; on the rear wall to the left of the clock, *Nude with White Scarf,* 1909, and finally two works of 1911—*Large Nude with Necklace* on the left wall, and on the other stand the (possibly unfinished) plaster of *Jeannette, III* (see page 94).

Matisse himself is absent from the scene, though implements of his craft lie on the table. This may imply that the artist lives most significantly through his works.

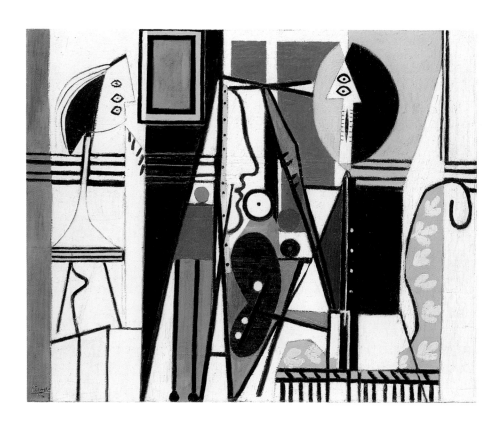

PABLO PICASSO. Spanish, 1881–1973. To France 1904.
Painter and Model. 1928. Oil on canvas, 51⅛ x
64¼ inches. The Sidney and Harriet Janis Collection.
[644.67]

Like Matisse in *The Red Studio*, Picasso here presents an
interpretation of the relation between the artist and the
works he creates which implies that the latter may have
the greater "reality." He also comments upon the process
whereby the natural world is transformed into the world
of art. As Harriet Janis pointed out: "The artist and his
model are abstracted to an advanced degree while the
concept in the canvas on the easel is in terms of realism.
By this reversal in the scheme of reality the extraordi-
nary artist and model are declared ordinary and the natu-
ral profile becomes the astonishing product of the artist's
invention."

The painter is seated at the right on a chair with curved
back, upholstered in a floral pattern and adorned with a
fringe. He holds a kidney-shaped palette in his left hand
and a brush or palette knife in his right. His head is a two-
toned oval split at the top, with the features arranged
within an arrow shape; the two eyes are superimposed on
his nose, and the mouth is a vertical slit with small hairs

on either side. A canvas with a classical profile drawn
upon it stands before him; at his right is a window with a
view of blue sky beyond. On the opposite side of the easel
is a table with a green fruit on a red cloth. The model,
shown in profile at the left, has been variously interpreted
as a standing human figure or as a sculptured portrait
bust on a stand, with the horizontal lines below the neck
representing the molding of its pedestal.

The composition is a flat design structured on a system
of horizontals and verticals and dominated by repeated
geometrical elements—rectangles, triangles, circles, par-
allel lines, and dots. The color range is limited: the hu-
man figures or their semblances (the artist, his model,
and the picture on the easel) are rendered in neutral
black, white, and gray, while color—red, yellow, blue,
green, and brown—is reserved for the inanimate objects.

William Rubin believes that the thrice-reiterated eye-
like form on the model's face may derive from a device
found in African masks, in which a repeated given form
can be variously read as eyes, nostrils, or mouth depend-
ing upon its location along a vertical axis.

Among Picasso's many portrayals of the artist and his
model, *The Studio* of 1927–28 is even more strictly geo-
metrical than this.

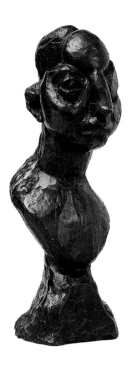

HENRI MATISSE. French, 1869–1954.
Jeannette, V. 1916. Bronze, 22⅞ x 8⅜ x 10⅝ inches.
Acquired through the Lillie P. Bliss Bequest. [10.52]

Jeannette, V is the final version in a series of five sculptured portraits that Matisse made between 1910 and 1916 of Jeanne Vaderin, a young woman living in the Parisian suburb of Clamart near Matisse's home in Issy-les-Moulineaux. He had painted her in a picture of 1910, *Girl with Tulips* (now in the Hermitage Museum), a large charcoal study for which, owned by The Museum of Modern Art, shows the prominent nose and asymmetrical eyes beneath strongly marked brows that characterize the sculptures.

Jeannette, I and Jeannette, II were done from life and are quite realistic, the second being more animated and more roughly modeled than the first. *Jeannette, III* and *Jeannette, IV* date from 1911 and 1913, respectively—the former appearing, as previously noted, in *The Red Studio* (page 92) as a plaster, probably in its unfinished state. With this pair, the motif was radically altered; the portrait head was replaced by a three-part structure of head, bust, and base, with the hair arranged in three prominent volumes. The nose became beaklike, the bulging eyes and rounded cheekbones far more prominent, and together with the grimacing mouth produced an effect almost like caricature.

A few years later, Matisse decided to rework the image again, creating in *Jeannette, V* the most original, abstract rendition of the subject. Taking the plaster of *Jeannette, III* as basis, Matisse boldly cut away the hair and the back of the head and joined pompadour, brow, and nose in a single expressive form. The left eye and side of the face were slashed and flattened to bring it into greater unity with the simplified neck and bust below. These alterations, together with the markedly different treatment of the two eyes, intensify the head's asymmetry. Louis Aragon quoted Matisse as saying that he "had discovered that the resemblance in a portrait comes from the opposition which exists between the model's face and the other faces, in a word, from its particular asymmetry. Each face has its particular rhythm and it is the rhythm that creates the resemblance."

The influence of Cubism has been cited to account for the way in which Matisse dissected the solid forms of the head and freely reorganized the separate parts into a whole. Another source of inspiration has been traced to an African sculpture, a seated Bambara wooden figure that Matisse had recently acquired. Resemblances between *Jeannette, V* and this work are to be found in the unity between beaklike nose, brow, and hair above a relatively recessive mouth and chin.

With its radical departure from realism, *Jeannette, V* is the most original and forceful of the series. In Jack Flam's words: "Stripped of the melancholy charm of the first three Jeannette heads and the energetic wit of the fourth, the *Jeannette, V* conveys an extraordinary sense of psychological nakedness."

PABLO PICASSO. Spanish, 1881–1973. To France 1904.
Head of a Woman (Marie-Thérèse Walter). 1932. Plaster,
52¼ x 25⅝ x 28 inches. Gift of Jacqueline Picasso.
[210.82]

The classic beauty of his beloved, Marie-Thérèse Walter,
which Picasso portrayed in *Girl Before a Mirror* in the
spring of 1932 (page 98), had inspired him during the
preceding winter to produce four oversize plaster heads,
far more idealized representations than the last three of
Matisse's Jeannettes. All four of Picasso's heads have a
basic ovoid form, to which hair and features have been
added; the cheeks are rounded, the nose prominent, and
the neck elongated. In an interview with the critic and
publisher E. Tériade in the year that this *Head of a
Woman (Marie-Thérèse Walter)* was produced, Picasso
said: "If you start out with a portrait and eliminate more
and more in your search for pure form—the clean, basic
volume—you can't help ending up with an egg. On the
other hand, if you start out with an egg and follow the
same path in the opposite direction, you can arrive at a
portrait. But art, I think, must avoid this oversimplified
approach which consists of going from one extreme to
the other. One always has to be able to stop in time."

William Rubin believes that Picasso's love of Marie-
Thérèse's soft, sensual body led him to choose the mal-
leable clay in which these heads were modeled—a
material pressed and squeezed by his own hand—and to
resist having them cast in bronze, despite the urging of
his secretary and confidante, Jaime Sabartés, who cited
the perishability of plaster versus the permanence of
metal. Picasso did allow one of the heads to be cast in
concrete for its first exhibition at the Spanish Pavilion at
the 1937 International Exposition in Paris, for which he
also created his great mural, *Guernica*.

Just as Matisse was influenced by his Bambara figure
in making *Jeannette, V*, so Picasso incorporated into
Head of a Woman some forms derived from a classic
wood-and-fiber Nimba shoulder mask from Guinea that
he owned (now in the Musée Picasso, Paris). As Rubin
noted: "Marie-Thérèse was for Picasso the incarnation of
sensuality and, by extension, of fertility. The full shapes,
salient nose, and large prominent breasts of classic
Nimbas would have certainly reminded Picasso of
Marie-Thérèse even if he had not been aware—as, in-
deed, he was—of the mask's cult associations to fertility.
It is not by chance that Picasso's Nimba stood like a clan
totem in the entrance of the château at Boisgeloup where
he executed the large plaster busts and heads of Marie-
Thérèse."

Head of a Woman is among eight works presented to
The Museum of Modern Art by Picasso's widow,
Jacqueline.

PABLO PICASSO. Spanish, 1881–1973. To France 1904. *Three Musicians*. 1921. Oil on canvas, 6 feet 7 inches x 7 feet 3¾ inches. Mrs. Simon Guggenheim Fund. [55.49]

Picasso began to provide decor for Diaghilev's Ballets Russes in 1917; and in 1920, the year before this picture was painted, he designed the costumes for *Pulcinella*, a ballet based on the old commedia dell'arte with a score by Stravinsky adapted from music by Pergolesi.

Within a stagelike space, *Three Musicians* sets two commedia dell'arte characters, Pierrot and Harlequin, together with a third, mysteriously veiled figure at the right, who wears a domino or a monk's garb. Beneath the table before them at the left sprawls a dog, its body as fragmented as are those of the three musicians.

In spite of the indications of a floor and walls, the picture is uncompromisingly two-dimensional. The figures are made up of flat, zigzag shapes that recall those in earlier Analytic Cubist pictures using cut-and-pasted papers, such as Gris's *Breakfast* (page 56). Here, however, the composition is of monumental scale, and, notwithstanding the implicit gaiety of its subject, the total effect is one of hieratic solemnity. This is owing, in large part, to the sobriety of the color scheme, in which black, brown, and white predominate. The brighter colors—blue, reddish-orange, and yellow—are concentrated in the center of the picture. The tiny, clawlike hands emphasize both the large size of the figures and the complete subordination of their anatomy to geometrized forms.

In the same summer of 1921, Picasso painted another version of the *Three Musicians*, similar in size and composition to this one; it is now in the Philadelphia Museum of Art.

FERNAND LÉGER. French, 1881–1955. In U.S.A. 1940–45.

Three Women. 1921. Oil on canvas, 6 feet ¼ inch x 8 feet 3 inches. Mrs. Simon Guggenheim Fund. [189.42]

Painted in the same year as Picasso's *Three Musicians*, Léger's *Three Women* is of almost the same dimensions and presents a similar subject—three personages within an interior, seen in strict frontality. (The cat may even be regarded as a counterpart of Picasso's dog!) But whereas Picasso's geometrized figures are wholly flat and weightless and are drawn with angular contours, Léger's are solid, heavy, and curvilinear. Though the women are more recognizably human than the robots in his earlier *Exit the Ballets Russes* (page 74), they reflect an even greater admiration for machinelike forms. The severely simplified, rounded heads and bodies are as highly pol-

ished as if made of metal. With their impassive faces and static poses, and the white, black, gray, and brown tones in which they are painted, the three women seem almost more inanimate than the brightly patterned decor and accessory objects that surround them.

Léger said this picture expressed the "classical" rather than "romantic" side of his art; choice of a conventional theme let him focus on pictorial means instead of subject. Simplification of forms and emphasis on volumes does, in fact, go back beyond Cubist abstraction to one of the major traditions within French art. This classic style is notably exemplified in the work of the seventeenth-century artist Poussin, who tended to repress emotionalism and sensuousness in his paintings in order to give emphasis to a strictly organized compositional structure and a disciplined harmony between human figures and their setting.

97

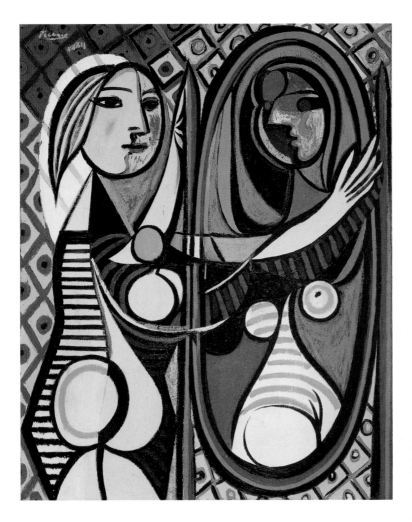

PABLO PICASSO. Spanish, 1881–1973. To France 1904.
Girl Before a Mirror. 1932. Oil on canvas, 64 x
51¼ inches. Gift of Mrs. Simon Guggenheim. [2.38]

The fascination of this picture lies not only in its rich,
stained-glass colors and decorative patterning of
lozenges, circles, and stripes, but also in its psychological
implications, which have given rise to a host of interpre-
tations. Certainly, we have here no realistic, objective
representation of a young girl engaged in the banal act of
contemplating her own reflection. The face of the "real"
girl at the left is young and rather expressionless; her
features are those of Marie-Thérèse Walter, with whom
Picasso had recently begun a liaison, and whom he fre-
quently represented at this time. Her face is shown twice:
behind the cool, smoothly painted lavender profile there

appears, like a crescent moon, a brilliant, intensely
yellow, frontal face, built up in heavy impasto. The dou-
ble head suggests a psychic conflict between the girl's
seeming innocence and her intense awareness of her own
sexuality. This is manifest in her body, which has been
described as "simultaneously clothed, nude, and
X-rayed," with an emphasis on the rounded breasts and
the bulging belly enclosing a circular womb.

By contrast, the face reflected in the mirror seems
older and, with its unfathomable stare, at once more
anxious, aggressive, and inscrutable. It suggests a myste-
rious aspect of the girl's personality—as she is, or as she
may become. The striping of her bathing costume is here
transformed into a diagrammatic rib cage.

This picture is a modern re-creation of a traditional
Vanity image, in which a woman gazing into a mirror
sees herself reflected as a death's head. One painting of
this subject almost certainly known to Picasso was a
prized possession of his friend the poet Ramón Gómez de
la Serna. It has also been noted that the looking glass is
of a type called, in French, *psyché*—the Greek word for
soul. It thus relates to a popular belief that a mirror has
magic properties and can reflect the inner self, rather
than the outward likeness, of the person who peers into it.

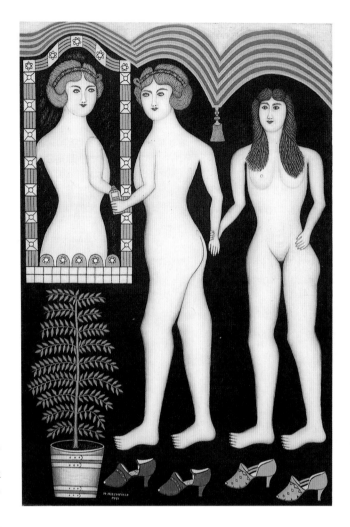

MORRIS HIRSHFIELD. American, born Russian Poland. 1872–1946. To U.S.A. 1890.
Inseparable Friends. 1941. Oil on canvas, 60⅛ x 40⅛ inches. The Sidney and Harriet Janis Collection. [609.67]

No introspective musings trouble Hirshfield's young girl before a mirror, accompanied in unabashed nudity by her friend. Hirshfield came to the United States in his youth and, after working for several years in a woman's coat factory, became a manufacturer of boudoir slippers. He took up painting as a pastime at the age of sixty-five, when a severe illness forced him to retire from business. Like many self-taught artists, Hirshfield aimed at the literal rendition of reality; but, as he observed, at the outset "my mind knew well what I wanted to portray but my hands were unable to produce what my mind demanded." What he succeeded in achieving were compositions notable for their imaginative invention, rhythmic curves, and sense of texture.

Hirshfield was inspired to paint nudes by seeing Rousseau's *Dream* (page 124). In *Inseparable Friends*, his second painting of nudes, he attempted a view of the front as well as the back, which he considered "even more beautiful." The reflection defies the laws of optics, for the mirror gives us another rear view of the girl who faces it. Her smooth bust line swelling above a narrow waist and rounded hips is less suggestive of a human body than of a tailor's dummy, recalling one of Hirshfield's former occupations. The two pairs of slippers aligned at the bottom of the picture likewise remind us of his activity as a slipper manufacturer. Both girls have two left feet, which in spite of the difference in their poses are shown in profile.

The predilection for decoration that Hirshfield shared with many primitive artists is apparent in the flowing lines of the pale bodies against the dark background, the red and blue slippers, the banded pot and symmetrical leaves of the plant, the ornamental framework of the mirror, the curves of the striped and tasseled canopy, and the carefully detailed strands of the girls' coiffures.

99

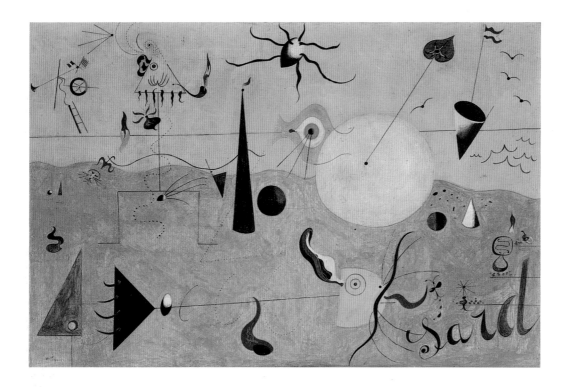

Joan Miró. Spanish, 1893–1983. In Paris 1919–40. *The Hunter (Catalan Landscape)*. 1923–24. Oil on canvas, 25½ x 39½ inches. Purchase. [95.36]

In Paris in the winter of 1922–23, Miró was in close contact with the Surrealist painters and poets, whose influence encouraged him to "go beyond Cubist form to attain poetry" and develop in his painting his bent for wit and fantasy. A return visit to his family home in Montroig led to the unique fusion in his art of the cosmopolitan culture to which he had been exposed with features of his indigenous Catalan environment.

In *The Hunter (Catalan Landscape)*, Miró freely combined biomorphic and geometric shapes with calligraphic motifs to create a composition that at first glance seems abstract. Actually, each element in the picture is a kind of visual shorthand signifying something in nature and can be identified, thanks to indications that Miró provided on a visit to the Museum in 1959 and later amplified in conversation with William Rubin.

The yellow area in the upper half of the picture represents both the Mediterranean and the sky; the rayed object in the upper center is the sun. In the left corner, an airplane on the Toulouse-Rabat route, with a rope ladder let down for landing, bears the flags of France and Catalonia. In the opposite corner an inverted cone, a fisher-

man's bark, flies a Spanish flag from its mast; nearby seagulls hover over the waves.

The stick figure on the terra-cotta shore at the left is the hunter, with cap, moustache, and beard. He smokes a pipe and holds a gun in one hand and a rabbit in the other. To the right a large eye stands for the artist's persona—an obvious symbol for the painter, whose name means "he saw." Beside it a large circular carob tree sprouts a single leaf. In the foreground, from left to right, appear a green cone representing a grapevine, and the parts of a sardine—tail, egg, spine, ear, and tongue. It is identified by the large letters SARD for "sardine." Just above is a grill and flame for cooking the hunter's lunch. The monumental size of the fish stretched across the lower part of the picture emphasizes its importance; Miró recalled that at the time he painted *The Hunter*, he was nearly starving and put into his compositions hallucinations provoked by his hunger.

This interpretation adds to our enjoyment of Miró's whimsical humor, just as we can derive amusement from knowing how he transformed the elements of a seventeenth-century genre picture into his *Dutch Interior* (page 90). But even without deciphering *The Hunter*, we can appreciate the skill with which he deployed his black and colored motifs against the terra-cotta and yellow background to create a flat, decorative design.

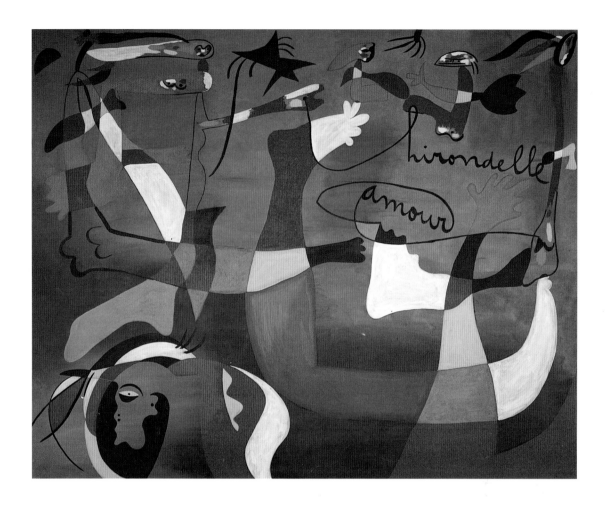

JOAN MIRÓ.
Hirondelle/Amour. 1933–34. Oil on canvas, 6 feet 6½ inches x 8 feet 1½ inches. Gift of Nelson A. Rockefeller. [723.76]

The forms in *Hirondelle/Amour* are fewer in number and larger than those in Miró's earlier paintings, *The Hunter (Catalan Landscape)* of 1923–24 and the *Dutch Interior, I* of 1928, and for the most part cannot be identified as having a specific meaning. At the top of the canvas, however, against the blue background of the sky, one can recognize a flight of soaring birds, including a swallow from whose eye a black line emerges to write its name— *hirondelle*. Just below, another flowing line inscribes the word *amour*. The light, fluent calligraphy contrasts with the heavier letters SARD that anchor the composition of

The Hunter at the lower right. A hand extending from an arm at the right and a gravity-defying foot in the center stretch upward as if aspiring to the birds' liberated flight.

This is one of four paintings by Miró that were commissioned as cartoons for tapestries by Mme Marie Cuttoli. Seeking to revive the French tapestry industry after its nearly two centuries of decline, she commissioned a number of artists, including Matisse, Braque, and Picasso, to create cartoons. But in this work, Miró made no concessions to the technical demands of the weaving process, as he filled the mural-size picture with exuberant shapes that serve as a joyous paean to love and freedom. Using only a few colors—red, yellow, green, and the neutrals black, white, and tan, set off against the bright blue sky—he created an effect of spontaneous abandon.

ALEXANDER CALDER. American, 1898–1976. Lived in France and U.S.A.
Lobster Trap and Fish Tail. 1939. Hanging mobile: painted steel wire and sheet aluminum, about 8 feet 6 inches high x 9 feet 6 inches in diameter. Commissioned by the Advisory Committee of The Museum of Modern Art. [590.39a–d]

Though movement is implicit in Boccioni's *Unique Forms of Continuity in Space* (page 41) and Brancusi's *Bird in Space* (page 51), and several artists, including Gabo and Duchamp, had experimented with mechanized constructions, it remained for Calder to progress from his earlier mechanized pieces, to which Duchamp gave the name "mobiles" (now a generic term), to works that depend for their motion on natural forces: currents of air. The principle is similar to that of sails: an air current will cause a vertical piece to move horizontally and a horizontal one to rise. Trained as a mechanical engineer at the Stevens Institute of Technology before deciding to become an artist, Calder was familiar with the mechanics of balance and counter-balance.

Lobster Trap and Fish Tail, one of his earliest hanging mobiles, was commissioned by the Museum's Advisory Committee in 1939 to hang in the stairwell of the new building. H. H. Arnason has described it: "The topmost element is a curious looking, torpedo-shaped object which could be the lobster cautiously approaching the trap, represented by a delicate wire cage balancing at one end of the crossbar. Around the other end is clustered a group of fan-shaped metal plates suggestive of a school of fish." These flat black metal pieces recall the biomorphic shapes in works by Arp and Miró. The slightest current of air sets the mobile and its separate parts into slow, gentle motion and creates a changing play of shadows on the nearby wall. The element of chance, so favored by the Surrealists, is thereby introduced into the conception.

Wire was a material for which Calder had a special affinity; he first made his reputation with portraits and animals in drawn and bent wire, including *Josephine Baker*, the *Cow*, and the *Sow,* and the many pieces composing his *Circus*, now in the Whitney Museum of American Art. In these and many of Calder's works, humor is an essential ingredient.

In 1951 Calder said of his mobiles: "the idea of detached bodies floating in space, of different sizes and densities . . . and some at rest, while others move in peculiar manners, seems to me the ideal source of form. . . . Then there is the idea of an object floating— not supported—the use of a very long thread . . . seems to best approximate this freedom from the earth." Thus Calder, seeking to express in his art the idea of liberation from the force of gravity, joins company with others such as Brancusi, Malevich (page 50), La Fresnaye (page 52), and Miró (page 101).

NANCY GRAVES. American, born 1940.
Extend-Expand. 1983. Bronze with polychromed patina,
7 feet 1 inch x 51 inches x 33⅝ inches. Gift of Anne and
Sid Bass. [647.83]

Graves's *Extend-Expand* is not a mobile, for neither it nor
any of its parts move, but, like Calder's *Lobster Trap and
Fish Tail*, it is an assemblage of colored metal parts, its
imagery derives from nature, and it thrusts outward into
space, as its name implies. In spite of being actually very
heavy, the construction appears to be delicate and
gravity-defying. "The weightless quality is enhanced by
the retention in bronze of the original surface of the
directly cast forms, many of which are fragile," Graves
has said.

It is these individual forms that constitute the origi-
nality of Graves's concept and medium. With an ob-
session for scavenging rivaling that of Schwitters, but
seeking three-dimensional ephemera rather than scraps
of paper or cardboard, she ransacks city streets (espe-
cially those near her loft in New York City's SoHo dis-
trict), markets, restaurants, beaches, or the countryside to
collect bits and pieces that, cast in bronze, become the
building blocks of her constructions. A diagram she
made of *Extend-Expand* identifies many of its elements.
The base is formed by two pieces cast in solid bronze—
beans from the Dominican Republic and a Chinese cook-
ing scissors whose triangular shape points the way up-
ward. Halfway up, also in solid bronze, is the back of a
chair. The other pieces, all cast directly in bronze, in-
clude beehive ginger; a gourd; vines, halyconia, and
twigs from flower markets; palmetto and philodendron
leaves; carob beans from a tree in SoHo; and, at the top, a
chain of sardines with a string tied around them. These
have been assembled into filaments and tendrils that
creep out in a semblance of growth, presenting from
every aspect changing appearances in shape, color, and
shadow.

Calder cut and shaped the elements of *Lobster Trap
and Fish Tail* himself, but Graves is dependent upon a
foundry for the realization of her concepts. She was for-
tunate to discover the Tallix Foundry in Peekskill, New
York, a firm whose commitment to innovation and exper-
imentation is equal to her own. Instead of presenting the
foundry with a finished model, Graves brings to it the
raw materials she has collected and relies on the exper-
tise of its artisans to cast them. She then gives the sur-
faces of the pieces a patina, paints them in matte
pigments, or coats them with enamels whose colors run
together in the firing in an unpredictable way. She brings
to this process her delicate sense of color as a painter and
blurs the boundaries between painting and sculpture.

From hundreds of finished pieces, Graves then selects
those she wishes to assemble and has them welded to-
gether for her constructions. Unlike most cast works,
which can be reproduced in multiples, each one is a
unique fabrication.

Graves is only one among many contemporary artists
who, seeking to express themselves through new mate-
rials and techniques, have relied on the skill and adapt-
ability of artisans to produce their works. Modern
printmaking, for example, especially lithography and
silkscreen, could not have developed as it has without the
versatility and willingness of experienced craftsmen to
experiment. Dick Protich, the president of Tallix, says,
"We have learned to be pretty ingenious. To be in the
foundry business is to be aware of the impact that a
change in materials can have on an artist." A work such
as *Extend-Expand* is a testimonial to the empathetic col-
laboration between an artist with vision and artisans with
virtuosity.

ARTHUR G. DOVE. American, 1880–1946.
Grandmother. 1925. Collage of shingles, needlepoint,
page from the Concordance, pressed flowers, and ferns,
20 x 21¼ inches. Gift of Philip L. Goodwin (by ex-
change). [636.39]

The stamps, bits of tickets, and other scraps in Schwit-
ters's collages (see page 57) were selected and arranged
solely for their color, form, and texture and not because
they had any intrinsic significance. Each of the elements
in Dove's *Grandmother*, however, was chosen for its spe-
cific connotations. Alfred H. Barr, Jr. has described it:
"The artist in making his composition has taken a page
from an old Bible concordance, some pressed ferns and
flowers, a piece of faded needlepoint embroidery and a
row of weathered shingles turned silvery grey with age;

these he has combined into a *visual poem*, each element,
each metaphor of which suggests some aspect of the idea
of grandmother: her age, her fragility, her silvery hair,
her patience, her piety."

The fragments are arranged in a more rigidly rec-
tilinear pattern than those in Schwitters's *Picture with
Light Center*; the textures, on the other hand, are consid-
erably more varied. It has been pointed out that Dove's
collages probably owe less to the sophisticated use of this
medium in Europe than to the American nineteenth-
century folk-art tradition of creating assemblages with
various materials having associations with their subject.
The folk artists, however, usually aimed at representa-
tion, whereas Dove's collages are abstract, with greater
emphasis on compositional unity. His later works placed
him in the forefront of American abstraction.

Joseph Cornell. American, 1903–1972.
Untitled (*Bébé Marie*). Early 1940s. Papered and painted
wood box, with painted corrugated cardboard floor, con-
taining doll in cloth dress and straw hat with cloth flow-
ers, dried flowers, and twigs, flecked with paint, 23½ x
12⅜ x 5¼ inches. Acquired through the Lillie P. Bliss
Bequest. [682.80]

Cornell was an even more compulsive collector of ob-
jects than is Graves. The thousands of items, some
bought and others found, that he gathered included old
postcards, photographs, and reproductions clipped from
books and magazines; maps and astronomical charts;
compasses; parts of clocks and watches; bits of fabric;
soap-bubble pipes; wineglasses and fragments of glass
and mirrors; stuffed birds; seashells, both real and plas-
tic; pressed flowers—the variety and quantity are mind-
boggling. All were carefully sorted and placed in labeled
boxes and cases that filled the shelves and floors of Cor-
nell's workshop in the basement of his house on Utopia
Parkway in the borough of Queens, New York.

Bringing together a selection from among these un-
likely materials, Cornell constructed shadow boxes that
recalled the toy stages he had played with as a child. It
has been suggested that he began making them to divert
his younger brother, Robert, who was partially paralyzed
and confined to a wheelchair. The boxes became, as Cor-
nell said, "poetic theatres or settings wherein are meta-
morphosed the elements of a childhood pastime." He
nevertheless resented the fact that the press dismissed his
work as lightweight, one review of an exhibition in De-
cember 1939 describing it as "a holiday toy shop for
sophisticated enjoyment, . . . intriguing as well as amus-
ing." Cornell maintained that "as long as I have been
making the objects my feeling has been a more serious
one than mere 'amusement.'"

The objects that Cornell assembled within his boxes
seem to be as incongruously associated as those in Sur-
realist paintings and constructions. Though Surrealism
undoubtedly served as the catalyst to liberate Cornell's
poetic imagination, and he was first shown at Julien
Levy's gallery in 1932 in the first survey of artists of that
movement to be seen in New York, he disliked being
grouped with them. In a letter to Alfred H. Barr, Jr., at
the time of The Museum of Modern Art's 1936 exhibition
"Fantastic Art, Dada, Surrealism," he wrote: "I do not
share in the subconscious and dream theories of the
Surrealists. While fervently admiring much of their
work, I have never been an official Surrealist."

If we compare Cornell's *Bébé Marie* with Miró's quint-
essentially Surrealist *Object* (page 69), we note that
Miró's assemblage exists within our space and appeals to
our touch as well as to our sight, whereas Cornell's wide-
eyed French doll in her elegant *fin-de-siècle* attire is
closed off from us not only by the framing glass of the
box but also by the high hedge of twigs that acts as a
further barricade. We may gaze at her but may not touch;
distanced from us, she exists in her own world, not ours.
Yet, as the poet and critic John Ashbery said of Cornell's
boxes, "We all live in his enchanted forest."

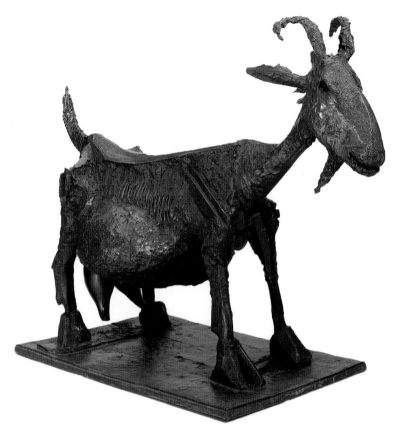

PABLO PICASSO. Spanish, 1881–1973. To France 1904. *She-Goat*. 1950. Bronze (cast 1952), after an assemblage of palm leaf, ceramic flowerpots, wicker basket, metal elements, and plaster, 46⅜ x 56⅜ x 28⅛ inches, including base. Mrs. Simon Guggenheim Fund. [611.59]

Picasso's *She-Goat* is an assemblage, though the bronze cast tends to muffle the identity of its components. These are somewhat more apparent in the model now in the Musée Picasso in Paris: the goat's spine is the stalk of a palm leaf, the rib-cage is a wicker basket, and two earthenware jugs form the udder. Bits of scrap metal used for other parts of the body were put together and filled out with plaster, which also served to model the head before the whole construction was cast in bronze. In true Surrealist fashion, the incorporated elements were found objects, but they were selected by Picasso only after he had made preparatory drawings for the work.

Birds and beasts are prominent in Picasso's repertory. He represented them in paintings and drawings, prints, sculpture, and ceramics, and in 1937 he was commissioned by the publisher Ambroise Vollard to execute an entire suite of thirty-one etchings to illustrate the Comte de Buffon's *Histoire naturelle*. Though his many portrayals of the bull come immediately to mind, the range of Picasso's fauna includes, among other sculptures cast from found objects, *Baboon and Young*, as well as cocks, sparrows, and a host of owls. Throughout his life Picasso owned a variety of pets, among them a monkey, cats and kittens, a St. Bernard dog, and, most relevant to this sculpture, a goat. A photograph taken by David Douglas Duncan about 1957 shows Picasso in his garden at the Villa Californie, Cannes, with his pet goat tethered to the only other cast of the *She-Goat*.

Though because of their concupiscence goats became symbolic of evil in medieval Christian art and even provided the horns and tail for images of the devil, Picasso portrayed them as frolicsome creatures capering with nymphs and fauna in Arcadian bliss. More profoundly, however, *She-Goat* is a symbol of life itself—in the words of Alfred H. Barr, Jr., "a monument to fecundity at its earthiest." By contrast, in another bronze cast from found objects, *Goat, Skull, and Bottle* of 1951–52, the animal's severed head in conjunction with the dwindling candle set in the neck of the bottle—an emblem of the transience of life—becomes a *memento mori*, analogous to the Vanity image, the *Girl Before a Mirror* (page 98). These assemblages, as Barr reminds us, "superficially . . . are amusing tricks or technical stunts. But on a deeper level they are magic metamorphoses, poetic similes and metaphors."

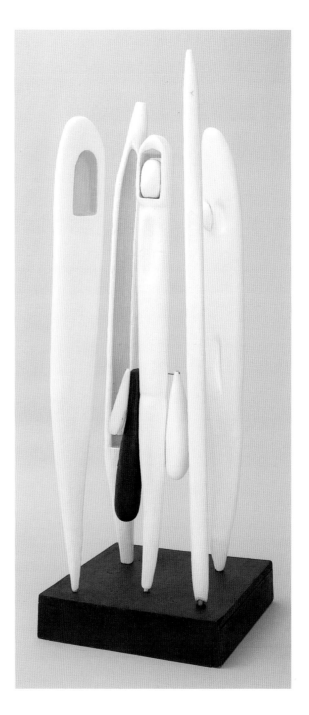

LOUISE BOURGEOIS. American, born France 1911. To U.S.A. 1938. Naturalized American citizen 1953. *Quarantania, I*. 1948–53. Painted wood on wood base, 6 feet 9¼ inches high, including base 6 x 27¼ x 27 inches. Gift of Ruth Stephan Franklin. [1076.69]

The assemblage *Quarantania, I* has been described by Robert Goldwater: "Each of its wooden elements, painted white or blue, is a separate unit anchored in a base that serves as common ground for a concentrated gathering of carved abstract shapes. Similar but not identical, their rhythms and relations give the work its formal interest. At the same time, as the attenuated, organic curves suggest, there is a symbolic reference. Here is a human group, its members alike but various, leaning toward one another in an intensity of feeling that unites them even as it leaves each one silent and alone."

Bourgeois's sensibility as an artist had developed within the Surrealist tradition, with its concern for the exploration and expression of the unconscious, before she immigrated to the United States in 1938. This tendency was enhanced in the early 1940s by her close contacts with the Surrealist artists who came to the United States as emigrés during the Second World War. Late in the decade she turned increasingly from painting and printmaking to sculpture, with single, polelike wooden figures representing people that were shown clustered together within the space of the exhibition gallery.

Quarantania, I was worked on over a period of several years, from 1948 to 1953. Its title thus relates to the French word *quarantaine*, "around forty"—Bourgeois's own age at the time. It may also allude to the other meaning, "quarantine," a state of enforced isolation. In this assemblage, the personages' psychological state of solitude seems to persist despite their physical proximity.

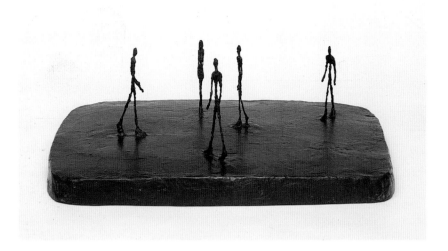

ALBERTO GIACOMETTI. Swiss, 1901–1966. To Paris
1922.
City Square. 1948. Bronze, 8½ x 25⅜ x 17¼ inches.
Purchase. [337.49]

During the late 1920s and early 1930s, Giacometti par-
ticipated with the Surrealists in their activities, publica-
tions, and exhibitions. He made objects and some abstract
sculptures, like the nightmarish bronze, *Woman with Her
Throat Cut*, as well as constructions with movable parts
and others with figures and objects set within a cagelike
enclosure, such as *The Palace at Four A.M.*, made of
wood, glass, wire, and string.

When in 1935 Giacometti resumed making sculpture
from nature, he was officially expelled from the Surreal-
ist group. After working briefly from the model, he began
to work once more from memory, but he found that "to
my terror the figures became smaller and smaller, they
had a likeness only when they were small, yet their
dimensions revolted me. . . . A large figure seemed to me

false, and a small one equally unbearable. . . . But head
and figures seemed to me to have a bit of truth only when
small."

In *City Square*, Giacometti created a potent symbol of
man's loneliness—a composition of tiny emaciated fig-
ures entirely oblivious of one another as they pass like
sleepwalkers within an open space. In contrast to the
huddled grouping in Bourgeois's *Quarantania, I*, here the
intervals between the figures are as important as their
nude, skeletal bodies. Albert Elsen has said that "they
share a space that the artist has created. . . . [It] is greater
than the figures, but it belongs to them and is not shared
by us, the spectators . . . across an interval that prohibits
touch. . . . Giacometti shows us the depersonalized body
in movement, as a remotely observed visual phenome-
non, so drastically reduced by effects of light and vision
as to border on dissolution." As in Cornell's very dif-
ferent *Bébé Marie* (page 105), there are psychological
implications in the location of the figures within their
own self-contained space, beyond the reach of our grasp.

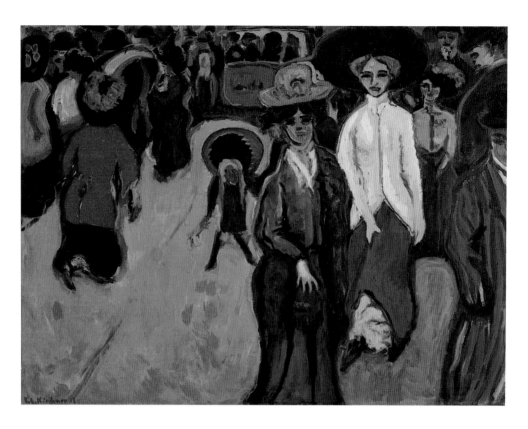

ERNST LUDWIG KIRCHNER. German, 1880–1938.
Street, Dresden. 1908 (dated on painting 1907). Oil on
canvas, 59¼ inches x 6 feet 6⅞ inches. Purchase.
[12.51]

The loneliness of the individual even when among others
is the theme of Kirchner's *Street, Dresden*, as it is of
Bourgeois's *Quarantania, I* and Giacometti's *City
Square*. "My work stems from the nostalgia of solitude,"
Kirchner wrote in 1919. "I was always alone, for the
more I mixed with people the more I felt my loneliness."
Though, in contrast to Giacometti's empty plaza, the
avenue in this painting, Dresden's fashionable König-
Johannstrasse, is thronged with people, the figures seem
equally oblivious of one another, in spite of their physical
proximity. Their faces are masks assumed to hide their
private selves from the public gaze. This effect of mas-
querade is accentuated by their unnatural coloring,
which is keyed to the strident tonality of the whole
composition.

Kirchner, who said his aim was to give pictorial form
to contemporary life, was the dominant personality
among several young artists in Dresden who banded to-
gether in 1905 to form the first group of German Expres-
sionists. They called themselves *Die Brücke* ("The

Bridge"), because they wished to establish a bridge be-
tween traditional art and modern modes that were still
being formulated. The establishment of *Die Brücke* coin-
cides with that of the looser association of the Fauves in
France; both groups, reacting against Impressionism, ex-
ploited bold distortion and unnatural color.

In common with many avant-garde artists in the early
years of the twentieth century who did not wish to aban-
don representation but instead adapt it in accordance
with new pictorial concepts, Kirchner faced the problem
of maintaining an illusion of depth in his canvas while at
the same time asserting its essential flatness. In *Street,
Dresden*, he has skillfully coordinated spatial recession
with surface design—a design greatly enlivened by the
women's flamboyant headgear and the enormous cart-
wheel of the hat worn by the child in the middle of the
roadway. In the foreground, in the right half of the com-
position, life-size figures advance toward us in strict
frontality. Their curving shapes stand out clearly in con-
trast to the pink road that leads the eye up and back. At
the top of the picture, toward which the women at the left
advance, the tram in the center and a crowd of densely
massed pedestrians completely shut off any opening to-
ward a more distant space, producing a claustrophobic
sense of constriction and tension.

JEAN DUBUFFET. French, 1901–1985.
Business Prospers. 1961. Oil on canvas, 65 inches x 7 feet 2⅝ inches. Mrs. Simon Guggenheim Fund. [115.62]

In *Business Prospers*, as in Kirchner's *Street, Dresden* (page 109), city-dwellers are shown crowded together yet psychologically apart. To signify their isolation from their fellows, Dubuffet has enclosed them in cells, within which they carry on their separate activities. Unlike Kirchner, Dubuffet makes no attempt to portray realistic figures in three-dimensional space. Instead, he has filled his entire canvas with a jumbled panorama of buildings, personages, and vehicles—some upright, some sideways, some upside down. They and the graffitilike inscriptions are all drawn in a deliberately childlike fashion, in keeping with Dubuffet's admiration for the creative expression of children, self-taught artists, and the insane. There is nothing naïve, however, in his attitude toward the city and its inhabitants, as is evident from the painting's satirical title and the legends parodying signs of shop fronts and public buildings. They testify to his opinion that Paris is peopled by rascals and scoundrels of every description, characterized by greed and hypocrisy. At the upper center, for example, the fascia of the "Grotesque

Bank" appears above the words "At the Funereal Smile"; the establishments next door are identified as "At the Sign of the Thief" and "The Short-Weight Shop." Below the blue oblong of the Chancellery at the center right is the "Ministry of Greasy Paws."

This picture is one of a series called Paris Circus, which preoccupied Dubuffet in 1961–62. During the previous seven years, he had been living in Vence in the south of France, devoting himself almost exclusively to themes drawn from nature and the countryside. Returning to Paris for his first extended sojourn since 1955, he took up again with enthusiasm the subject of the city, which had engaged him some twenty years before.

Beyond Dubuffet's caustic humor is another intent: to impart a magical sense of wonder to everyday persons, objects, and occurrences. "Every work of art should in the highest degree lift one out of context, provoking a surprise and a shock," he declared. Of his Paris Circus, he wrote: "What I wish is to give a phantasmagoric character to the locale evoked by the painting, and this can be done only by mingling elements that are more or less true to life with interposed features that are arbitrary and unreal. I want my street to be mad, and to have my sidewalks, shops, and buildings participate in a crazy dance."

JOHN MARIN. American, 1870–1953. In Paris 1905–10. *Lower Manhattan (Composing Derived from Top of Woolworth).* 1922. Watercolor and charcoal with paper cutout attached with thread on paper, 21⅝ x 26⅞ inches. Acquired through the Lillie P. Bliss Bequest. [143.45]

Unlike Giacometti, Kirchner, and Dubuffet, Marin found the city exhilarating, though it was its buildings rather than its people that stirred him. Like Calder, he had studied engineering at the Stevens Institute of Technology, then worked briefly as a free-lance architect before going abroad for a five-year sojourn.

Returning to New York in 1910, Marin was captivated by the "beautiful, fantastic" spectacle of the city's soaring buildings and the dynamic tempo of its traffic. In the catalogue of his exhibition in 1913, he defended the "non-photographic" character of the fourteen watercolors of New York it included, saying that: "The whole city is alive; the buildings, people, all are alive; and the more they move me the more I feel them to be alive. It is this 'moving of me' that I try to express. . . . I see great forces at work; great movements; the large buildings and the small buildings; the warring of the great and the small; influences of one mass on another greater or

smaller mass. . . . While these powers are at work pushing, pulling, sideways, downwards, upwards, I can hear the sound of their strife and there is great music being played."

The watercolor *Lower Manhattan* was painted almost a decade later, after Marin had developed a style even further removed from exact representation. His vantage point was the top of the Woolworth Building, then the world's tallest skyscraper. "From this dizzy height," Alfred H. Barr, Jr. wrote, "the eye plunges into the zigzag perspectives of buildings and car-dotted streets, grinding out to sea like a dynamited ice floe." Lines radiate outward from the rounded shape at the bottom with a yellow sunburst stitched to its center, inspired by the gilded dome of the now-demolished Pulitzer Building. Above is the blue and white background of water and sky.

The painting is charged with an explosive energy, expressed through plunging diagonals, bold outlines, and brilliant color. The fragmented planes and the irregular frame-within-a-frame surrounding the buildings are devices borrowed from Cubism, while the compositional scheme, with paths of energy radiating outward from a circular nucleus, also owes something to Futurist works by such artists as Boccioni.

JOSEPH PICKETT. American, 1848–1918.
Manchester Valley. 1914–18? Oil with sand on canvas,
45½ x 60⅝ inches. Gift of Abby Aldrich Rockefeller.
[541.39]

An industrial town rather than a metropolis is the subject
of Pickett's *Manchester Valley*; the two buildings in the
foreground are flax mills where mill hands from Man-
chester, England, worked. The canal, running between
Lumberville and New Hope, Pennsylvania, was a very
active artery of communication until it was supplanted
by the railroad. The train in the picture, here given the
gay colors of a child's toy, belonged to the Philadelphia
and Reading Line, which first came through the town
about 1890.

The strong sense for decorative patterning that distin-
guishes many of the best works by self-taught artists,

such as Hirshfield, is especially evident in Pickett's pic-
ture. In order to show every detail clearly, he made no
attempt at scientific perspective but tilted the scene up-
ward and arranged his objects in tiers one above the
other, as in ancient Egyptian reliefs or Oriental land-
scapes. The trees in the distance are as large as those in
the foreground, and the sides of the buildings are shown
as completely as their façades. The delicate foliage of the
trees does not mask the lacy network of their branches;
the rhythmic verticals and horizontals of fence posts and
rails are matched by the lines of the railroad tracks and
ties; the white of the flowing current is repeated in the
puff of steam issuing from the engine, the cascade plung-
ing down in the distance at the left, and the clouds
streaming across the sky. Each brick or square of mason-
ry is distinct, and the repeated rectangles of the win-
dowpanes are as bright as if they were illuminated from
within, though this is a daytime scene.

The large building that dominates this view of the
town is the schoolhouse, topped by the oversize flag that
shows off the stars and stripes to full advantage. The
painting hung in the school for many years, as a gift from
Pickett's widow, who bought it for a dollar when his
effects were put up for auction after his death.

Pickett was a canal-boat builder, a carpenter, and in his
later years a storekeeper in New Hope, who took up
painting toward the end of his life. A meticulous crafts-
man, he made his own brushes and invented his own
technique. In *Manchester Valley*, he mixed ordinary
house paints with sand, building up his forms in low
relief and giving each surface a special texture.

CHARLES SHEELER. American, 1883–1965.
American Landscape. 1930. Oil on canvas, 24 x
31 inches. Gift of Abby Aldrich Rockefeller. [166.34]

The elements of this landscape are essentially the same
as those in Pickett's *Manchester Valley*: a channel of
water in the foreground flanked by a railroad track and
train, with buildings beyond. At first sight, by compari-
son with Pickett's painting, the view seems to have been
rendered with photographic accuracy. Sheeler was, in
fact, a master of the camera, besides being a painter, and
American Landscape was based on one of a series of
photographs of the Ford Plant in River Rouge, Michigan,
that he had been commissioned to make in 1927. When
we look more closely, however, we realize that no camera
could have captured the scene with such allover exacti-
tude, without the slightest atmospheric blurring of the
sharp outlines and clean surfaces. Every accidental detail
has been eliminated; no factory and railroad siding could
possibly be so free from any traces of grime.

Early in his career, Sheeler had been influenced by
Cubism. In the 1920s, attracted by the beauty inherent in

machines, he was one of a group of artists who attempted
a compromise between the principles of abstract art and
the realistic representation of the American industrial
scene. Because of the smooth, precise technique adopted
by these artists, who used flat, even areas of color to
emphasize the geometrical simplicity of the forms in
their paintings, they were known as the Immaculates or
Precisionists.

American Landscape, like all of Sheeler's pictures, has
a firm compositional structure. A strong pattern of verti-
cals is established by the curved walls of the building at
the left, the high smokestack, the chute at the right, and
their reflections in the calm water. As counterpoint to
these vertical accents is a sequence of repeated parallel
lines of varying lengths that run diagonally across the
face of the canvas at slightly different angles. There is a
skillful, rhythmic alternation of lights and darks. The
longer we look at this landscape, the more we perceive
that its seeming realism has been achieved through care-
fully calculated artifice—"the painting being," in
Sheeler's words, "the result of a composite image and the
photograph being the result of a single image."

EDWARD HOPPER. American, 1882–1967.
Night Windows. 1928. Oil on canvas, 29 x 34 inches. Gift of John Hay Whitney. [248.40]

At the New York School of Art, where Hopper was enrolled from 1900 to 1905, his teacher Robert Henri told his students: "Low art is just telling things; as, There is the night. High art gives the feel of the night. The latter is nearer reality although the former is a copy." *Night Windows* is one among many of Hopper's paintings that show how thoroughly he had absorbed this precept.

Returning to the United States in 1907 from his first trip to Paris, Hopper found it "a chaos of ugliness"; nevertheless, it was the contemporary American city that he was to make his particular theme. He did not perceive New York astir with human activity, like Henri, admire the dynamism of its traffic and skyscrapers, like Marin, or distill its structures into abstract patterns, like the Precisionists. Instead, he was interested in the forms and materials of the city's streets and buildings—stone, brick, asphalt, steel, and glass—and the effect of light falling upon them. Light was the most powerful and personal of Hopper's expressive means. He used it as an active element in his paintings to model forms, define the time of day, establish a mood, and create pictorial drama by contrasting it with areas of shadow and darkness.

An instructive comparison was drawn by Alfred H. Barr, Jr. between Hopper's *Night Windows* and an etching of 1910 with the same title by John Sloan, a member with Henri of the so-called Ashcan School. In the engraving, "One looks from a fire escape into the disorderly windows of a tenement in which figures are busy opening sashes, shouting, undressing, hanging clothes to dry; the print teems with casual humanity. In Hopper's oil of the same subject, there are three windows, three brilliant rectangles, framed by the black walls as symmetrically as a triptych. In spite of one half-seen figure there grows as one studies this curious picture an impression of silent immobility. The drifting curtain . . . [is] evocative to a degree beyond [its] visual importance." As James Thrall Soby has noted, "In numerous paintings . . . Hopper has used the flutter of curtains as a sign of heartbeat in the coma-like silence of his images."

In the 1920s and 1930s Hopper was an enthusiastic theater-goer. The continuous curve of the outer sill in the foreground of *Night Windows* is like the edge of a stage beyond which the scene within the room unfolds. Many of Hopper's paintings use the compositional device of an interior with a nude or half-dressed woman glimpsed through a window by an unseen viewer who looks in from outside. The impression conveyed, however, is not one of prurient voyeurism but rather of loneliness and isolation. Engaged in a private act, the woman is unaware of the spectator; despite their proximity, each leads a life entirely separate from the other.

Hopper once declared, "My aim in painting has always been the most exact transcription possible of my most intimate impressions of nature." The operative words here are "my most intimate impressions"; to quote Lloyd Goodrich, "In exactly conveying the mood of these particular places and hours, Hopper's art transcended realism and became highly personal poetry." Though the figures in his pictures engage in mundane activities, and the settings are commonplace, he paints them in a way that invests them with an underlying sense of mystery.

Maine

ANDREW WYETH. American, born 1917.
Christina's World. 1948. Tempera on gessoed panel,
32¼ x 47¾ inches. Purchase. [16.49]

This is the best known of several paintings by Wyeth of
Christina Olson, who with her brother, a former fisher-
man turned truck gardener, was a neighbor of the artist's
in Maine. Christina, severely crippled by polio, possessed
a keen mind and a love of nature. Wyeth said: "The
challenge to me was to do justice to her extraordinary
conquest of a life which most people would consider
hopeless. Christina's world is outwardly limited—but in
this painting I have tried to convey how unlimited it
really is."

The direct inspiration for the picture was a glimpse of
Christina that Wyeth caught one day when she was out
picking berries and stopped to gaze back across the field
toward her house. As in all his best paintings, there are
few elements in the composition, and what seems to be a
very simple subject, realistically depicted, has evocative
implications. Taking as his point of departure a momen-
tary impression, Wyeth has recorded it by a slow and
painstaking procedure, in an effort to capture the minu-
tiae of texture and the effects of light and shade. The
tempera medium that he used is exacting, well suited to
his precise draftsmanship and methodical manner of con-
structing his paintings through the accumulation of small,
delicate strokes, in contrast to Hopper's oil pigments
applied with smooth brushwork to model his forms.

The separate blades of grass and the strands of Chris-
tina's hair are rendered more distinctly than the eye
would register them, and the cast shadows, such as those
of her right arm and the ladder leaning against the wall of
the house, are seen in sharp focus. This type of painting
has been called "magic realism" because it invests ordi-
nary objects with poetic mystery; the term had been used
earlier to describe some works of the New Objectivity
tendency in Germany, such as Dix's *Dr. Mayer-Hermann*
(page 84). Though seemingly having little in common
with de Chirico's "metaphysical" paintings, *Christina's
World*, like *The Great Metaphysician* (page 66), exploits
the romantic suggestions implicit in deep perspective and
the use of a high horizon line against which buildings are
silhouetted.

115

GEORGES ROUAULT. French, 1871–1958.
The Three Judges. 1913. Gouache and oil on cardboard,
29⅞ x 41⅝ inches. Sam A. Lewisohn Bequest. [17.52]

Though sin and its potential consequence, death, are an underlying theme of Picasso's *Demoiselles d'Avignon* (page 35), his painting has none of the ferocious intensity of moral judgment that permeates Rouault's *Three Judges*. In the preceding century, Daumier had satirized the debasement of the French legal system under the regime of Louis Philippe, and in fact Daumier was an early influence upon Rouault, whose maternal grandfather, Alexandre Champdavoine, collected Daumier's lithographs and encouraged his grandson to become an artist.

Rouault was deeply devout, having been converted to Catholicism through his friendship with Léon Bloy, whose novels dealt with the theme of sin and redemption. He was also no doubt aware of the precepts of another pious Catholic writer, Ernest Hello, who declared: "Art must be one of the forces that will cure the imagination; it must say that evil is ugly." In 1903 and 1904, Rouault began to paint powerful studies of prostitutes as exemplars of society's degradation. Though he participated with the Fauves in the Salon d'Automne of 1905, in temperament and technique he had little in common with other members of the group. The sober, moralistic mood of his subjects was at variance with their generally blithe hedonism, and though his color was strong, it depended more on an overlay of glazes and an inner luminosity than on the clear brilliance of the Fauves' spontaneous brushwork. Rouault's sense of color, like his use of heavy outlines, derived in part from his apprenticeship as a youth to a repairer of stained glass, and also from his training as the favorite pupil of Gustave Moreau at the École des Beaux-Arts. In *The Three Judges*, the limited range of dark colors, highlighted with white, is laid on with a relatively dry brush in successive layers of pigment that allow the underpainting to show through and result in an encrusted surface.

Rouault's hatred of evil and indignation at his subjects' venality and stupidity led him to "hewing out the brutal planes of his three jurists' faces as if his brush were an avenging axe," in the words of Alfred H. Barr, Jr. The features of the two figures at the right and left of the canvas seem like caricatures of avarice and complacency, while the heavy-set judge in the center stares out as if to involve the spectator in his own corruption.

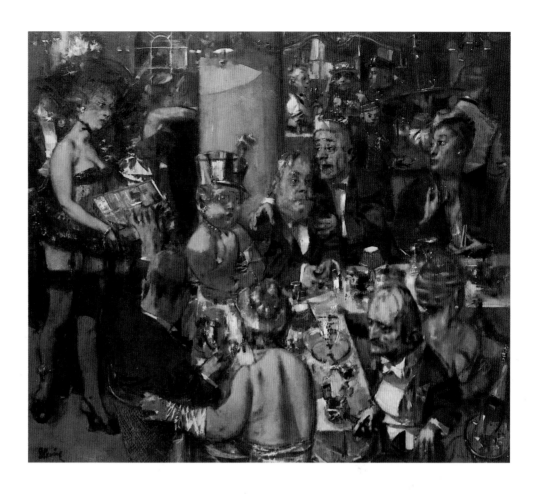

JACK LEVINE. American, born 1915.
Election Night. 1954. Oil on canvas, 63⅛ inches x
6 feet ½ inch. Gift of Joseph H. Hirshhorn. [153.55]

Corrupt politicians rather than jurists are the targets in
Levine's *Election Night*, but he treats his subject with a
humor and resigned cynicism quite unlike Rouault's
moral indignation in *The Three Judges* or the savage
indictment of tyranny in Bacon's *Painting* (page 89).
Levine here focuses on no particular election, party, or
individual but lampoons a common phenomenon of pub-
lic life in America. He is an astute reporter, and his types
are sharply observed.

The complacent figure in the center can be identified as
the successful candidate. He is surrounded by those who,
having helped to bring him to power, now obviously
expect to profit by sharing in the spoils of victory. The
lantern-jawed man embracing him while ogling the ciga-
rette girl appears to be a professional politico, while the

sharp-nosed, distinguished-looking gentleman in the
right foreground, apparently as heedless of his surround-
ings as of the disarray of his attire, seems to typify a
capitalist banker. All the personages seated around the
table seem equally alienated from one another, either
sunk in self-absorption or, bored with their companions,
letting their attention stray beyond their own circle.

Levine draws a distinction between expressionistic
representation, which he considers too subjective a re-
flection of the artist's own reaction, and what he terms
"distortion for empathy," which leads him to adopt a
canon for his figures that gives them disproportionately
large heads. He explains: "You give something a larger
area because it is more important. . . . You distort for
editorial reasons—a dignified way of saying carica-
ture. . . . Distortion is always a dramatic vehicle." An-
other hallmark of Levine's style is a clear focus that is
partially blurred by glazes of semitransparent oil paint,
applied in a technique like that of Titian and Rubens.

DIEGO RIVERA. Mexican, 1886–1957. Worked in Europe 1907–21. In U.S.A. 1930–33, 1940.
Agrarian Leader Zapata. 1931. Fresco, 7 feet 9¾ inches x 6 feet 2 inches. Abby Aldrich Rockefeller Fund. [1631.40]

The art of fresco—painting a mural on moist plaster with pigments that are incorporated into the plaster as it dries—was common in Italy during the late Middle Ages and early Renaissance for the decoration of churches and civic buildings. It was revived in Mexico in modern times, when a group of artists saw its value for social propaganda to educate the people in the aims and achievements of the recently concluded revolution. During the 1920s and 1930s, they adorned public buildings throughout Mexico with frescoes that emphasized the glorious pre-Columbian civilization, the Spanish Conquest, the oppression of the Indians, the domination of the populace by the clergy during the colonial period, the subsequent exploitation of Mexico by foreign capitalists (especially those from the United States), and the heroic struggle that began in 1910 and ended with the firm establishment of the revolutionary régime in 1920.

Rivera was one of the principal artists engaged in these vast government-sponsored mural projects. *Agrarian Leader Zapata* is the replica of a portion of one of the panels he painted in 1930 in the Palace of Cortés, Cuernavaca, in which, accepting anachronism for the sake of symbolism, he portrayed Zapata holding Cortés's stallion. Emiliano Zapata was among the earliest agitators for social and agrarian reforms, but during the internecine strife of the revolution, he opposed one of the other leaders, Carranza, who became head of the government in 1915. After seeking for several years to gain control by guerrilla warfare, Zapata was killed by Carranza's forces in 1919.

There is little reflection of such a bloody and agitated history in this static composition, one of seven frescoes commissioned in 1931 for an exhibition of Rivera's work at The Museum of Modern Art. The knife Zapata carries is of a type used for cutting sugar cane, and he and the figures behind him wear the regional costumes of Morelos, the state in which Cuernavaca is located. The horse, however, has another, more distant derivation. It is based on paintings by the fifteenth-century Florentine Paolo Uccello, whose works Rivera had studied during a long sojourn in Europe from 1907 to 1921. In the latter year, he returned to Mexico and became active in the ranks of the revolutionary artists.

José Clemente Orozco. Mexican, 1883–1949. In U.S.A. 1917–18, 1927–34, 1940, 1945–46.
Zapatistas. 1931. Oil on canvas, 45 x 55 inches. Given anonymously. [470.37]

In this painting of the followers of the assassinated agrarian leader Zapata, there is no individual hero. A line of peons, followed by their womenfolk, press onward. The large figures of the mounted horsemen guarding them loom above them, and in the background mountains rise beneath a dark, cloud-filled sky. The composition is based on rhythmic repetitions: the forward inclination of the figures in the foreground, the alternation of the almost identical frontal postures of the first and third horsemen with those of the second and fourth seen in profile. Except for the men's white shirts and pants and their yellow hats, the color is somber, with dark red predominating. This is in keeping with Orozco's tragic view of life. He saw the Mexican Revolution largely in terms of human suffering, including that caused by strife among the rival factions.

Together with Rivera and Siqueiros, Orozco was one of the great triumvirate of Mexican artists who revived the art of fresco. Though *Zapatistas* is an easel painting in oil, it is closely related in style and theme to frescoes by Orozco in Mexico, especially those for the National Preparatory School in the capital. This picture, however, was painted in New York during Orozco's second sojourn in the United States. Among the frescoes he executed in this country are those at Pomona College in Claremont, California, the New School for Social Research in New York City, and Dartmouth College in Hanover, New Hampshire, as well as the *Dive Bomber and Tank*, a portable mural with six interchangeable panels commissioned by The Museum of Modern Art for its exhibition "Twenty Centuries of Mexican Art" in 1940.

119

BEN SHAHN. American, born Lithuania. 1898–1969. To
U.S.A. 1906. Naturalized American citizen 1918.
Willis Avenue Bridge. 1940. Tempera on paper over com-
position board, 23 x 31⅜ inches. Gift of Lincoln Kir-
stein. [227.47]

The presence of the Mexican muralists in the United
States during the 1920s and 1930s had an important
influence on artistic developments in this country. Their
work set a precedent in technique, style, and content for
many American artists who, in rebellion against the dom-
ination of foreign—especially French—art, were seek-
ing to develop a native school of painting based on
regional themes, and whose attention was focused on
social problems as a major subject for art by the Great
Depression that began in 1929. In 1933 the government,
embarking for the first time in our history on wide-scale
art patronage, initiated programs to give work to unem-
ployed artists. Some created murals for public buildings,
others produced easel paintings, and photographers were
recruited to record the devastating effects that the De-
pression and prolonged years of drought had upon the
farm population.

Ben Shahn was among those engaged in a photo-
graphic project for the Farm Security Administration.

Previously, he had been hired by Diego Rivera to work as
an assistant on frescoes for Rockefeller Center. *Willis
Avenue Bridge*, however, was painted in 1940 as an inde-
pendent work, though a few years later Shahn repeated
the subject in murals for the Social Security Building in
Washington. Using his own photographs as a basis, he
freely synthesized elements from two of them for this
picture. He declared: "Photographs give those details of
form you think you'll remember but don't—details that I
like to put in my paintings."

The symmetrical composition is dominated by the
bright red struts of the bridge against the dark blue,
cloudy sky. Their diagonals are crossed by the horizontal
slats of the bench on which two elderly women sit side by
side, rapt in separate concerns and gazing in opposite
directions. Though this painting is of a type often classed
as "social realism," Shahn has made no overt comment
here but has contented himself with the role of objective
reporter; nor can *Willis Avenue Bridge* accurately be
called realistic. All unnecessary details are eliminated
from the composition, and Shahn has indulged in such
distortions as truncating the legs of the bench and dis-
placing them with relation to the elements of the bridge,
and elongating the crutches to give them greater impor-
tance in both the design and the content of his picture.

Jacob Lawrence. American, born 1917.
The Migration of the Negro: No. 48, "Housing for the Negroes was a very difficult problem"; No. 58, "In the North the Negro had better educational facilities." 1940–41. Tempera on gesso on composition board, 18 x 12 inches and 12 x 18 inches. Gift of Mrs. David M. Levy. [28.42.24 and .29]

These are two of sixty paintings constituting *The Migration of the Negro* (the thirty with odd numbers being owned by the Phillips Collection in Washington, D.C., and the thirty with even numbers by The Museum of Modern Art). The pictures and their accompanying captions tell how, beginning about 1916, thousands of Blacks left the poverty, discrimination, and brutality they found in the South to seek work opportunities in the more industrialized North. Lawrence has pointed out, "My parents were a part of this migration—on their way North when I was born in Atlantic City in 1917." The family moved to Harlem when he was a youngster, and these paintings reflect his experiences, which he supplemented by extensive research on the migration.

Lawrence began painting as a child, and the tempera medium he uses is a natural outgrowth of the poster paints given him then. His pure colors and the flat, simplified compositions of his pictures also suggest posters. After attending a number of art schools, he, like Shahn, was employed by one of the government's programs, working from 1938 to 1939 in the Easel Division of the WPA Federal Art Project. Thereafter, a fellowship enabled him to continue research and develop *The Migration of the Negro.*

Among the artists whom he has admired, Lawrence has placed Orozco in the first rank, followed by Daumier and Goya, because "they're forceful. Simple. Human." These adjectives well apply to Lawrence's own work. He relies on clear, forthright statements rather than on rhetoric, and on the cumulative effect of individual episodes within the narrative. As regards his style, he has said: "In your work, the human subject is the most important thing. My work is abstract in the sense of having been designed and composed, but it is not abstract in the sense of having no human content. An abstract style is simply your way of speaking. As far as you yourself are concerned, you want to communicate. I want the idea to strike right away."

121

GIACOMO BALLA. Italian, 1871–1958.
Street Light. 1909. Oil on canvas, 68¾ x 45¼ inches.
Hillman Periodicals Fund. [7.54]

In *The Photographer's Eye*, John Szarkowski points out that by taking a fragment of the real world and isolating it from its context, the photographer could "claim for it some special significance, a meaning which went beyond simple description. The compelling clarity with which a photograph recorded the trivial suggested that the subject had never before been properly seen, that it was in fact perhaps *not* trivial, but filled with undiscovered meaning. . . . Photographs . . . could be read as symbols." In all likelihood, it was this perception by photographers that led modern painters to adopt the device of making a single object or detail the subject of a picture, as in *Street Light*. We know, in fact, that Balla was interested in photography—though obviously from a technical standpoint this picture could hardly be further removed from camera work.

Electric street lights had only recently been installed in Rome and were generally regarded as unartistic when, in 1909, Balla was struck by seeing one in the Piazza Termini with "the moon in such a position that it gave the impression of being less luminous than the lamp." The motif appealed to him for two reasons. For several years, he had painted works in which light was the principal theme. Secondly, he was one of a number of dissident painters and poets who sought to free Italy from enslavement to the past by glorifying the dynamism of modern life and the new beauty of machines. Balla has said that *Street Light* was "above all a demonstration that romantic moonlight had been surpassed by the light of the modern electric street lamp. This was the end of Romanticism in art. From my picture came the phrase 'Let's Kill the Moonlight!' " This was the title of a proclamation published later in the same year by the poet Filippo Tommaso Marinetti, who shortly before had issued the first Manifesto of Futurism—a movement that Balla, with Boccioni and other avant-garde artists, soon joined.

Street Light is painted in a technique derived from Seurat, but instead of dots of pigments, Balla has used brilliant chevrons. The rays of light are shown refracted into their component pure colors—of maximum intensity, rather than rainbow delicacy, carrying out his concept that the artificial illumination produced by a modern mechanism is far more powerful than the effects of nature. There is additional symbolism in the star shape placed at the core of the lamp. Dark, sketchily painted masses of foliage enframe Balla's striking image in curves reminiscent of Art Nouveau, the style that from the turn of the century until the rise of Futurism had epitomized "modernism" in Italy.

GEORGIA O'KEEFFE. American, 1887–1986.
Lake George Window. 1929. Oil on canvas, 40 x
30 inches. Acquired through the Richard D. Brixey Be-
quest. [144.45]

Like Balla, O'Keeffe has taken a single motif from per-
ceived reality and, by isolating it from its surroundings,
intensified its visual and emotional impact. At first sight,
her *Lake George Window* seems far closer to photography
than his *Street Light*; and it is tempting to push the
analogy to camera work, in view of the fact that
O'Keeffe's art was first exhibited in 1916 at the famous
avant-garde "291" gallery directed by the master pho-
tographer Alfred Stieglitz, whom she subsequently mar-
ried. On closer inspection, however, what seems

paramount in this painting is the rigid selectivity of
O'Keeffe's approach, which is highly stylized, deleting
any details that might mar the immaculate precision of
the forms and the surface of the canvas. By contrast, a
photograph of the same Lake George farmhouse by
Stieglitz is more complex in composition and is taken at
an angle, with a raking light to accentuate the textures of
the clapboards.

O'Keeffe presents the structure in a strictly frontal,
symmetrical view and drastically reduces its three-
dimensionality. Commenting on this painting, Lloyd
Goodrich has said: "Though entirely realistic, its severe
simplification, stark rectangular forms and austere color
harmony, and the fine relations of all elements, give it the
quality of a handsome abstract design."

123

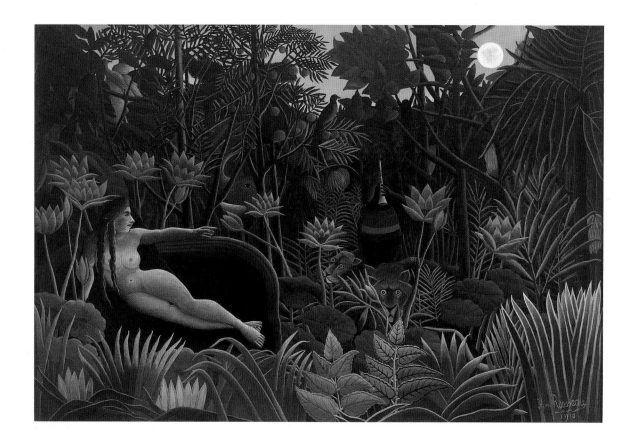

HENRI ROUSSEAU. French, 1844–1910.
The Dream. 1910. Oil on canvas, 6 feet 8½ inches x 9 feet
9½ inches. Gift of Nelson A. Rockefeller. [252.54]

In contrast to the open spaces and few compositional
elements in Rousseau's earlier painting *The Sleeping
Gypsy* (page 13), the entire surface of *The Dream*, like
some densely woven medieval tapestry, is filled with an
allover pattern of branches, leaves, fruit, gigantic flowers,
birds, a serpent, and animals. Once again we have a night
scene illuminated by a full moon. At the left, in the midst
of the jungle, a nude woman reclining on a sofa listens
attentively to the music of a snake charmer. This incon-
gruous apparition is explained by verses, possibly by
Apollinaire, that Rousseau attached to the painting when
he sent it to the Salon des Indépendants in 1910:

> *Yadwigha in a lovely dream,*
> *Having most sweetly gone to sleep*
> *Heard the snake-charmer blow his flute,*
> *Breathing his meditation deep.*

> *While on the streams and verdant trees*
> *Gleam the reflections of the moon,*
> *And savage serpents lend their ears*
> *To the gay measures of the tune.*

Yadwigha was the name of a Polish woman with whom
Rousseau had been in love many years before. Although
in his verses and in a letter he wrote to a critic at the time
Rousseau explained that the picture represented the
dream of the woman on the couch, on another occasion
he declared that the couch was present only because he
felt the painting needed just that touch of glowing red.

Rousseau never traveled outside France or saw an ac-
tual jungle; his flora and fauna were based on illustra-
tions in books and magazines and observations made on
visits to botanical gardens and the zoo. Setting down each
detail with painstaking fidelity and subtle nuances of
color, and combining the imagined jungle with the "real"
figure on the couch, Rousseau created in *The Dream*, his
last and largest picture, the culminating masterpiece of
his career.

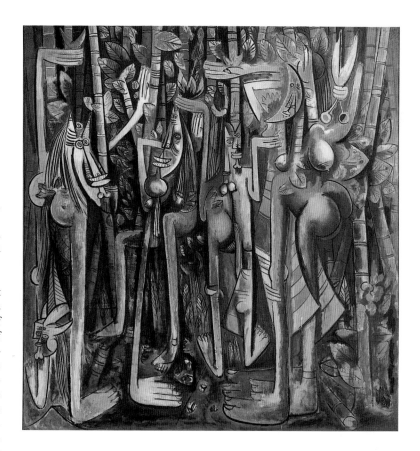

WIFREDO LAM. Cuban, 1902–1982. Worked in France, Spain, and Italy 1923–41; in Paris 1952–82.
The Jungle. 1943. Gouache on paper mounted on canvas, 7 feet 10¼ inches x 7 feet 6½ inches. Inter-American Fund. [140.45]

Lam's painting, like Rousseau's *Dream*, presents a night scene in the jungle, filled with a large number of forms crowded into the foreground plane. The atmosphere of the two works, however, is entirely different. Instead of the serenity of Yadwigha's dream, Lam depicts a terrifying vision, with intimations of savage magical rites. As described by Evan Maurer: "*The Jungle* creates an impression of thick, impenetrable jungle vegetation, in the midst of which stand female figures whose tubular legs and rounded knees, buttocks, torsos, and breasts are conceived so as to be almost indistinguishable from the foliage surrounding them. Thus camouflaged, they are an integral element of the natural environment—a Primitive-inspired representation of humanity's union with nature. Lam himself described this synthesis when he wrote that in his jungle scenes we can witness 'beings in their passage from the vegetal state to that of the animal still charged with the vestiges of the forest.'"

Rousseau's concept of the jungle was the imaginative projection of a city-dwelling petit bourgeois. Lam's was based more closely on actual experience. Born in Cuba, he was the son of a Chinese businessman who had emigrated from Canton and a mother of mixed African, Indian, and European origin. His godmother was a "professional sorceress" in the voodoo cult popular in Cuba and elsewhere in the Caribbean, and as a child he had witnessed animal sacrifices and other magic rituals and had become familiar with the ceremonial use of African or African-style objects.

As an adult, Lam first became attracted to African tribal sculpture while an art student in Madrid. In 1938, at the end of the Spanish Civil War, he moved to Paris, where he was befriended by Picasso, and where he became a member of the Surrealist group. At the outbreak of the Second World War, he returned to Cuba, visited Haiti, and, reevaluating his heritage, began to make explicit use of Antillean subject matter, expressed in terms of the artistic conventions he had learned in Europe.

Lam's debt to Picasso is apparent in *The Jungle* in the female figure standing at the left, whose raised arm directs the eye to the other nearby figure, which has a counterpart in *Les Demoiselles d'Avignon* (page 35). From Primitive sculpture Lam took, for the figure at the left, the forward-curving head, long nose, and outthrust mouth of the Senufo style, while the formal characteristics of other African styles are reflected in the emphatic treatment of buttocks and breasts and the simplified arms, legs, hands, and feet. He gave to these forms, however, a highly personal expression and imparted to the painting a coherent, though mysterious and Surrealist, context. The use of the fast-drying medium of gouache, applied in thin washes of color, allowed multiple images to be read through one another, creating subtle effects of transparency suggestive of the interpenetration of phenomena that is an important aspect of the Primitive vision of nature.

125

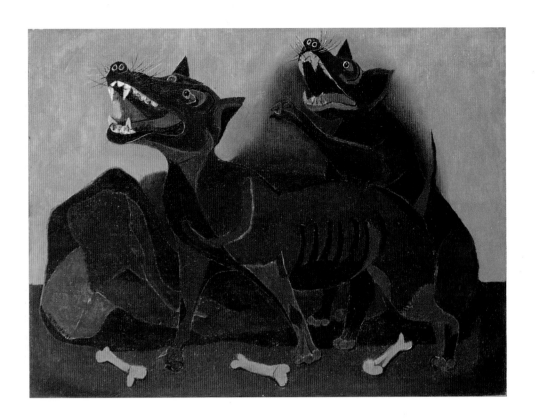

RUFINO TAMAYO. Mexican, 1899–1991. In U.S.A. 1926–28, 1930–31, 1936–48; in France 1949–50, 1957–64. Traveled in the U.S.A., Europe, and South America. *Animals*. 1941. Oil on canvas, 30⅛ x 40 inches. Inter-American Fund. [165.42]

Against a lurid background of yellow and red, two ferocious beasts raise their heads and howl. On the barren ground at the left stands a large rock, and in the foreground lie three bare bones. Out of these simple elements Tamayo has created a terrifying image, all the more powerful because of its unnaturalistic color. The bared fangs, bristling muzzles, balefully glaring eyes, sharply pointed ears and tail, and upraised paw with extended claws all evoke fear. These do not seem to be specific animals in any actual moment of time but symbolic incarnations arousing our primordial dread.

Born in Oaxaca of Zapotec Indian stock, Tamayo came to maturity when the Mexican Revolution was finding expression in art through the activities of muralists such as Siqueiros, Orozco, and Rivera, and through archaeological projects sponsored by the government, which revived interest in the indigenous pre-Columbian culture. At the age of twenty-two, Tamayo was appointed head of the Department of Ethnographic Drawing in the National Museum of Archaeology, where he came to know thoroughly the sculpture of the Aztecs, Mayans, and Toltecs. In the late 1920s, he made the first of his periodic visits to the United States and in the late 1930s, divided his time between Mexico and New York, where he taught during the winter. His encounter with the art of Picasso, which he saw in strength in The Museum of Modern Art's retrospective exhibition of 1939, was particularly crucial for his development and led him to adopt certain exaggerations and distortions to intensify emotion.

In his monograph on Tamayo, Robert Goldwater wrote: "His power lies in his ability to fuse naturally the most primitive and the most sophisticated. . . . By a fortunate chance of birth Tamayo grew up in the midst of a primitive culture and a folk tradition. By happy circumstances he was thrown, during his formative years, into the birth struggles of a modern style based in part upon the tradition he knew. And by his own artistic intelligence and sensibility he has assimilated some of the most advanced of contemporary artistic expression. . . . Yet he has remained close to the first sources of his art, and at his best has preserved the primitive immediacy with which it began."

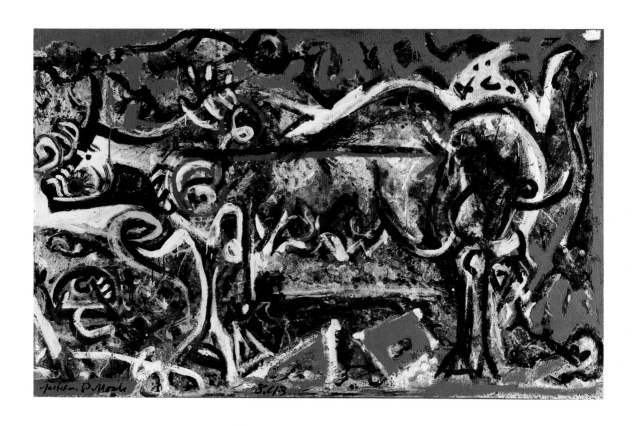

JACKSON POLLOCK. American, 1912–1956.
The She-Wolf. 1943. Oil, gouache, and plaster on canvas,
41 7/8 x 67 inches. Purchase. [82.44]

Tamayo's beasts stand out with stark clarity against their background, but it is only with difficulty that we descry Pollock's she-wolf amid what at first appears to be a purely abstract network of thick calligraphic strokes filling the entire surface of the canvas. Heavily outlined in black, with strong white highlights, the creature advances to the left. Her body is overlaid with lines, curves, and patches of paint that do not serve to model it in any conventional manner, and the forms within the remaining areas are indecipherable.

The She-Wolf was one of the first paintings in which Pollock achieved a personal means of expression. Previously, he had undergone successive influences: the realism of his teacher, Thomas Hart Benton, at the Art Students League; Picasso's late-Cubist, decorative pat-

terning; the dramatic content of the Mexican muralists; and the Surrealists' tapping of the unconscious as a source for imagery—fortified by Pollock's own Jungian psychoanalysis in 1939–40. In this picture, he seems to be striving for an amalgam of accepted mythology (the subject perhaps being identifiable as the foster-mother of Romulus and Remus, the founders of Rome) and a private iconography based on images dredged from his own unconscious. In 1944, Pollock said: "*She-Wolf* came into existence because I had to paint it. Any attempt on my part to say something about it, to attempt explanation of the inexplicable, could only destroy it."

Included in Pollock's first individual exhibition in 1943, *The She-Wolf* was bought by The Museum of Modern Art in the following year—the first of his works to enter into a museum collection. In its vigorous rhythms and filling of the entire surface with forceful strokes, it anticipates the allover patterning that soon evolved in such classic "drip" paintings as his *One* of 1950 (page 140).

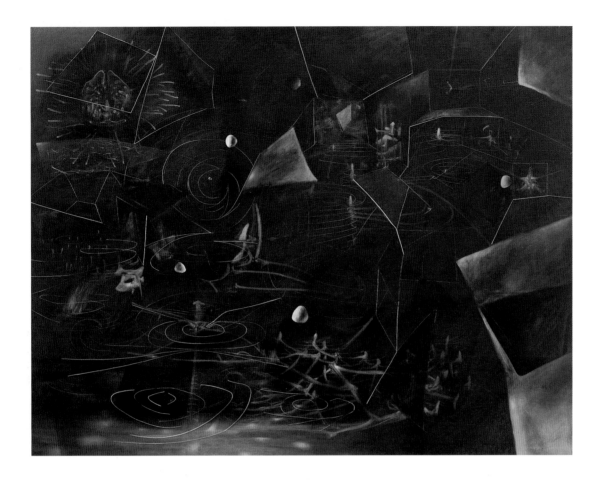

MATTA (Sebastian Antonio Matta Echaurren). Chilean, born 1911. In U.S.A. 1939–48. Lived in Paris 1955–69; in Italy since 1969.
The Vertigo of Eros. 1944. Oil on canvas, 6 feet 5 inches x 8 feet 3 inches. Given anonymously. [65.44]

The Chilean-born artist Matta studied architecture and was enrolled for three years in Le Corbusier's office in Paris, but he found his true affinity was with the Surrealists, whose group he officially joined in 1937. Unlike the realistic representations of dreamlike fantasies by Dali and Magritte, Matta's paintings were closer to the abstract, spontaneous improvisations of Kandinsky. He called his works of 1938–43 "Inscapes"—imaginary landscapes that were the outward projections of subjective psychological states.

The large canvas *The Vertigo of Eros* portrays a violently disturbed state of mind as a scene of cosmic upheaval that takes place within a deep space rendered by means of linear perspective. Black washes are overlaid on the pigments beneath and partly rubbed away, so that the resulting gradations of shading produce the effect of a dark atmosphere within which brightly colored, indefinable shapes float or explode. As described by William Rubin: "Afloat in a mystical world of half-light that seems to emerge from unfathomable depths, a nameless morphology of shapes suggesting liquid, fire, roots, and sexual organs stimulates the awareness of our inner consciousness as it is when we trap it in reverie and dreams." Webs and spirals of thin white lines like automatic writing run around and among these symbolic objects.

Matta has said that the title of this work derives from Freud's statement that the life spirit, Eros, constantly challenged by the death instinct, Thanatos, induces in most people a state of vertigo that they must continually combat in order to achieve a state of equilibrium. But when Matta told a friend that the name of the painting was *Le Vertige d'Éros*, she repeated it as *les verts tiges des roses* ("the green stems of roses"), inadvertently making just such a pun as delighted the Surrealists.

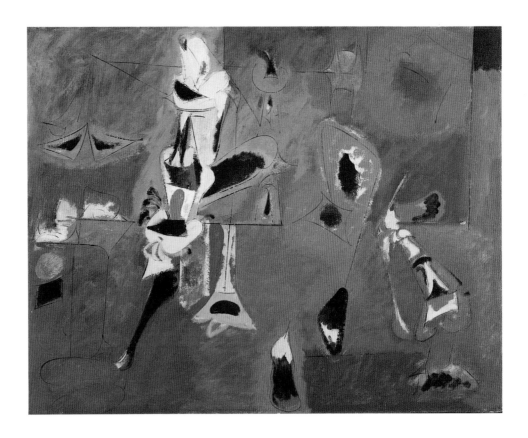

ARSHILE GORKY (Vosdanig Manoog Adoian). American,
born Armenia. 1904–1948. To U.S.A. 1920.
Agony. 1947. Oil on canvas, 40 x 50½ inches. A. Conger
Goodyear Fund. [88.50]

Gorky's encounter with the art of Matta was crucial in
liberating his own painting from the imitation of earlier
influences and in revealing to him "the idea of the canvas
as a field of prodigious excitement, unloosed energies,
bright reds and yellows opposed to cold greys," in the
words of Meyer Schapiro. This picture, like Matta's *Ver-
tigo of Eros*, depicts a state of intense psychological
perturbation, but in Gorky's case this was more personal
than cosmic. The title *Agony* aptly conveys the artist's
anguish, provoked by a succession of misfortunes begin-
ning with a fire in January 1946 that destroyed his studio
and about twenty-seven of his paintings, an operation for
cancer the following month, and disruptions in his pri-
vate life. *Agony* was painted in the interval between these
tragic events and Gorky's suicide in July 1948, following
an automobile accident in the previous month in which
his neck was broken and his painting arm injured.

Like Matta, Gorky makes use of perspective, but in-
stead of being set in deep space, his forms are situated
within an interior defined by the lines of the floor and a
wall in the background. The stage thus constructed is
occupied by objects and by hybrid figures, vaguely ani-
mate or even humanoid in appearance. They are, how-
ever, only metaphors for personages. Gorky once said
that he did not wish his pictures to have faces. The dark
reds, browns, pale yellows, and weighty patches of black
impart a sense of tragedy and foreboding.

A consummate draftsman, Gorky usually made pre-
paratory drawings from which he systematically devel-
oped his major compositions. *Agony* was preceded by a
series of bold studies in pencil, several wash drawings,
and a smaller version in oil. The final painting, however,
differs considerably from these studies, for to a great
extent it was allowed to evolve through free improvisa-
tions in the course of execution. Such a procedure had
precedents both in Kandinsky's spontaneous method of
working and in the theory and practice of the Surrealists,
who emphasized the role of automatism and the uncon-
scious as wellsprings of creativity.

MAX ERNST. French, born Germany. 1891–1976. In France 1922–41, 1953–76; in U.S.A. 1941–53. Naturalized American citizen 1948, French citizen 1958. *The King Playing with the Queen.* 1944. Bronze (cast 1954, from original plaster), 38½ inches high, at base 18¾ x 20½ inches. Gift of D. and J. de Menil. [330.55]

In December 1944 the Julien Levy Gallery in New York presented an exhibition "The Imagery of Chess," with paintings and sculpture by thirty-two invited artists, mostly Surrealists or their associates. They had accepted a challenge to replace the two existing standard chess sets: "Cannot a new set be designed, that is, without too radical a departure from the traditional figures, at once more harmonious and more agreeable to the touch and to the sight, and above all, *more adequate to the role the figure has to play in the struggle?* Thus, at any moment of the drama its optical aspect would represent (by the shape of the actors) a clear incisive image of its inner conflicts." Among the participants, besides Duchamp, an avid player and a master of the game, were Breton, Calder, Gorky, Matta, Man Ray, Motherwell, Tanguy, and Ernst. It seems paradoxical that Duchamp and the Surrealists should have been devotees of chess, which among all games in the world is unique for its total dependence upon logic, without the slightest opportunity for the intervention of chance—the very opposite, in fact, of the Surrealists' reliance upon irrationality and hazard in their art; but then paradox, too, was another of their cherished tenets.

For this occasion Ernst not only contributed a chess set, two of whose pieces appeared as silhouettes on the cover of the exhibition's checklist, but he also showed the plaster of *The King Playing with the Queen.* He had executed it at Great River, Long Island, where he had transformed the garage of a house that he and Julien Levy had rented for the summer into a studio. Ernst had begun to make sculpture in the round following his stay on Lake Geneva in 1934 and his transformation into art objects of the granite stones that he and Giacometti had gathered from the riverbed at Maloja (see page 29). After immigrating to America in 1941, he traveled across the country and acquired a large collection of the Kachina figures that Hopi and Zuni Indians use to instruct their children about the deities in their cosmology. The horned

rectangular head of the king in Ernst's sculpture resembles that of a buffalo Kachina in his collection and also has a precedent in the horned creature rising from a tabletop in his 1927 painting *One Night of Love* (Private collection, Paris). Several other sculptures that Ernst made during the same summer in which he produced *The King Playing with the Queen* share some of its features: horns surmount the round head in *Moonmad,* and a flat rectangular head thrust forward from a long neck appears in *An Anxious Friend* (both in the Museum's collection), while four abstract, mostly geometrical forms, somewhat like the chess pieces he designed or those on the table in *The King Playing with the Queen,* are displayed in another bronze of 1944, *The Table Is Set* (The Menil Collection, Houston). The horned figure recurs later as the central figure in Ernst's enormous sculpture, *Capricorn* of 1948 (The Donald M. Kendall Sculpture Gardens at PepsiCo, Purchase, New York).

Side by side with his fascination with the art of the Indians of America's Southwest, Ernst continued his interest in other tribal arts. William Rubin has pointed out that the sharply angled position of the king's arms in *The King Playing with the Queen* and their relation to his torso have affinities with anthropomorphic Mossi whistles of the Upper Volta. One may also compare the king's rectangular head surmounted by horns with a similar configuration that tops a helmet mask of the Senufo people of the Ivory Coast, now in the Museum of Primitive Art in New York.

Far from being a frightening figure, the horned creature in Ernst's sculpture is a rather endearing one, as his right hand tenderly caresses the little queen. (We may perhaps wonder what sly deception he plans with the other chess piece that he holds in his left hand, half-concealed behind his back.) Ernst's wife, Dorothea Tanning, wrote to the Museum in 1957 after it had acquired a bronze cast of this work that the artist "wishes to imply here a kind of double sense, a hypothetical king and queen playing a game involving kings and queens—there is no end to the interpretations that could be put upon such a situation. The title also says that even a king may love his queen and like to play with her." It is perhaps relevant in this regard that Ernst retained one of the six casts of this sculpture and set it up in the garden of their home at Huilmes in France.

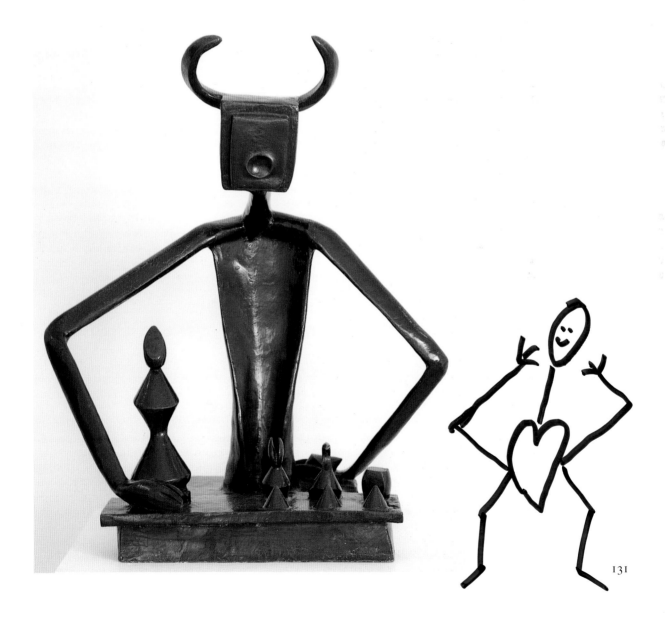

131

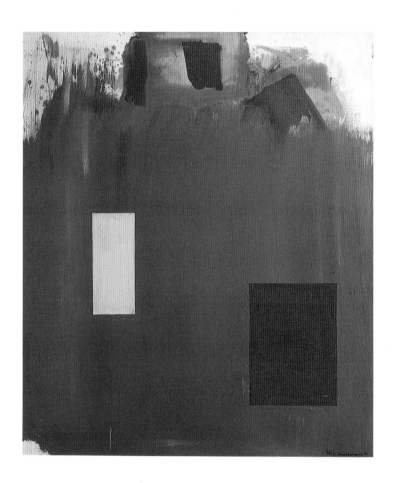

HANS HOFMANN. American, born Germany. 1880–1966.
To U.S.A. 1932. Naturalized American citizen 1941.
Memoria in Aeternum. 1962. Oil on canvas, 7 feet x
6 feet ⅛ inch. Gift of the artist. [399.63]

Throughout his life, Hofmann was both a theorist and an
outstanding teacher of painting. After coming to the
United States in 1932, he first taught in California and
subsequently opened schools in New York and Province-
town, Massachusetts. Beginning about 1940, his work
developed increasingly toward abstraction, and he was
one of the principal formative influences on the "New
American Painting" that began to emerge during that
decade. Besides providing the stimulus of his own cre-
ative vitality, he was among the first in this country to
encourage exploration of the possibilities of accidental
effects in painting. He also advocated retention in the
finished work of the clear traces of the painter's activity
in creating it—the paths of energy made by the gestures
of his hand in its simultaneous response to his emotion
and the properties inherent in the medium.

Memoria in Aeternum is a monumental painting pro-
duced when the artist was over eighty. Hofmann, how-
ever, still retained his vigorous good health, and the
works done in the last decade or so of his life are gener-
ally regarded as the crowning achievements of his long
and active career. In this work, he paid tribute to five
American artists whom he had known and admired, and
who had all died while still in their prime: his contempo-
rary Arthur B. Carles, an early American Cubist, and
four of the avant-garde abstractionists who came into
prominence after the Second World War—Arshile
Gorky, Jackson Pollock, Franz Kline, and Bradley Walker
Tomlin.

The bright yellow and red rectangles in *Memoria in
Aeternum* are placed far apart and given a background of
murky brown streaked with red, yellow, and blue that
covers almost the entire surface of the canvas. This
ground lightens at the top, where an irregular trapezoid
occupies the center of a truncated semicircular shape
flanked with spatters of light blue. The openness at the
upper corners repeats on a larger scale a small area of
brightness at the lower left. Against the variegated
brushwork of the background, the two rectangles seem to
shift their positions vertically, as well as to recede and
advance. Thus, a tension is set up between the forms and
space, between the plane of the canvas and the depth
suggested by the implied movement of the shapes upon
its surface. "The mystery of plastic creation is based
upon the dualism of the two-dimensional and the three-
dimensional," Hofmann declared. He called this dy-
namic interaction of flatness and depth "push and pull."

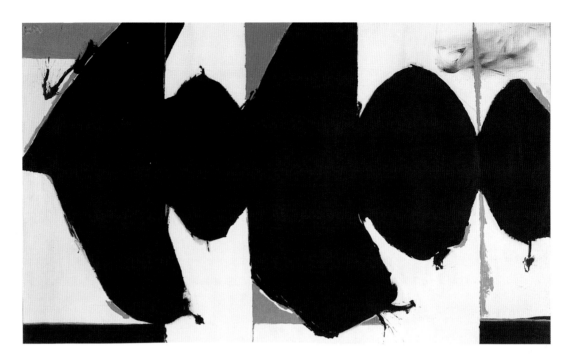

ROBERT MOTHERWELL. American, 1915–1991.
Elegy to the Spanish Republic, 108. 1965–67. Oil on
canvas, 6 feet 10 inches x 11 feet 6¼ inches. Charles
Mergentime Fund. [155.70]

Motherwell came to art by way of philosophy; other of
his special interests included music, psychoanalytic the-
ory, and the Symbolist poets. Soon after he decided to
turn from the study of art history to painting, he came
into contact with a number of the Surrealist artists-in-
exile in New York, and he became especially friendly
with Matta. Though deeply influenced by the Surrealists'
theories about automatism, he differed from them in his
commitment to abstraction. He stated: "One might truth-
fully say that abstract art is stripped bare of other things
in order to intensify it, its rhythms, spatial intervals, and
color structure." In 1948, Motherwell and several other
artists, including Mark Rothko and Barnett Newman,
founded a short-lived cooperative school; they called it
"The Subjects of the Artist," to emphasize that abstract
painting, though nonrepresentational, has subject matter.
In the same year Motherwell discovered the theme that
he was to develop in more than a hundred paintings—the
series of Spanish Elegies.

Elegy to the Spanish Republic, 108 is among the
largest of these. For young intellectuals of Motherwell's
generation, the Spanish Civil War precipitated a moral
crisis somewhat like that induced by the Vietnam War in
the 1960s and 1970s. But like Beckmann, who said that

his *Departure* had a wider significance beyond any nar-
rowly topical meaning (page 86), Motherwell declared:
"I take an elegy to be a funeral lamentation or funeral
song for something one cared about. The 'Spanish Ele-
gies' are not 'political,' but my private insistence that a
terrible death happened that should not be forgot. They
are as eloquent as I could make them. But the pictures are
also general metaphors of the contrast between life and
death, and their interrelation."

In formal terms, the Spanish Elegies have in common
their structural arrangement of irregularly ovoid shapes
abutting vertical bars or rectangles of various widths. At
the most elementary level, they may be read simply as
composed of contrasting, basically geometrical forms.
The shapes nevertheless evoke associations of male and
female genitalia; it has also been suggested that they may
refer to the phallus and testicles of the sacrificial bull
hung up on the wall of the ring after a *corrida*.

Though Motherwell sometimes made use of accidental
effects, in general his compositions are strictly con-
trolled, depending on the precise relationships between
the forms and their arrangement on the flat surface of the
canvas, the rhythms established by the spatial intervals,
and the interaction of the colors—especially their power
to give off light or, in the case of black, absorb and negate
it. Here, besides black and white, there is ocher, sym-
bolizing earth, and green, grass, the colors thus repre-
senting the opposition and interrelation between death
and anxiety, life and radiance.

HENRI MATISSE. French, 1869–1954.
The Swimming Pool. 1952–53. Gouache on cut-and-pasted paper mounted on burlap; details of nine-panel mural in two parts, a–e, 7 feet 6⅝ inches x 27 feet 9½ inches; f–i, 7 feet 6⅝ inches x 26 feet 1½ inches. Mrs. Bernard F. Gimbel Fund. [302.75a–i]

At the age of eighty-three, confined by ill health to his bed or a wheelchair, and no longer able to work at an easel, Matisse turned to a medium he had explored earlier—cut-and-pasted paper—and expanded it to monumental dimensions to decorate the dining room of his apartment at Nice overlooking the Mediterranean. Certainly when Braque and Picasso produced their cut-and-pasted paper compositions (see pages 54–55), they could hardly have foreseen such an application of their innovative technique.

Using scissors and paper specially painted with blue gouache to his specifications, Matisse cut shapes that were then pasted onto heavy white paper and mounted on the beige walls (now approximated with burlap), producing a two-part frieze almost fifty-four-feet long that ran around the entire room. Though the blues are all ultramarine, they vary slightly according to the different batches of gouache and the way in which they were mixed and applied to the paper. "Scissors," Matisse once said, "can acquire more feeling for line than pencil or charcoal." At another time, he remarked, "Cutting directly into color reminds me of a sculptor's carving into stone." He found that "cutting colored papers permits me to draw in the color. . . . Instead of establishing a contour, and then filling it with color—the one modifying the other—I draw directly in the color. . . . This guarantees a precise union of the two processes; they become one."

Matisse had first used scissors as an artist's tool in 1931, when he made paper cutouts to aid him in working out the placement of forms in his mural decorations for the museum of the Barnes Foundation in Merion, Pennsylvania. He later turned to the cut-and-pasted-paper technique to design covers of magazines, catalogues, and books, posters, ballet sets and costumes, tapestries, rugs, and ceramics, and in 1947 he used it for the twenty plates of his picture book, *Jazz.* Between 1948 and 1952, when most of his creative energies were devoted to the decora-

tions of the Chapel of the Rosary at Vence, he made cut-and-pasted maquettes for its windows and chasubles. In the last four years of his life, he produced cutouts for the designs of several stained-glass windows, the largest being for *Nuit de Noël*, commissioned by *Life* magazine for the Time-Life Building at Rockefeller Center. Both the maquette, completed late in February 1952, and the window itself are now in the Museum's collection.

The Swimming Pool, however, was made purely for Matisse's private enjoyment. He said that he had chosen the subject because "I have always adored the sea, and now that I can no longer go for a swim, I have surrounded myself with it." Through the length of this exuberant frieze, figures swim, dive, and splash in waters inhabited by fish, starfish, a dolphin, and a mermaid, their aquatic ballet sometimes going beyond the limits of the horizontal band of the white paper background to extend onto the wall. Just to the right of the starfish that serves as a final punctuation mark for the left end of the frieze, Matisse surprises us by reversing the relation of figure to ground; it is now the swimmer that is white, surrounded by blue water. In the same year that he made *The Swimming Pool*,

Matisse told an interviewer that it was the spaces between the cut-and-colored papers that give "this *white-atmosphere* a rare and impalpable quality."

The imagery of the cut-out figures in *The Swimming Pool* relates to poses in Matisse's vast repertory of reclining figures, dancers, and odalisques (see pages 60 and 78). But, as John Elderfield observes: "It separates itself from nearly all of these . . . in the way that the human figure itself here creates the decorative configuration of the entire composition. Of Matisse's preceding works, only the 1909 and 1910 versions of the *Dance* . . . and the Barnes murals, . . . also devoted to the dance theme, truly achieve this effect."

For Matisse this last cycle was a culmination rather than a change. "There is no separation between my old pictures and my cutouts," he said in 1951, "except that with greater completeness and abstraction, I have attained a form filtered to its essentials, and of the object which I used to present in the complexity of its space, I have preserved the sign which suffices and which is necessary to make the object exist in its own form and in the totality for which I conceived it."

MILTON AVERY. American, 1893–1965.
Sea Grasses and Blue Sea. 1958. Oil on canvas,
60⅛ inches x 6 feet ⅜ inch. Gift of friends of the artist.
[649.59]

Though *Sea Grasses and Blue Sea* is based on nature, its
elements have been so stringently reduced that it seems
almost abstract. Avery has distilled his recollections
of Provincetown into the simplest of compositional
schemes, held together by subtle color harmonies. Be-
neath the narrow horizontal band of sky at the top, the
remainder of the canvas is divided diagonally into two
trapezoids of almost equal area. The sea grasses below
present a surface that is lightly streaked and of the same
tonality as the sky, but paler. By contrast, the water above
ranges from a very light blue to a deeply saturated hue,
broken by the waves, which are painted black, rimmed
and flecked with white foam. The black here does indeed
seem to be used as "a color of light and not as a color of
darkness," as Matisse remarked about his painting of
1915–16, *The Gourds*.

Avery has, in fact, often been compared to Matisse,
though his development took place entirely in America,
and he did not make his first trip to Europe until 1952,

when he was nearly sixty. Any similarity between the
two artists is attributable less to a direct influence than to
a like attitude toward painting. Avery appears to have
shared Matisse's view that a picture must be a "condensa-
tion of sensations," achieved through composition—
"the art of arranging in a decorative manner the various
elements at the painter's disposal for the expression of his
feelings." He also believed that, as Matisse declared,
"the chief aim of color should be to serve expression as
well as possible," and that the choice of color, though
based on observation, should depend on "instinct and
sensibility."

A highly original artist, Avery followed his own bent,
developing a lyrical mode almost totally independent of
the prevailing styles in American art during most of his
lifetime. The chromatic sensibility of his late paintings,
such as *Sea Grasses and Blue Sea*, has won increasing
respect among more recent color abstractionists. The
critic Clement Greenberg wrote: "His art demonstrates
how sheer truth of feeling can galvanize what seem the
most inertly decorative elements—a tenuous flatness;
pure, largely valueless contrasts of hue; large, unbroken
tracts of uniform color; an utter, unaccented simplicity of
design—into tight and dramatic unities."

RICHARD DIEBENKORN. American, 1922–1993.
Ocean Park 115. 1979. Oil and oil-based enamel on canvas, 8 feet 4 inches x 6 feet 9 inches. Mrs. Charles G. Stachelberg Fund. [953.79]

Ocean Park 115 is one of a series that Diebenkorn began in 1967 and continued to develop in over a hundred paintings for more than a decade. The name derives from the section of Santa Monica, California, in which his studio was located. In its reduction of a motif taken from nature, it goes much further toward abstraction than Avery's treatment of a similar theme in *Sea Grasses and Blue Sea*. By contrast to Mondrian's rendering of a related subject in *Pier and Ocean* of 1914, which records the moving patterns of sea, lights, sky, and stars by a multiplicity of small units of intersecting verticals and horizontals, Diebenkorn's painting is limited to only a few elements and produces an effect of motionless calm.

Like Avery, Diebenkorn was influenced by Matisse, and especially by the abstract structuring of such works as *View of Notre Dame* of 1914 and *Piano Lesson* of 1916 (page 83). Were we to block out from the latter picture the boy at the piano, the arabesques of music stand and balustrade, and the strong diagonal shaft of green, we would find that it has in common with Diebenkorn's painting a geometric division of space into broad areas of flat color separated by vertical and horizontal bands, and also a general likeness in the color scheme. In both works, emphasis is on the frontal plane of the canvas, and spatial illusion depends on luminosity rather than on any vestiges of linear perspective.

The luminous quality of *Ocean Park 115* is achieved by Diebenkorn's technique of applying layer upon layer of diaphanous oil paints treated like washes, producing a lively surface that mitigates the severity of the composition's strict geometry. In the words of Robert T. Buck, Jr.: "the Ocean Park paintings depend crucially on the artist's ability to create an alliance—strike a balance—between structural concern and tonal, spatial illusion. . . . [They] result from the artist's full resolution of creative impulses, a blend of spontaneity and painterly qualities with a deepened sense of emerging structure and space."

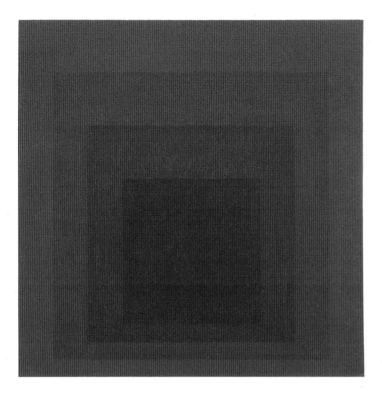

JOSEF ALBERS. American, born Germany. 1888–1976. To U.S.A. 1933. Naturalized American citizen 1939. *Homage to the Square: Broad Call.* 1967. Oil on composition board, 48 x 48 inches. The Sidney and Harriet Janis Collection. [664.67]

Though Malevich in 1915 had made the square the basis of his Suprematist Compositions and hailed it as a "living, royal infant . . . the first step of pure creation in art," it was its shape and that of the rectangle that he esteemed as expressions of ultimate reality. Albers, by contrast, selected the square as a man-made, universal symbol to serve as a vehicle for color and light, becoming "the stage, the actor and the voice which perform the endless drama of the excitements of color instrumentation."

Many modern artists have devoted themselves to the problem of the interaction of colors, among them Seurat, Kupka, and Delaunay, but none has done so with greater tenacity than Albers. He began his Homage to the Square series in 1949 and carried it on until his death. Each work consists of a symmetrical arrangement of squares-within-squares, but they differ from one another in the placement and proportion of these elements and in the choice of colors, attaining a strikingly rich variety. The paint was applied directly from the tube, generally with a palette knife, allowing no textural effects to interfere with the autonomy of the colors and their free interplay.

Albers's was an exploration into the flexibility of color, its ability to fool the eye and challenge perception. "Though the underlying symmetrical and quasi-symmetrical order of squares remains the same in all paintings—in proportion and placement these same squares group or single themselves, connect and separate in many different ways," he wrote. "In consequence, they move forth and back, in and out, and grow up and down and near and far, as well as enlarged and diminished. All this, to proclaim color autonomy as a means of plastic organization."

Homage to the Square: Broad Call was painted in response to a request from Albers's dealer, Sidney Janis, for a painting using red only. But as Albers said: "In visual perception, a color is almost never seen as it really is—as it physically is. This fact makes color the most relative medium in art. . . . If one says 'red' and there are fifty people listening, it can be expected that there will be fifty reds in their minds." A meticulous craftsman, Albers customarily inscribed on the back of each of his works a list of the pigments used and the names of their manufacturers. For *Broad Call*, he provided a further analysis: "Factually, the painting is executed in 4 red oil paints. . . . Actually, the color instrumentation may be read in 3 colors: Thus the central red and the outer appear touching each other underneath a third translucent red which overlaps the 2 first ones within 2 illusionary frames of equal width. Then the third red, acting as an intermediary color, turns the darker underneath—lighter, and the lighter underneath—deeper, although all colors used are fully opaque."

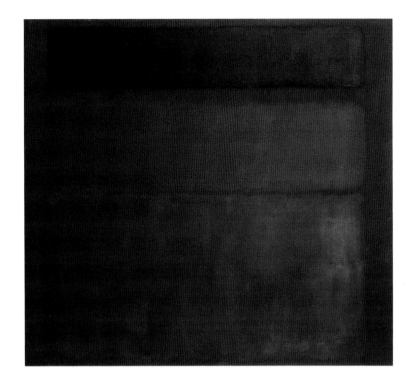

MARK ROTHKO. American, born Latvia. 1903–1970. To U.S.A. 1913. Naturalized American citizen 1938. *Red, Brown, and Black.* 1958. Oil on canvas, 8 feet 10⅝ inches x 9 feet 9¼ inches. Mrs. Simon Guggenheim Fund. [21.59]

Like many of his contemporaries painting in New York in the 1940s, Rothko found in Surrealism a liberating force that led him to the adoption of automatism and the creation of abstract, biomorphic shapes that seem to enact some undefined tragic myths. By 1947, he abandoned figuration in favor of the compositional format to which he was to adhere throughout the rest of his life. These paintings have in common with Albers's Homage to the Square series their concentration upon color and their dependence on a simple geometrical shape—in Rothko's case, a rectangle rather than a square. But in place of the sharp precision of Albers's squares, Rothko's rectangles are blurred, with irregular edges that give them a three-dimensional effect, though they seem less like solid bodies than impalpable clouds capable of expanding within an enveloping atmosphere. Their potentiality for change is also implied by the subtle modulations within their matte painted surfaces—exactly the opposite of Albers's deliberate suppression of any trace of brushwork or textural variation in the application of pigment.

Red, Brown, and Black displays the dark, somber, and close-valued tonality that Rothko favored toward the end of his life. The large size of the work is essential for its powerful impact.

In a much-quoted essay, the critic Robert Rosenblum wrote in 1961: "In his *Critique of Judgment* (1790), Kant tells us that 'whereas the Beautiful in nature is connected with the form of the object, which consists in having boundaries, the Sublime is to be found in a formless object, so far as in it, or by occasion of it, *boundlessness* is represented.' . . . Indeed, such a breathtaking confrontation with a boundlessness in which we also experience an equally powerful totality is a motif that continually links the painters of the Romantic Sublime with a group of recent American painters who seek out what might be called the 'Abstract Sublime.' . . . Rothko . . . places us on the threshold of those shapeless infinities discussed by the aestheticians of the Sublime. . . . We [stand] silently and contemplatively before these huge and soundless pictures as if we were looking at a sunset or a moonlit night. . . . The floating, horizontal tiers of veiled light . . . seem to conceal a total, remote presence that we can only intuit and never fully grasp. These infinite, glowing voids carry us beyond reason to the Sublime; we can only submit to them in an act of faith and let ourselves be absorbed into their radiant depths." Nevertheless, the closeness to the picture plane of Rothko's suspended rectangles prevents us from being totally enveloped within the misty clouds of color. As Rothko once remarked, "My paintings are sometimes described as façades, and indeed, they *are* façades."

139

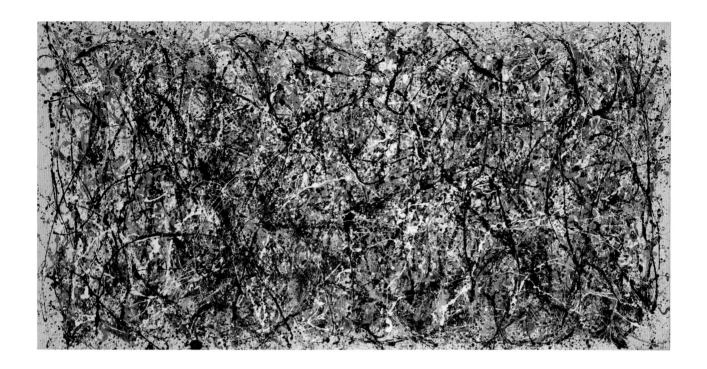

JACKSON POLLOCK. American, 1912–1956.
One (Number 31, 1950). 1950. Oil and enamel on un-
primed canvas, 8 feet 10 inches x 17 feet 5⅝ inches.
Sidney and Harriet Janis Collection Fund (by exchange).
[7.68]

Pollock's immense, wall-size painting represents the
apotheosis of the gestural procedure advocated by
Hofmann (see page 132), but the labyrinthine web of
pigments in *One* results from the action not of hand and
arm alone but of the artist's entire body. In this, as in
Pollock's other "drip" paintings, enamel and oil paints
were not only dripped but poured, spurted, or flung from
sticks, brushes, or syringes as he walked around the
canvas tacked to the floor. He explained that in this way
he could "work from the four sides and literally be *in* the
painting. This is akin to the method of the Indian sand
painters of the West."

The technique enabled Pollock to unleash an
exuberant—almost ecstatic—energy. In Kirk Varnedoe's
words: "He could make of his art the kind of dance that
was a walk that was felt. He could get into his work a kind
of new motion and freedom, and get free of the tangled
conflicts of a troubled Surrealism that had marked his
work in the years before. Instead, he could produce a new
kind of painting that was expansive and lyrical, with a
new kind of space to it."

Many critics and members of the public, focusing on
the procedure and not on the results, dubbed Pollock
"Jack the Dripper"; overestimating the degree of autom-
atism involved, they failed to perceive the control that
the artist exerted by his sense of rhythm, his intense
concentration, and his virtuosity in determining the di-
rection, thickness, and continuity of the lines and drips.
In *One*, for example, note how the skeins of pigments
respect the top, bottom, and sides of the canvas, turning
with sweeping curves at the corners.

The painting has a restrained palette of tans, blues, and
grays, speckled and lashed through with black and white.
The pigment is sometimes matte, sometimes glossy. In
some areas its interwoven threads and clusters give tex-
ture to the surface; elsewhere, the paint is stained into the
unprimed ecru canvas to become part of its warp and
woof. There is an effect of flickering light, with the
mysterious suggestions of depth lying beyond the surface.

The poet Frank O'Hara has discussed the particular
significance of scale in Pollock's large paintings and its
emotional effect upon the spectator. He writes: "The
scale of the painting becomes that of the painter's body,
not the image of a body, and the setting for the scale . . .
the canvas surface itself. . . . It is the physical reality of
the artist and his activity of expressing it, united to the
spiritual reality of the artist in a oneness which has no
need for the mediation of metaphor or symbol."

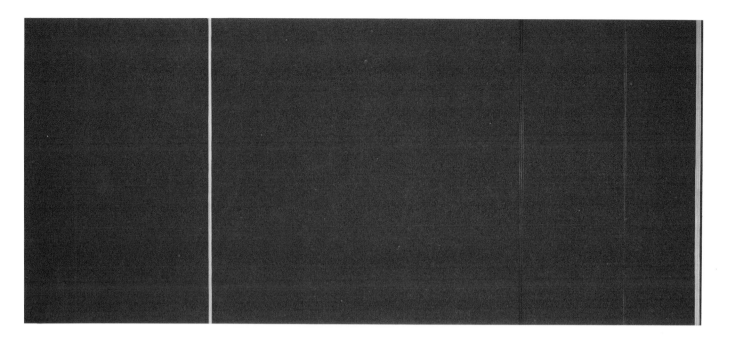

Like Pollock's *One*, Newman's huge painting functions
like a mural, yet without reference to any architectural
setting. Its vast expanse becomes the viewer's environ-
ment and thus engages him in direct, intimate contact.

Barnett Newman, Mark Rothko (page 139), and
Clyfford Still were leaders of the branch of Abstract
Expressionism that differed from gestural painting by
eliminating evidences of the arm's motion, instead rely-
ing for expression on large color areas of various shapes.
Like Albers's *Homage to the Square: Broad Call* (page
138), *Vir Heroicus Sublimis* is a study in red, the canvas
serving as vehicle for the brilliant hue with which it is
evenly covered from edge to edge. There are no recogniz-
able images or incidents to differentiate the parts of the
painting. All that "happens" is the division of the area by
five vertical stripes of different widths and colors that
vary in intensity from extreme brightness to near invis-
ibility. Newman called these vertical stripes "zips"; he
established their positions by affixing tapes to his canvas,
as Mondrian did in *Broadway Boogie Woogie* (page 65).
The painting's center is occupied by an eight-foot square;
the surface to left and right is asymmetrically divided.

In spite of the rigid discipline with which the elements
of the composition are ordered, Newman vehemently
espoused the idea that art must free itself from what he
called "this death image, the grip of geometry. . . .
Painting, like passion, is a living voice, which, when I
hear it, I must let speak, unfettered." A key to his inten-
tions as an artist may be found in an essay he wrote
several years before he painted *Vir Heroicus Sublimis*,
the first of his very large works: "The subject matter of
creation is chaos. . . . The present painter can be said to
work with chaos not only in the sense that he is handling
the chaos of the blank picture plane but also in that he is
handling the chaos of form. In trying to go beyond the
visible and the known world he is . . . engaged in a true
act of discovery in the creation of new forms and symbols
that will have the living quality of creation. . . . In his
will to set down the ordered truth, that is the expression
of his attitude towards the mystery of life and death, it
can be said that the artist like a true creator is delving
into chaos. It is precisely this that makes him an artist for
the Creator in creating the world began with the same
material, for the artist tries to wrest truth from the void."

The title of this painting, with its reference to man's
sublime and heroic nature, is in itself an affirmation of
Newman's mystical sense of the human condition.

FRANZ KLINE. American, 1910–1962.
Painting Number 2. 1954. Oil on canvas, 6 feet 8½ inches x 8 feet 9 inches. Mr. and Mrs. Joseph H. Hazen and Mr. and Mrs. Francis F. Rosenbaum Funds. [236.69]

In a work such as Kline's *Painting Number 2*, with its monumental size and austere scaffolding of powerful brushstrokes, gestural painting reached its apogee. In contrast to the densely woven network of thin lines in Pollock's *One* (page 140), here the white ground is as prominent as the bold black strokes. Though his work has sometimes been compared to Oriental calligraphy, Kline has pointed out that the white frequently cuts into and over the black, and he also declared that his work was firmly based on Western tradition, "the tradition of painting the areas which, I think, came to its reality here through the work of Mondrian—in other words, everything was equally painted—I don't mean that it's equalized, but I mean the white or the space is painted."

The impression of complete spontaneity that the picture gives is somewhat misleading. Kline usually worked from preparatory sketches, though his actual execution was rapid, retaining the sense of gesture. He used the large brushes of house painters as well as the smaller ones generally employed by artists, and he favored commercial enamels, both because they were quick-drying and because they offered the possibility of contrasts between matte and glossy surfaces.

Despite its abstraction, *Painting Number 2* evokes suggestions of machinery or urban structures like the steel girders of bridges or of buildings under construction. Coming to New York from his native Pennsylvania in 1939, Kline delighted in the city: "Hell, half the world wants to be like Thoreau at Walden worrying about the noise of traffic on the way to Boston; the other half use up their lives being part of that noise. I like the second half."

The painting is rendered almost entirely in black and white, with some touches of bluish-gray. Following its rejection by the Impressionists, black as a color has been highly esteemed by many twentieth-century artists. Matisse once said: "Black is a force: I depend on black to simplify the construction. . . . Doesn't my painting of *The Moroccans* use a grand black which is as luminous as the other colours in the painting? . . . Since the Impressionists it seems to have made continuous progress . . . comparable to that of the double-bass as a solo instrument." Among the Abstract Expressionists, both Pollock and de Kooning preceded Kline by creating many of their major paintings exclusively in black and white.

MARK DI SUVERO. American, born 1933.
Ladderpiece. 1961–62. Wood and steel, 6 feet
2½ inches x 15 feet 3 inches x 10 feet 10 inches (irregular). Gift of Philip Johnson. [510.84]

Di Suvero's constructions have often been compared to the paintings of Kline, and in fact he was deeply impressed by an exhibition of the older artist's work that he saw in 1953. The suggestion of beams and girders evoked by Kline's imagery becomes explicit in *Ladderpiece*, which is composed of waste products—an old ladder, discarded timbers, a chain, and steel rods bolted rather than welded together. Soon after coming to New York from California, di Suvero began to collect cast-off materials he found on the streets, and timbers and bolts picked up on the docks. Though the roots of his art go back to the use of "found objects" by Duchamp and the

Dadaists, nevertheless, as Robert Goldwater reminds us, di Suvero's style, in which sheer physical size is essential, comes from a later time: "Its open composition through which space flows, its strongly linear elements crossing at sharp angles, its concentrated blacks massed against uneven whites, all these reveal the proximity of abstract expressionism, whose irregular edges and drips seem here to have their wooden counterparts."

Ladderpiece owes its expressive power to the contrasts between the pliant wood and the rigid metal, and between its massive and its slender components. The swinging chain and leaning ladder suggest potential movement. The work cannot be apprehended from any single vantage point but requires the spectator to walk around it to view from different positions the interrelation of its separate parts, the angles they form, and the constantly changing interplay between solids and voids.

DAVID SMITH. American, 1906–1965.
Australia. 1951. Painted steel, 6 feet 7½ inches x 8 feet 11⅞ inches x 16⅛ inches; at base, 14 x 14 inches. Gift of William Rubin. [1533.68]

The Russian Constructivists transformed the age-old conception of sculpture in terms of mass and volume by opening up their works to space and making it an essential component of their theory and art. Other artists thereafter found another means of delimiting space by connecting lines and points; thus, Picasso in the 1920s made a number of constructions by joining the ends of iron-wire rods to form a series of transparent, intersecting and overlapping cages, as in his *Monument* of 1928, an enlarged version of which was made under his direction in 1972 from the original maquette. In *Lobster Trap and Fish Tail* (page 102), Calder used delicate steel wires to create a lighter, more buoyant kind of drawing in space.

David Smith in *Australia* welded together steel pieces to form a monumental creature like a menacing totem. He had learned the technique of welding when working as a riveter at the Studebaker plant in 1925 and was inspired to apply it to sculpture when, about 1931, he saw maga-

zine reproductions of some of Picasso's welded-metal pieces. He later said that this had been "the liberating factor which permitted me to start with steel which . . . until now only meant labor and earning power for the study of painting"—heretofore his chosen medium.

Australia departs from traditional sculpture not only because it replaces mass with space, with a resultant transparency, but also because it is meant to be viewed frontally like a drawing, rather than in the round. Almost nine feet long, it was by far the largest of the works that Smith had completed to date. The critic Rosalind Krauss has identified the subject as a kangaroo, but perhaps a more plausible interpretation is that offered by Edward Fry, who sees it as a bird. There appear to be obvious connections between *Australia* and a work titled *Jurassic Bird* (Private collection) that Smith made in 1945, based partly on the skeleton of a prehistoric creature he had seen in New York's Museum of Natural History, and a later version of the same theme, *Royal Bird*, a steel-and-bronze construction of 1948, now in the Walker Art Center, Minneapolis. Smith gave the work its title after receiving from his friend the critic Clement Greenberg photographs of prehistoric Australian cave drawings.

DAVID SMITH.
Zig VII. 1963. Painted steel, 8 feet ¼ inch x 8 feet 3½ inches x 7 feet 1¼ inches. Mrs. Simon Guggenheim Fund (by exchange) and gift of Candida and Rebecca Smith. [119.84]

In technique and conception, *Zig VII*, made a dozen years after *Australia*, exemplifies a completely different phase in Smith's development. Instead of metal rods welded together to form a linear composition, it is constructed of flat steel plates; instead of depicting a creature from the world of nature, its elements are abstract and geometrical; instead of being a transparent drawing in space to be viewed frontally, the work gives an impression of weight and solidity, and its composition, like that of di Suvero's *Ladderpiece* (page 143), cannot be apprehended from a single point of view but presents entirely different aspects as one walks around it.

Zig VII is one of seven works in a series whose name Smith explained was "an affectionate term for Ziggurat. Ziggurat is too big a word and . . . [Zig] seems more intimate, and it doesn't have to be as high as the towers of Babylon; but it is a vertical structure of more than one level." The Zigs have in common monumental scale and radical experimentation with structure and color. A striking feature of *Zig VII* is the sense of movement, imparted by its wheeled base and the tilting of its largest element, a square plane, at a forty-five-degree angle to form a diamond—a motif that Smith had previously used in his *Zig IV* of 1961, now in Lincoln Center for the Performing Arts. It has been suggested that precedents for this shape can be found within the Constructivist tradition, in some of Mondrian's diamond-shaped paintings of around 1918. The movable base, Smith said, was inspired by the wheels of Hindu temple reliefs and chariots. The round-

ness of the wheels is repeated in several circular elements or flat rings with holes in their centers, affixed to the diamond or its vertical support and painted in different colors. These colored circles derive from the Target paintings by Kenneth Noland, such as *Turnsole* of 1961, in which concentric rings of color are centered on a square white canvas. "I do not recognize the limits where painting ends and sculpture begins," Smith said. "Sometimes you deny the structure of steel, and sometimes you make it appear with all its force in whatever shape it is."

Most of Smith's sculptures after 1940 were made at his home in Bolton Landing in upstate New York and were meant to be seen in the open. "I like outdoor sculpture," Smith said, "and the most practical thing for outdoor sculpture is stainless steel, and . . . I polished them in such a way that on a dull day, they take on the dull blue, or the color of the sky in the late afternoon sun, the glow, golden like the rays, the colors of nature." One such burnished steel construction is *Cubi X*, made in the same year as *Zig VII*.

145

HELEN FRANKENTHALER. American, born 1928.
Jacob's Ladder. 1957. Oil on unprimed canvas, 9 feet
5⅜ inches x 69⅞ inches. Gift of Hyman N. Glickstein.
[82.60]

Frankenthaler, who represents the second generation of
Abstract Expressionist painters, early manifested her ex-
ceptional talent as a colorist, working principally in wa-
tercolor. She was influenced by Gorky's curving images

floating freely in open spaces, as in *Agony* (page 129),
and by de Kooning's brushwork (page 151), with its
overlapping passages of color and what John Elderfield
has called his "painterly transformation of Synthetic
Cubism's piece-to-piece method of composition." The
most decisive influence upon Frankenthaler, however,
came from Pollock's *One* (page 140) and his related
paintings of 1950–51. Their scale, graphic rhythms, and
allover patterning impressed her strongly, but above all
she was struck by Pollock's method of dripping paint
directly onto the raw canvas, emphasizing both the flat-
ness of the canvas and the physical actuality of the sup-
port. She later said that what she took from Pollock was
"the real concern with line, fluid line, calligraphy, and
my thoughts and experiments with line, not as line, but as
shape, or play on shape, or connecting shape, or color
shape acting as line."

Carrying Pollock's drip technique still further, Frank-
enthaler thinned her pigments with large quantities of
turpentine so that they soaked directly through the un-
primed cloth and stained it. The resultant images no
longer lie on top of the picture plane but are embedded
within it; the transparent, matte colors of varying inten-
sity modulate from light to dark without creating any
illusion that they exist in a space other than that of the
woven, textural surface. Frankenthaler also adopted Pol-
lock's practice of painting with the canvas stretched out
on the floor, allowing the artist to be "in" the picture,
work from all four sides, and produce a configuration
seen from above. Despite their large scale, her pictures
still retain the lyricism, blond tonalities, and light-filled
areas of watercolor. Her friend the poet and critic Frank
O'Hara said of her: "Frankenthaler is a daring painter.
She is willing to risk the big gesture, to employ huge
formats so that her essentially intimate revelations may
be more fully explored and delineated, appear in the hot
light of day."

The rectangles and circles in the lower half of *Jacob's
Ladder* may be reminiscences of Frankenthaler's early
training in the Cubist tradition, while the expressionist
abandon of the upper section recalls her admiration for
both Gorky and Kandinsky. These and other influences,
however, are all assimilated within a style of notable
originality.

Like many of Frankenthaler's paintings, this picture
contains within its abstract design certain allusive refer-
ences. Such images and their subconscious content are
generated spontaneously in the course of execution and
frequently suggest titles to her. Of this work she has said:
"The picture developed (bit by bit while I was working
on it) into shapes symbolic of an exuberant figure and
ladder, therefore *Jacob's Ladder*. (A favorite picture of
mine in the Prado is Ribera's *Dream of Jacob*.)"

MORRIS LOUIS. American, 1912–1962.
Third Element. 1962. Synthetic polymer paint on un-primed canvas, 7 feet 1¾ inches x 51 inches. Blanchette Rockefeller Fund. [200.63]

Louis began to experiment with soak-staining unprimed canvas after seeing works by Helen Frankenthaler while on a visit to New York in 1953. The technique and the possibilities it opened up led him to abandon his previous Cubist-derived style and develop in a wholly independent way his notable gifts as a colorist. But instead of creating cursive, expressionist shapes, such as those in Frankenthaler's *Jacob's Ladder*, which bear the traces of the artist's gesture and suggest references to the outside world, Louis evolved types of configuration that made the flat surface of the canvas an open field for color areas, asserting the supremacy of color itself as an optical reality.

As his medium, Louis chose a kind of synthetic polymer paint, fabricated to his specifications, that could be diluted almost to the consistency of watercolor and still retain its transparency, even when several layers were superimposed. He tacked his canvas to a stretcher that he manipulated so that he could control the flow of the poured pigments by tilting the canvas until he obtained the effect he desired.

A highly prolific artist, Louis continually experimented with the technique he had devised in successive series, which have been named by critics and not by the artist. In the Veil paintings, he allowed waves of paint to flow into and over one another in loosely defined, fluctuating shapes. In the Florals, the verticality of the Veils was replaced by a focus toward the center, as the colors were poured inward into the middle of the field, resulting in more isolated shapes that suggested to some the petals of a gigantic flower. By contrast, a centrifugal effect was produced in the Unfurled series, in which the pigments occupied symmetrical areas on opposite sides of the canvas, leaving a large unpainted expanse in the center, as in *Beta Lambda* of 1960.

Third Element is one among hundreds of paintings in the Stripe series, which preoccupied Louis in the last sixteen months of his life. Straight, vertical bands varying in width are grouped together and placed asymmetrically within the upright rectangle of the ground. The stripes do not overlap; each preserves its own identity within the group. Against the areas of raw canvas left bare at the edges, the colors, ranging from bright yellow to black, seem disembodied. In John Elderfield's words, "they present the illusion of an almost corrugated surface, until the visible weave of the canvas tautens it, pulling out its creases, as it were."

Louis often changed the direction in which these Stripes were hung, so that sometimes the rounded ends appear at the bottom instead of at the top. They are oriented not so much to gravity as to the verticality of the canvas. As the critic Clement Greenberg has emphasized: "The configurations . . . are not meant as images and do not act as images; they are far too abstract. They are there to organize the picture field into eloquence. . . . Louis is not interested in veils or stripes as such, but in verticality and color. . . . And yet the color, the verticality . . . are not there for their own sakes. They are there, first and foremost, for the sake of feeling, and as vehicles of feeling. And if these paintings fail as vehicles and expressions of feeling, they fail entirely."

147

STUART DAVIS. American, 1892–1964.
Visa. 1951. Oil on canvas, 40 x 52 inches. Gift of Mrs. Gertrud A. Mellon. [9.53]

In *Visa*, Davis made words the dominant subject matter of his painting. "We see words everywhere in modern life; we're bombarded by them," he said. "But physically words are also shapes. You don't want banal boring words any more than you want banal boring shapes or a banal boring life."

Davis's selection of words was based in part on their shapes and in part on their associations. This composition is one of several having as their central feature the word "champion," which was suggested by nothing more significant than the name of a brand of spark plugs printed on a book of matches. The final form of the letters, their color, and their arrangement, however, have no connection whatever with that source. Davis explained that he chose "else" because it answered his need for a short word that would have no specific associative meaning to divert the spectator's attention; it "nevertheless has a fundamental dynamic content which consists of the thought that something else being possible there is an immediate sense of motion as an integrant of that thought. Therefore the word 'else' is in harmony with the dynamic color intervals of the painting as a whole." The phrase "the amazing continuity," besides being necessary "to animate the area at the extreme right," refers to "the experience of seeing the same thing in many paintings of completely different subject and style"—a mysterious common factor that unites them as works of art. "Therefore, the content of this phrase is real," Davis said, "as real as any shape of a face or a tree." His signature in its distinctive script is also an integral part of the design, not an extraneous adjunct. As for the title *Visa*, he called it "a secret. Because I believe in magic."

Davis declared that all his pictures, including those that he painted in Paris in 1928–29, "have their originating impulse in the impact of the contemporary American environment,"—the tempo of New York, its ubiquitous signboards, its cacophony, and the basic rhythms of jazz. The bold, bright colors, combined with black and white, are applied in flat areas, with no textural effects to detract from the firm clarity of the design elements; nevertheless, by implying advancing and receding planes, they serve to establish spatial relationships.

FERNAND LÉGER. French, 1881–1955. In U.S.A. 1940–45.
Big Julie. 1945. Oil on canvas, 44 x 50⅛ inches. Acquired through the Lillie P. Bliss Bequest. [141.45]

As an artist-in-exile during the Occupation of France, Léger lived in the United States from 1940 to 1945 and, like Davis, was stimulated by the American environment. He traveled extensively across the continent and was impressed by the country's "vitality, its litter and its waste," its quest for novelty, its dynamism, and "the contrast between the mechanical and the natural." He discovered that "bad taste is one of the valuable raw materials of this country," and pointed out: "Bad taste—strong colors—it is all here for the painter to organize and get the full use of its power. Girls in sweaters with brilliant colored skin; girls in shorts dressed more like acrobats in a circus than one would ever come across on a Paris street. If I had only seen girls dressed in 'good taste' here I would never have painted my Cyclist series, of which *Big Julie* in The Museum of Modern Art was the culmination."

Needless to say, Léger transformed this raw material in accordance with his own predilections and distinctive style. *Big Julie* combines his love for machine forms and for the stylized human figure, manifest in such earlier works as *Exit the Ballets Russes* (page 74) and *Three Women* (page 97). Despite the extreme simplifications of drawing and modeling, and the use of gray and black instead of natural flesh tones, the cyclist is a far more supple and feminine creature than the stolid women at breakfast in the latter canvas. Léger's fondness for clearly defined patterns is evident throughout *Big Julie*, in combination with strong colors chosen to show off the shapes of the figures and objects to full advantage. The black background at the left contrasts sharply with the cyclist's gray body, red hat with spiky cockade, and orange suit, against which is silhouetted a big yellow flower with green leaves. At the right, a dark red cross is superimposed on a yellow background. The color and angularity of these shapes serve as foil for the woman's rounded arm and the rhythmic, interlacing curves of her bicycle. The two blue butterflies are gay accents punctuating the black and yellow fields.

149

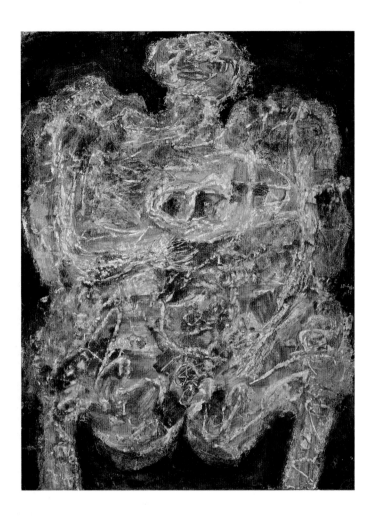

JEAN DUBUFFET. French, 1901–1985.
Corps de Dame: Blue Short Circuit. 1951. Oil on canvas, 46⅛ x 35¼ inches. The Sidney and Harriet Janis Collection. [593.67]

From the standpoint of female pulchritude, the naked women in Dubuffet's Corps de Dame series are even more shockingly repellent than those in Picasso's *Demoiselles d'Avignon* (page 35). But Dubuffet explained that he had other criteria in mind when painting this theme: "The female body, of all objects in the world, is the one that has long been associated (for Occidentals) with a very specious notion of beauty (inherited from the Greeks and cultivated by the magazine covers); now it pleases me to protest against this aesthetic, which I find miserable and most depressing. . . . The beauty of an object depends on how we look at it and not at all on its proper proportions. . . . Certain people believe the mood of my art to be bitter. These people have seen that I intend to sweep away everything we have been taught to consider—without question—as grace and beauty, but have overlooked my effort to substitute another and vaster beauty. . . . I would like people to look at my work as an enterprise for the rehabilitation of scorned values and, in any case, make no mistake, a work of ardent celebration."

In a romantic quest for the wellsprings of "true art," Dubuffet repudiated classical canons in favor of "barbaric" art and rejected controlled and rational means of expression for those that were automatic, spontaneous, and even psychotic. Believing that creative impulses operate independently of cultural conventions, he collected, exhibited, and extolled what he called *l'art brut*—the raw expressions of primitives and the insane. Besides his "anticultural position," Dubuffet's other major preoccupation was a passionate concern with materials and their properties. Abandoning traditional mediums, he endlessly developed new substances or "pastes" and worked his surfaces with his fingers, incised them with sticks, or incorporated into them heterogeneous stuff.

In *Corps de Dame: Blue Short Circuit*, the figure is cut off below the knees and crowded within the dimensions of the canvas. The head is small and flat, the body bloated. The tiny breasts are rendered in relief and encircled in blue, as is the navel; the exposed pubic area is emphasized as in paleolithic sculptures of the Earth Mother or fertility goddesses. If we are to find in this picture the beauty that Dubuffet would have us see, we must not judge the image as we would judge a living woman, but rather take pleasure in his vigorous rendering, with its swirling contours and exuberant handling of materials. As the title implies, the work is informed with an electric tension. The medium is generally fluid, but in certain areas it is worked into a thick impasto, with incised lines. The high-keyed, rosy color is intended to evoke the body's vital fluids.

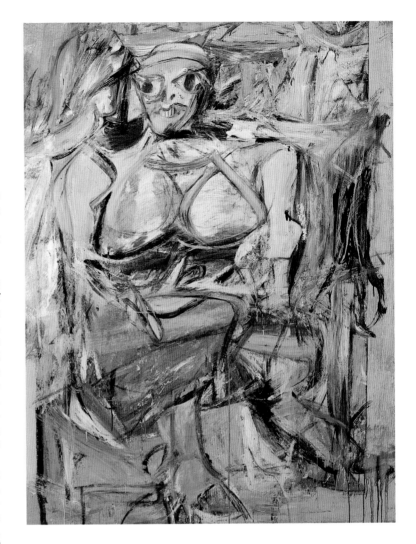

WILLEM DE KOONING. American, born the Netherlands 1904. To U.S.A. 1926. Naturalized American citizen 1963.
Woman, I. 1950–52. Oil on canvas, 6 feet 3⅞ inches x 58 inches. Purchase. [478.53]

At the very time that Dubuffet was involved with his Corps de Dame series, de Kooning, a leading member of the Abstract Expressionist group in New York, was struggling to create this, the first of his Women series. Besides producing quantities of preparatory drawings and studies, de Kooning was continually painting and repainting the canvas in what Harold Rosenberg has called a "synthesis of will and chance," allowing accidental effects to coexist with those deliberately planned. He worked on the picture for over two years before considering it completed, and at the last moment he added a strip to the right side of the canvas so that the figure would be off center.

If Dubuffet's *Corps de Dame: Blue Short Circuit* is a celebration of some primordial, timeless Earth Mother, de Kooning's *Woman, I* is a savage travesty of the aggressive modern female. De Kooning says he had in mind the long classical tradition of woman as "the idol, the Venus, the nude," but, like Davis, he was also keenly aware of the contemporary American environment and incorporated into his images references to such idols as pinup girls and the banal stereotypes found in billboard and magazine advertisements. These allusions are apparent in the large, ogling eyes, overdeveloped breasts, and toothy grin of *Woman, I* (in one study for the picture, de Kooning actually pasted onto the canvas a color reproduction of a mouth cut from a cigarette ad). The final figure certainly seems far more predatory than seductive; but if *Woman, I* reveals de Kooning's hostility toward womankind, he is said to have been disappointed that, when it was first exhibited, nobody noticed its comic aspect.

Obviously, de Kooning was at least as much concerned with the paint medium itself, and his handling of it, as with the subject he portrayed. In this respect, his attitude toward creative expression is analogous to the approach of Dubuffet. In *Woman, I* the brushstrokes do not, for the most part, outline the forms or model them in a conventional way. They seem to have an independent life of their own, animating the entire surface with overlapping passages of pure color, so that one fragment of the canvas— or one part of the body—seems almost interchangeable with any other. The painting is, in fact, replete with ambiguities, such as the tension between the three-dimensional figure and the purposefully unidentifiable environment in which it is seated. De Kooning observed that the woman's form reminded him strongly "of a landscape—with arms like lanes and a body of hills and fields, all brought up close to the surface, like a panorama squeezed together."

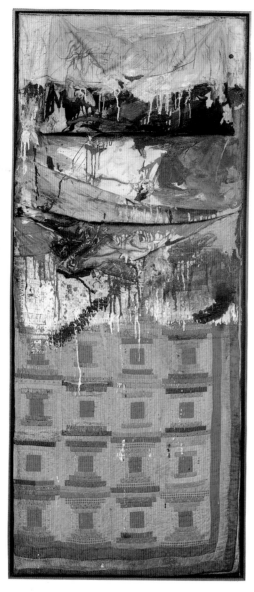

ROBERT RAUSCHENBERG. American, born 1925.
Bed. 1955. Combine painting: oil and pencil on pillow,
quilt, and sheet on wooden supports, 6 feet 3¼ inches x
31½ inches x 8 inches. Fractional gift of Leo Castelli in
honor of Alfred H. Barr, Jr. [79.89]

When Rauschenberg came to New York in 1949, he was
too poor to buy conventional artists' materials and, like
di Suvero (see page 143), began to collect cast-off debris
from the city streets, which he assembled into three-
dimensional collages. He coined the word "combine" to
describe his technique of attaching onto the support dis-
parate objects with unexpected associations.

One of the earliest of these Combines is *Bed*. Waking
up one morning in 1955, he was eager to paint but lacked
canvas or the money with which to buy it. He seized a
shabby old quilt that he had brought with him from the
South, mounted it onto a stretcher with the sheet and
pillow from his bed, and began to paint. Like Bearden
(see page 81), he was attracted by the color and patch-
work pattern of the quilt, but its design of squares-
within-squares was also reminiscent of the Homage to
the Square series of Albers (page 138), who had been his
teacher at Black Mountain College in North Carolina.

Even more important was the influence of the com-
poser John Cage, to whose ideas Rauschenberg had been
exposed when at Black Mountain College as an artist-in-
residence in 1952. Cage stressed "randomness" by incor-
porating into his compositions such "accidental" sounds
as the noise of a passing truck, and he advocated accep-
tance of the contemporary environment and the integra-
tion of art and life. Rauschenberg articulated these con-
cepts in a much-quoted dictum, "Painting relates to both
art and life. . . . (I try to act in that gap between the two)."

The manner in which the paint is applied in *Bed* reveals
still another influence. The free, gestural brushwork,
with its splashes, clots, and drips, clearly derives from
Abstract Expressionism; but *Bed* breaks with the tenets
of that movement by incorporating recognizable objects
and rupturing the flatness of the picture plane.

Bed has a coherence and energy comparable to that of
the best Abstract Expressionist works. When it was first
exhibited in 1958, however, it stirred heated controversy.
Some were shocked that Rauschenberg had "deliberately
chosen to use materials that were ugly or dirty. . . . To
some it looked like the scene of a bloody ax murder," and
the Italian authorities removed it from an exhibition of
works by young American artists at the Festival of Two
Worlds at Spoleto. These reactions puzzled Rauschen-
berg, who had only the pleasantest associations with the
quilt. "I think of the *Bed* as one of the friendliest pictures
I've ever painted," he said. "My fear has always been
that someone would want to crawl into it." In accepting it
as a gift to the Museum from Leo Castelli, Kirk Varne-
doe, Director of the Department of Painting and Sculp-
ture, said: "*Bed* is a work of unique stature and
importance. Truly an icon of postwar American art, it
brings together the painterly style of the Abstract Ex-
pressionists and a new openness to found materials. Like
several other of Rauschenberg's works of the period, *Bed*
has been regarded both as a sign of a revived interest in
the principles of earlier Dada experiments, and as a har-
binger of the concerns of American art in the 1960s.
And, beyond questions of historical rubric, it is a sin-
gularly arresting, and still unsettlingly vivid, work of
art."

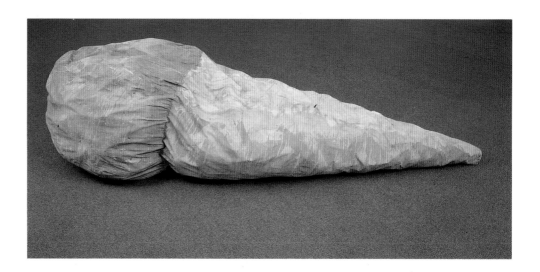

CLAES THURE OLDENBURG. American, born Sweden 1929. To U.S.A. 1936. Naturalized American citizen 1953.
Floor Cone (Giant Ice-Cream Cone). 1962. Synthetic polymer paint on canvas filled with foam rubber and cardboard boxes, 53¾ inches x 11 feet 4 inches x 56 inches. Gift of Philip Johnson. [425.81]

Coming to New York from Chicago in 1959, Oldenburg, like Rauschenberg and many other young artists of his generation, enthusiastically embraced the city's vibrant environment, particularly that of the dilapidated Lower East Side where he lived. In 1961, he rented a storefront in which to present The Store. Its inventory consisted of merchandise available in the neighborhood—clothing such as women's stockings, shoes, tights, girls' dresses; foodstuffs; advertisements and signs like *7-Up* and *39 Cents*. These objects were made of muslin soaked in plaster over a wire frame, with ragged edges to indicate that they were, in Oldenburg's words, "fragments . . . 'torn' from reality," and they were brightly colored with enamel dripped and spattered in the manner of Abstract Expressionist painting.

The following year Oldenburg was invited to present an exhibition at the Green Gallery uptown on prestigious Fifty-seventh Street. Realizing that the small size of The Store pieces could not adequately fill the ample gallery space available, and admiring the way in which automobiles occupied a nearby showroom, he decided to enlarge his objects to the size of cars.

Besides gigantic scale, his second innovation was his medium. Going beyond Rauschenberg's use of soft materials in the *Bed*, Oldenburg constructed fully three-dimensional objects out of pieces of cloth stitched together, stuffed with foam rubber and paper cartons, and painted. Sculpture that was soft and pliable rather than hard and immutable was as radical a departure from tradition as Calder's introduction of movement in his mobiles, and it shared with that invention a dependence on chance and change. As the mobile is activated by air currents, a soft piece such as *Floor Cone* rests on the ground and depends upon gravity, which Oldenburg called "my favorite form creator." "The possibility of movement of the soft sculpture, its resistance to any one position, its 'life' relate it to the idea of time and change."

Critics were enraged by the brashness and vulgarity of the exhibition, which they castigated for embracing what they regarded as the most objectionable features of America's consumer society. They failed to comprehend how significantly these disconcerting objects challenged preconceptions of art and reality. Enlargement to colossal proportions makes the viewer consider the relation between his own size and that of the object, and both of these in relation to the surrounding space. The material's wrinkled, uneven surface also invites the sense of touch, establishing a personal involvement with the piece. Furthermore, soft sculpture is a kind of metaphor which, in Oldenburg's words, stands for "a state of nature, a condition that I want to represent above all—the large formal realm of softness, which one's own body suggests."

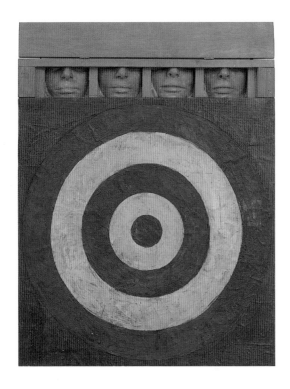

JASPER JOHNS. American, born 1930.
Target with Four Faces. 1955. Assemblage: encaustic on newspaper and cloth over canvas, 26 x 26 inches, surmounted by four tinted plaster faces in wood box with hinged front. Box 3¾ x 26 x 3½ inches, closed; overall dimensions with box open, 33⅝ x 26 x 3 inches. Gift of Mr. and Mrs. Robert C. Scull. [8.58]

From about 1955 to 1960, Johns lived in the same building on the Lower East Side as Rauschenberg, and the two engaged in daily conversations and discussions about one another's work. Both had been influenced by Cage's ideas about effacing the boundaries between life and art. In his Combines, such as *Bed* (page 152), Rauschenberg introduced objects virtually unchanged. By contrast, in his early works Johns created simulacra of simple, banal objects such as the two Ballantine ale cans in his *Painted Bronze, II* of 1960 (Collection of the artist).

In his first exhibition at Leo Castelli's gallery in 1958, Johns showed a number of paintings of completely flat objects, *Target with Four Faces* among them. Taking a familiar object such as a flag or a target, he contravened its flatness by giving it an uneven surface, using a complex medium of pigments mixed in melted wax and applied over newsprint with broken strokes derived from Abstract Expressionism. Stretching from side to side so that its edges are almost tangential to those of the sup-

port, the target fills the whole of the pictorial space, thus eliminating any vestiges of illusionism. Johns explained that taking something already designed, like a flag or a target, that "the mind already knows," gave him "room to work on other levels"; and he chose "objects so familiar that the spectator can cease to think about them and concentrate on the poetic qualities of the picture itself."

Paradox and ambiguity are the distinguishing characteristics of *Target with Four Faces*. A target would normally have the flattest possible coat of paint, not the varied texture that Johns has given its surface. Furthermore, in looking at a target one tends to focus on the bull's-eye; Johns countered this tendency by giving the enframing square a strong red color to deflect one's gaze. He then topped the flat canvas with a box divided into four compartments, each containing a three-dimensional head painted orange. These are not identical casts, but differ slightly from one another, and their tops have been cut off at a point below the eyes. Johns provided them with a narrow horizontal container with a hinged top that can be left open or shut.

Target with Four Faces has certain fortuitous similarities to Ernst's *Blind Swimmer* (page 29); both have an emblematic quality, a symmetrical composition built around concentric circles, and a reference to sightlessness. Ernst's image, however, originated in a figure of speech and was intended to evoke poetic associations to its literary content, whereas Johns's target is a commonplace, man-made, universal object. Johns's mentor Cage wrote that the key to an understanding of the artist's works is the way he allows them to evolve during execution: "The end is not in view; the method (the way one brush stroke follows another) is discursive. . . . Not in order through consideration to arrive at a conclusion. . . . A target needs something else. Anything in fact will do to be its opposite. Even the space in the square in which it is centrally placed. This undivided seeming leftover area miraculously produces a duplex symmetrical structure. Faces."

Johns has resisted critics' attempts to interpret his paintings and refused to admit that they have any latent significance. It is nevertheless impossible for the spectator to disregard the associations that this mysterious icon evokes and respond only to its formal qualities. What is meant by the strange juxtaposition of the target and the four eyeless casts of a single face? And what is the implication of the hinged top that can be raised to reveal them or else shut to hide them from our view?

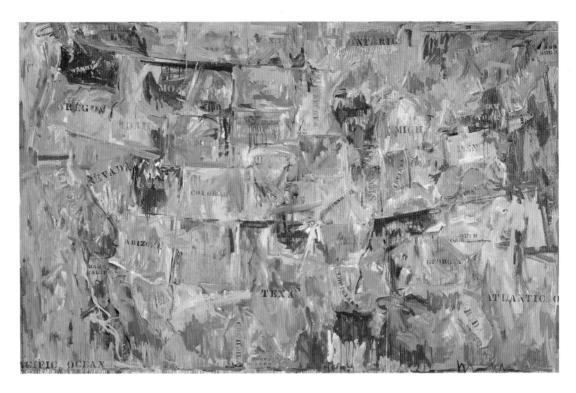

JASPER JOHNS.
Map. 1961. Oil on canvas, 6 feet 6 inches x 10 feet 3⅛ inches. Gift of Mr. and Mrs. Robert C. Scull. [277.63]

In *Map*, Johns carried ambiguities and paradoxes still further than in *Target with Four Faces*. Taking an equally familiar object—a map of the United States—he completely altered and disguised it by an overlay of bright colors laid on in broken, overlapping strokes. The normal conventions of cartography would demand clearly drawn boundaries between the states, each with its name legibly described and distinctively tinted to differentiate it from its neighbors; shading to indicate mountains and valleys; and blue to distinguish water from land. Here, every one of these devices is subverted. Though the states and bodies of water are in their correct positions, and their limits are respected, only some are labeled, with partially obliterated lettering. Colors and brushstrokes create shading that has nothing to do with topography, and the blue ordinarily reserved for oceans and lakes floods the continent and is contrasted with its complementary, orange.

Again, as in *Target with Four Faces*, Johns is concerned with process rather than with the end result, as Cage makes clear: "He had found a printed map of the United States that represented only the boundaries between them. . . . Over this he had ruled a geometry which he copied enlarged on a canvas. This done, freehand he copied the printed map, carefully preserving its proportions. Then with a change of tempo he began painting quickly, . . . here and there with the same brush, changing brushes and colors, and working everywhere at the same time, . . . going over it again, and again incompletely. Every now and then using stencils he put in the name of a state . . . but . . . as he continued working he often had to do again what he had already done. . . . And this necessitated the repetitions, Colorado, Colorado, Colorado, which were not the same being different colors in different places. I asked how many processes he was involved in. He concentrated to reply and speaking sincerely said: It is all one process."

Johns admired Duchamp's "wit and high common sense, . . . his brilliantly inventive questioning of visual, mental, and verbal focus and order"; and the entire concept of *Map* manifests a kinship with Duchamp's irony and love of paradox. As in *Target with Four Faces*, there is an obvious derivation from Abstract Expressionism in the free, gestural handling of paint, and Analytic Cubism is also evoked in the retention of a subject that becomes recognizable if one decodes the system that fragments its constituent parts. The pleasure that *Map* offers the spectator is intellectual as well as aesthetic; it challenges him to participate in a balancing act between what the eye perceives and the preconceptions called into question.

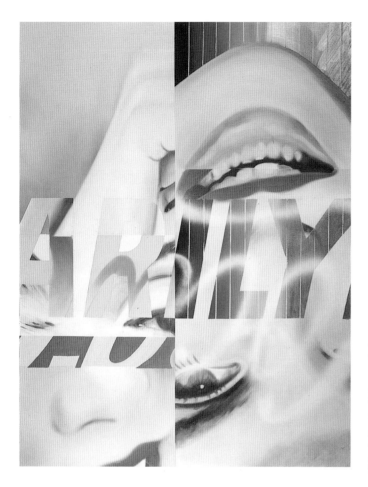

James Rosenquist. American, born 1933.
Marilyn Monroe, I. 1962. Oil and spray enamel on canvas, 7 feet 9 inches x 6 feet ¼ inch. The Sidney and Harriet Janis Collection. [646.67]

Even more specifically than Davis's *Visa* (page 148), *Marilyn Monroe, I* reflects the visual impact of outdoor advertising signs. Rosenquist, in fact, earned his living for several years as a sign painter, perched high on scaffolds above Broadway and other sites in New York while he worked on enormous billboards. Though he had attended art schools, Rosenquist has said that it was actually from his commercial experience that he learned the properties of paint. The billboards also affected his sense of scale. He discovered that if an image, such as the fragment of a face or an object, is painted in gigantic scale, it becomes as immediately unrecognizable as if it were brought up directly under the viewer's nose. As Oldenburg, too, recognized (see page 153), gross enlargement alters our perception of things, making us

question the nature of our vision and the assumptions that we make about reality.

Rosenquist was one of the first of a number of young artists who around 1960 came to terms with the most vulgar banalities of modern urban life and America's industrialized landscape by incorporating them into their art. The public and the majority of critics at the time tended to see this chiefly as a reaction to Abstract Expressionism and a return to representation. Concentrating on the themes portrayed, they failed to perceive the formal qualities inherent in the work of the so-called Pop artists. Rosenquist, however, has stated firmly that the objects he paints do not, as such, constitute his subject: "The relationships between them may be the subject matter, the relationships of the fragments I do. The content will be something more . . . will, hopefully, be fatter, balloon to more than the subject matter. One thing, though, the subject matter isn't popular images, it isn't that at all."

This portrait of the ill-fated film star was painted shortly after her death. Her face, fragmented and divided among compartments as if it were a collage, appears upside down behind the huge silvery letters of her name, partially spelled out, as is the word "Coca-Cola" that drifts across it like skywriting. By this juxtaposition, Rosenquist subtly implies that Marilyn Monroe's fame had entrenched her in American iconography as firmly as the soft drink, thus making her an equally expendable consumer product. He recalls having painted the picture in an exceptionally short time, "as short as her career and her life."

156

ANDY WARHOL. American, 1928–1987.
Gold Marilyn Monroe. 1962. Synthetic polymer paint, silkscreened, and oil on canvas, 6 feet 11¼ inches x 57 inches. Gift of Philip Johnson. [316.62]

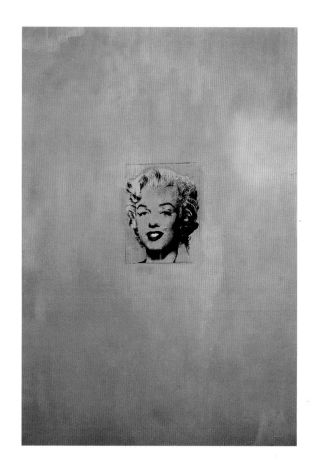

From the early 1960s until the time of his death, Warhol became arguably America's best-known artist, as much by virtue of his notoriously exhibitionist behavior as by the works that he produced. The result was that, as with other Pop artists, overmuch attention was focused on his subject matter—which included within its wide range comic strips, commercial products, celebrities, flowers, cows, current events, and political figures such as Chairman Mao—thus deflecting serious consideration of the formal qualities of his art.

Warhol's subjects are, of course, important, but beyond the circumstance that they are immediately recognizable by the public at large are the questions *why* he selected them and *how* he depicted them. *Gold Marilyn Monroe* is one of a large number of his portrayals of the equally notorious actress. From the age of about six, he had collected autographed photographs of film stars, beginning with his contemporary Shirley Temple. His many representations of Marilyn Monroe are within the context of several of his preoccupations in the early 1960s. First, like Rosenquist, who equated her with Coca-Cola, he regarded her as an object of mass consumption, like the Campbell's soup cans that are among his best-known images. Second, Monroe, whom he depicted shortly after her suicide, was, like Elizabeth Taylor and Jacqueline Kennedy, a celebrity known for beauty and glamour but doomed to suffer highly publicized personal tragedies. Simultaneously, Warhol was producing numerous other works that dealt with death and disaster—execution in the electric chair, airplane and automobile crashes, and nuclear holocaust.

That these personages and events were so familiar to the public was, of course, due to the mass media. Kierkegaard said: "Ours is an age of advertisement and publicity. Nothing ever happens but there is immediate publicity everywhere." Warhol frequently took news photographs as his point of departure. His portraits were never done from life but always through the intermediary of an existing photograph, which was then still further removed from the living model by photomechanical enlargement and silkscreening onto canvas, in a procedure that he began to adopt in 1962. The printing and coloring of these images, often repeated serially in rows of squares, was usually left to assistants. Both the individuality of the subject and that of the artist himself were negated by this process; but the images vary from repetition to repetition according to the color and quantity of ink used and the amount of pressure with which it was applied, with resultant nuances in both texture and hue.

The basis for all Warhol's Marilyn Monroe portraits was a cropped publicity still for the 1953 film *Niagara*. He showed her in single, double, and multiple images, or just her seductively parted lips alone, colored in turquoise, green, blue, lemon yellow, or black and white. Among all these representations, *Gold Marilyn Monroe* is unique. Isolated in the center of the canvas, the star's head is surrounded by a wide expanse of gold, as if it were the object of veneration in a Byzantine icon. Warhol had used gold earlier, in a 1952 collage of women's slippers included in an exhibition called "Andy Warhol: The Golden Slipper Show" at the Bodley Gallery in New York, and the following year he presented a series of blotted-ink line drawings on paper covered with gold leaf in "Show of Golden Pictures by Andy Warhol."

Kynaston McShine has described the portrait: "This sensuous radiance transforms the unhappy Marilyn Monroe of real life—the victim of abuse, failed marriages, affairs, and finally suicide. In Warhol's paintings of her, the very human and vulnerable Marilyn becomes a symbolic image of the need for love and to be loved."

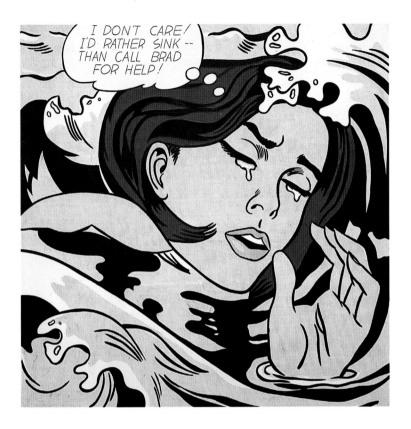

Roy Lichtenstein. American, born 1923.
Drowning Girl. 1963. Oil and synthetic polymer paint on canvas, 67⅝ x 66¾ inches. Philip Johnson Fund and gift of Mr. and Mrs. Bagley Wright. [685.71]

The imagery and techniques of commercial art are an even more obvious point of departure for *Drowning Girl* than for Rosenquist's *Marilyn Monroe* (page 156). When in the early 1960s Lichtenstein first exhibited paintings such as this, based on comic strips, the shock to accepted ideas of what constitutes "art" and the contrast with the still-prevailing style of Abstract Expressionism were so great that, as with other Pop artists, the formal qualities of his works were almost entirely overlooked.

With ironic humor, Lichtenstein selected images that are both stereotyped and ubiquitous in our culture. Even more remote from living models than Warhol's silk-screened portraits, his prototypes are neither living persons nor photographs, but flat representations already far removed from naturalism by the artificial conventions of cartooning. Highly decorative and abstract, cartoon style has in large part been determined by the requirements of cheap commercial printing. It is characterized by a few primary colors, applied either in flat areas or with benday dots for shading and tinting, and by drawing with broad outlines to mask the overlapping of colors that may occur when many thousands of copies are rolled off the presses. In this picture, the blue of the girl's hair—the same color as that used for the dots in the waves—still further removes from the subject any sense of reality.

By isolating one frame from a comic strip's serial mode of narration and enlarging the figure to over life-size, Lichtenstein greatly enhanced the impact that his image has upon the viewer. Furthermore, he did not slavishly copy that model but altered it by such devices as cropping, by manipulating its forms into a uniform, all-over pattern, and exaggerating certain features of its style. Lichtenstein has pointed out that, intentionally or not, cartooning already resembles other kinds of art, and he makes these similarities more explicit and recognizable: "In the *Drowning Girl*, the water is not only Art Nouveau, but it can be seen as Hokusai. . . . I saw it and then pushed it a little further until it was a reference that most people will get." Another such reference is the suggestion of Seurat's pointillist technique (see page 17) implicit in the simulated benday dots. These can be read in two ways, as Lichtenstein has noted: "Dots can mean printed surface and therefore 'plane' but in contradiction, particularly in large areas, they become atmospheric and intangible—like sky."

The balloon caption is incorporated as a functioning element of the total design. There is an inherent paradox in the incongruity between the urgent emotional content of its message and the picture's wholly depersonalized style and technique; but the emotion conveyed is in itself as trite and synthetic as that in comic strips and soap operas.

158

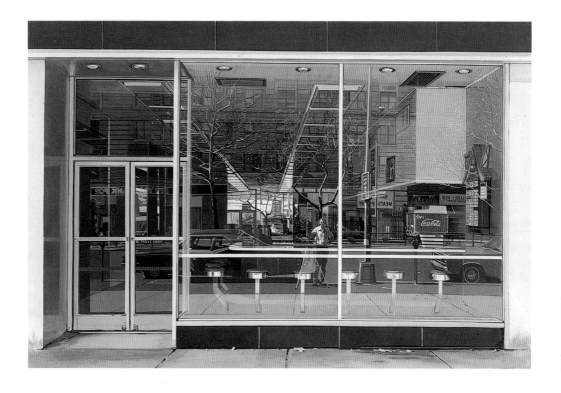

RICHARD ESTES. American, born 1936.
Double Self-Portrait. 1976. Oil on canvas, 24 x 36 inches.
Mr. and Mrs. Stuart M. Speiser Fund. [594.76]

Double Self-Portrait belongs to a tendency that arose in the late 1960s, which because of its literal transcription of banal images taken from the modern environment became known as Super Realism or Photo-Realism. Like Warhol, Estes makes photographs his point of departure; he takes color slides and blows them up so that he can see details with greater clarity, but his painting is anything but realistic. Whereas Charles Sheeler imposed upon the scene he had photographed for his *American Landscape* (page 113) a classical, abstract order, Estes's picture with its profusion of overlapping visual information defies us to sort out exterior from interior, as we simultaneously see the surface of the plate-glass façade, what is behind it, and what it reflects. The sharp focus throughout only intensifies our bewilderment. "I don't like to have some things out of focus and others in focus because it makes very specific what you are supposed to look at, and . . . I want you to look at it all," Estes says. He applies oil glazes over acrylic underpainting to give the surfaces a sensuous texture that mitigates the image's icy precision.

The locale of *Double Self-Portrait* is the corner of Eighty-sixth Street and Broadway, New York, looking at and into a Chock Full o' Nuts coffee shop that has since been torn down. We see clearly a small segment of the pavement, the shop's glass door and façade divided into rectangles by shiny bands of metal and bordered by blue tiles, the row of stools, the edge of the curved counter, the Coca-Cola machine, the price list posted at the right, and the overhead lights and air vents. Beyond that, everything is confusion, as we try to isolate these elements from the reflections and re-reflections of objects outside: parked automobiles, iron palings, the trunks and thin leafless branches of trees, the façades and signs of a bank, a clothing shop, a butcher's, and two images of Estes himself with camera and tripod—the second one as reflected by the plate glass at the restaurant's far wall.

Just as Lichtenstein's isolation and enlargement of his figure and the ambiguity of his benday dots alter the way in which we read his image, so Estes's painting, too, concerns perception: the interaction between our retinal responses and our mental concepts, and the extent to which the latter modify our notions of reality.

159

GEORGE SEGAL. American, born 1924.
The Bus Driver. 1962. Figure of plaster over cheesecloth; bus parts including coin box, steering wheel, driver's seat, railing, dashboard, etc.; figure, 53½ x 26⅞ x 45 inches; overall, 7 feet 5 inches x 51⅝ inches x 6 feet 4¾ inches. Philip Johnson Fund. [337.63a–u]

Though Segal has often been grouped with the Pop artists and included with them in exhibitions, his sensibilities and intentions set him apart. Typically, what concerns him is the individual human being, its expressive or occupational gesture, and its immediate situation within the environment.

After ten years as a painter in an expressionist mode, Segal became increasingly interested in space. Rather than trying to depict it illusionistically on canvas, he decided to make life-size figures out of armatures, wire mesh, and burlap dipped in plaster, and to accompany them with real objects, which, he said, were "not props, but rather plastic presences powerful in their own right." In July 1961, a student in one of his painting classes at a community center, whose husband worked in the Johnson & Johnson laboratories, brought him a sample of a recently perfected bandage made to facilitate the setting of broken bones. Seeing its potential for his sculpture, Segal used himself as model, wrapped his body in bandages, and had his wife apply a plaster coating.

The Bus Driver was one of Segal's earliest works in this new medium. He conceived the idea one evening when, returning to his chicken farm in New Jersey, he took a bus from the Port Authority Bus Terminal driven by a grim, sullen, and arrogant man. "I really wanted to order the air around him and give him the dignity of helplessness—a massive, strong man, surrounded by machinery, and yet basically a very unheroic man trapped by forces larger than himself that he couldn't control and least of all understand," Segal said. He found a junked vehicle lying on its side in a Newark scrap yard and cold-chiseled from it the parts for his sculpture. He always uses relatives or friends as models; for *The Bus*

Driver, the sitter was his brother-in-law, a teacher of physics. Segal's process is an exacting one, both for the subject, who after being encased in the wet bandages must hold the pose for as long as forty minutes while they are layered with plaster, and for the artist, who must painstakingly reassemble and join together the removed parts of the casing in order to form the whole figure. The finished work is not an impression of the mold's interior, as it would be in a bronze made by the lost-wax process, but rather of its exterior. Segal modulates the surface of the plaster so that, as he says, "in a sense it's my own version of drawing or painting. . . . It bears not the work of my hand so much as the mark of my decisions in emphasis." The texture is varied by drips like those in Abstract Expressionist painting, and some of the underlying net casing is allowed to show through.

Segal regrets that viewers tend to focus only on the figures, for what interests him is "a series of shocks and encounters that a person can have moving through space around several objects placed in careful relationship. . . . The peculiar shape and qualities of the actual empty air surrounding the volumes becomes an important part of the expressiveness of the whole piece. . . . My pieces often don't end at their physical boundaries."

In contrast to Oldenburg's soft sculptures with their suggestions of mobility and the softness of the human body (see page 153), Segal's white plaster figures have been called "vital mummies" and likened to the hapless victims of Pompeii, frozen forever in their final attitudes at the moment when Etna's lava engulfed them. Segal says that though many people find them shocking, "The whiteness intrigues me; for all its special connotations of disembodied spirit, inseparable from the fleshy corporeal details of the figure." Contemplating his sculptures forces us to rethink our definition of realism, for, in the words of Phyllis Tuchman: "Segal's ghostly, catatonic figures put the viewer at a distance. They are like us, and yet they are not of our world. . . . A feeling is evoked . . . of being an unexpected guest at a hallucinatory event in ordinary life."

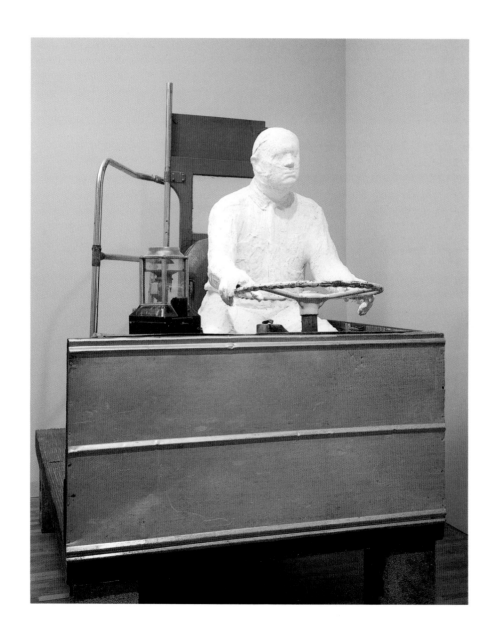

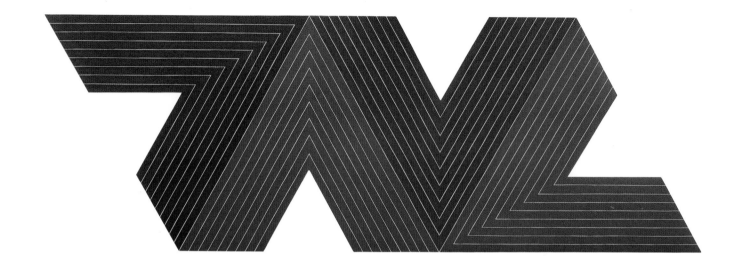

Frank Stella. American, born 1936.
Empress of India. 1965. Metallic powder in polymer emulsion on shaped canvas, 6 feet 5 inches x 18 feet 8 inches. Gift of S. I. Newhouse, Jr. [474.78]

Though other modern artists had departed from the use of a traditional rectangular or circular support, Stella was the first to make the shape of his canvas coincide with the pattern painted upon it. The palpable reality of such a "shaped canvas" emphasizes its existence as a tangible object and not as the depiction of something else.

Stella typifies the detached "cool" generation of the 1960s that reacted against the "romanticism" of Abstract Expressionism, with its mythic and heroic implications. Though he admired Pollock's allover compositions, such as *One* (page 140), Newman's frontal paintings with their evenness of surface and minimal visual incident (page 141), and Rothko's symmetrically arranged, simplified, yet expressive shapes (page 139), Stella wished to expunge from his own paintings any vestiges of illusionistic space. He was impressed by the Flag paintings in Johns's first show in 1958 (see page 154), saying that "the thing that struck me most was the way he stuck to the motif . . . the idea of stripes—the rhythm and interval—the idea of repetition," but he did not want to retain any gestural brushwork, as Johns and Rauschenberg had.

The Black series that Stella produced in 1959 and 1960 consisted of paintings with parallel black lines two-and-a-half inches wide, separated by very narrow strips of unpainted canvas, arranged in symmetrical patterns and painted with commercial black enamel. In his next series, the Aluminum paintings, he used metallic paints and shaped his canvases by cutting small notches in the areas where the stripe patterns met the framing edge.

Empress of India belongs to a still later series, the Notched V paintings. They take their titles from British clipper ships; Stella spoke of them as "flying wedge" pictures, and the critic Robert Rosenblum noted that, as their names suggest, they imply dynamic movement and speed, and their ancestry goes back to the Futurists' "lines of force." This work is composed of four juxtaposed V-shaped sections, symmetrically placed, each segment containing nine evenly spaced bands arranged in concentric chevrons. The metallic particles in four closely valued tones of paint radiate luminosity that reflects the light differently, according to the direction of the brushstrokes. This creates an illusory ripple effect that makes the entire surface seem to be in motion.

In a 1964 interview, Stella declared: "My painting is based on the fact that only what can be seen there *is* there. . . . All I want anyone to get out of my paintings . . . is the fact that you can see the whole idea without any confusion. . . . What you see is what you see." To exclude "interpretation," however, is not to deny sensuous pleasure: "The worthwhile qualities of painting are always going to be both visual and emotional, and it's got to be a convincing emotional experience. Otherwise, it will not be a good—not to say, great—painting."

Donald Judd. American, 1928–1994.
Untitled. 1968. Five open rectangles of painted steel spaced approximately 5⅛ inches apart, each 48⅜ inches x 10 feet x 20¼ inches; overall, 48⅜ inches x 10 feet x 10 feet 1 inch. Mr. and Mrs. Simon Askin Fund. [715.68a–e]

Judd was a leading practitioner and outstanding theoretician of Minimalism, one of the most radical among the reactions to Abstract Expressionism that developed in the 1960s. The quest for a means of expression based on drastically simplified, universally comprehensible forms can be traced to Malevich's Suprematism, which he called "the new realism in painting" (see page 50). In making what he called "specific objects," Judd's aims were parallel to those of Stella: "What you see is what you see." With its five evenly spaced painted-steel rectangles, this construction might be thought of as a translation into three dimensions of one of Stella's Black paintings with their stripes separated by narrow intervals of unpainted canvas.

The components of this work, and similar ones having a different number of units, are identical, and they are arranged one behind the other, separated by identical spaces. In other works Judd used a vertical application of the same principle, stacking a number of boxes of the same size one above the other, with equal distances between them. The intention is to confront the viewer with a "presence" that stimulates his awareness of its shape and scale in relation to his kinesthetic sense of his body and the surrounding space of their common environment.

The Minimalists object to what they consider to be the falsely negative emphasis of the term "reductive" as applied to their art. They stress that for every value they reject, they would substitute an equally valid one: 1) the exploration of new approaches vs. a continuation of what they regard as an outworn European tradition; 2) the creation of self-contained objects vs. those with references to associative meanings in the outside world; 3) the creation of objects that are "real" in themselves vs. those with a "reality" produced illusionistically; 4) the making of objects that are immediately comprehensible as a whole, with equal and symmetrical components, vs. those composed by the balancing of varying constituent parts; 5) anonymity through the use of neutral, industrially produced materials vs. the revelation of the artist's personality through the residual evidence of his handling of the material; 6) repetition, serialization, and simplification vs. variety and complexity; 7) clear, unequivocal statements vs. ambiguity or the possibility of alternative, subjective interpretations; 8) creation of objects that involve the beholder's sense of his own body and the environment vs. a self-sufficient work that exists irrespective of the viewer.

Though one of his own works might be rationally conceived before being executed, Judd said: "Even if you can plan the thing completely ahead of time, you still don't know what it looks like until it's right there. . . . You can think about it forever in all sorts of versions, but it's nothing until it is made visible."

TONY SMITH. American, 1912–1980.
Cigarette. 1961 (fabricated 1971 from a maquette of 1961). Painted steel, 15 feet 1 inch x 25 feet 6 inches x 18 feet 7 inches. Mrs. Simon Guggenheim Fund. [114.73]

Though Tony Smith has often been classed with the Minimalists, in fact his premises and the resulting works are entirely different from theirs. Instead of making clear, symmetrical objects that can be immediately apprehended, such as Judd's Untitled, Smith created irregular shapes that, like David Smith's *Zig VII* (page 145) or di Suvero's *Ladderpiece* (page 143), present the viewer with completely different appearances as he walks around them. He said, "They may be seen as interruptions in an otherwise unbroken flow of space." Whereas the Minimalists wished their works to be devoid of any extraneous references, Smith thought of his pieces as inscrutable and mysterious "presences" that conjure up associations in his own mind and that of the beholder. Though, like the Minimalists, he sought to create an "awareness of oneself as existing in the same space as the work," he did not want his sculptures to be placed within the confines of an architectural interior but preferred them to be seen in an outdoor setting, so that "trees or plants, rocks, can combine with the piece in forming space around it." The forms of *Cigarette* derive from an inanimate object rather than from living organisms, but in its openness, mutability of aspects, and relation to the environment it offers interesting analogies to Moore's *Large Torso: Arch* (page 21).

Smith was a painter for many years and, though never formally trained as an architect, he served for a while as an apprentice to Frank Lloyd Wright. Between 1940 and 1960, he designed several residences and projects for unexecuted monuments, while continuing to paint and

holding several teaching positions. Through Wright, he became interested in modular planning, but after reading some theoretical writings and discovering the kites, towers, and other structures made by Alexander Graham Bell in 1901, he began to experiment with more complex, less symmetrical units. He found himself moving "farther and farther from considerations of function and structure toward speculation in pure form," which he said was the domain of sculpture rather than of architecture. By the mid-1950s he also became dissatisfied with painting, which seemed to him too pictorial and wholly irrelevant to his new preoccupation with scale, monumentality, and the environment.

Instead of making preliminary drawings, Smith worked from three-dimensional maquettes, "because I don't have any sense of how a piece is going to turn, or even if it is going to turn, until the end." Like the Surrealists and the Abstract Expressionists, many of whom were his friends, Smith believed that his structures resulted from "processes which are not governed by conscious goals but almost come into existence by some kind of spontaneous generation." He described the genesis of *Cigarette*: "I had set out to make a serious piece of sculpture, and thought I had done so. Upon seeing the smooth plaster model, I realized that I had been taken in by the irregularities of the paper one. The piece was redundant, and had the look of a war memorial. Stripping away everything but the spine, I wound up with a cigarette from which one puff had been taken, before it was ground out in the ashtray." His first thirteen-inch-high maquette of 1961 was followed in 1966 by plywood models in half and then full size, from which the Cor-ten steel structure was fabricated. One cast, placed outside the Albright-Knox Art Gallery in Buffalo, was left unpainted and has weathered to a rich brown; the Museum's has been painted black, like most of Smith's work.

ANSELM KIEFER. German, born 1945.
The Red Sea. 1984–85. Oil, lead, woodcut, photograph, and shellac on canvas, 9 feet 1¾ inches x 13 feet 11⅜ inches. Enid A. Haupt Fund. [211.85]

Born in 1945 just as the Second World War came to its close with the crushing defeat of Hitler's Third Reich, Kiefer grew up when Germany was struggling to rebuild itself and establish its place in the postwar world. The problem for artists was to create an art affirming a national identity, cognizant of achievements in the recent and more distant past but transcending them in a new and meaningful way better suited to the present.

For Kiefer, this led to a search for relevance in ancient myths and historical events. His approach was philosophical and spiritual, like that of Marc, but it was totally devoid of that artist's romanticism. Kiefer believed that Germany could find redemption and be made whole again only by confronting all the sins and tragic losses of her past and accepting responsibility for them.

From about 1973 Kiefer began to create huge, theatrical paintings, in which the symbolic significance of the landscape or architectural setting was equal to that of the figures and episodes portrayed. The surfaces of his pictures became increasingly complex as he used a variety of materials—oil, lead, sand, straw, woodcuts and photographs, blackened and roughened by charring.

Following a trip to Israel in 1984, the Old Testament account of the Exodus became an important source for Kiefer and led to a series of Departure pictures, among them *The Red Sea.* In the center of the painting, a large zinc tub filled with a red liquid links two Biblical events: the first plague visited upon the Egyptians, when Aaron's rod smote the waters and turned them to blood, and the parting of the Red Sea, which allowed the fleeing Israelites to pass safely through before closing to drown the pursuing Pharaoh and his hosts. The tub also has another ironic, more recent historical reference. It alludes to the zinc baths that the Nazis allocated to German households to raise standards of hygiene and was a symbol Kiefer had used earlier in his Operation Sea Lion series—a code name for Hitler's misguided plan to cross the Channel and invade Britain. The folly of Pharaoh and of the Nazis and their punishment by divine justice were thus equated, while for the Jews their figurative baptism in the Red Sea initiated a new and more hopeful beginning. The landscape below is blackened and scorched, but at the top of the canvas appears a white cloud that will lead the children of Israel in their wanderings through the desert. Affixed to the canvas are strips of lead, a material that Kiefer often used metaphorically as the base metal that alchemists sought to transmute into gold. With its layers of meaning and intricately wrought surface, *The Red Sea* exemplifies Kiefer's ability to fuse subject, underlying content, and tangible substances into a powerful visual and intensely physical entity.

SANDRO CHIA. Italian, born 1946.
The Idleness of Sisyphus. 1981. Oil on canvas in two parts, overall, 10 feet 2 inches x 12 feet 8¼ inches. Acquired through the Carter Burden, Barbara Jakobson, and Saidie A. May Funds and purchase. [418.81a–b]

In contrast to the tragic overtones and spiritual intensity with which Kiefer deals with legendary themes of the past, Chia here treats the classical myth of Sisyphus with a tongue-in-cheek insouciance. Sisyphus was the crafty king of Corinth who, after incurring the wrath of Zeus, escaped from Hades by tricking Thanatos. After he was recaptured, the gods devised a punishment to keep him in the underworld forever; he was required to push a huge rock up a mountain, but whenever he neared the summit, the stone rolled back down, obliging him to repeat this wearisome task throughout eternity.

The protagonist in Chia's canvas is no heroic figure from antiquity but an ineffectual little man with an inane expression, wearing a tight-fitting business suit and with a tiny fedora perched atop his head. What can be the meaning of this odd rendition of the Sisyphus myth? It may be relevant to note that Chia was born one year after Kiefer, in another country that had been defeated in the war. Though Italy, like Germany, made a remarkable economic recovery in the postwar years, it has had an unparalleled succession of governments able to sustain themselves only briefly in power, and its bureaucracy is notorious for its ability to paralyze initiatives. The Italian word *pigrizia* means not only idleness but also futility, uselessness, and pettiness. Perhaps, therefore, we may read the mountain up which Chia's cartoonlike figure toils as made up of an accumulation of scrapped papers, and the burden he so ineffectually pushes as composed of a mass of official forms and documents.

Chia has provided this rather trivial subject with a two-part canvas over ten feet high and twelve feet wide and has lavished upon it a richly varied coloration. The surface is textured with thickly applied pigment, and the sky is enlivened with calligraphic scribblings. The chevron-shaped brushstrokes that appear throughout the mountain recall the Futurists' "lines of force," comparable to those in Balla's *Street Light* (page 122), while the cross-hatching and scratching in the sky was influenced by the technique of the American painter Cy Twombly, a resident in Rome since the late 1950s.

Like many younger painters today, Chia feels at liberty to adapt and mingle past styles without regard to chronology. In 1980, he said: "We are living in an historic period where the sensation of accumulation is very strong. . . . The present is like the entire history of art. . . . We should work in tranquility upon this accumulation, this labyrinth of styles. . . . We must find a way to travel inside this labyrinth, getting freely in and out of it."

167

DAVID SALLE. American, born 1952.
Géricault's Arm. 1985. Oil and synthetic polymer paint
on canvas, 6 feet 5⅞ inches x 8 feet ¼ inch. Gift of the
Louis and Bessie Adler Foundation, Inc., Seymour M.
Klein, President; Agnes Gund Fund; Jerry I. Speyer
Fund; and purchase. [285.86]

For Salle, as for Chia, all the art of the past constitutes a
vast grab bag from which the artist is free to pluck
objects, motifs, and styles and combine them at will. The
term "postmodernism" has been coined to describe an
art that, in Kristin Olive's words, "no longer claims mod-
ernist logic, autonomy, purity, or unity. Instead, post-
modernist art accentuates its dependence on outside
references, quoted images, and disharmony of parts.
David Salle is exemplary of these characteristics. . . . He
tantalizes the viewer with bits of information that carry
many meanings without providing the viewer with a legi-
ble reading. . . . The task of assigning meaning is trans-
ferred to the viewer, but as Salle knows and emphasizes,
no single interpretation can be devised."

In *The Art of Assemblage*, William C. Seitz quotes
Bergson's *Introduction to Metaphysics*: "Many diverse
images, borrowed from very different orders of things,
may, by the convergence of their action, direct the con-
sciousness to the precise point where there is a certain
intuition to be seized. By choosing images as dissimilar
as possible, we shall prevent any one of them from usurp-

ing the place of the intuition it is intended to call up."
"Classic" modern art provides many precedents for
Salle's approach. The Dadaists and Surrealists jux-
taposed wholly unrelated elements to shock or confuse
the viewer or to effect a poetic transformation, as is the
case for example with Miró's *Object* (page 69). One might
also apply to Salle's paintings what Cage wrote of
Rauschenberg's Combines (see page 152): "There is no
more subject in a combine than there is in a page from a
newspaper. Each thing that is there is a subject. It is a
situation involving multiplicity."

Every element in Salle's *Géricault's Arm* was appropri-
ated from a pre-existing printed source. In the upper right
corner of the canvas, and giving the work its title, are an
arm and a foot copied from a color plate of one of
Géricault's studies of severed limbs. The two life-size
views of a nude at right and left are painted blowups of
photographs, probably taken from among the large quan-
tity of such images that Salle took with him when he left
the pornographic magazine *Scrap*, for which he worked
as paste-up artist in 1976 and 1977. The object within the
rectangular white field in the center of the picture has
been likened to a children's toy, but Peter Schjeldahl, a
critic who has written extensively on Salle, identifies it as
"a stridently cheerful painting of a Futurist ceramic,
improbably colored (it was copied from a black-and-
white photograph)." Its bright rings of color against the
white panel contrast with the painting's black back-
ground, the yellowish flesh of the putrefying arm and
foot, and the grayish-sepia tonality of the nudes.

As in a painting by Caravaggio, the figures are the-
atrically lit, and they have been brought forward to the
front plane of the picture as if we were observing them
from a position close to a stage. Salle was influenced by
film making, and he is also a very active stage designer;
he has created sets and costumes for the choreographer
Karole Armitage, as well as for operas and ballets.

Salle's paintings have frequently been criticized as por-
nographic, but the grisaille nudes in *Géricault's Arm*
seem far from seductive, and since their eyes are not
shown, they do not entice the beholder with the provoca-
tive gaze of strip-teasers. Is the pose with underpants
pulled down more "indecent" than the similar gesture of
the woman disrobing at the left in Derain's *Bathers*
(page 34), whose breasts, furthermore, are exposed as
those in Salle's painting are not? Or is it simply that we
are more disquieted by the photographic "realism" that
makes us acutely aware of our confrontation with a live
model? "The point about the poses in my work," Salle
says, "is that they are the body in extremes—often seen
from a strange point of view and spatial orientation. It has
more to do with the abstract choreography and angles of
vision than with pornographic narrative."

Jennifer Bartlett. American, born 1941.
Swimmer Lost at Night (for Tom Hess). 1978. Two silk-screen on baked-enamel-on-steel units, each composed of 20 steel plates 12 x 12 inches, placed 1 inch apart, hung diagonally; and two oil on canvas panels, each 48½ x 60⅛ inches, also hung diagonally; overall, 6 feet 6 inches x 26 feet 5 inches. Mrs. George Hamlin Shaw Fund. [850.78a–pp]

In Jennifer Bartlett's work, two seemingly contradictory tendencies exist side by side: an analytical, systematic approach and a spontaneous, experimental inclination for risk-taking. Like many artists whose styles developed in the late 1950s and 1960s, such as Johns, Louis, and Stella, she works in series, setting herself problems to solve and ambitious projects to undertake. Unlike their works, however, Bartlett's are replete with personal references; not coincidentally, she is also the author of a thousand-page autobiography brashly entitled *The History of the Universe*.

In 1968, becoming impatient with the cumbersome paraphernalia of oil paints, canvas, and stretchers, she conceived the idea of adopting as supports modular units—one-foot-square steel plates coated with baked-on white enamel, onto which she had professional jobbers silkscreen a grid of light gray lines, suggested by the graph paper she had been using for her drawings. For her medium she chose a type of enamel sold mainly in hobby shops for making model cars and planes. She employed this technique in successive series of works; in 1976, she filled the Paula Cooper Gallery in New York with nearly a thousand squares, on which were variations on four stylized figurative images—a house, a tree, a mountain, and the ocean—and three nonfigurative shapes—a square, a circle, and a rectangle. These were organized into six sections, in each of which Bartlett established a "color problem" by combining the twenty-five colors according to a formula—a physical mix, a retinal mix, or layering.

The *Swimmer Lost at Night (for Tom Hess)* is one among twenty large paintings in the Swimmers series that engaged Bartlett from 1977 to 1978. The subject was a natural choice for her, since she had been brought up on the Pacific Coast in southern California and had a brother who was an Olympic swimmer. This work is a memorial to her friend the critic Thomas B. Hess, who had written a perceptive review of her work, and who had recently died suddenly (not by drowning, but of a heart attack) shortly after having been appointed a curator at The Metropolitan Museum of Art. The dual format was an innovation, two of the four units being executed in enamel on steel and the other two in oil on canvas, so that the shiny surface of one pair contrasts with the matte surface of the other. The swimmer is an abstract, elliptical pink form; in John Russell's words, in this "panorama of panic and loss . . . the vulnerable figure turned over and over in a waste of turbulent water [is] a metaphor for pain and anguish." Short, parallel curves designate the water; the black background is filled with bright dots and a tic-tac-toe pattern of intersecting horizontal and vertical strokes that overlap the body of the swimmer. The pairs of enameled and painted units, hung diagonally and with tangent corners, are installed on two walls at right angles to one another. As with Tatlin's Corner Constructions and Gabo's *Head of a Woman* (page 39), the viewer is drawn into the enfolding space and thus experiences a more direct and immediate confrontation with the tragic event.

MARCEL DUCHAMP. American, born France. 1887–1968. In U.S.A. 1915–18, 1920–23, 1942–68. Naturalized American citizen 1955.
To Be Looked At (From the Other Side of the Glass) with One Eye, Close To, for Almost an Hour. 1918. Oil paint, silver leaf, lead wire, and magnifying lens on glass (cracked), 19½ x 15⅝ inches, mounted between two panes of glass in a standing metal frame, 20⅛ x 16¼ x 1½ inches, on painted wood base, 1⅞ x 17⅞ x 4½ inches. Katherine S. Dreier Bequest. [150.53]

While still in his twenties, Duchamp determined to get away from the physicality of painting and "put painting once again at the service of the mind" by creating works that would appeal to the intellect rather than to the retina.

To Be Looked At is a study for the upper right section in the lower half of Duchamp's *Bride Stripped Bare by Her Bachelors, Even* (the *Large Glass*) (Philadelphia Museum of Art)—the culminating work in his preoccupation with the theme dealt with in *The Passage from Virgin to Bride* (page 58). While *To Be Looked At* goes back to ideas with which Duchamp had been concerned since 1912, it also marks the beginning of his growing interest in the study of optics, which he was to pursue in the 1920s. (If such an interest seems to run counter to his scorn for the "retinal," this is only one among the innumerable paradoxes that abound throughout Duchamp's career.)

The portion of the *Large Glass* for which this is a study is devoted to the "oculist witnesses" of the Bride's disrobing. Typical of Duchamp's fondness for puns is the fact that *témoins oculistes* is also the French term for "eye charts." Besides being an instruction to the voyeurs of an anticipated titillating event, the full title, which is written on the diagonal bar, was also meant to sound like an oculist's prescription. Compliance with this direction by gazing fixedly through the magnifying lens attached to the glass would produce hallucinatory experiences like those provoked by Duchamp's optical machines, such as *Rotary Demisphere (Precision Optics)* of 1925.

Another kind of optical effect in *To Be Looked At* is created by the overlapping of the parallel red, yellow, blue, and green lines in the pyramid. Instead of appearing continuous, they seem to break at the angles of intersec-

tion. Duchamp created still a further illusion, that of three-dimensional depth, by using scientifically studied perspective to render the pyramid, the obelisk shape below the lens, and the rays that fan out around its base. He said, however, that he actually wished the *Large Glass* to be a kind of projection of the fourth dimension, which the eye cannot perceive.

The most novel feature of *To Be Looked At*, of course, is that, like *The Bride Stripped Bare by Her Bachelors, Even*, it is painted on glass. With this innovation, Duchamp not only did away with the conventional background for a painting but also provided one that changes according to what is seen through and beyond it. The work of art, therefore, does not create an environment for the spectator, as does Monet's *Water Lilies* (pages 22–23) or later wall-size paintings such as Newman's *Vir Heroicus Sublimis* (page 141). Instead, the environment is absorbed by, and becomes part of, the work of art, whose transparency makes it subject to constant change and the laws of chance. The breaking of this glass, and of *The Bride Stripped Bare by Her Bachelors, Even*, were accidents that Duchamp had not foreseen; nevertheless, in the case of the latter happening, he expressed delight both at the aesthetic effect produced by the silvery cracks and at the intervention of chance in his work.

The cultivation of chance and accident in art is only one of the ideas from Duchamp's inexhaustible store that has continued to stimulate artists to this day. Among many others, we may mention his efforts to construct metaphors for abstract ideas and for processes that take place in time, and his elevation to the status of art of "found" objects, which he called "Readymades." But undoubtedly Duchamp's major contribution was his incessant challenging of all the usual assumptions about life and art, which forces artists and the public alike to a continual reappraisal of accepted values. As John Tancock wrote in 1973: "To the degree that Duchamp embodied conflicting possibilities, that he was a 'one man movement but a movement for each person and open to everybody,' he succeeded in influencing artists of the most diverse persuasions, and no more so than at the present time. . . . Almost fifty years after the period of Duchamp's greatest productivity, the issues raised by his work still make him an inescapable point of reference."

SOURCES

Grateful acknowledgment is made to the sources listed below for the use of quotations on the pages indicated.

P. 7. Christian Zervos, "Conversation avec Picasso," *Cahiers d'Art* (Paris), vol. 10, no. 10, 1935, pp. 173–78; quoted in English trans. in Alfred H. Barr, Jr., *Picasso: Fifty Years of His Art* (New York: The Museum of Modern Art, 1946), p. 274.

P. 8. Van Gogh, Letter No. 652 to Theo van Gogh, found on his person July 29, 1890; pub. in English trans. in *Further Letters of Vincent van Gogh to His Brother Theo, 1886–1889* (New York and Boston: Houghton Mifflin, 1929), p. 488.

P. 9. Duchamp, "The Creative Act," speech delivered at convention of American Federation of Arts, Houston, Tex.; pub. in *Art News* (New York), vol. 56, Summer 1957, pp. 28–29.—Van Gogh, Letter No. 531 to Theo van Gogh, early Sept. 1888, *Further Letters,* p. 165.—Matisse, "Notes of a Painter" (1908); pub. in English trans. in Alfred H. Barr, Jr., *Matisse: His Art and His Public* (New York: The Museum of Modern Art, 1951), p. 122.—Steinberg, "Contemporary Art and the Plight of Its Public," based on a lecture given at The Museum of Modern Art, New York, Spring 1960; pub. in Leo Steinberg, *Other Criteria: Confrontations with Twentieth-Century Art* (New York: Oxford University Press, 1972), pp. 10, 15–16.—Marianne Moore, "When I Buy Pictures," in *Collected Poems of Marianne Moore,* copyright 1935 by Marianne Moore, renewed 1963 by Marianne Moore and T. S. Eliot, p. 48 (repr. with permission of Macmillan Publishing Co.).

P. 10. Matisse, statement, July 1951; quoted in E. Tériade, "Matisse Speaks," *Art News Annual* (New York), no. 21, 1952, p. 62.

P. 11. Étienne Gilson, *Painting and Reality,* The A. W. Mellon Lectures in Fine Arts, vol. 4 (New York: Pantheon Books, 1957), p. 299.

P. 13. Rousseau, letter to the mayor of Laval, July 10, 1898; pub. in English trans. in *Henri Rousseau,* essays by Roger Shattuck, Henri Béhar, Michel Hoog, and Carolyn Lanchner and William Rubin (New York: The Museum of Modern Art, 1985), p. 140.—Jean Cocteau, sale catalogue of John Quinn Collection, Hôtel Drouot, Paris, Oct. 28, 1926; quoted in English trans. in Alfred H. Barr, Jr., ed., *Masters of Modern Art* (New York: The Museum of Modern Art, 1954), p. 13.

P. 18. Barr, *Masters of Modern Art,* p. 30.

P. 19. Van Gogh, Letters (to Theo van Gogh) No. 583, April 1889; No. 516, early August 1888; No. 517, n.d.; No. 572, Jan. 19, 1889, *Further Letters,* pp. 309–10, 129, 132, 278.

P. 20. Rodin, quoted in English trans. in Albert E. Elsen, *Rodin* (New York: The Museum of Modern Art, 1963), p. 93.—*Ibid.,* p. 103.—Michelle Facos in Lynne Ambrosini and Michelle Facos, *Rodin: The Cantor Gift to The Brooklyn Museum* (New York: The Brooklyn Museum, 1987), p. 130.—Elsen, *Rodin,* p. 101.

P. 21. Rodin, statement, 1915; quoted in English trans. in Elsen, *Rodin,* p. 174.—Moore, letter to Alfred H. Barr, Jr., Aug. 19, 1965, The Museum of Modern Art, collection records.—Moore, letter to Betsy Jones, May 21, 1970, The Museum of Modern Art, collection records.—Moore, quoted in David Finn, *Sculpture and Environment* (New York: Harry N. Abrams, 1976), p. 342.

Pp. 22–23. Monet, letter to Gustave Geffroy, June 22, 1890, in Gustave Geffroy, *Claude Monet, sa vie, son oeuvre* (Paris: Crès, 1924), vol. 2, p. 24; quoted in English trans. in William C. Seitz, *Claude Monet* (New York: Harry N. Abrams, 1960), p. 150.—Monet; quoted in Roger Marx, "Les Nymphéas de M. Claude Monet," *Gazette des Beaux-Arts* (Paris), sér. 4, vol. 1, 1909, p. 529.

P. 24. Duranty, "La Nouvelle peinture," pamphlet concerning a group of artists exhibiting at Durand-Ruel Galleries, Paris, 1876; quoted in English trans. in John Russell, "The Vocation of Édouard Vuillard," in ex. cat. "Édouard Vuillard," Toronto, Art Gallery of Ontario, 1971, p. 18.

P. 26. Ensor, speech at exhibition of his works, Jeu de Paume, Paris, June 1932; pub. in English trans. in Paul Haesaerts, *James Ensor* (New York: Harry N. Abrams, 1959), p. 357.

P. 28. Goldwater, *Symbolism* (New York: Harper & Row, 1979), p. 29.

P. 29. Ernst, "An Informal Life of M. E. (as told by himself to a young friend)," in William S. Lieberman, ed., *Max Ernst* (New York: The Museum of Modern Art, 1961), p. 9.—Ernst, *Beyond Painting,* The Documents of Modern Art (New York: Wittenborn, Schultz, 1948), pp. 9, 11.—Ernst, "An Informal Life of M.E.," p. 18.

P. 32. Cézanne, English trans. of quotation in Émile Bernard, "Souvenirs sur Paul Cézanne," *Mercure de France* (Paris), Oct. 1 and 16, 1907; repr. in P. M. Doran, ed., *Conversations avec Cézanne* (Paris: Collection Macula, 1978), p. 63.

P. 33. Monet, quoted in M. Georges-Michel, *De Renoir à Picasso* (Paris: Fayard, 1954), p. 24; cited in John Rewald, *Cézanne: The Late Work* (New York: The Museum of Modern Art, 1977), p. 402.

P. 34. Marcel Nicolle, *Journal de Rouen*; quoted in Barr, *Matisse*, p. 55.—Louis Vauxcelles, in *Gil Blas* (Paris), March 20, 1907; quoted in John Elderfield, *The "Wild Beasts": Fauvism and Its Affinities* (New York: The Museum of Modern Art, 1976), p. 112.

P. 35. Picasso, quoted in André Malraux, *Picasso's Mask*, English trans. June Guicharnaud with Jacques Guicharnaud of *La Tête obsidienne* (New York: Holt, Rinehart and Winston, 1976), p. 18; cited by William Rubin, "Picasso," in William Rubin, ed., *"Primitivism" in 20th Century Art* (New York: The Museum of Modern Art, 1984), vol. 1, p. 255.—Leo Steinberg, "The Philosophical Brothel," Part II, *Art News* (New York), vol. 71, Oct. 1972, p. 45.—Rubin, "Picasso," p. 252.—Barr, *Picasso*, p. 56.

P. 36. Braque, quoted in "Braque: La Peinture et nous, Propos de l'artiste recueillis par Dora Vallier," *Cahiers d'Art* (Paris), vol. 29, Oct. 1954, p. 14; cited in William Rubin, *Picasso and Braque: Pioneering Cubism* (New York: The Museum of Modern Art, 1989), p. 47.

P. 37. Braque, quoted in "Braque: La Peinture et nous," p. 16; quoted in English trans. in Douglas Cooper and Gary Tinterow, *The Essential Cubism: Braque, Picasso & Their Friends, 1907–1920*, (London: The Tate Gallery, 1983), p. 64.

P. 39. Gabo, "Realistic Manifesto," Aug. 5, 1920; repr. in English trans. in *Gabo* (Cambridge, Mass.: Harvard University Press, 1957), p. 152.

P. 40. "Initial Manifesto of Futurism," *Le Figaro* (Paris), Feb. 20, 1909; quoted in English trans. in Joshua C. Taylor, *Futurism* (New York: The Museum of Modern Art, 1961), p. 124.—"Futurist Painting: Technical Manifesto," April 11, 1910; quoted in English trans. in *ibid.*, pp. 125–26.—Bergson, *An Introduction to Metaphysics*, pub. in Italian trans. 1909; trans. T. E. Hulme (London: Macmillan, 1913), pp. 1–2.; quoted in English in John Golding, *Boccioni: Unique Forms of Continuity in Space* (London: The Tate Gallery, 1985), p. 10.

P. 41. Boccioni, "Technical Manifesto of Futurist Sculpture," April 11, 1912; quoted in English trans. in Taylor, *Futurism*, pp. 130–31.—*Ibid.*, p. 93.—Marinetti, "Initial Manifesto of Futurism," in *ibid.*, p. 124.

P. 42. Fritz Novotny and Johannes Dobai, *Gustav Klimt*, English trans. Karen Dega Philippson (London: Thames and Hudson; New York: Frederick A. Praeger, 1968), no. 155.

P. 44. Kokoschka, letter to Dorothy C. Miller, Oct. 4, 1953, The Museum of Modern Art, collection records.

P. 45. August Hoff, *Wilhelm Lehmbruck: Life and Work* (New York and Washington: Frederick A. Praeger, 1969) [English trans. of 2nd German ed. of 1961], p. 255.

P. 46. Compton, in ex. cat. "Chagall," London, Royal Academy of Arts; Philadelphia Museum of Art, 1985, p. 167.—Chagall, *My Life*, English trans. of *Ma Vie*, 1931; quoted in Franz Meyer, *Chagall* (New York: Harry N. Abrams, 1963), p. 41.

P. 48. Kupka, interview with W. Warshawsky, *New York Times*, Oct. 19, 1913, p. 4; cited by Meda Mladek, "Central European Influences," in ex. cat. "František Kupka 1871–1957: A Retrospective," New York, The Solomon R. Guggenheim Museum, 1975, p. 31.

P. 49. Delaunay, notebooks, 1939–40, English trans. of quotation in Robert Delaunay, *Du Cubisme a l'art abstrait*, ed. Pierre Francastel (Paris: S.E.U.P.E.N., 1957), p. 81.—*Ibid.*—Klee, "Die Ausstellung modernen Bundes im Kunsthaus Zürich," *Die Alpen* (Berne), vol. 6, Aug. 1912, p. 700; quoted in English trans. in *Three Generations of Twentieth-Century Art: The Sidney and Harriet Janis Collection of The Museum of Modern Art* (New York: The Museum of Modern Art, 1972), p. 18.

P. 50. Malevich, "From Cubism and Futurism to Suprematism: The New Realism in Painting," in K. S. Malevich, *Essays on Art 1915–1928*, trans. Xenia Glowacki-Prus and Arnold McMillin, ed. Troels Andersen (Copenhagen: Borgen, 1968), vol. 1, p. 37.—*Ibid.*, p. 24.—Malevich, "Suprematism," Part II of *The Non-Objective World*, English trans. Howard Dearstyne (Munich: Bauhaus Books, 1927), vol. 11, p. 96.—Malevich, statement in ex. cat. "Tenth State Exhibition," Moscow, 1919: quoted in Camilla Gray, *The Great Experiment: Russian Art 1863–1922* (New York: Harry N. Abrams, 1962), p. 226.

P. 51. Brancusi, quoted in Sidney Geist, *Brancusi: A Study of the Sculpture* (New York: Hacker Art Books, 1983), p. 38.

P. 57. Schwitters, "Kurt Schwitters Katalog," *Merz 20* (Hanover), March 1927; quoted in English trans. in William S. Rubin, *Dada, Surrealism, and Their Heritage* (New York: The Museum of Modern Art, 1968), p. 53.—Schwitters, "Merz" (1920), repr. in English trans. in Robert Motherwell, ed., *The Dada Painters and Poets* (New York: Wittenborn, Schultz, 1951), p. 59.—Rubin, *Dada, Surrealism, and Their Heritage*, p. 53.

P. 58. Duchamp, quoted in James Johnson Sweeney, "Eleven Europeans in America," *Museum of Modern Art Bulletin* (New York), vol. 13, 1946, p. 20.—Letter from Duchamp to Alfred H. Barr, Jr., Feb. 21, 1963, The Museum of Modern Art, collection records.

P. 59. Picabia, paraphrased in interview with Hutchins Hapgood, "A Paris Painter," *The Globe and Commercial Adviser* (New York), Feb. 20, 1913, p. 8; repr. in *Camera Work* (New York), nos. 42–43, April–July 1913, pp. 50, 51.

P. 60. Shchukin, letter to Henri Matisse, March 31, 1909; quoted in English trans. in Barr, *Matisse*, p. 133.—John Elderfield, *Matisse in the Collection of The Museum of Modern Art* (New York: The Museum of Modern Art, 1978), p. 57.

P. 61. Information paraphrased from Man Ray's reply to questionnaire, June 19, 1959, The Museum of Modern Art, collection records.

Pp. 62–63. Kandinsky, *Rückblicke* (Berlin: Herwarth Walden, 1913); quoted in English trans. in Robert L. Herbert, ed., *Modern Artists on Art* (Englewood Cliffs, N.J.: Prentice-Hall, 1964), pp. 31–32.

P. 64. Piet Mondrian, "The New Plastic as 'Abstract-Real Painting': The Plastic Means and Composition," *De Stijl* (Leyden), vol. 1, no. 3, 1917; quoted in English trans. in Hans L. C. Jaffé, *De Stijl* (New York: Harry N. Abrams, 1970), p. 54.

P. 65. Mondrian, quoted in Sweeney, "Eleven Europeans in America," p. 36.

P. 66. Alfred H. Barr, Jr., gallery label for exhibition "Twentieth-Century Italian Art," The Museum of Modern Art, New York, 1949.

P. 68. Dali, *Conquest of the Irrational*, English trans. from the French by David Gascoyne (New York: Julien Levy, 1935), p. 12.

P. 69. William Rubin, *Miró in the Collection of The Museum of Modern Art* (New York: The Museum of Modern Art, 1973), p. 70.

P. 70. James Thrall Soby, *Balthus* (New York: The Museum of Modern Art, 1956), p. 5.—Information paraphrased from letter of Soby, April 29, 1965, to J. Kunkel, The Museum of Modern Art, collection records; pub. in Sabine Rewald, *Balthus* (New York: The Metropolitan Museum of Art/Harry N. Abrams, 1984), pp. 60–61.

P. 71. Magritte, letter to James Thrall Soby, May 20, 1965; pub. in Soby, *René Magritte* (New York: The Museum of Modern Art, 1965), p. 8.—David Sylvester, *Magritte* (New York and Washington: Frederick A. Praeger, 1969), p. 13, quoting Suzi Gablik, "A Conversation with René Magritte," *Studio International* (London), vol. 173, March 1967, p. 128.

P. 72. Jean (Hans) Arp, "Notes from a Diary," *Transition* (Paris), no. 21, 1932, p. 191.—Arp, "Looking," in James Thrall Soby, ed., *Arp* (New York: The Museum of Modern Art, 1958), p. 14.

P. 73. Barr, quoted in *ibid.*, p.7.—Arp, "Looking," pp. 14–15.—Margherita Andreotti, *The Early Sculpture of Jean Arp* (Ann Arbor/London: U.M.I. Research Press, 1989), p. 234.

P. 76. Carolyn Lanchner, Preface, in Carolyn Lanchner, ed., *Paul Klee* (New York: The Museum of Modern Art,

1987), p. 9.—Klee, in ex. cat. "Kandinsky Jubeläums-Ausstellung zum 60. Geburtstage," Dresden, Galerie Arnold, 1926; quoted in English trans. in *ibid.*, p. 36, n. 5.

P. 79. French, quoted in Gerald Nordland, *Gaston Lachaise: The Man and His Work* (New York: George Braziller, 1974), p. 21.

P. 80. James Thrall Soby, *Modigliani* (New York: The Museum of Modern Art, 1963), p. 11.

P. 81. Bearden, quoted in Carroll Greene, Introduction, in ex. cat. "Romare Bearden: The Prevalence of Ritual," New York, The Museum of Modern Art, 1971, p. 3.—Bearden, *ibid.*

P. 82. Nadelman, "A Letter to the Press," sent to the *New York World, Sun, Herald,* and *Times,* Dec. 19, 1917; repr. in Lincoln Kirstein, *Elie Nadelman* (New York: The Eakins Press, 1972), pp. 269–70.—Henry Tyall in *The World Magazine* (New York), Nov. 30, 1919; quoted in *ibid.*, p. 216.—W. J. Bouderin in the *New York Evening Sun*; quoted in *ibid.*, p. 215.—Lincoln Kirstein, *The Sculpture of Elie Nadelman* (New York: The Museum of Modern Art, 1948), p. 52.

P. 83. Jean Guichard-Meili, *Henri Matisse, son oeuvre, son univers* (Paris: Hazan, 1967), p. 86; quoted in Elderfield, *Matisse in the Collection,* p. 116.—Elderfield, *ibid.,* p. 114.—Theodore Reff, "Matisse: Meditations on a Statuette and a Goldfish," *Arts Magazine* (New York), vol. 51, Nov. 1976, p. 115.—Barr, *Matisse,* p. 174.

P. 84. Hartlaub, prospectus, 1923, describing the forthcoming show; quoted in ex. cat. "German Realism of the Twenties: The Artist as Social Critic," Minneapolis Institute of Arts, 1980, p. 32.

P. 85. M. Herrmann [Neisse], "Mein Erlebnisse mit der bildenden Kunst," *Das Kunstblatt* (Berlin), 1929, pp. 78 ff.; repr. in ex. cat. "George Grosz: Porträt des Schriftsteller Max Herrmann-Neisse 1925," Mannheim, Städtische Kunsthalle, 1979–80; English trans. Judith Cousins.

P. 86. Beckmann, "Creative Credo," 1918; quoted by Margot Clark, "Beckmann and Esoteric Philosophy," in ex. cat. "Max Beckmann: The Triptychs," London, The Whitechapel Art Gallery in association with the Arts Council of Great Britain, 1980–81, p. 33.—Beckmann, letter to Curt Valentin, Feb. 11, 1938; pub. in English trans. in Peter Selz, *Max Beckmann* (New York: The Museum of Modern Art, 1964), p. 61.—Perry T. Rathbone, Introduction, in ex. cat. "Max Beckmann," City Art Museum of St. Louis, 1948, p. 36.—Lilly von Schnitzler, quoted in Selz, *Beckmann,* p. 58.—Beckmann, diary entry, Sept. 12, 1940; quoted in Clark, "Beckmann and Esoteric Philosophy," p. 36.—Gropius, quoted in Claude Gandelman, "Max Beckmann's Triptychs and the Simultaneous Stage of the 'Twenties," in "Max Beckmann: The Triptychs," p. 28.

P. 89. Bacon, quoted in *Francis Bacon Interviewed by David Sylvester* (New York: Pantheon Books, 1975), p. 11.—*Ibid.*, pp. 23, 46, 48.

P. 90. Rubin, *Miró in the Collection*, pp. 43–44.

P. 92. Elderfield, *Matisse in the Collection*, pp. 88–89.

P. 93. Harriet Janis, in Alfred H. Barr, Jr., *Cubism and Abstract Art* (New York: The Museum of Modern Art, 1936), opp. fig. 88.

P. 94. Aragon, in ex. cat. "A la rencontre de Matisse," St. Paul de Vence, Fondation Maeght, 1969, p. 12; cited in Albert E. Elsen, *The Sculpture of Matisse* (New York: Harry N. Abrams, 1972), p. 133.—Jack Flam, "Matisse and the Fauves," in Rubin, *"Primitivism,"* vol. 1, p. 230.

P. 95. E. Tériade, "En causant avec Picasso: quelques pensées et réflexions du peintre et de l'homme," *L'Intransigeant* (Paris), June 15, 1932; English trans. in Wilhelm Boeck and Jaime Sabartés, *Picasso* (New York: Harry N. Abrams, 1955), p. 504.—Rubin, "Picasso," in *"Primitivism"* vol. 1, pp. 326–28.

P. 97. Léger, letter to Alfred H. Barr, Jr., Nov. 20, 1943, The Museum of Modern Art, collection records.

P. 98. Marion Bernardik, unpub. essay (copy in The Museum of Modern Art Library); cited in Barr, *Picasso*, p. 176 and n., p. 262.

P. 100. James Thrall Soby, *Joan Miró* (New York: The Museum of Modern Art, 1959), p. 37.

P. 102. H. H. Arnason and Pedro E. Guerrero, *Calder* (New York: Van Nostrand, 1966), p. 78.—Calder, statement at symposium "What Abstract Art Means to Me," New York, The Museum of Modern Art, Feb. 5, 1951; pub. in *Museum of Modern Art Bulletin* (New York), vol. 18, Spring 1951, p. 8.

P. 103. Graves, quoted in Avis Berman, "Nancy Graves' New Age of Bronze," *Art News* (New York), vol. 85, Feb. 1986, p. 64.—Protich in *ibid.*, p. 63.

P. 104. Alfred H. Barr, Jr., *What Is Modern Painting?*, 9th ed. (New York: The Museum of Modern Art, 1975), p. 11.

P. 105. Cornell, in ex. cat. "Joseph Cornell," Beverly Hills, Copley Galleries, 1948; quoted in Dore Ashton, *A Joseph Cornell Album* (New York: The Viking Press, 1974), p. 64.—"Playful Objects," *The New York Herald Tribune*, Dec. 10, 1939, sec. VI, p. 8; quoted by Lynda Rose Hartigan, "Joseph Cornell: A Biography," in Kynaston McShine, ed., *Joseph Cornell* (New York: The Museum of Modern Art, 1980), p. 103.—Cornell, letter to J. B. Neumann, Oct. 25, 1946, in *ibid.*—Cornell, letter to Alfred H. Barr, Jr., Nov. 13, 1936, in McShine, *Cornell*, p. 103.—John Ashbery, "Cornell: The Cube Root of Dreams," *Art News* (New York), vol. 66, Summer 1967, p. 64.

P. 106. Barr, "Museum Acquires Picasso Sculpture of She-Goat," press release, The Museum of Modern Art, New York, July 5, 1959.

P. 107. Robert Goldwater, *What Is Modern Sculpture?* (New York: The Museum of Modern Art, 1969) p. 97.

P. 108. Giacometti, letter to Pierre Matisse, 1947, in ex. cat. "Alberto Giacometti: Exhibition of Sculptures, Paintings, Drawings," New York, Pierre Matisse Gallery, 1948; repr. in *Alberto Giacometti*, intro. Peter Selz (New York: The Museum of Modern Art, 1965), p. 28.—Elsen, *Rodin*, pp. 86–87.

P. 109. Kirchner, in ex. cat. "E. L. Kirchner," Frankfurt-am-Main, Galerie Ludwig Scharnes, 1919; quoted in Will Grohmann, *E. L. Kirchner*, trans. Ilse Falk (New York: Arts, Inc., 1961), p. 18.

P. 110. Dubuffet, "Statement on Paintings of 1961," in Peter Selz, *The Work of Jean Dubuffet* (New York: The Museum of Modern Art, 1962), p. 165.—Dubuffet, letter to H. Damisch, May 31, 1962, in Max Loreau, ed., *Catalogue des travaux de Jean Dubuffet*, fasc. 19, "Paris Circus" (Paris: Jean-Jacques Pauvert, 1965), p. 57.

P. 111. Marin, in ex. cat. "John Marin," New York, "291" Gallery, 1913; repr. in MacKinley Helm, *John Marin* (Boston: Pellegrini & Cudahy/Institute of Contemporary Art, 1948), pp. 28–29.—Barr, *Masters of Modern Art*, p. 114.

P. 113. Sheeler, quoted in Henry Geldzahler, *American Painting in the Twentieth Century* (New York: The Metropolitan Museum of Art, 1965), p. 139.

P. 114. Henri, "Notes Taken by M. R. from Robert Henri's Criticisms and Art Talks," in *Robert Henri: The Art Spirit*, compiled by Margery Ryerson (Philadelphia and New York: J. B. Lippincott, 1960), p. 265.—Alfred H. Barr, Jr., in ex. cat. "Edward Hopper: Retrospective Exhibition," New York, The Museum of Modern Art, 1933, p. 15.—James Thrall Soby, "Max Weber and Edward Hopper," in *Contemporary Painters* (New York: The Museum of Modern Art, 1948), p. 36.—Hopper, "Notes on Painting," in Barr, "Edward Hopper," p. 17.—Lloyd Goodrich, *Edward Hopper: Selections from the Hopper Bequest* (New York: Whitney Museum of American Art, 1971), p. 10.

P. 115. Wyeth, reply to questionnaire, The Museum of Modern Art, collection records.

P. 116. Ernest Hello, quoted in Sam Hunter, *Modern French Painting, 1855–1956* (New York: Dell Publishing Company, 1956), p. 149.—Barr, *Masters of Modern Art*, p. 57.

P. 117. Levine, quoted in Frederick S. Wight, "A Jack Levine Profile," *Art Digest* (New York), vol. 26, Sept. 15, 1952, p. 10.

P. 120. Shahn, quoted by Van Deren Coke in ex. cat. "The Painter and the Photograph," Albuquerque, The Art Gal-

lery, University of New Mexico, 1964, p. 32.

P. 121. Lawrence, reply to questionnaire, March 28, 1971, The Museum of Modern Art, collection records.—Lawrence, quoted in Elizabeth McCausland, "Jacob Lawrence," *Magazine of Art* (Washington), vol. 38, Nov. 1945, p. 251.

P. 122. Szarkowski, *The Photographer's Eye* (New York: The Museum of Modern Art, 1966), pp. 8–9.—Balla, letter to Alfred H. Barr, Jr., April 24, 1954, The Museum of Modern Art, collection records.

P. 123. Lloyd Goodrich and Doris Bry, *Georgia O'Keeffe* (New York: Whitney Museum of American Art, 1970), p. 17.

P. 124. Rousseau (or Apollinaire?), poem, 1910; English trans. Bertha Ten Eyck James, in Daniel Catton Rich, *Henri Rousseau* (New York: The Museum of Modern Art, 1942), p. 69.

P. 125. Evan Maurer, "Dada and Surrealism," in Rubin, *"Primitivism,"* vol. 2, p. 583, incl. quotation by Lam in "Oeuvres récentes de Wifredo Lam," *Cahiers d'Art* (Paris), vol. 26, 1951, p. 186.

P. 126. Goldwater, *Rufino Tamayo* (New York: Quadrangle Press, 1947), p. 7.

P. 127. Pollock, quoted in Sidney Janis, *Abstract & Surrealist Art in America* (New York: Reynal & Hitchcock, 1944), p. 112.

P. 128. William S. Rubin, *Dada and Surrealist Art* (New York: Harry N. Abrams, 1968), p. 348.

P. 130. "On Designing Chessmen," in ex. checklist "Imagery of Chess," New York, Julien Levy Gallery, 1944.—Dorothea Tanning Ernst, letter to Dorothy C. Miller, March 7, 1957, The Museum of Modern Art, collection records.

P. 132. Hofmann, "Selected Writings on Art," unpub. typescript (copy in The Museum of Modern Art Library); quoted in William C. Seitz, *Hans Hofmann* (New York: The Museum of Modern Art, 1963), p. 27.

P. 133. Motherwell, statement at symposium, "What Abstract Art Means to Me"; pub. in *Museum of Modern Art Bulletin*, Spring 1951, p. 12.—Motherwell, "A Conversation at Lunch," transcribed by Margaret Paul, in ex. cat. "Robert Motherwell," Northampton, Mass., Smith College Museum of Art, 1963, n.p.

Pp. 134–35. André Verdet, "Entretiens avec Henri Matisse," *Prestiges de Matisse* (Paris: Émile-Paul, 1952), pp. 37–76; English trans. in Flam, *Matisse on Art*, p. 144.—Matisse, *Jazz* (Paris: Éditions Verve, 1947), English trans. in *ibid.*, p. 112.—Matisse, quoted in interview with André Lejard, *Amis de l'art* (Paris), n.s. 2, Oct. 1951; quoted in English trans. in Monroe Wheeler, *The Last Works of Henri Matisse: Large Cut Gouaches* (New York:

The Museum of Modern Art, 1961), p. 10.—Statement recorded by Margaret Scolari Barr, Sept. 1952, The Museum of Modern Art Archives; quoted in Elderfield, *Matisse in the Collection*, p. 162.—Verdet, "Entretiens," English trans. in Flam, *Matisse on Art*, p. 144.—Elderfield, *Matisse in the Collection*, p. 167.—Matisse, quoted in Maria Luz, "Témoignages: Henri Matisse," *XXe Siècle* (Paris), n.s. 2, Jan. 1952, p. 57; English trans. in Flam, *Matisse on Art*, p. 137.

P. 136. Matisse, quoted in Barr, *Matisse*, p. 190.—Matisse, "Notes d'un peintre," *La Grande Revue* (Paris), Dec. 25, 1908; quoted in English trans. in *ibid.*, pp. 119, 120, 121–22.—Greenberg, "Milton Avery," *Arts Review* (London), vol. 14, Sept. 22–Oct. 6, 1962, p. 12.

P. 137. Buck, "The Ocean Park Paintings," *Art International* (Lugano), vol. 22, Summer 1978, pp. 32 and 29.

P. 138. Malevich, "From Cubism and Futurism to Suprematism," p. 38.—Albers, quoted by Kynaston McShine in ex. cat. "Josef Albers: Homage to the Square," circulated by The International Council of The Museum of Modern Art, 1964–65, n.p.—Albers, "On My 'Homage to the Square,'" in *ibid.*—Albers, *Interaction of Color* (New Haven and London: Yale University Press, 1963), p. 13.—Albers, reply to questionnaire, Feb. 12, 1968, The Museum of Modern Art, collection records.

P. 139. Robert Rosenblum, "The Abstract Sublime," *Art News* (New York), vol. 59, Feb. 1961, pp. 40, 56.—Mark Rothko, lecture given at Pratt Institute, Brooklyn, Oct. 1958; excerpted by Dore Ashton, "Letter from New York," *Cimaise* (Paris), sér. 6, no. 2, Dec. 1958, p. 38; quoted in Maurice Tuchman, ed., ex. cat., "The New York School: The First Generation," Los Angeles County Museum of Art, 1965, p. 30.

P. 140. Pollock, "My Painting," *Possibilities* (New York), Winter 1947/48, pp. 78 ff., quoted in Francis V. O'Connor, *Jackson Pollock* (New York: The Museum of Modern Art, 1967), p. 40.—Varnedoe, *A Fine Disregard: What Makes Modern Art Modern* (New York: Harry N. Abrams, 1990), p. 274.—O'Hara, *Jackson Pollock* (New York: George Braziller, 1959), pp. 28–29.

P. 141. Barnett Newman, statement (1958) in ex. cat. "The New American Painting as Seen in Eight European Countries," New York, The Museum of Modern Art, 1959, p. 60.—Newman, "The Plasmic Image, Part I, 1943–1945," in Thomas B. Hess, *Barnett Newman* (New York: The Museum of Modern Art, 1971), p. 37–38.

P. 142. "Franz Kline 1910–1960: An Interview with David Sylvester," *Living Arts* (London), vol. 1, Spring 1963; quoted in Tuchman, "New York School," pp. 18–19.—Kline in interview with Frank O'Hara, "Franz Kline Talking," *Evergreen Review* (New York), vol. 2, 1958; repr. in O'Hara, *Art Chronicles: 1954–1966* (New York: George Braziller, 1975), p. 52.—Matisse, "Témoig-

nages de peintres: Apropos de notre exposition: Le noir est une couleur, Galerie Maeght," *Derrière le Miroir* (Paris), Dec. 1946, pp. 2, 6, 7; quoted in English trans. in Flam, *Matisse on Art*, pp. 106–07.

P. 143. Goldwater, *What Is Modern Sculpture?*, pp. 99, 101.

P. 144. David Smith, lecture given at Portland Art Museum, Portland, Oreg., March 23, 1952; quoted in Cleve Gray, ed., *David Smith by David Smith* (New York: Holt, Rinehart and Winston, 1968), p. 68.

P. 145. Smith, quoted in Gene Baro, ed., "Some Late Words from David Smith," *Art International* (Lugano), vol. 9, no. 7, Oct. 1965, p. 49.—Smith, "The Secret Letter," interview with Thomas B. Hess in ex. cat. "David Smith," New York, Marlborough-Gerson Gallery, Oct. 1964; repr. in Garnett McCoy, ed., *David Smith* (New York: Praeger Publishers, 1973), p. 183.—*Ibid.*

P. 146. Elderfield, *Frankenthaler* (New York: Harry N. Abrams, 1989), p. 36.—Frankenthaler, quoted in *ibid.*, p. 50.—O'Hara, "Helen Frankenthaler," review of ex. "Helen Frankenthaler," New York, The Jewish Museum, 1960; repr. in O'Hara, *Art Chronicles*, p. 126.—Frankenthaler, reply to questionnaire, Jan. 15, 1961; The Museum of Modern Art, collection records.

P. 147. Elderfield, *Morris Louis* (New York: The Museum of Modern Art, 1986), p. 74.—Greenberg, in ex. cat. "Three New American Painters: Louis, Noland, Olitski," Regina, Saskatchewan, Norman Mackenzie Art Gallery, 1963; repr. in ex. cat. "Morris Louis, 1912–1962," Boston, Museum of Fine Arts, 1967, p. 83.

P. 148. Davis, quoted in Katharine Kuh, *The Artist's Voice: Talks with Seventeen Artists* (New York and Evanston: Harper & Row, 1962), p. 52.—Davis, conversation with Alfred H. Barr, Jr., Nov. 3, 1952, transcript in The Museum of Modern Art, collection records; excerpted in Diane Kelder, ed., *Stuart Davis* (New York: Praeger Publishers, 1971), pp. 100–102.—Davis, quoted in Kuh, *The Artist's Voice*, p. 56.

P. 149. Léger, quoted in Sweeney, "Eleven Europeans in America," p. 15.

P. 150. Dubuffet, "Landscaped Tables, Landscapes of the Mind, Stones of Philosophy," trans. by the artist and Marcel Duchamp in ex. cat. of the same name, New York, Pierre Matisse Gallery, 1952; repr. in Selz, *The Work of Jean Dubuffet*, p. 64.

P. 151. De Kooning, quoted in Thomas B. Hess, "De Kooning Paints a Picture," *Art News* (New York), vol. 52, March 1953, p. 67.

P. 152. Rauschenberg, quoted in Seitz, *The Art of Assemblage*, p. 116.—Calvin Tomkins, *Off the Wall: Robert Rauschenberg and the Art World of Our Time* (New York: Doubleday, 1980), pp. 136–37.—Varnedoe, press release, The Museum of Modern Art, May 9, 1989.

P. 153. Oldenburg, quoted in Barbara Rose, *Claes Oldenburg* (New York: The Museum of Modern Art, 1970), p. 69.—Oldenburg, *ibid.*, p. 194.—Oldenburg, in ex. cat. "Claes Oldenburg: Selected Texts for the Traveling Exhibition of 1971–73," Pasadena Art Museum, 1971, p. 8.

P. 154. Johns, quoted in *Time* (New York), May 4, 1959, p. 58.—Cage, "Jasper Johns: Stories and Ideas," in ex. cat. "Jasper Johns," New York, The Jewish Museum, 1964; repr. in Gregory Battcock, ed., *The New Art: A Critical Anthology* (New York: E. P. Dutton, 1966), pp. 218–19.

P. 155. Cage, "Jasper Johns: Stories and Ideas," p. 214.—Johns, "Duchamp," *Scrap* (New York), no. 2, 1960, n.p.; quoted in Lawrence Alloway, *American Pop Art* (New York: The Macmillan Company, Collier Books, 1974), p. 60.

P. 156. Rosenquist, quoted in G. R. Swenson, "What Is Pop Art?," Part II, *Art News* (New York), vol. 62, Feb. 1964, p. 64.—Rosenquist, quoted in ex. cat. "James Rosenquist," Cologne, Wallraf-Richartz Museum, 1972, p. 83.

P. 157. Kierkegaard, *The Present Age*, trans. by Alexander Dru (New York: Harper, Torchbooks, 1962), p. 35; quoted in Alloway, *American Pop Art*, pp. 42, 47.—Kynaston McShine, Introduction, in Kynaston McShine, ed., *Andy Warhol: A Retrospective* (New York: The Museum of Modern Art, 1989), pp. 17–18.

P. 158. Lichtenstein, quoted by John Coplans, "Roy Lichtenstein: An Interview," in ex. cat. "Roy Lichtenstein," Pasadena Art Museum, 1967, p. 16.—Lichtenstein, quoted in "Lichtenstein Interviewed by Diane Waldman," in Diane Waldman, *Roy Lichtenstein* (New York: Harry N. Abrams, 1971), p. 28.

P. 159. Estes, quoted in "The Photo-Realists: Twelve Interviews," *Art in America* (New York), vol. 60, Nov.–Dec. 1972, p. 81.

P. 160. Segal, "The Sense of 'Why Not?': George Segal on His Art," *Studio International* (London), vol. 174, Oct. 1967, p. 149.—Segal, quoted in Jan van der Marck, *George Segal* (New York: Harry N. Abrams, 1975), p. 34.—Segal, "The Sense of 'Why Not?,'" p. 147.—Segal, quoted in Henry Geldzahler, "Interview with George Segal," Nov. 1963, in ex. cat. "Recent American Sculpture," New York, The Jewish Museum, 1964, pp. 24–27; repr. in *Quadrum* (Brussels), vol. 19, 1965, pp. 115–16.—Tuchman, *George Segal* (New York: Abbeville Press, 1983), pp. 24–25.

P. 162. Stella, interview with Alan Solomon, 1966, in series "U.S.A. Artists," National Educational Television (NET), New York; quoted in William S. Rubin, *Frank Stella* (New York: The Museum of Modern Art, 1970), p. 12.—Stella, taped interview with Bruce Glaser broadcast by WBAI-FM, New York, Feb. 1964; pub. in Lucy R. Lippard, ed., "Questions to Stella and Judd," *Art News*

(New York), vol. 65, Sept. 1966; repr. in Gregory Battcock, ed., *Minimal Art: A Critical Anthology* (New York: E. P. Dutton, 1968), p. 158.

P. 163. Judd in Lippard, "Questions to Stella and Judd," p. 162.

P. 164. Smith, quoted by Samuel Wagstaff, Jr., "Talking with Tony Smith," *Artforum* (Los Angeles), vol. 5, Dec. 1966, pp. 15–16; repr. in Battcock, *Minimal Art*, p. 382.—Smith in ex. cat. "Tony Smith—Two Exhibitions of Sculpture," Hartford, Conn., Wadsworth Atheneum, 1966; Philadelphia, Institute of Contemporary Art, University of Pennsylvania, 1966–67.

P. 167. Chia, interview with F. Vincitorio, *L'Espresso* (Rome), Feb. 3, 1980, p. 91; English trans. in press release for Chia exhibition, Sperone, Westwater, Fischer Gallery, New York, 1981.

P. 168. Kristin Olive, "David Salle's Deconstructive Strategy," *Arts* (New York), vol. 60, Nov. 1985, pp. 82–83.—Bergson, quoted in Roger Shattuck, *The Banquet Years* (New York: Harcourt Brace, 1958), p. 259; cited in Seitz, *The Art of Assemblage*, pp. 83–84.—Cage, "On Rauschenberg, Artist, and His Work," *Metro* (Milan), vol. 1, no. 2, 1961, pp. 36–50.—Schjeldahl, in ex. cat. "David Salle," Cologne, Michael Werner Gallery, 1985, n.p.—Salle, quoted in Schjeldahl, *An Interview with David Salle* (New York: Vintage Books, 1987), p. 74.

P. 169. Russell, review, "Tenth Anniversary Show at Paula Cooper," *Art in America* (New York), vol. 60, Nov.–Dec. 1978, p. 156.

P. 170. Tancock, "The Influence of Marcel Duchamp," in Anne d'Harnoncourt and Kynaston McShine, eds., *Marcel Duchamp*, (New York: The Museum of Modern Art; Philadelphia Museum of Art, 1973), p. 176, incl. quotation from statement by Willem de Kooning in "What Abstract Art Means to Me," p. 7.

THIS BIBLIOGRAPHY includes books and catalogues issued by The Museum of Modern Art that relate to artists or tendencies represented in *An Invitation to See*. Publications not currently in print but to be found in many libraries, including that of The Museum of Modern Art, are indicated with an asterisk. A number were reissued by Arno Press in reprint editions, in which the original color plates appear only as black-and-white reproductions; these are designated by an (A) following the entry. In addition, a number of titles originally issued by the Museum have been reprinted by other publishers; these are designated by (H) for Harvard University Press, (P) for Prestel Verlag.

Special mention should be made of *Masters of Modern Art*, edited by Alfred H. Barr, Jr., and published in 1954 on the occasion of the Museum's twenty-fifth anniversary. Though long out of print, it is readily available in libraries and is especially recommended for its valuable information on the Museum's collection and its many illustrations, including large color plates. Currently in print are *Painting and Sculpture in The Museum of Modern Art, 1929–1967*, edited by Alfred H. Barr, Jr., cataloguing 2,622 works, with 1,693 black-and-white illustrations and a chronology of the development of the collection (1977); *The Museum of Modern Art: The History and the Collection*, containing a brief history of the Museum and texts on each of the six divisions of the collection (painting and sculpture being introduced by William Rubin), with 1,070 illustrations, including 319 in color (1984); and *Painting and Sculpture in The Museum of Modern Art: Catalog of the Collection*, edited by Alicia Legg with Mary Beth Smalley (1988), enumerating the Museum's holdings of 3,230 paintings, sculptures, and selected works on paper as of December 31, 1987.

ABSTRACT PAINTING AND SCULPTURE IN AMERICA, by Andrew Carnduff Ritchie. 1951. 160 pages; 127 illustrations (8 in color).* (A)

AMERICAN ART SINCE 1945 FROM THE COLLECTION OF THE MUSEUM OF MODERN ART, by Alicia Legg. 1975. 84 pages; 66 illustrations (4 in color).*

THE ART OF ASSEMBLAGE, by William C. Seitz. 1961. 176 pages; 146 illustrations (11 in color).*

ART OF THE FORTIES, edited and with an introduction by Riva Castleman; essay by Guy Davenport. 1991. 160 pages; 173 illustrations (48 in color).

ART NOUVEAU: ART AND DESIGN AT THE TURN OF THE CENTURY, edited by Peter Selz and Mildred Constantine; essays by Greta Daniel, Alan M. Fern, Henry-Russell Hitchcock, and Peter Selz. 1959; rev. ed. 1975. 196 pages; 165 illustrations (8 in color).*

BAUHAUS: 1919–1928, edited by Herbert Bayer, Walter Gropius, and Ise Gropius. 1938; reprint 1988. 224 pages; 550 illustrations.

BERLINART: 1961–1987, edited and with an introduction by Kynaston McShine; essays by René Block, Laurence Kardish, Kurt Ruhrberg, Wieland Schmied, Michael Schwartz, and John Willett. 1987. 282 pages; 415 illustrations (86 in color). Pub. with Prestel Verlag.

CONTEMPORARY PAINTERS, by James Thrall Soby. 1948. 152 pages; 65 illustrations.* (A)

CONTRASTS OF FORM: GEOMETRIC ABSTRACT ART 1910–1980, by Magdalena Dabrowski; introduction by John Elderfield. 1985. 288 pages, 158 illustrations (71 in color).

CUBISM AND ABSTRACT ART, by Alfred H. Barr, Jr. 1936; reissued, with new foreword by Robert Rosenblum, 1986. 249 pages; 223 illustrations. (H)

DADA, SURREALISM, AND THEIR HERITAGE, by William Rubin. 1968; reprint 1977. 252 pages; 300 illustrations (6 in color).

FANTASTIC ART, DADA, SURREALISM, edited by Alfred H. Barr, Jr. 1947 (3rd ed.). 284 pages; 222 illustrations (6 in color).*

FUTURISM, by Joshua C. Taylor. 1961. 154 pages; 141 illustrations (22 in color).*

GERMAN ART OF THE TWENTIETH CENTURY, edited by Andrew Carnduff Ritchie; essays by Werner Haftmann, Alfred Hentzen, and William S. Lieberman. 1957. 240 pages; 185 illustrations (50 in color).*

GERMAN PAINTING AND SCULPTURE, by Alfred H. Barr, Jr. 1931. 94 pages; 50 illustrations.* (A)

THE HISTORY OF IMPRESSIONISM, by John Rewald. 1946; 4th rev. and enlarged ed. 1973. 672 pages; 623 illustrations (82 in color).

THE MEANINGS OF MODERN ART, by John Russell. 1981; rev. and enlarged ed. 1991. 430 pages; 328 illustrations (101 in color). Pub. with Harper & Row.

MODERN MASTERS–MANET TO MATISSE, edited by William S. Lieberman. 1975. 272 pages; 129 illustrations (16 in color).*

THE NATURAL PARADISE: PAINTING IN AMERICA 1800–1950, edited by Kynaston McShine; essays by Barbara Novak, Robert Rosenblum, and John Wilmerding. 1976. 180 pages; 185 illustrations (16 in color).*

THE NEW AMERICAN PAINTING AS SHOWN IN EIGHT EUROPEAN COUNTRIES, 1958–1959, introduction by Alfred H. Barr, Jr. 1959. 96 pages; 86 illustrations.* (A)

POST-IMPRESSIONISM: FROM VAN GOGH TO GAUGUIN, by John Rewald. 1962; 3rd rev. ed. 1978. 592 pages; 534 illustrations (50 in color).

"PRIMITIVISM" IN 20TH CENTURY ART: AFFINITY OF THE TRIBAL AND THE MODERN, edited by William Rubin; essays by Kirk Varnedoe and 13 other contributors. 1984. 2 vols., 706 pages; 1,087 illustrations (378 in color).

THE SCHOOL OF PARIS: PAINTINGS FROM THE FLORENE MAY SCHOENBORN AND SAMUEL A. MARX COLLECTION, preface by Alfred H. Barr, Jr.; introduction by James Thrall Soby; notes by Lucy Lippard. 1965; reprint 1979. 58 pages; 46 illustrations (16 in color).

SCULPTURE OF THE TWENTIETH CENTURY, by Andrew Carnduff Ritchie. 1952. 288 pages; 225 illustrations.*

THREE GENERATIONS OF TWENTIETH-CENTURY ART: THE SIDNEY AND HARRIET JANIS COLLECTION OF THE MUSEUM OF MODERN ART, foreword by Alfred H. Barr, Jr.; introduction by William Rubin. 1972. 252 pages; 157 illustrations (17 in color).*

TWENTIETH-CENTURY ITALIAN ART, by James Thrall Soby and Alfred H. Barr, Jr. 1949. 144 pages; 143 illustrations (5 in color).* (A)

VIENNA 1900: ART, ARCHITECTURE, DESIGN, by Kirk Varnedoe. 1986. 264 pages; 354 illustrations (114 in color).

WHAT IS MODERN PAINTING?, by Alfred H. Barr, Jr. 1943; 9th rev. ed. 1966; reprint 1988. 48 pages; 64 illustrations (2 in color).

WHAT IS MODERN SCULPTURE?, by Robert Goldwater. 1969. 148 pages; 117 illustrations.*

THE "WILD BEASTS": FAUVISM AND ITS AFFINITIES, by John Elderfield. 1976. 168 pages; 206 illustrations (24 in color).*

INDIVIDUAL ARTISTS

ARP, edited and with an introduction by James Thrall Soby; essays by Jean Hans Arp, Richard Huelsenbeck, Robert Melville, and Carola Giedion-Welcker. 1958. 126 pages; 114 illustrations (2 in color).* (A)

BALTHUS, by James Thrall Soby. 1956. 36 pages; 29 illustrations (2 in color).*

ROMARE BEARDEN: THE PREVALENCE OF RITUAL, by Carroll Greene. 1971. 24 pages; 18 illustrations (4 in color).*

MAX BECKMANN, by Peter Selz; contributions by Perry T. Rathbone and Harold Joachim. 1964. 160 pages; 121 illustrations (13 in color).* (A)

PIERRE BONNARD, by John Rewald. 1948. 151 pages; 112 illustrations (5 in color).*

BONNARD AND HIS ENVIRONMENT, by James Thrall Soby, James Elliott, and Monroe Wheeler. 1964. 116 pages; 106 illustrations (41 in color).*

LOUISE BOURGEOIS, by Deborah Wye. 1982. 124 pages; 188 illustrations (4 in color).*

GEORGES BRAQUE, by Henry R. Hope. 1949. 170 pages; 133 illustrations (10 in color).*

BRAQUE, see also PICASSO AND BRAQUE: PIONEERING CUBISM

ALEXANDER CALDER, by James Johnson Sweeney. 1951. 64 pages; 55 illustrations.* (A)

A SALUTE TO ALEXANDER CALDER, by Bernice Rose. 1969. 32 pages; 34 illustrations.*

CÉZANNE: THE LATE WORK, edited by William Rubin; essays by Theodore Reff, Lawrence Gowing, Liliane Brion-Guerry, John Rewald, F. Novotny, Geneviève Monnier, Douglas Druick, George Heard Hamilton, and William Rubin; catalogue by John Rewald. 1977. 416 pages; 427 illustrations (50 in color).

CÉZANNE, GAUGUIN, SEURAT, VAN GOGH: FIRST LOAN EXHIBITION, by Alfred H. Barr, Jr. 1929. 150 pages; 97 illustrations.* (A)

MARC CHAGALL, by James Johnson Sweeney. 1946. 102 pages; 81 illustrations.* (A)

DE CHIRICO, edited by William Rubin; essays by Maurizio Fagiolo dell'Arco, Joan M. Lukach, William Rubin, Marianne W. Martin, Wieland Schmied, and Laura Rosenstock. 1982. 208 pages; 241 illustrations (34 in color).*

GIORGIO DE CHIRICO, by James Thrall Soby. 1955. 268 pages; 194 illustrations.* (A)

JOSEPH CORNELL, edited and with an introduction by Kynaston McShine; essays by Dawn Ades, P. Adams Sitney, and Lynda Roscoe Hartigan. 1980; reprint 1990. 296 pages; 32 illustrations (32 in color). (P)

SALVADOR DALI, by James Thrall Soby. 2nd rev. ed. 1946. 112 pages; 80 illustrations (4 in color).*

STUART DAVIS, by James Johnson Sweeney. 1945. 40 pages; 31 illustrations.* (A)

CHARLES DEMUTH, by Andrew Carnduff Ritchie. 1950. 96 pages; 70 illustrations.* (A)

THE WORK OF JEAN DUBUFFET, by Peter Selz; texts by the artist. 1962. 188 pages; 125 illustrations.* (A)

MARCEL DUCHAMP, edited by Anne d'Harnoncourt and Kynaston McShine; essays by ten contributors. 1973; reprint 1989. 360 pages; 429 illustrations (12 in color). Pub. with Philadelphia Museum of Art. (P)

JAMES ENSOR, by Libby Tannenbaum. 1951. 128 pages; 110 illustrations.* (A)

MAX ERNST, edited by William S. Lieberman; text by Max Ernst. 1961. 62 pages; 87 illustrations.* (A)

GAUGUIN, see CÉZANNE, GAUGUIN, SEURAT, VAN GOGH

ALBERTO GIACOMETTI, introduction by Peter Selz. 1965. 120 pages; 112 illustrations (16 in color).*

VINCENT VAN GOGH, edited by Alfred H. Barr, Jr. 1935. 194 pages; 88 illustrations.* (A)

VAN GOGH, see also CÉZANNE, GAUGUIN, SEURAT, VAN GOGH

ARSHILE GORKY, by William C. Seitz; foreword by Julien Levy. 1962. 60 pages; 85 illustrations.* (A)

JUAN GRIS, by James Thrall Soby. 1958. 128 pages; 126 illustrations.* (A)

HANS HOFMANN, by William C. Seitz. 1963. 64 pages; 47 illustrations.* (A)

EDWARD HOPPER, by Alfred H. Barr, Jr. and Charles Burchfield. 1933. 84 pages; 49 illustrations.* (A)

PAUL KLEE, by Alfred H. Barr, Jr., James Johnson Sweeney, and Julia and Lionel Feininger. 1946. 64 pages; 54 illustrations (2 in color).*

PAUL KLEE, edited by Carolyn Lanchner; essays by Ann Temkin, O. K. Werckmeister, Jürgen Glaesemer, and Carolyn Lanchner. 1987. 344 pages; 583 illustrations (137 in color).

WILLEM DE KOONING, by Thomas B. Hess. 1968. 170 pages; 147 illustrations (16 in color).*

GASTON LACHAISE: RETROSPECTIVE EXHIBITION, by Lincoln Kirstein. 1935. 64 pages; 42 illustrations.*

LAUTREC–REDON: TENTH LOAN EXHIBITION, by Jere Abbott. 1931. 72 pages; 39 illustrations.* (A)

LÉGER, by Katharine Kuh. 1953. 90 pages; 60 illustrations (2 in color).*

WILHELM LEHMBRUCK AND ARISTIDE MAILLOL. 1930. 24 pages; 12 illustrations.* (A)

MORRIS LOUIS, by John Elderfield. 1986. 192 pages; 97 illustrations (46 in color).

JOHN MARIN, essays by Henry McBride, Marsden Hartley, and E. M. Benson. 1936. 102 pages; 47 illustrations.*

MATISSE: HIS ART AND HIS PUBLIC, by Alfred H. Barr, Jr. 1951. 610 pages; 508 illustrations (8 in color).* (A)

MATISSE IN THE COLLECTION OF THE MUSEUM OF MODERN ART, by John Elderfield; commentaries by William S. Lieberman and Riva Castleman. 1978. 232 pages; 318 illustrations (34 in color).

HENRI MATISSE: 64 PAINTINGS, by Lawrence Gowing. 1964. 64 pages; 67 illustrations (3 in color).*

THE LAST WORKS OF HENRI MATISSE: LARGE CUT GOUACHES, by Monroe Wheeler. 1961. 62 pages; 42 illustrations (13 in color).*

THE SCULPTURE OF MATISSE, by Alicia Legg. 1972. 56 pages; 78 illustrations.*

JOAN MIRÓ, by James Thrall Soby. 1959. 164 pages; 148 illustrations.* (A)

MIRÓ IN THE COLLECTION OF THE MUSEUM OF MODERN ART, by William Rubin. 1973. 140 pages; 157 illustrations (22 in color).*

MONDRIAN, by James Johnson Sweeney. 1948. 16 pages; 18 illustrations.*

CLAUDE MONET: SEASONS AND MOMENTS, by William C. Seitz. 1960. 64 pages; 50 illustrations (1 in color).*

HENRY MOORE, by James Johnson Sweeney. 1946. 95 pages; 102 illustrations (4 in color).*

ROBERT MOTHERWELL, by Frank O'Hara. 1965. 96 pages; 98 illustrations (8 in color).*

THE SCULPTURE OF ELIE NADELMAN, by Lincoln Kirstein. 1948. 64 pages; 58 illustrations.*

BARNETT NEWMAN, by Thomas B. Hess. 1971. 158 pages; 175 illustrations (12 in color).*

CLAES OLDENBURG, by Barbara Rose. 1969. 222 pages; 276 illustrations (52 in color).

PICASSO: FIFTY YEARS OF HIS ART, by Alfred H. Barr, Jr. 1946; reprint 1974. 316 pages; 338 illustrations (8 in color).* (A)

PICASSO IN THE COLLECTION OF THE MUSEUM OF MODERN ART, by William Rubin; texts by Elaine L. Johnson and Riva Castleman. 1972. 248 pages; 307 illustrations (49 in color).*

PABLO PICASSO: A RETROSPECTIVE, edited by William Rubin; introduction by Dominique Bozo; chronology by Jane Fluegel. 1980. 464 pages; 939 illustrations (208 in color).

PICASSO AND BRAQUE: PIONEERING CUBISM, by William Rubin; chronology by Pierre Daix and Judith Cousins. 1980. 464 pages; 551 illustrations (208 in color).

THE SCULPTURE OF PICASSO, by Roland Penrose. 1967. 232 pages; 264 illustrations.*

JACKSON POLLOCK, by Francis V. O'Connor. 1967. 148 pages; 120 illustrations (1 color foldout).*

JACKSON POLLOCK: DRAWING INTO PAINTING, by Bernice Rose. 96 pages; 79 illustrations (6 in color).*

ODILON REDON, GUSTAVE MOREAU, RODOLPHE BRESDIN, by John Rewald, Harold Joachim, and Dore Ashton. 1961. 184 pages; 123 illustrations (31 in color).*

REDON, see also LAUTREC–REDON

DIEGO RIVERA, introduction by Frances Flynn Paine; notes by Jere Abbott. 1931. 128 pages; 74 illustrations.*

RODIN, by Albert Elsen. 1963. 228 pages; 172 illustrations (4 in color).*

MARK ROTHKO, by Peter Selz. 1961. 44 pages; 29 illustrations.* (A)

GEORGES ROUAULT: PAINTINGS AND PRINTS, by James Thrall Soby. 1945; 3rd ed. 1947. 142 pages; 131 illustrations.* (A)

HENRI ROUSSEAU, by Daniel Catton Rich. 1942; 2nd rev. ed. 1946. 80 pages; 53 illustrations.* (A)

HENRI ROUSSEAU, essays by Roger Shattuck, Henri Béhar, Michel Hoog, and Carolyn Lanchner and William Rubin. 1984. 272 pages; 233 illustrations (66 in color).

KURT SCHWITTERS, by John Elderfield. 1983. 424 pages; 356 illustrations (32 in color). Pub. with Thames and Hudson.*

SEURAT: PAINTINGS AND DRAWINGS, edited by Daniel Catton Rich. 1958. 92 pages; 66 illustrations (4 in color).*

SEURAT, see also CÉZANNE, GAUGUIN, SEURAT, VAN GOGH

BEN SHAHN, by James Thrall Soby. 1947. 52 pages; 34 illustrations (16 in color).*

CHARLES SHEELER: PAINTINGS, DRAWINGS, PHOTOGRAPHS, introduction by William Carlos Williams. 1939. 54 pages; 31 illustrations.* (A)

FRANK STELLA, by William Rubin. 1970. 176 pages; 101 illustrations (18 in color).

FRANK STELLA: 1970–1987, by William Rubin. 1987. 172 pages; 203 illustrations (74 in color).

HENRI DE TOULOUSE-LAUTREC: IMAGES OF THE 1890s, edited by Riva Castleman and Wolfgang Wittrock; essays by Matthias Arnold, Julia Frey, and Phillip Dennis Cate. 1985. 254 pages; 293 illustrations (94 in color).

TOULOUSE-LAUTREC, see also LAUTREC–REDON

ÉDOUARD VUILLARD, by Andrew Carnduff Ritchie. 1954. 104 pages; 91 illustrations.* (A)

ANDY WARHOL: A RETROSPECTIVE, edited and with an introduction by Kynaston McShine; essays by Robert Rosenblum, Benjamin H. D. Buchloh, and Marco Livingstone. 1989. 480 pages; 646 illustrations (287 in color).

ACKNOWLEDGMENTS

MY FIRST THANKS go to the staff of the Museum's information desk and bookstore, whose unremitting reports over many years of the public's demand for material on the collection provided the impetus for writing this book. I am grateful to Richard E. Oldenburg, Director of the Museum, for entrusting me with this task, and to William Rubin, Director Emeritus of Painting and Sculpture, who, in addition to approving the selection of paintings for the original edition, was the first to propose the inclusion of three-dimensional works in this revised version. Kirk Varnedoe, Director of Painting and Sculpture, was consulted on the selection for the present edition and kindly read the completed manuscript.

Encouragement and valuable editorial advice for the first edition were given by Carl Morse, then Editor-in-Chief. Betsy Jones, former Curator of Painting and Sculpture, read the manuscript and through her unparalleled knowledge of the collection eliminated a number of factual errors. The design of the original edition was skillfully devised by Carl Laanes, and adapting and building on this basis Jody Hanson, Assistant Director of Graphics, and Michael Hentges, Director of Graphics, ably produced the present layout.

Among those in the Department of Publications, under its Director, Osa Brown, to whom I am indebted for assistance, my greatest thanks go to Harriet Schoenholz Bee, Managing Editor, whose constant encouragement and enthusiastic support have been matched by her editorial acumen. Her patient and painstaking attention to detail and that of Jessica Altholz, Assistant Editor, rescued the author from numerous inaccuracies. Word processing of the manuscript was efficiently performed by Barbara Ross. Vicki Drake, Associate Production Manager, brought her high standards of quality to the supervision of production. Nancy T. Kranz, Manager of Promotion and Special Services, contributed information for the preparation of the selected bibliography.

In the Department of Painting and Sculpture, I benefited particularly from the cooperation of Victoria Garvin, Assistant to the Director; Judith Cousins, Researcher; and Mary Beth Smalley and Ann Umland, Curatorial Assistants. The staff of the Library was as always unfailingly helpful; I owe particular thanks to Janis Ekdahl, Executive Secretary, and Daniel Starr, Associate Librarian, Cataloguing.

With his customary goodwill, Richard Tooke, Supervisor of Rights and Reproductions, undertook the task of assembling the existing color transparencies and coordinating the large quantity of new photography required, ably produced by the Fine Arts Photographers, Kate Keller, Chief, and Mali Olatunji.

—H. M. F.

PHOTOGRAPH CREDITS

LIST OF ILLUSTRATIONS